From Greenwich Village to Taos

CultureAmerica

Karal Ann Marling and Erika Doss
SERIES EDITORS

Published in cooperation with the
William P. Clements Center for Southwest Studies,
Southern Methodist University

From Greenwich Village to Taos

Primitivism and Place
at Mabel Dodge Luhan's

Flannery Burke

UNIVERSITY PRESS OF KANSAS

Portions of Chapter 6 first appeared in "An Artist's Home: Gender and the Santa Fe Culture Center Controversy," *Journal of the Southwest* 46, no. 2 (2004): 351–379.

Published by the University Press of Kansas (Lawrence, Kansas 66045), which was organized by the Kansas Board of Regents and is operated and funded by Emporia State University, Fort Hays State University, Kansas State University, Pittsburg State University, the University of Kansas, and Wichita State University

Library of Congress Cataloging-in-Publication Data
Burke, Flannery.
From Greenwich Village to Taos : primitivism and place at Mabel Dodge Luhan's / Flannery Burke.
p. cm. — (CultureAmerica)
Includes bibliographical references and index.
ISBN 978-0-7006-1579-7 (cloth : alk. paper)
1. Luhan, Mabel Dodge, 1879–1962. 2. Luhan, Mabel Dodge, 1879–1962—Friends and associates. 3. Luhan, Mabel Dodge, 1879–1962—Homes and haunts. 4. Intellectuals—United States—Biography. 5. Taos (N.M.)—Intellectual life. 6. Radicalism—New Mexico—Taos. 7. Subculture—New Mexico—Taos. I. Title.
CT275.L838B87 2008
978.9'53092—dc22
[B]
2008003948

British Library Cataloguing-in-Publication Data is available.

Printed in the United States of America

10 9 8 7 6 5 4 3 2 1

The paper used in this publication is recycled and contains 30 percent postconsumer waste. It is acid free and meets the minimum requirements of the American National Standard for Permanence of Paper for Printed Library Materials Z39.48-1992.D-DH

Contents

Acknowledgments

I have fantasized many times about finding myself at Mabel Dodge's salon in New York or at her home in Taos, New Mexico, and each time it has been the diversity of guests and their passion for their individual projects that have made the fantasy a compelling one. How delightful to realize, then, that this book has introduced me to a similarly broad range of talented companions.

I first thank Bill Cronon at the University of Wisconsin–Madison for his untiring support for me and my work and for the generosity of spirit and curiosity that allow him to see the promise in what I do. I arrived at Madison because Sharon Ullman at Bryn Mawr College told me that I could be a historian if I really wanted to, and she taught history in a way that made me really want to. At Madison, the Havens Center series on Chicano/a studies; conversations with Cherene Sherrard, Bruce Burgett, Julie D'Acci, Michele Hilmes; and the supportive community surrounding Nancy Worcester in the Department of Women's Studies introduced me to the excitement and challenges of interdisciplinary work. As much as I enjoyed my ventures outside the History Department, I always tried to take the discipline and intellectual rigor I had learned in my history classes with me. Jeanne Boydston, Linda Gordon, Steve Sterne, Suzanne Desan, Steve Kantrowitz, Tony Michels, and Paul Boyer repeatedly insisted that I ground myself in the painstaking work that is everyday practice for historians, and I appreciate their never-ending patience with my progress.

My colleagues at Madison kept me going through seemingly interminable winters, and Bill's breakfast meetings provided weekly inspiration from my peers. I owe special thanks to Hannah Nyala, Marsha Weisiger, Honor Sachs, Karen Spierling, Greg Summers, Lisa Levenstein, Thea Browder, Sarah Costello, Laura McEnaney, Deirdre Egan, Abby Markwyn, and Joe Cullon, who were always willing to listen (and listen they did!) and to remind me gently that this was a project I wanted to finish. Louise Pubols not only listened to me, she fed and housed me and provided a welcome to Los Angeles and the

Huntington Library (perhaps the most magical of places for a scholar). I know that all of these individuals had more important things on their mind than helping me find my feet in the world of academe. That they have produced stunning scholarship while also extending their friendship only makes their work more impressive.

My writing group is the most heavenly collection of individuals any historian could assemble. Katie Benton-Cohen doesn't balk at anything, including some of the pieces of writing I handed to her. I am humbled by the idea that our books might someday share space together on the same shelf. If I had the right connections I would nominate Jenka Sokol as the patron saint of western historians. I would like to be as patient and kind and gracious as Jenka someday, but if I never achieve it, it will only be because I'm human. I don't know how to thank Thomas Andrews properly. There is no part of my professional life he has not improved. He started our group, kept it going as we scattered to all corners of the country, and remained steady, brilliant, kind, and generous throughout, all the while producing stellar work of his own. When we started working together at California State University–Northridge, I felt like we were sitting back-to-back in a field, holding each other up as we took in different parts of where we were. We're farther apart now, but I know we will support each other still.

I could never have finished this book without financial assistance. Hannah Nyala worked some kind of magic to find me a fellowship to head off to my first archive. Fellowships and awards from the Huntington Library, the Smithsonian Institution, the Southern Methodist University Clements Center for Southwest Studies, the Beinecke Rare Book and Manuscript Library, the Charles Redd Center for Western Studies, the Harry Ransom Humanities Research Center at the University of Texas–Austin, the California State University–Northridge College for Social and Behavioral Sciences, the Autry National Center Institute of the American West and its Women of the West Museum funded research and writing time and brought me into a host of stimulating intellectual environments.

Indeed, it is the intellectual camaraderie that I most appreciate. At the Huntington, Carla Bittle and Andrew Lewis helped me through my first plunge from research to writing. I hold Bill Deverell and Amy Meyers responsible for my addiction to Los Angeles. Their visual culture interpretative seminar held jointly at the Huntington and the California Institute of Technology, and funded by the Andrew Mellon Foundation, introduced me to the city and

insured that I would never encounter a place again without thinking long and hard about how it came to look as it did. My seminar mates provided one of the best academic experiences of my career and continue to make academic life enjoyable. Ryan Carey has continued to provide inspiration, entertainment, and provocation in equal measure. Jen Seltz pushes me in all the right directions with kindness and good humor. Paul Karlstrom, Virginia Mecklenberg, Bill Truettner, and Liza Kirwin of the Smithsonian welcomed me during my first foray into the world of art history and encouraged my project on both coasts. I am especially grateful to Sherry Smith, David Weber, Alexis McCrossen, Ben Johnson, Michelle Nickerson, Andrea Boardman, Ruth Ann Elmore, and my fellow "fellas," Colleen O'Neill and Tisa Wenger, for the wonderful year I spent at Southern Methodist University, incisive commentary on my manuscript, and enthusiasm for all things New Mexican and southwestern. The Clements Center manuscript workshops are a brilliant idea, and my own workshop improved this book immeasurably. I am especially grateful to Phil Deloria, Sharyn Udall, and Lois Rudnick (who read the whole book twice!), whose scholarship, insights, and commentary insured that I would at least try to match the enviable examples each have set. Although he was not present, he has been so helpful that I have begun to imagine David Wrobel at my workshop, offering gentle corrections and cheerful suggestions. He has been incredibly generous with his time and support, and I can't imagine that this book would exist without him. At the Ransom Center, staff members steered me through both the art and letters of those who visited Mabel Dodge and introduced me to some of the lesser-known writings of her visitors. At Northridge I have found colleagues who share my enthusiasm for teaching and have graciously shared their abilities to balance instruction and scholarship. The Department of History reading group; my fellow Whitsett Committee members, Tom Maddux, Merry Ovnick, Josh Sides, and Thomas Andrews; along with Tom Devine, Patricia Juarez-Dappe, Susan Fitzpatrick-Behrens, Clementine Oliver, and Jeffrey Auerbach, have all provided useful comments and consistent support. All of my students inspire me, but I owe a special debt to Paula Ellias, whose thesis work led me to reconsider some of my own conclusions and whose own work ethic is an inspiration to us all. Steve Aron, Gingy Scharff, Louise Pubols, and Erik Greenberg have made the Autry an even more fabulous place to be for a western historian. I am grateful to each of them and to those who attend the Autry's monthly workshop for comments on my work and support for my project.

At the Huntington, Peter Blodgett, Jennifer Martinez, and Jenny Watts deserve my thanks for helping me find my way through the Huntington collections. At the Beinecke, George Miles helped me connect Mabel Dodge's story to that of the American West. The staff at the Smithsonian Archives of American Art let me hole up in their offices while they were in the middle of moving, fixed innumerable microfilm machines for me, and made me feel welcome. The University of Wisconsin libraries, the State Historical Society of Wisconsin, Seton Hall University Library, and the West Orange Public Library always provided just the book I needed. I am extraordinarily grateful to the government document librarians at the Los Angeles Public Library, who helped me track down Pablo Abeita's congressional testimony. I will always be indebted to Lee Wilson, who introduced me to the governor of Taos Pueblo, Gilbert Suazo. Mr. Suazo then facilitated interviews with members of Tony Lujan's family—Juan, Jimmy, and Natividad Suazo and Alfred Lujan. Their memories of Dodge and Lujan were invaluable to my project, and I am honored that they shared their recollections with me. Nancy Scott Jackson, Kalyani Fernando, Larisa Martin, Melanie Stafford, Susan Schott, and staff members at the University Press of Kansas insured that this book made it into print and proved to be unfailing cheerleaders and graceful teachers.

Many friends shared their passion for New Mexico as I worked on this book. I first met Lisa Krassner, Tarra Hassin, Anneke Swinehart, and Mohan Ambikaipaker in the mountains of New Mexico, and I am grateful to each of them for never forgetting the inspiration that we found there. Amanda Rounsaville helped me recast some of my work in a more creative form and generously provided a sounding board for my ramblings. This book, in many ways, began when I was twelve years old and met Maria Archuleta. Since then, we have talked about writing and about loving the places we live in and about how to make a difference in the world, and, of course, about New Mexico. We will always have home when we talk to each other.

Every member of my family supported me as I struggled through this project. To Jim, Aleda, Kristen, Aaron, Nathan, Jesse, Joel, Dena, Justin, Terri, Sharon, Tom, Dena, Erin, August, little August, Philip, Mallory, Michael, Roch, Pre, Sarah, Travis, Helen, Brett, Maren, Connor, Kris, Terri, Thomas, Frank, Diane, and Amy, thank you. My brother Martin made me laugh and made me think in equal measure. He also let me keep a photo of himself jumping from what looks like a perilous height into the falls at Havasu Canyon. His courage and sense of adventure have inspired me every time I sat down at my desk and tried to write.

This book is dedicated to my parents, Sandra and Gary Haug, whose patience with me and this project has been extraordinary. A local and a transplant, my parents taught me to see New Mexico through their eyes. Avid readers both, they taught me to love books. I do hope this one is worthy of their enthusiasm.

Finally, I want to thank my son, Kevin, whose smile provides much-needed perspective, and my husband Pat. In every home we have shared, there has been a place, somewhere between Pat's desk and mine, where we have met and hugged before sitting at the other's keyboard to help with the arduous process of writing. I am grateful for that place, and I am grateful for him.

Flannery Burke

Introduction:
A World Apart

On November 4, 2001, the *New York Times* published a lighter piece than normal for its section "A Nation Challenged." The article ran under two headlines. The first, in smaller type, read, briefly, "Off the Grid." The second was more sensational: "Coming to Terms with Ground Zero Terror in a World Apart." The "world apart" of the title was Taos, New Mexico, and the article emphasized Taos's remote location in the mountains, its beauty, and its distance from the confusion and stress of places farther east. According to the *Times* reporter, the people of Taos were satisfied with their community in "this ruggedly beautiful haven for drop-outs from the American mainstream." A local architect was pleased to note that more visitors were investigating his solar-powered alternative homes as they "anxiously considered a retreat from conventional modernity." Newcomers were apparently attracted by the town's reputation as "the quintessential American sanctuary for retiring 20th-century protesters, New Age thinkers, astral travelers, philosophical upstarts, funky tramps, determined artists, and unabashed lovers of the beauty-steeped mix of the mesa and Sangre de Cristo Mountains."[1] In short, Taos provided an ideal retreat from the confusion plaguing New York City. It was a haven from modernity, a refuge of natural beauty, and an island of calm in a suddenly anxious nation.

Although the article ran in a section usually devoted to issues of national security, international diplomacy, and the new military endeavor of "homeland defense," its author never mentioned Los Alamos National Laboratories, one of the nation's premier defense research centers, located a scant sixty miles from Taos. Nor did the *Times* feel it necessary to include any mention of

Nuevomexicanos, those who claim descent from Spanish colonists and iden-
tify New Mexico as a homeland.[2] In keeping with its New Age portrait of Taos,
the *Times* did address the influence of Native American spiritual traditions on
Taos residents and their reactions to the events of September 11, 2001, but the
rituals described were those of the Lakota Nation of the northern Great
Plains, not the local Taos Pueblo Indians. Nor did the *Times* feel it necessary
to address the centuries-long history of conflict and accommodation between
descendents of Spanish settlers and the indigenous people of the Southwest.
With its timeless spirituality, and voided of modern military technology and
ethnic complexity, Taos seemed like an alternate universe where the rules of
the modern world did not apply. *Times* readers unfamiliar with Taos probably
had little trouble agreeing that the place is "a world apart."

This book is the story of a world apart and the people who called it home.
Between 1917 and 1929, a series of visitors to the Taos home of Mabel Dodge
Luhan transformed northern New Mexico into a cultural hinterland for those
on the avant-garde of cultural expression in New York City. Although promo-
tion for the Atchison, Topeka, and Santa Fe Railroad; booster activism; and a
nationwide quest for authentic experience had already connected aesthetic net-
works in southern California and Chicago to northern New Mexico, particularly
to Santa Fe, Dodge's household would cement Taos's reputation as a "haven for
drop-outs from the American mainstream."[3] Drawing on their experience in
bohemian circles in Greenwich Village, Dodge and her visitors sought to cre-
ate in Taos what they had dreamed of finding in New York: a naturally beauti-
ful place in which their passions for art and political activism united.

Dodge and her guests believed firmly that Taos was the place they had set
out to find, and when Taos failed to meet their expectations, they changed
Taos. Local New Mexicans accepted, altered, and challenged the changes that
Dodge and her friends wrought. Their dialogue with Dodge's visitors had an
impact far beyond aesthetic expression. Together, Dodge's visitors and New
Mexican locals shifted land ownership patterns in New Mexico, transformed
the racial language of art patronage efforts both in New Mexico and in New
York City, established northern New Mexico's reputation as an ideal destina-
tion for artists and writers, and intimately connected that reputation to ideas
about the role of women in arts production and consumption in Taos. The in-
teraction between the Dodge household and native New Mexicans made Taos
very much a part of the world, yet, paradoxically, the legacy of their discus-
sions, battles, and collaborations left an image of a place far off the grid.

Our story begins with Mabel Dodge Luhan. Most readers familiar with her know her as a Greenwich Village salon hostess or as an "expatriate" who moved to Taos in its early days as an art colony and married Tony Lujan, a Taos Indian. She is a common figure in books about the Greenwich Village scene of the 1910s and the early twentieth-century artists' havens of northern New Mexico. Because she hosted guests as diverse as artist Georgia O'Keeffe, modernist writers D. H. Lawrence and Gertrude Stein, and journalist John Reed, she also appears frequently in cultural histories of that time period. Before establishing her salon in New York City, she hosted a diverse range of creative and talented guests at a home she shared with one of her previous husbands in Florence, Italy. Growing up in Santa Fe, I learned to resent her. Sure, chambers of commerce liked to tout her and the guests she lured to Taos, but many locals saw her as an Anglo interloper, a rich white woman from back East who thought that she could be fulfilled if she called an Indian her husband and Taos her home. As a child, I absorbed these opinions even as I fantasized about New York City and imagined it filled with women like Mabel Dodge who entertained guests from all walks of life. Although I am Anglo myself, my family goes back at least five generations in New Mexico and reflects that region's diverse peoples. I felt sufficiently local to pass judgment on Dodge.

That she changed the spelling of her last name by substituting an "h" for the soft Spanish "j" especially bothered me. This was one of the first steps, I thought, in the transformation of northern New Mexico from a proud, rural community with living indigenous and Spanish traditions into a playground for rich and superficial outsiders. When the comfort of white New Yorkers' tongues outweighed linguistic tradition, surely that was when the region ceased to belong to those who lived there.

Years later, investigation of John Reed's coverage of the Mexican Revolution led me to consider what New Yorkers saw in the southwestern landscape, and I found myself reconsidering Mabel Dodge Luhan's role in New Mexico. She had a sharp mind, a curious soul, and an iron will. Though wealth allowed her greater latitude than other women had in her life choices, it did not provide the freedom of career that a woman like her would probably seek today. I developed admiration for Mabel Dodge Luhan. Like myself, she adored the landscape surrounding Taos. Indeed, she dedicated much of her life to its celebration. Moreover, were it not for her, the enthusiasm and public support for artistic expression and an artist's life that I witnessed growing up in northern New Mexico might hardly be present. As my work progressed, I realized

that it was through her that I and many other historians were introduced to the community of artists I believe was responsible for the dominant cultural trends of the early twentieth century. Mabel Dodge Luhan even taught me to love New York City, a more dramatic transformation for a proud westerner like myself than it might seem. After years of wrestling, I have learned to know Mabel Dodge Luhan in the way that her peers knew her, as a hostess and a guide to the American bohemian community of the early twentieth century and as a keen appreciator of New Mexico.

I am not the first person to wrestle with Mabel Dodge. (Nor am I the first to wrestle with her name. I call her Dodge because that is the name she had when my narrative begins and because it allows me, without causing confusion, to refer to her husband by the name Lujan, with its proper Spanish spelling.) In addition to the substantial secondary literature regarding Dodge, she left her own weighty collection of materials related to her life. Dodge wrote four volumes of autobiography that were published during her lifetime, and five that were not. The sheer mass of her collection, combined with the force of her personality, have led me on more than one occasion to imagine myself in conversation with her. In these conversations, she pushes me to tell her story again—the way that she told it in her volumes of autobiography. Dodge's voice has sometimes been so insistent that I have felt compelled to remind her that she is dead. Without the aid of biographies and historical criticism of Dodge's time in New York and New Mexico, I could never have held my own in this battle with her.[4] On the one hand, I wanted to celebrate Dodge as an unconventional woman who had brought New Mexico international acclaim. On the other hand, I wanted to make clear the opinion of her that I and many other locals held: she was a meddler who took advantage of New Mexican culture. In my imagined conversations with her, Dodge tended to favor the first presentation and eschew the second. Scholars who address the gendered dynamics of northern New Mexico's cultural community helped me to balance these competing and skewed portraits. Their work, which shows how Dodge struggled with gendered expectations but also used such expectations to further her efforts, allowed me to place her in proper perspective.[5] With the assistance of such insights, I have managed to convince Dodge to serve as a guide to her times and to the community of artists, writers, and activists whom she hosted.

This community and its relationship to three significant concepts—modernism, primitivism, and place—are the subjects of this book. The individuals who made up this community, a group that I call alternately the Dodge salon or the Dodge art colony, had many interests in common and a vast

number of differences. Dodge exploited these differences mercilessly—some-
times manipulating her guests discreetly, sometimes fighting with them
openly. Having felt compelled to remind her that she is dead in the course of
my research, I can only imagine how others responded to her when she was
alive. Although the conflicts she fomented or merely witnessed have made
my work fascinating, they also made it all the harder. I was looking for a com-
mon theme among her peers beyond their mere presence in her home, and
initially, I kept coming up short. The briefest of surveys of Dodge's associates
reveals a contradictory mess of goals. During Dodge's New York years, while
Gertrude Stein toyed with revolutionary (and nearly incomprehensible) narra-
tive structure in a famous written "portrait" of Dodge, Dodge herself toyed
with revolutionary politics in her support of the Paterson Pageant, a dramati-
zation of the 1913 Paterson, New Jersey, silk workers' strike. While John Reed
trailed after Pancho Villa in his coverage of the Mexican Revolution, Marsden
Hartley began experimenting with abstraction in his painting. While Eliza-
beth Duncan taught her sister Isadora's dance techniques on Dodge's country
estate, Dodge's third husband, the sculptor Maurice Sterne, made paintings
of Maine's rocks. After Dodge settled in New Mexico, Indian rights advocate _web_
John Collier battled in Congress while D. H. Lawrence set up house on
Dodge's land and began laying the foundations for his novel _The Plumed Ser-
pent_. While writer Witter Bynner satirized Anglo women artists in New Mex-
ico, Anglo women artists created an arts community open to gay men like
Bynner. There is no doubt that Dodge's homes would have been intriguing
places to be, but finding a common thread among such diverse individuals
and creative endeavors was no easy task.

From this cacophony of contradictory voices, though, I demanded an an-
swer to one consistent question: Why Taos? Many of those who surrounded
Dodge possessed both the financial and personal resources to seek refuge in
any number of places. Indeed, Dodge herself had created a refuge of sorts at
her Italian villa, and Greenwich Village served as a place apart from the bustle
of the city for many of her salon guests. What made Taos ideal? The more I
asked the question, the more often I found Dodge and her peers preoccupied
with how the places in which they lived influenced the work they produced.
From the skyscrapers of New York City to the ancient marble of Florence,
Italy, to the dunes of Provincetown, Massachusetts, to the countryside of the
Hudson River Valley, and finally, to the terraced Pueblo lodgings of northern
New Mexico, Dodge's associates dwelled on the quality of the air, the shape of
the waves, the sound of the wind, the reach of the trees, the strength of the

mountains, the stretch of the sky, and the personal characteristics of those who identified with the places in which they lived. Lest some readers dismiss these concerns as the absent-minded musings of artists caught in moments of reverie, it is worth noting that often these preoccupations led this group of artists, writers, intellectuals, and activists to protest inequitable living and working conditions, fund institutions of education, participate in national Indian policy, contribute to the nascent tourist industry of the West, and create what many critics recognize today as the foundational works of American modernist art and literature. The members of the Dodge salon, then, had far more in common than time spent in her living room. For all of them, place mattered.

Of course, Dodge's salon was not the first group of people to go looking for an ideal place, and they were not the first to claim that they had found one. Utopian communities, transcendentalists, and the arts and crafts movement provide ample precedent for the activities of Dodge and her friends. From the early nineteenth century until the Dodge salon's own move to Taos in the late 1910s and early 1920s, American artists, writers, intellectuals, and activists gathered on farms in western Massachusetts and upstate New York and along the coasts in New England, California, and Oregon. Expatriate communities in Europe, including the one surrounding Dodge's friend Gertrude Stein, occasionally cast their gaze to East Asia, seeking in "the Orient" a sense of belonging. Even the residents of Taos and Santa Fe had already watched newcomers establish art colonies in their midst. Like Dodge and her cohort, the members of these earlier communities were looking for a naturally beautiful place in which they could explore an authentic connection to the natural world, their own work, and their companions.[6] The quest for an ideal place, particularly a place apart, was not new to the United States or to Dodge's generation. Nonetheless, the changes that occurred in the United States in the late nineteenth and early twentieth centuries gave the quest of Dodge and her friends a particular urgency, an urgency both they and later historians have associated with modernity.

Modernism

In the early days of their salon, Dodge and her associates embraced an image of themselves as modern. They often called themselves "modern," and they

loved to apply the adjective "new" to everything they did. Many of their efforts were focused on finding the next new thing in art, politics, literature, theater, dance, and class relations. The women of their circle were New Women; they soon offered support to the African American artists and writers known as New Negroes; and everyone in Dodge's milieu was following developments in new art, new politics, and new theater.[7] The disparate nature of their interests did not bother Dodge and her friends. They frequently expressed faith that they could combine what was modern in politics, art, and social interactions into a single project.

What the Dodge salon meant by "modern" presents a terminological quandary. The salon's members called themselves modern. Moreover, that the salon patronized the abstract art and pared-down literature scholars today still associate with modernism leads to the conclusion that the salon's interests were modernist. The art colony's later interest in places without factories, skyscrapers, and dense populations, however, presents the possibility that the colony's interests were not modern.[8] Like an earlier generation of intellectuals who questioned modern advances, Dodge and her friends were skeptical of their own privilege. They were nervous about class inequality, their separation from the processes that put food on their tables and clothes on their backs, and the growing cacophony of noise that seemed to accompany modernity. And, like earlier antimodernists, Dodge and her friends were obsessed with authenticity. They fed their enthusiasm for the New Woman, the new theater, and the new politics with their faith in an authentic womanly nature, a pure form of theatrical expression, and a genuine democratic impulse. Authenticity, framed in this way, was modernity's antidote, antimodernism the cure for the evils of modernity.[9]

But the members of Dodge's salon, even when they settled permanently in Taos, never abandoned the modernist art and literature that was their greatest source of enthusiasm. Indeed, the aesthetic sensibility of modern art and literature often drove Dodge and her peers to political involvement and activism.[10] This was particularly true for Dodge herself. In her study of white appropriations of Indian identity, Sherry Smith acknowledges that the modern world left Dodge unsatisfied and that Taos, particularly through Dodge's relationship with Lujan, "provided the perfect place for an American antimodern woman."[11] Smith, however, looks at the entire trajectory of Dodge's time in Taos and concludes that Dodge's volumes of autobiography give a skewed portrait of her years there. In reality, Smith argues, Dodge "never did

leave her world behind. She never could nor did she truly want to. What Mabel hoped to do was transform the world, not forsake it. Moreover, she tried hard, through force of will and the lure of her Taos place, to bring her world of artists and writers to New Mexico."[12] Smith argues that despite her antimodernist public persona, Dodge's true identity was a modern one, and that the task to which she dedicated herself was to bring the celebrants of modern art to Taos.[13]

Primitivism

To see Dodge's salon and the art colony surrounding Dodge's Taos home as products of modernist artistic and literary trends it is necessary to understand the racial relationships that formed in both arenas. As modernists, Dodge and her visitors had already been exposed to what critics call "primitivist" art and literature when they arrived in Taos. They had collected art created by people whom they regarded as primitive. They had seen art created by European artists like Picasso that took its inspiration from African art. The smooth lines and abstraction that marked modern art predisposed many modernists to favor art that was outside the western European mode. Indeed, they would thrill to the artwork of the Pueblo Indians in part because they found it "modern by tradition."[14] Within Dodge's salon and places like it, modernists also nurtured theories that celebrated so-called primitive people for their simplicity, their closeness to nature, their spirituality, and their spontaneity. Modernists saw in "primitives" and their artistic practices what they believed were the solutions to the problems of modernity.[15] Primitivism, then, was a part of modernist movements, and it would mark the relationships between Dodge's household and the local New Mexicans whom she encountered.[16]

Conversations about primitive authenticity were widespread in the 1910s and 1920s. Dodge and her friends sought out Taos at just the moment when some arts and crafts patrons were arguing that the poor, white inhabitants of the Appalachian Mountains reflected the essence of American identity, and at a time when other white patrons seized on African American artists, musicians, and writers as the epitome of American cultural expression.[17] Native Americans, in particular, drew the interest of white primitivists in the early twentieth century. As a symbol of the past, the authentic, the pure, the natural, and the spiritual, Native Americans appeared repeatedly in primitivists'

representations.[18] Indeed, Dodge and her peers were not even the first to cast a primitivist eye toward indigenous inhabitants of New Mexico. Scholars, artists, and writers associated with the Santa Fe institutions created by anthropologist Edgar L. Hewett promoted northern New Mexico, and particularly the city of Santa Fe, using primitivist themes and rhetoric.[19] Some Santa Fe artists and writers even promoted both Pueblo Indians and Nuevomexicanos in similar primitivist terms. Primitivist perspectives, then, were unique neither to Dodge and her peers nor to New Mexico.

Extensive scholarly study of primitivism within and outside New Mexico allows me to place in dialogue multiple groups of primitivists and those they patronized. Scholars have shown repeatedly that the quest to find a world apart in northern New Mexico was profoundly modern. It was the nature of that modern pursuit to disguise itself by casting the Pueblo Indians as everything civilization was not, that is, as primitive.[20] Scholars have also returned repeatedly to the racial dynamics of primitivist relationships both within and far outside New Mexico. They have focused, in particular, on the agency of nonwhite people who benefited from white patrons but also suffered conscription to a world presumably outside the bounds of modernity.[21] Patronized people often had an ambivalent relationship both to their patrons and to the idea of race itself. With these insights as my foundation, I asked what happened in northern New Mexico when multiple patrons encountered many people of many different races who seemed to fulfill various patrons' primitivist visions?

Just such a combination of people mingled in Dodge's salon and in her Taos household: African American writers seeking entry to the publishing world, white writers seeking authentic material, Native American artists seeking patrons, Nuevomexicanos seeking respect for their cultural traditions, white artists seeking the key to abstraction. Within this milieu, I show that primitivism was not a white discourse about a single nonwhite other, but rather a white discourse about multiple nonwhite others. Via the network of Dodge's salon and colony, discussions of primitivism in New Mexico, which focused on Native Americans, intersected with discussions of primitivism in New York, which focused on African Americans. Although this primitivist network allowed white patrons to patronize (in all senses of that word) Native Americans, African Americans, and Nuevomexicanos, it also allowed patronized people to reflect on and compare their experiences. I focus here on how Native Americans and African Americans considered the primitivist patronage

that they received. Few native people or African Americans actively challenged the power that patrons within Dodge's network exercised, but they do appear to have reconsidered their own position. My study provides insight into the subjectivity of patronized people and their thoughts on primitivism. Their thoughts and responses to their patrons allow us to imagine a diverse and complicated cultural landscape in the early twentieth-century United States—a landscape that had its roots in the actual land.

Place

Indeed, as Dodge and her peers passed from urban salon to country retreat to northern New Mexican art colony, they forged, in their art and their writing and even in their politics, an inextricable link between places and the people who called those places home. Most of Dodge's guests were primitivists, to be sure, but they formed their primitivism while on a quest for a place where they felt they could belong. When Dodge and her allies repeatedly insisted that Native American people had an authentic and deep connection to the earth, they did so in part because they, themselves, sought an authentic and deep connection to the earth. When Dodge contrasted Native Americans with African Americans, she contrasted Taos and Harlem. People and place were inseparable parts of a single agenda.

For each of Dodge's guests, however, an ideal place had a different meaning. As a result, each of them saw the charms and challenges of Taos and the broader space of northern New Mexico differently. Their portrayals of Taos and its environs depended, in large part, on how they understood the idea of place itself. For some, place meant their status in gender and racial hierarchies as much as it did a geographic region. For others, place meant their role within the broader community of artists, writers, and activists who made up Dodge's orbit. For still others, place meant the sensual qualities of northern New Mexico's landscape. And for still others, place meant the land of New Mexico itself. Each of these places intersected as Dodge, her visitors, and local New Mexicans negotiated how they would claim Taos as their own.

The chapters that follow parallel the structure of this experience for those who made up or interacted with Dodge's Taos household. Each chapter presents a place as it took shape for a different individual. Throughout, I note the dialogue between ideas of primitivism and ideas of place that marked the im-

pact of Dodge's household on northern New Mexico. In some cases this dialogue took especially concrete form, as when John Collier threw himself into Indian affairs to defend New Mexico's Pueblo Indian land rights, or when local Nuevomexicana Nina Otero-Warren objected to the terms of his defense. In other cases, this dialogue existed in the realm of creative expression, as when Mabel Dodge and her salon celebrated the New York Armory Show, or when D. H. Lawrence struggled to represent both the land and the people of New Mexico in modernist and misogynist prose. In still other cases, it is difficult to separate the material from the aesthetic among Dodge's friends, as when Tony Lujan insisted that Dodge end her romantic pursuit of African American writer Jean Toomer, or when writer Mary Austin invoked her identity as both a woman and an artist in a campaign against a Texas women's summer culture colony. From this kaleidoscope of places emerges a vision of what place meant to modernist creative workers as well as a narrative of what happened in the real place of northern New Mexico when visitors decided it was the place where they belonged.[22]

There are as many visions of New Mexico as there are visitors to and residents of the area, and I cannot offer a permanent and comprehensive view of the region. What I can do is highlight previously overlooked connections and meanings that affected not just northern New Mexico but wider cultural trends in the early twentieth century. In this regard, too, I am indebted to other scholars. Through extensive and painstaking work, academics have recreated the world of early twentieth-century northern New Mexico. They have revealed how northern New Mexico began to market itself as a "land of enchantment," how that image has penetrated the national consciousness, how New Mexico's Indians and Nuevomexicano residents have participated in the formation of and resistance to such an image, and how that image has persistently covered over the poverty and ethnic tensions that continue to plague New Mexico residents.[23] Such scholarship provides the foundation of this study and also fills many of the gaps left by it. Existing research on New Mexico has allowed me three luxuries, each of which has yielded new insights. First, I have been able to focus almost exclusively on the Dodge salon and art colony, and give my full attention to how they articulated their longing for an ideal place in modernist and primitivist terms. Second, I have been able to highlight the dialogue between promotional efforts in Santa Fe, which have had the most enduring impact on the public image of New Mexico, and aesthetic and political activities in Taos, which reflect more ambivalence toward

the region's promotion, and which have received less historical attention. Finally, scholarship on New Mexico has allowed me to leave the state altogether to consider New York, where New Mexico's land and people left a lasting imprint on how artists, writers, and activists imagined their place in the world.

That New Yorkers still turn to northern New Mexico as a world apart during times of modern stress is an indication of just how deep that imprint was. Although I cannot reverse, erase, or expunge this image from the historical record, I hope the pages that follow drain it of some of its power. For artists and writers to have a positive impact outside aesthetics, they must remain present in the world they portray and seek to change. A world apart is not a world creative people can change for the better. Moreover, for New Mexicans to engage in modern political battles, address modern economic ills, and promote modern New Mexican culture, northern New Mexicans need an image of themselves that makes them a part of the world rather than residents of a world apart. As long as New Mexico's "untouched" and "primitive" beauty allows outsiders and locals alike to view the region as outside time, few of the area's problems are likely to find genuine solutions. This book journeys to a world apart not to revel in it but finally to leave that world behind.

Mabel Dodge's Place

In 1913, Mabel Dodge's living room in Greenwich Village was hopping. On Wednesday evenings Dodge gathered just about everybody who was anybody. Radical journalists, anarchist activists, gallery owners, artists, and writers rubbed shoulders as they argued over the ties between art and politics and jostled for food at Dodge's well-stocked table. John Reed, the romantic journalist who later covered the Russian Revolution in *Ten Days That Shook the World*, was Dodge's lover. Max Eastman, the editor of the radical journal the *Masses*, visited regularly. Emma Goldman, Big Bill Haywood, Alfred Stieglitz, and Georgia O'Keeffe were just a few of the activists and artists who wandered through Dodge's door and later found widespread fame. Dodge herself was not an artist or a writer or an activist. At thirty-four years old, Dodge was wealthy, twice-married, familiar with the principles of free love, and well-connected, having hosted Gertrude Stein and prominent European cultural figures when she lived in a villa in Florence. A background of wealth, bohemian inclinations, and cultural connections made her the person to know in Greenwich Village.

Dodge's salon nurtured three experiments in the years preceding World War I that would have a significant influence on how she viewed Taos: the Armory Show of modern art; a theatrical representation of a Paterson, New Jersey, textile strike; and Reed's coverage of the Mexican Revolution for the *Metropolitan*, a New York newspaper. These activities were, for several months, the central focus of conversation for Dodge's guests, particularly when they met for salon evenings. When Dodge and her friends argued over the Armory Show, they ruminated over whether Americans could produce

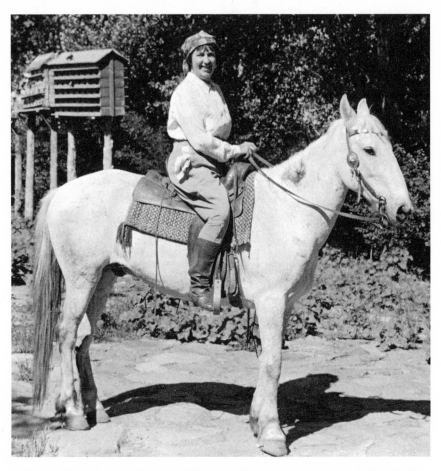

Mabel Dodge Luhan, 1938. (Yale Collection of American Literature, Beinecke Rare Book and Manuscript Library.)

original modern art. When they interviewed Big Bill Haywood about the strikes in the New Jersey textile mills, they asked if Americans could unite despite class divisions. When they set on stage at Madison Square Garden the events Haywood and others described to them, they broadcast their hope for a union of art and political action. When they welcomed Reed back after reading his dispatches from his travels with the revolutionary Pancho Villa, they asked how he had managed to penetrate to the inner circle of Villa's intimates. In all three efforts, they expressed their desire for art to have material impact, their passion for authentic experience, and their faith that such authenticity could be found in "primitive" expression.

World War I shattered their efforts. The members of Dodge's salon scattered. Some abandoned political activity. Some abandoned art. Still others tried to find political and artistic expression that did not run afoul of federal officials involved with the Red Scare. Dodge herself moved to a country retreat at Croton-on-Hudson. There she continued to host artists, but she dedicated most of her time to appreciating the countryside. She hoped for a greater connection to the natural world and to find the sense of satisfaction that had eluded her even in the headiest days of her salon. As she cast about for a stronger purpose, she sent her third husband, Maurice Sterne, on a one-man honeymoon to New Mexico.

Dodge soon joined him, and there, finally, she found what she had been seeking. Although she would always claim that she had been empty until she arrived in Taos, she brought much of what she had always wanted along with her. Dodge had sought a place for herself first in Italy, then in New York City, then in Croton, and finally, in Taos. In her efforts to claim Taos as her own, she would bring elements of every previous place she had called her home to New Mexico. It is not surprising, then, that she found what she came for.

Dodge had first made her presence felt not in New York City, but in Italy. She was a wealthy woman; she came from a wealthy family and in her second husband, Edwin Dodge, she had found a wealthy husband. She had rushed into an early marriage to escape the oppressive neglect she felt from her parents, a prosperous Buffalo, New York, couple living off the spoils of Dodge's grandfather's success in banking. After her first husband, Karl Evans, died in a hunting accident, Dodge and her young son, John, sailed to Europe. Along the way, they met Edwin Dodge, and soon thereafter, Mabel and Edwin married. Edwin Dodge was trained as an architect, and his new wife had a flair for decoration and ostentatious living. The two established themselves in a villa in Florence called the Villa Curonia. They soon put their wealth to work decorating and redesigning their villa according to an elaborate Renaissance theme. They also collected artists, writers, and other creative people who pleased them and who were pleased to stay for a while in the Villa Curonia. Major cultural actors like Gertrude and Leo Stein, the British tenor Paul Draper and his wife, salon hostess Muriel Draper, and the sculptors Jo Davidson and Janet Scudder all joined the Dodges in their Renaissance dining room and participated in the celebration of art and beauty to which Mabel Dodge had dedicated herself.

Despite the activity in their home, the Dodges were not happy. Mabel Dodge chafed against the constraints of marriage, engaged in more than one

affair, at one point even attempted suicide, and withdrew even deeper into the fantasy life of the Villa.[1] When the couple concluded that John should return to the United States for his education, Edwin Dodge jumped at the opportunity to return as well. Although Mabel had done little to place her relationship with Edwin on steady ground, she was unwilling to end her marriage or to separate from her family. She agreed to return with her husband, and the family arrived in New York City in November of 1912.

In Greenwich Village Dodge found an alternative to the fantasy life she had led in Italy. By 1910, "the Village" meant the area blocked by Tenth Street to the north, Houston Street to the south, Washington Square and Fifth Avenue to the east, and the Hudson River to the west. Unlike other areas of New York, the Village looked shabby and incoherent. Crooked streets, narrow alleys, unexpected courtyards, and small buildings made the Village seem like a place apart, especially to those looking for an antidote to the city's bustle. Artists and writers and those who liked to call themselves "bohemians" liked the Village's cozy feel and its cheap rents. Usually from more prosperous backgrounds than their tenement-dwelling neighbors, these Villagers were sometimes guilty of hypocrisy. Though many of them decried the inequalities plaguing the nation, they were more inclined to dwell on the picturesque appeal of laundry in tenement courtyards than they were the inadequate living conditions of the tenements themselves. These bohemian Villagers were a high-spirited, talkative bunch eager to make their mark on modern culture.[2]

As soon as the Dodges arrived at their new home at 23 Fifth Avenue, Mabel Dodge fell into a deep depression, but her spirits were not low for long. Her doctor advised that her husband give her time and space alone, and Edwin Dodge soon left to live in his own place at the Brevoort Hotel across the street. Edwin Dodge would figure into the stories that followed hardly at all, but for one important exception. One day, in an effort to raise his wife's spirits, Edwin Dodge brought the sculptor Jo Davidson, their old friend from Florence, to visit. Davidson introduced Mabel Dodge to a man named Hutchins Hapgood, and Dodge's salon was under way.

Hutchins Hapgood seemed to embody every current of prewar bohemia in his slight frame. A Chicago-born Harvard graduate, he worked in the 1890s as a reporter for the *Commercial Advertiser* under muckraker Lincoln Steffens. Steffens encouraged his staff to find common ground between the subjects of the *Commercial* human interest stories and its readers. Hapgood leapt to the challenge, publishing a series of articles about Jewish immigrant

life on the Lower East Side. Though an Ivy League graduate, he identified with the people he wrote about in his articles and books, and by the time Dodge arrived in New York City, he called himself an anarchist.[3] Hapgood found a companion in his adventures in fellow *Commercial* staff member Neith Boyce. A delicate beauty with a steely dedication to her career as a writer, Boyce had joined the *Commercial* staff after working for her father's newspaper in Boston. When she and Hapgood embarked on a tumultuous open marriage, she kept her name and her right to engage in extramarital affairs. Hapgood, as a Midwesterner who found his calling as a writer in the East, a privileged man who championed the poor, and a free-love advocate who jealously guarded his wife's attentions, could open his arms widely enough to embrace almost every cause that filled the streets of Greenwich Village in the years before World War I.

It was Hapgood, according to Dodge's memoirs, who introduced Dodge to Lincoln Steffens. Steffens had participated even earlier in activism than Hapgood had. A muckraker of the Progressive era, he had more experience with reform movements than with the radical interests that would soon occupy Dodge's salon. Nonetheless, Steffens looked to younger generations for the cutting edge of politics. He had recruited Hapgood from Harvard to work at the *Commercial,* and continued to make a project of transforming Harvard men into the eyes and ears of New York. His recruits would have a major influence on Dodge's days in Manhattan, but Steffens himself would leave the most significant mark. It was his idea, according to Dodge's memoirs, to start a salon in the first place. "You have a certain faculty," she much later remembered him saying, "'a centralizing, magnetic, social faculty. You attract, stimulate, and soothe people, and men like to sit with you and talk to themselves! You make them think more fluently and they feel enhanced. . . . Now why don't you see what you can do with this gift of yours? Why not organize all this accidental, unplanned activity around you? This coming and going of visitors, and see these people at certain hours? Have Evenings!'"[4]

Dodge's evenings rapidly became a success in large part because of the Armory Show of 1913. The show was the inspiration of three members of the Association of American Painters and Sculptors. Arthur Davies, Walt Kuhn, and Walter Pach endeavored to stage a comprehensive show of the modern art that had been sweeping art communities in Europe. They began their preparations in May of 1912, and by February of 1913, they opened a massive show at the Armory of the Sixty-Ninth New York Regiment at Lexington

Avenue between Twenty-Fifth and Twenty-Sixth Streets. The show's locale lent its name for posterity and, because it was not in a museum or traditional gallery, suggested the antiestablishment goals of its creators. The Armory Show was not another museum exhibition designed to instruct young artists interested in the academy's mores. It was, instead, a dramatic statement on the potential for modern art to transform the meaning of artistic creation altogether. Although modernism had ample precedent in the United States by the time of the show, it generated extraordinary excitement.[5] Indeed, even a brief overview of the works in the show reads like a survey of the foundations of modern art: more than a hundred works by Vincent Van Gogh, tens of paintings by Cézanne and Gauguin, and startling, stimulating, and terrifying pieces like Wassily Kandinsky's painting *The Garden of Love,* Pablo Picasso's charcoal *Standing Female Nude,* and the most shocking of all, Marcel Duchamp's *Nude Descending a Staircase.* Even before the show began Dodge told Stein that it would be "a scream! . . . I am *all for it.* I think it is splendid. . . . There will be a riot & a revolution & things will never be quite the same afterwards."[6]

Dodge's enthusiasm for the show sprang in part from her dedication to a subset of modern art: primitivism. Her primitivism was nothing new. As early as 1775 Rousseau had suggested that humanity's authentic expression existed only in "natural man," and implied that vestiges of authenticity could be found only in those races Rousseau and his contemporaries viewed as primitive.[7] Closer to Dodge's frame of reference, many European modern painters had turned to nonwhite groups they considered primitive for artistic inspiration. The work of Picasso and Matisse was probably familiar to Dodge from her visits with Gertrude and Leo Stein in Paris. She probably also had seen similar works at Alfred Stieglitz's gallery, 291. Stieglitz sometimes frequented Dodge's salon and considered himself to be in the vanguard of modern art, so much so that he passed up an opportunity to contribute to the Armory Show because he believed his gallery already beyond the show's message. Picasso had shown work at 291 in 1911, and critics had remarked on the similarities they saw between his work and that of "primitive" carvings from West Africa. Indeed, a year after the Armory Show, Stieglitz opened an entire show of African art titled, tellingly, "Statuary in Wood by African Savages— The Root of Modern Art." Because Stieglitz, Picasso, and Matisse considered themselves civilized contemporaries of the modern developments they saw around them, they felt they had lost touch with authentic expression. Because

they believed Africans were not civilized, because they saw them as "savages," they believed Africans were suspended in a primitive era.[8] Contrary to the opinions of most of their parents' generation, celebrants of African art believed that being primitive was good. If Africans were primitive, they were also authentic, and in emulating and celebrating African art, many of Dodge's friends were striving to bring the same authenticity into their own lives.

Primitivism would again play a role when Dodge and several members of her salon became involved in a Paterson, New Jersey, silk workers' strike. In January 1913, while Dodge was busily writing Stein of her new enthusiasm for the International Exhibition at the Armory, a group of silk workers in Paterson, New Jersey, walked away from their looms and began a six-month strike. Mill owners had demanded what strike organizers called a speed-up. Owners had introduced new looms that allowed workers to tend four looms when they had previously tended only two. Fearing the new system would lead to layoffs, the workers chose to strike. They found ready allies in the Industrial Workers of the World (IWW), who had been trying to organize in Paterson for years.

The Paterson silk workers had chosen a propitious time for cooperation with the IWW. The IWW had formed in Chicago in 1905 from a coalition of radical leaders including William "Big Bill" Haywood of the Western Miners Association and Eugene V. Debs of the American Socialist Party. The nascent labor organization cut its teeth on mining strikes in Cripple Creek and Telluride, Colorado, and in free speech fights in the Pacific Northwest, where, in the course of battling employment agencies, they successfully challenged municipal ordinances restricting public speeches. At some point, followers and critics started calling the organization the Wobblies. Just a year before the Paterson silk workers walked away from their factories, the Wobblies had successfully led a textile strike in Lawrence, Massachusetts. The American Federation of Labor had long held that it could not successfully organize unskilled immigrant laborers. The IWW believed otherwise. Its leaders barreled out of the West to prove that the tactics they had honed in mines and lumber mills west of the Mississippi would work just as well in the industrial centers of the East. Two of their more picturesque leaders, Haywood and Elizabeth Gurley Flynn, joined existing organizers and made headlines as Paterson's strikers engaged in strategies the Wobblies had mastered: picketing, holding rallies, parading, and packing local jails. By the time the Lawrence strikers finally won, Flynn and Haywood's names were well known in New York, partic-

ularly to people like Hapgood who were sympathetic to the radical elements of the labor movement.[9]

In May, Dodge accompanied Hapgood to see Big Bill Haywood speak at the house of a friend elsewhere in Greenwich Village. Haywood used the event to publicize the strike in Paterson. A news blackout had prevented word of the strike from reaching New York, and even many radicals in the Village had not heard of it. Haywood was angry and frustrated, and Dodge's memoirs suggest that she found him intimidating. An enormous man with only one eye, Haywood intimidated a lot of people. Dodge, however, was also witnessing his indignation at the events in Paterson. Twenty-five thousand workers, most of them immigrants who did not speak English as their first language, were striking in Paterson. Their demands were an eight-hour day, minimum wages in certain job categories, and an end to the four-loom system. They had been met with violent repression from the mill owners and Paterson police, and Haywood was desperate for some sympathetic press. In her memoirs, Dodge remembered Haywood lamenting that no one had covered the funeral of one of the strikers who had been killed accidentally by a policeman. He described the mill workers covering the man's coffin with red carnations and singing the "Internationale." They needed food and money, and Haywood believed that IWW members in New York would provide support if they only knew what was happening in Paterson. Dodge chose that moment to speak up. "Why don't you bring the strike to New York and show it to the workers?" she asked. "Why don't you hire a great hall and reenact the strike over here?"[10] Dodge later remembered a young man from the back of the room shouting, "I'll do it," and rushing forward to sit with Dodge at the front of the room. The young man was John Reed; Dodge had launched one of the two most famous love affairs of her life.

Reed had it in him to jump up and volunteer himself for a theater project unlike any other. Seven years Dodge's junior, he had grown up in Portland, Oregon, and attended college at Harvard. He had landed in New York in 1911 after a stint in Europe where he had journeyed on a cattle freighter. Like Hapgood, he was a protégé of Lincoln Steffens, the muckraker who had inspired Dodge to begin her salon evening. After Steffens's wife died, he took an apartment on Washington Square, located immediately above the run-down set of rooms Reed shared with three roommates from his Harvard days. Steffens's new home gave Reed easy access to his mentor, and Reed would barge in at all hours to discuss his latest poem or article or love affair or urban adventure.

Though he lived only a few blocks from Dodge's apartment, Reed had a far more tenuous existence than she did. He made ends meet with a job as an editor and occasional contributor at a journal called *The American*. When he wasn't carousing with his college buddies, he was taking in the city's underbelly on long walks through the Bowery and the Tenderloin districts. By the time he and Dodge crossed paths, his slumming had begun to gather purpose.[11]

When Reed heard of the strike, he instantly volunteered to go to New Jersey to cover it for the radical magazine the *Masses*. Reed himself was arrested along with several workers, which made his report seem all the more real. Throughout, he stressed the authenticity of the workers and their struggle, and he did so, in part, by portraying the strikers in primitivist terms. In his piece for the *Masses*, his quotes from the workers are in dialect. Italian workers were a major element of the Paterson silk workers, and Reed recalled their frequent chants of "'We all one bigga da Union,'" and a young man telling him earnestly, "'I.W.W.—dat word is pierced de heart of de people.'" At times Reed almost seemed confused in his recollection of various accents. A Jewish man explained the cooperation among the various immigrants involved in the strike in language similar to that of his Italian coworkers. "'T'ree great nations stick togedder like dis.' He made a fist. 'T'ree great nations—Italians, Hebrews, an' Germans.'" When the strikers turned to music to lift their spirits, Reed recalled the scene in distinctly paternalistic tones. "'Musica! Musica!' cried the Italians, like children."[12] For Reed, the silk workers he met were colorful and authentic representatives of the working classes.

Authenticity also came to play a central role in the Paterson Pageant, which, as he had promised, Reed produced. The show took place on June 7, 1913. Reed and other organizers had initially wanted the pageant to run for three nights, but Madison Square Garden proved too expensive. Much of the pageant began in Paterson, where 1,147 workers boarded a train to Hoboken and eventually joined 800 other silk workers at Union Square. From there, one of the organizers led them up Christopher Street and Fifth Avenue to the theater, where they paraded through the audience. Robert Edmond Jones, the set designer, must have been pleased. He was a strong proponent of approaches proposed by the theater designer Gordon Craig. Craig advocated huge theaters and performances that blurred the lines between actors and audiences. Jones had created just such an environment. The sets were massive and drenched in red. One source reported that the authorities at Madison

Square Garden believed it the largest set ever built in America.[13] Huge, electric, red IWW signs shone from all four sides of the venue, and the climactic scene was the reenactment of the funeral Haywood described, with the coffin covered in red carnations donated from local flower shops. The pageant was huge, involving the people of New York City and the members of the audience. It was like nothing ever performed on a New York stage.

For everyone involved, the pageant's most innovative element was the use of workers as actors. The strikers showed their support by volunteering for the event in ever-increasing numbers. Initially, Reed expected 200 workers to take part, but at the pageant itself approximately 2,000 strikers played some kind of role. Reed's friends in the Village found the show's actors equally central to the endeavor. In the *Globe*, Hapgood, with typical exuberance, praised "Mabel Dodge who first thought of the pageant and who put her money and time and all her enthusiasm into it," and "John Reed, who put his youthful organizing ability, his instinct for art, and his light and happy humanity at [the strikers'] service. Nevertheless," Hapgood concluded, "this pageant was really the work and the recorded life of the striking mill workers of Paterson."[14] Even the New York newspapers thrilled to the idea of workers dramatizing their own struggle. The *New York Tribune* ran the headline: "The Paterson Strike from the Worker's Point of View," and reported that the production promised to be "the biggest pageant ever given in any theatre in New York City. And it is, of course, the only one ever planned and enacted by striking workers."[15] The show's highlight was briefly summarized in Jones's programs advertising the event. In it, a worker steps out of the frame, toward the viewer, and onto the words: "The Pageant of the Paterson Strike, Performed by the Strikers Themselves."[16]

Although the strike ultimately failed, Reed and Dodge spent succeeding months celebrating the pageant and exploring their burgeoning romance. In later years, Reed would insist on more substantive aid for the people whom he embraced, but in the exciting days following the pageant, he and Dodge congratulated themselves for advocating on behalf of the less fortunate, for staging the event with such artistic flair, and for having the workers themselves perform. Although Reed never followed Dodge to New Mexico, the political and aesthetic sensibility of the pageant would appear again among Dodge's friends when they advocated on behalf of the Pueblo Indians. Then, too, would Dodge and her peers find themselves fascinated with the people whom they were trying to help. Moreover, they would, once again, emphasize

that the people they patronized were authentic. Before Dodge ever considered going to Taos, however, a similar theme appeared in Reed's coverage of the Mexican Revolution.

Reed began reporting on the Mexican conflict at the end of 1913, an ideal time given his political sympathies. The revolution in Mexico had begun in 1910 and rapidly led to the resignation of Mexico's dictator of thirty-five years, Porfirio Díaz. The new president, Francisco Madero, had hardly begun to establish a government when one his generals, Victoriano Huerta, executed him in February 1913. Madero's death threw the already war-torn country into an uproar. In the south, agrarian radical Emiliano Zapata had already backed away from supporting Madero when Madero had refused to act quickly on the issue of land reform. Huerta was hardly an agrarian radical, and his seizure of power brought Zapata back to the battlefield. Meanwhile, in the north, one of Madero's supporters, Francisco "Pancho" Villa, had returned to battle Huerta. He appeared to share Zapata's desire for land reform and violently condemned foreigners who dominated the land and its profits at the expense of Mexican peasants. Villa fought under the authority of the more conservative Venustiano Carranza, but, by the close of 1913, Villa had begun to distance himself from Carranza and had achieved sufficient military success to bring him to the attention of the U.S. press. As the train carrying Reed neared the border, the news-reading public of the United States began to wonder if perhaps Villa would be Mexico's next leader.[17]

Reed instantly showed a romantic enthusiasm for Villa and his men. His vision of them was apparent in his first letters to his editor: "The thousand nondescript, tattered men, on dirty little tough horses, their serapes flying out behind, their mouths one wild yell, simply flung themselves out over the plain. That's how the general reviewed them. They had very little discipline, but gosh! What spirit! . . . A great bunch, believe me. And what pageant material!"[18] In later articles, the pageant Reed had predicted unfolded, complete with spontaneous "bailes" at which Reed learned to dance the "jota," drunken revelries at which Reed learned to drink "sotol," and even a defeat in battle at which Reed learned to run for his life. If Reed had followed Gordon Craig's lead by including the audience in the Paterson pageant, he took it a step further in the Mexican Revolution and participated in the original activity he described. His participation only increased the revolution's colorful appeal. As he summed up for his editor: "It's all as romantic as can be."[19]

The appeal of the Mexicans whom Reed encountered came from the same

source as the appeal of the Paterson silk workers: primitivism. Reed insisted on the distance between the Mexican poor and "civilization." Villa, for example, not only was "natural" and "wild," he was also without "the slightest conception of the complexity of civilization." When he left his life of banditry behind, he was "a mature man of extraordinary native shrewdness" who "encountered the twentieth century with the naïve simplicity of a savage."[20] Villa's "savagery" hardly hurt his standing with Reed. In fact, Reed saw it as an advantage. Just as Stieglitz saw artistic purity in African art and just as Reed himself had seen political sincerity in the "childlike" workers of Paterson, now Reed saw military prowess and social justice stemming from Villa's distance from "civilization." Although Villa traveled with a sophisticated medical crew and used modern railroads to his advantage, Reed credited Villa's guerrilla background for his military successes. In Reed's view "the Mexican soldier is still mentally at the end of the eighteenth century. He is above all a loose, individual guerrilla fighter. . . . When Villa's army goes into battle it is not hampered by salutes, or rigid respect for officers, or trigonometrical calculations of the trajectories of projectiles. . . . It reminds one of the ragged Republican army that Napoleon led into Italy."[21] Villa was "natural," "simple," and "savage," traits that, at least in Reed's eyes, made him Napoleonic.

Villa was the star of Reed's reports on Mexico, but so also was the land of Mexico itself. When Reed published his articles on Mexico as a book, the dedication explained that although his first trip away from the United States had not made him want to write about what he saw there, Mexico "stimulated" him to "express it in words." Indeed, in Reed's first report he called Mexico "more wonderful than Italy." The city of Chihuahua was like a "jewel" in the center of the "jagged mountains" and the "tawny desert, more brown and savage—much more—than anything around Presidio or El Paso."[22] Reed praised "the turquoise cup of sky" and the desert, where "a great silence and a peace beyond anything I ever felt wrapped me round. It is almost impossible to get objective about the desert; you sink into it—become a part of it." His descriptions of Mexican villages showed people living on the land as if they were the land itself. Reed told readers that it was "impossible to imagine how close to Nature the peons live on these great Haciendas. Their very houses are built of the earth upon which they stand, baked by the sun. . . . The animals are their constant companions, familiars of their houses. Light and darkness are their day and night."[23] Mexico was beautiful in Reed's eyes because the people he met seemed to live in the natural world without changing it. He

concluded that Mexicans' ties with the rhythms of the day made them act without artifice and without the trappings of what Reed called civilization.

Reed's rhapsodies over the beauty of the land had roots in his deep support for land reform. He made clear to his readers that he thought the revolution and Villa's revolutionaries were justified in their struggle in part because the place they fought to control was a beautiful one. In an article describing his travels with the troops of one of Villa's generals, he waxed over the beauty he witnessed while riding in their ranks. "In the late sunshine the desert was a glowing thing. We rode in a silent enchanted land that seemed some kingdom under the sea. All around were great cactuses colored red, blue, purple, yellow, as coral is on the ocean bed. Behind us, to the west, the coach rolled along in a glory of dust like Elijah's chariot. . . . It was a land to love, this Mexico—a land to fight for." Reed did not explain whether the beauty he witnessed inspired the revolutionaries or if he was reporting his own response to the landscape. Either interpretation led to the conclusion that because the desert was beautiful, the poor of Mexico were right to fight to control a part of it.[24]

As elsewhere, Reed's approach had strong parallels with how Dodge and her visitors in New Mexico later responded to the landscape and to the people of Taos. As Reed had in his portrayal of Mexico, Dodge and many of her guests would blur the lines between the land of Taos and the people who lived there, even drawing the same conclusion that adobe architecture showed an intimate connection to nature. Like Reed, Dodge and many of her guests would romanticize the connection they saw between people and place. And, like Reed, Dodge and many of her guests would gloss over the more complicated political, social, economic, and environmental problems that accompany conflicts over land. But for Dodge and her friends, these enthusiasms and missteps were in the future. As Reed returned from Mexico, he found himself drawn to cover another dramatic, violent confrontation: World War I. He then jumped at the opportunity to report on the Russian Revolution, and the passion he found in that endeavor ultimately untangled his path from Dodge's.[25]

When World War I began, Dodge was vacationing at her villa in Italy, and she and her fellow travelers wondered if they would return to find the United States in revolution. They did not, but they did find their peers in a state of confusion. Although the war decreased immigration and increased demand for metals, coal, and timber—all ideal conditions for the labor movement—most of the visitors to Dodge's salon began to drift away from political activ-

ity.[26] Some of Dodge's friends were stranded in Europe by the war and were hardly in a position to affect political affairs in the United States. Others suddenly saw art and politics not as a natural union, but as mutually exclusive. Still others chose art as their primary interest, finding politics and radical activity less satisfying endeavors. Still others suffered from the Red Scare and the dramatic move rightward of the federal government and the nation at large. Hapgood and Boyce became increasingly involved in the Provincetown Players, a theater group; Reed threw himself into the revolution in Russia; and artists like Marsden Hartley and Andrew Dasburg, who had frequently visited Dodge's salon, scrambled for patrons because the war limited their access to the art scene in Europe.[27] Dodge herself felt confused about where her loyalties lay and moved closer to more politically moderate members of her salon.

As they reassessed their relationship to political activity, many of Dodge's friends began to explore rural spaces. New York City had seemed the ideal place in which to unite the Dodge salon's modernist interests, but the war made Dodge and her friends question their devotion to a modern world. Whereas the technical marvels of New York had previously driven the artists of Dodge's salon to rapturous wonder, the technical advances of the war made them question humanity's goodness. If skyscrapers were twinned with machine guns, then Dodge and her friends wanted none of modernity. How to continue making modern art and literature without descending into the evils of modern life would preoccupy many of Dodge's New York associates, but in the years following the outbreak of war, Dodge and her friends moved away from celebrations of urban space and machines. Instead, she and her peers looked to the rural countryside of the eastern United States. Picturesque farmers and fishermen replaced the silk workers and Mexican revolutionaries who had intrigued Dodge's salon in the past. By the fall of 1915, 23 Fifth Avenue had ceased to be a center of cultural ferment. The members of Dodge's salon had begun to disperse to the seaside village of Provincetown, Massachusetts, the coast of Maine, and the farming community of Croton-on-Hudson, New York. In each place, they looked for a new union, not between politics and art, but between two ideals so vital to Dodge that she always placed them in capital letters: "Nature and Art."

Dodge rapidly set about re-creating much of the community and way of patronage that had marked her days in New York City, but she did so with a new appreciation of pastoral landscapes. She rented a house near that of Reed's editor from the *Masses,* Max Eastman. She later invited Robert Ed-

mond Jones, the theater designer from the Paterson Pageant, as well as artist Andrew Dasburg, arguably Dodge's most enthusiastic salon attendee. Most crucially, Dodge found herself a new cause. She found property for a school for Elizabeth Duncan, sister of the modern dancer Isadora Duncan, and she enrolled her son, John Evans, in the institution. In her memoirs, Dodge remembered Elizabeth Duncan visiting frequently for hiking excursions. "We would climb the hill till we came to the fields where we could sit and gaze all around us," Dodge recalled, "and watch the big white clouds go sailing along in the clean blue sky. We sat together in the new grass and felt we were being taken somewhere." Dodge felt that the "lovely, quaint countryside seemed to have the truer living in its deep pulse." [28] She remembered that the peace that she felt with Elizabeth Duncan in the countryside drove away any interest she had in reform or radical causes in New York City. "To see the evening sun come in the door from the porch and fall on the supper table, shining through a tumbler of red wine, falling on the orange-colored cheese and the fresh brown loaf while we sat—two or three of us—idly, at rest, after the purposeless day. How good it was!" Dodge felt that she had found her Arcadia, and she was content to stay there and do nothing so long as her salon retreated to the country with her.[29]

Almost as soon as Dodge became comfortable at Croton, however, she was caught in a personal whirlwind. Much of the instability that marked Dodge's life over the next two years revolved around her relationship with the man who was to become her third husband, Maurice Sterne. Dodge met Sterne at a performance of the students from the Duncan School in May 1915. Sterne's family had immigrated to the United States from Latvia when he was twelve; two years later they were living on the Lower East Side and Sterne was working in a flag factory. Sterne was determined to be an artist, and he took a job as a bartender at night so that he could attend the National Academy of Design by day. Sterne met Gertrude and Leo Stein while on an art scholarship in Paris, and when he met Dodge he had recently returned from a trip to Bali.[30] His work from his travels received favorable reviews, and one critic reported that he "had conventionalized and interpreted the spirit of Bali in a way like that in which Gauguin treated Tahiti."[31] His somewhat exotic background, his adventures abroad, and his profession made him attractive to Dodge, and she purchased some of his work.

Sterne, like Dodge and those she gathered at her Croton retreat, was drawn to the aesthetic inspiration he found in the natural world. Sterne was

also inclined to see a connection between the appeal he found in nature and the aesthetic models he favored in the art and literature of ancient civilizations. He was emphatic on this point when he was interviewed for the *New York Times Magazine* on his return from Bali. He explained that while he was traveling in Bali he encountered a group in a bazaar, "beautifully formed men and women almost nude. I was amazed," Sterne explained, because "they looked like ancient Greeks." For Sterne, the people of Bali almost became a part of the landscape. "When it rained there was a change in the looks of country and people; the rain made the landscape velvety and the people satiny. . . . I watched crowds of Balinese in the rain and saw the rain trickle over their collar-bones and breasts, and I seemed to understand the origin of rivers."[32] Dodge left no record of whether she had read Sterne's interview, but an artist, especially a Jewish immigrant working-class artist recently returned from an exotic locale and intent on finding an aesthetic vision in the natural world, was just the kind of person she would have wanted to meet and impress in the spring of 1915.

Dodge's relationship with Sterne would eventually end her Croton experiment, but not before she had drawn from it another inspiration that would influence her years in Taos. Whereas her Greenwich Village salon had taught Dodge to seek a union of art and politics and her ventures with Reed had taught her to cultivate activism and a primitivist aesthetic, Croton taught her to look to the natural world for personal and spiritual fulfillment. Dodge's walks through the hills; her patronage of the Duncan style, which sought inspiration from what Dodge called "Nature"; and her continued support for artists who devoted serious attention to landscape all contributed to Dodge's conviction that authentic and unmediated experiences were to be found in the natural world and among people whose bond with nature had not been broken by "civilization." Although Dodge never found in Croton the personal satisfaction or the public acclaim that she sought throughout her life, she did find there an appreciation for rural locales that would persist during her years in New Mexico.

Ironically, it was Sterne—who brought her the most grief in Croton—who ultimately took her to Taos. The relationship between Dodge and Sterne was a rocky one from the start, and tracing it is difficult, if only because they continued to argue about their affairs years after they had separated. Dodge directed her frustration with her previous relationships at Sterne. Sterne used Dodge for her wealth, and constantly intimated that he could not be faithful. One bi-

ographer has described their relationship as a "five-year long ring fight. No Queensberry rules. And many more than fifteen rounds. Both back in their respective corners, breathing messages of renewed affection and desire as they regain their wind."[33] It is particularly difficult to determine why they decided to marry. Nonetheless, in August 1917, after an impulsive suggestion from Dodge, they did so. Sterne had been planning a trip to Wyoming before the sudden wedding, and Dodge insisted that he continue on his trip without her. He returned briefly to New York, but they quarreled when Dodge insisted that he had looked at another woman. She soon packed him off on another western adventure, this time to New Mexico.

At first, Dodge insisted on staying home. Comfortable at Croton, she relished the distance and time apart from Sterne. But over time she began to long for him and for the adventures he recounted in his almost daily letters to her. Sterne traveled back and forth across northern New Mexico, entranced with the religious customs of the sizable Nuevomexicano Catholic community and with the Pueblo Indians, a diverse group of Native Americans who lived in permanent villages called *pueblos*. His tales of feast day dances, exquisite local crafts, and the unusual individuals he met at each pueblo drove Dodge to restless envy. After a few weeks, she turned her frustration into action and proposed an outrageous plan that would have brought Sterne, the Indians, and the prestige that came with exotic adventures to her. "I also have an idea," she wrote excitedly in December 1917.

> Couldn't you pick out a family of indians & put them to live in the cottage in Croton? You know from a grain of sand the master can construct the desert & from a man, woman & child a master can give a whole race! You could hire them for 6 months & you could get an infinite riches out of them. This, believe me, is a good idea . . . Do you see how good this is? Especially if you study the habits—rhythms, poses—& ways of them as a whole. Then the concrete will serve you as a structure for the imagination & memory you want to preserve in Art.[34]

Dodge's artistic vision of Native Americans condescended to those she hoped to celebrate. Like some of her previous endeavors, her plans for the Pueblo Indians of New Mexico echoed the sentiments of many of the members of her New York salon and Croton retreat. Although few in Dodge's orbit had the resources or audacity to suggest bringing a Pueblo family to the

banks of the Hudson River, most shared her fascination with nonwhite and poor people. Dodge never brought an entire Pueblo family back to Croton, but with the help of many of her friends, she would eventually bring much of the New Mexico she saw and enjoyed to New York City. This impulse, shared by many of the visitors whom she invited to New Mexico, ultimately was the key to transforming her New York salon and Croton retreat into an art colony. Dodge and her visitors actively nurtured their desire to bring what they found aesthetically desirable in New Mexico back to their creative metropole. Everyone in Dodge's cohort who promoted New Mexico eventually visited or moved permanently to the Southwest, but they never lost sight of their desire to package what they saw as unusual and primitive elsewhere and bring it back to New York.

In Dodge's memoirs, her move to New Mexico and eventual love for the place originated in a dream. She remembered seeing Sterne's face in a field of green leaves gradually give way to a different face, an Indian face that, as she recounted, "affected me like a medicine after the one that had been before it. I sighed and let it take me and cleanse me."[35] Shortly after her dream, Dodge remembered, Sterne wrote, begging her to come to New Mexico and "save the Indians."[36] Given the arc of Dodge's memoirs from an emotionally alienated Victorian girlhood in Buffalo to a spiritually satisfied womanhood in the Southwest, a certain skepticism seems a healthy response to how Dodge chose to remember her past.[37] But, in fact, she did dream of an Indian face replacing Sterne's only a few weeks before she left, a dream she recounted to Sterne in a letter in late November, and she did receive a letter from Sterne promising her a purpose in life if she would "save the Indians, their art-culture, and reveal it to the world. That which Emilie Hapgood and others are doing for the Negroes," Sterne promised, "you could, if you wanted to, do for the Indians, for you have energy and are the most sensitive little girl in the world."[38] Sterne probably hit a nerve when he drew a parallel between advocacy for African Americans and the work that he envisioned Dodge performing for Native Americans. Dodge's close friend, Carl Van Vechten, was soon to plunge into promotion of African Americans engaged in Harlem's aesthetic revolution known as the Harlem Renaissance. Like Sterne, though, Dodge was focused on a cure for what she saw as the malaise of modern life.

The bulk of Sterne's letters focused on the possibility that the Pueblos might offer an alternative model for the empty American culture he so detested. Increasingly, he believed that what distinguished Native Americans

from the Asians he had painted previously was their distinctly "American" quality.[39] That the Pueblo people were American, not Asian, made them the possible emissaries of redemption for a United States that Sterne saw as crowded and ugly. "I have had enough of the rhythm of civilization: the goose step of soldiers!" he told Dodge, echoing her own frustration with the war. "At the dance," he explained, "I found myself murmuring 'America I salute you' but I didn't mean Walt Whitman's America with its Rockefellers and machinery and crowds and cities—I meant the real America, the Indian."[40] Sterne's criticism of Whitman might have offended Dodge, but his potential discovery of a unique American culture must have excited her. Dodge had sought a "real America" in modern art, labor activism, and the pastoral beauty of farm life, all to no avail. Now Sterne wrote promising a real America in the American Indian.

What did Sterne and Dodge have to gain from playing Indian?[41] The search for a cure to America's modernity was not new to Sterne or Dodge or anyone else in their circle of friends. Such an endeavor had been the binding force of Dodge's salon in New York. But in the days of Dodge's Greenwich Village salon, most of her peers had believed firmly that all the causes they embraced—modern art, labor activism, immigrants' rights, and an even greater appreciation for nature—could be achieved as a single movement. During Dodge's years at Croton, the group's goals had grown more fragmented and less optimistic. Whereas members of the group had previously pooled their efforts in events like the Armory Show or the Paterson Pageant, now they competed for each other's attention. Sterne and Dodge could no longer count on the support of their broad range of friends and associates to adopt their newfound passion for Indians. To prove that Indians—rather than dance or theater or communism or jazz—would fill the American soul, they had to demonstrate that even they, as white, East Coast urbanites, could embrace Indian life.

Dodge finally did visit Sterne. Her journey revealed her typical impatience. Frustrated with the train's pace, she jumped off the train in eastern New Mexico, wiring Sterne that she would drive instead. After finding a local who agreed to chauffeur her to Santa Fe, however, she discovered that no car could get through northern New Mexico's rut-filled roads faster than a train, certainly not any car without lights or a suspension system. She traveled only as far as Wagon Mound, wiring Sterne again that she would arrive by train, and he could meet her at the station. On December 21, Dodge eventually did

arrive in Santa Fe, late at night, when the crystalline blue skies she would later celebrate had grown dark.[42]

Santa Fe may have been a far cry from New York or even Croton, but many parts of the city might have seemed familiar to the cosmopolitan Dodge. Like many European cities, Santa Fe had a long and varied past, stretching back to its founding by Spanish Governor Don Pedro de Peralta in 1610. Although a significant Anglo population had entered the state in the early nineteenth century because of trade along the Santa Fe Trail, the city maintained a large Nuevomexicano population, and some locals conducted their business and educated their children in Spanish. Few Santa Feans enjoyed extraordinary prosperity, particularly after the railroad was routed through Lamy to the east of Santa Fe, but for those artists and writers who began arriving shortly before and after statehood in 1912, the lack of development added to the area's charm. The area's long history, crooked streets, multilingual population, and nascent artists' colony may have reminded Dodge of her days in Florence and set her more at ease than she had anticipated.

What Dodge probably found surprising about northern New Mexico was its geography. Located at the tail end of the Rocky Mountain range, Santa Fe sits at the base of mountains now called the Sangre de Cristos. At 7,000 feet, Santa Fe probably felt far more like a mountain town than the desert community Dodge expected or the desert of Chihuahua that Reed had described in his coverage of the Mexican Revolution. Cottonwood and cedar trees lined Santa Fe's precious arroyos, and dark, low pine trees dotted the mesas outside the city's boundaries. The clear, dry air and high altitude deepened the blue of the sky and, in the cool nights, made the stars shine more brightly. Artists inevitably remarked on the intensity of the light in northern New Mexico, but many found it a mixed blessing. Some rejoiced in the sharp contrasts and variation of color, but others simply thought the light was too bright and found themselves painting inside.[43] As a patron, not a painter, Dodge thought the light was enchanting. The morning after her arrival, she trailed Sterne through the streets of Santa Fe, a bit tired from the altitude but captivated with the play of colors on the city's adobe walls.[44]

Sterne's first order of business was to take Dodge to visit the artist Paul Burlin and his wife, ethnologist Natalie Curtis, the couple who had first welcomed Sterne when he arrived in New Mexico. Burlin's work was the only Santa Fe art of which Sterne approved, and Sterne had written Dodge earlier that he liked Curtis "very much" and that he believed Dodge would like her

too. Upon their arrival at the Burlins' adobe home, Dodge was also introduced to Alice Corbin Henderson, the coeditor of *Poetry Magazine* and, at the time of Dodge's visit, an active supporter of the U.S. war effort. Like many of the Anglo artists and writers who adopted Santa Fe as home, Henderson had first visited Santa Fe while suffering from tuberculosis. The climate and the community agreed with her, and her husband, an artist, had joined her there.[45] When Dodge and Sterne arrived, the group discussed attending an Indian dance in the upcoming days. Perhaps in an effort to welcome Dodge into the local community, Henderson told her of the large number of sweaters she had knit for the Red Cross and invited Dodge to tea the following day.[46]

For the most part, Dodge's first social outing in Santa Fe sounds relatively innocuous, but her memoirs suggest that the visit threatened her plans for her own and Sterne's careers in New Mexico. Santa Fe and Taos were the artistic centers of the state, and if Dodge was to make a future for herself in New Mexico, it was likely to be in one of those two towns. Curtis's and Henderson's activities suggested, however, that there was little room in Santa Fe for another white woman interested in the arts. Given Dodge's jealousy of Sterne's interest in other women, Dodge probably did not believe that she would like Curtis, as Sterne had assured her. In fact, Sterne may have exacerbated what might have been only a passing envy when he praised Curtis's studies of Indian music, proclaiming, "There is no one living who has penetrated so deep into the soul of the Indian."[47] Alice Corbin Henderson similarly rankled Dodge. As a literary editor and a poet, Henderson knew just as diverse a range of interesting and artistic bohemians as Dodge did, and she had achieved more success on her own artistic merits. Since Dodge's frenzied departure from Europe in 1914, a subsequent uncomfortable split with John Reed, and her acknowledgment of the growing anti-German sentiment in the United States, she hated any mention of the war, particularly anything as staid and domestic as knitting sweaters for the Red Cross. Eager to leave the entire tea party atmosphere, she declined Henderson's invitation, explaining that the following day she intended to drive the difficult road up to Taos, a small village to the north of Santa Fe.

In her memoirs, Dodge claims that someone in New York, she couldn't remember who, had told her to visit Taos, and that the idea returned to her when she realized the social scene in Santa Fe was not for her. She does not mention any envy of Henderson or Curtis, and she contrasts her attitude to Sterne's, explaining that he had grown fond of Santa Fe and his friends there

and was reluctant to head to the lesser-known Taos. Yet it was Sterne, not someone in New York, who had suggested Taos in a letter to Dodge, a letter she must have received only a few days before she departed Croton. Sterne explained that initially he was frightened of going to Taos because so much "ghastly" painting was done there, "but," he explained, "now almost all the artists are away and I hear that at Taos it is much easier to find a place to live in and also to get the Indians to pose."[48] Sterne may have changed his attitude drastically by the time Dodge arrived, but it is more likely that Dodge found it preferable in her memoirs to portray her decision to visit Taos as entirely her own.

Regardless of whether Sterne liked Taos, what matters is that Dodge was aware of Taos, and possibly even eager to visit Taos, even before she left New York. Rather than the result of the near-mystical, spontaneous decision to leave Santa Fe that she describes in her memoirs, the visit was, more than likely, premeditated. She must have considered visiting Taos before she left, and she likely considered it for the reasons Sterne suggested. The existing white art colony in Taos, best represented by those artists who had joined together to form the Taos Society of Artists, had a more realist style than Sterne and the artists Dodge typically patronized. Moreover, she had already seen examples of the society's work and concluded that it was poor.[49] Fortunately for Dodge, most of the society's members had left for the winter by the time she arrived. Other artists had assured Sterne that plenty of housing existed in Taos, and Sterne certainly needed eager models. Given Dodge's interest in what she considered the primitive population of New Mexico, this seemed an opportune confluence of events. Dodge could distance herself from Curtis and Henderson, both of whom had already established a well-respected social presence in Santa Fe, thus preventing Dodge from making the area her own terrain. Sterne's modernist work would compare favorably with the more realist art of the Taos Society of Artists, and he would have a jump on more modernist artists like Burlin who had not yet ventured to Taos to paint. If Taos locals were more likely to model for Anglo artists, they might also be more willing to spend time with an Anglo woman who felt she had a special affinity for Indians.

Not surprisingly, Dodge wasted little time in making her presence felt in Taos. Although it was smaller, younger, and even higher in altitude than Santa Fe, Dodge liked the little village, particularly its proximity to the nearby Taos Pueblo. She rented a home by January 1, 1918, and in March she took

her plans for Taos public, praising its beauty and attractiveness in an article for the *Washington Times*. Dodge's article attacked the crass commercialism of U.S. society that would later irritate writers like Sinclair Lewis, and contrasted the simpler economy of northern New Mexico with the business bustle of New York. Instead of the poverty that had shocked Anglo visitors since the close of the Mexican American War, Dodge saw only the air "full of sunshine and cheer and vitality." She announced that everyone had "enough to eat and plenty of time to live and dance and sing." For the first time, Dodge included the Nuevomexicano population of northern New Mexico in her visions of the area, calling local Nuevomexicanos "Spanish Americans" and celebrating their picturesque adobe homes and agricultural livelihoods. In Dodge's view, Taos was freed from the burden of economic inequality, and she urged those with artistic leanings to look west. "Now, unless something has fooled the artists and people who love life for its own sake," she explained, "they would rise up and leave the big, overgrown cities and come out to Taos, and places like Taos, where they could be happy and enjoy themselves."[59] Dodge's promotion of Taos echoed the sentiments she and Sterne had expressed privately in their letters to each other. Taos, if adopted by the bohemians who had surrounded Dodge in New York, could save the United States from the commercialization and pettiness Dodge felt had come to dominate urban eastern life.

To further this aim, Dodge once again set about assembling her household. She had already suggested that Andrew Dasburg and Robert Edmond Jones leave Croton and join her in New Mexico. In January 1918, Dasburg and Jones traced Dodge's own journey. Traveling across the country on the Atchison, Topeka, and Santa Fe railroad, they arrived in Lamy and then switched to the spur that took passengers to Santa Fe. After a day in Santa Fe, they started the climb upward to Embudo on the narrow-gauge Denver–Rio Grande line. In Embudo, they finally left the train and made the remainder of the ascent by car along a route that Dasburg speculated "a goat must have planned." Circling on steep switchbacks, the car teetered over the brink of the valley until it made the final push up over the edge of the Taos plateau. Having noted that the day had started with "the crystalline clarity and brilliance of light that is like a vibrant tinkling icyness [*sic*] of sound," Dasburg pronounced the view of Taos "magnificent. The rolling desert reaches off for miles to the great divide," he told his wife, "while across it cuts the winding canyon of the Rio Grande. Off to one side the mountains in chaotic grandeur half encircle the

plain. In this hollow at their base is Taos."[51] Dasburg would soon translate the sense of space and light he saw in the landscape into cubist portrayals of northern New Mexico. Upon his arrival, he was in awe of the landscape and eager to learn more about the place in which Dodge had settled.

The group's own artistic inclinations, along with their attraction to local art, served as the foundation for a western Provincetown, the Massachusetts seaside community where Dodge spent portions of each summer and where Hapgood and Boyce had helped form the Provincetown Players. Dodge, Sterne, Dasburg, and Jones spent their days careening around the country-side, attending Pueblo ceremonial dances, buying Pueblo jewelry, and collect-ing Nuevomexicano santos, painted and carved wooden saint figures common in Nuevomexicano Catholic communities. The first weeks of Dasburg's and Jones's visit recalled Dodge's salon in New York. Just as she had in New York City and again at Croton, and just as many of her friends had in Provincetown, Dodge assembled a collection of artists around her and then set them to work investigating the aesthetic and political inspiration of the place.

The group rapidly attracted the attention of the local community with their unusual interests and lifestyle. Dasburg's visits to local Nuevomexicano communities to buy santos, Sterne's emphatic declarations about the war, and Dodge's own accumulation of household goods for her new home drew the suspicion of her landlord, and he insisted local officials investigate the group for espionage. The investigation only strengthened Dodge's love for the place. Just a month after her *Washington Times* article was published, she sketched for her old friend Neith Boyce all the recent scandals and events that had endeared Taos to her.

> We are in the maddest, most amusing country in the world—in the freaki-
> est—most insane village you ever dreamed of and *I* would like to stay for-
> ever. . . . We have indians, and mexican penitentes who beat themselves to
> death with Cactus. . . . We were *so* queer they thought we were german
> agents importing dynamite! That blew over and I got mixed up by trying
> to help the indians get a new American doctor—and we're in that now
> with maybe uprisings, and beating ups, council meetings of indians and
> blackmail by the present doctor. . . . Life is like one long comic opera—
> with the most exaggerated costumes and colors, and impossible scenery
> and sunsets. . . . You'd better come out here! I am in love with all the indi-
> ans and they think I am one and talk to me in indian.[52]

Written with her typical exuberance for new experiences, Dodge's letter followed remarkably familiar patterns. Just as she had in her Greenwich Village days, she adored her reputation as "queer" and "dangerous," and her letter reveals something close to glee in the potential "uprisings" she had helped instigate. As if that were not enough (and mere political ferment never had been enough for Dodge) all of the activities in Taos seemed staged for Dodge's delight, with costumes and colors and scenery, just like the Paterson Pageant. Most predictably, Dodge felt compelled to share her experiences with others. She reserved her greatest enthusiasm for her plea to Boyce to "come out here!"

Dodge's enthusiasm as a recent arrival to Taos might have obscured her understanding of the area. Most crucially she lacked a deep understanding of the ethnic structure of New Mexico. The triethnic split Dodge made among Indians, Mexicans, and "Americans" would have been familiar to northern New Mexicans, but many would have found her nomenclature odd or even offensive. Within their own pueblos, the Pueblo Indians often called themselves by their own Pueblo name and not by the generic "Indian." Nuevomexicanos might have had more strenuous objections. By the late 1910s, many Nuevomexicanos considered the term "Mexican" derogatory, because they traced their heritage to the state's Spanish colonial past. "Mexican," in their eyes, connoted more recent immigration to the area and implied intermarriage with native people. Although many Nuevomexicanos descended from Mexican families or Spanish–Native American unions in colonial times, they obscured this heritage with the names "Spanish American" or "Hispano." Americans, that is, anyone who was not "Indian" or "Mexican," might have gone by a more specific ethnic designation in New York, such as Irish or Jewish or German. In northern New Mexico, though, they were grouped into the generic "American" or, as Nuevomexicanos and Pueblo Indians often called English-speaking newcomers to the area, Anglos. For northern New Mexicans, these names implied more than an ethnic heritage; they were instrumental in understanding where New Mexicans lived, how they supported themselves, and how they perceived newcomers like Dodge.[53] When Dodge reduced the entire ethnic tapestry of northern New Mexico to a stage show, she overlooked how prominently ethnic designations fit into the local power structure. In her quest to find the ideal bohemian wonderland, she turned away from the differences and inequalities that made New Mexico a far from perfect place.

In fact, Dodge's picture of Taos reveals more about the Taos Dodge wanted to see than it does the Taos that existed in 1918. Dodge never mentioned the poverty that plagued northern New Mexico and that possibly contributed to some Nuevomexicanos' decision to sell her and her friends their religious objects. She seemed unaware that not all Nuevomexicano people participated in the penitente brotherhood, an all-male secret religious order that practiced self-flagellation. Nor did she seem to know or care that most Nuevomexicano men involved in the order would find her depiction of their practices as "beating themselves to death with cactus" offensive. Perhaps most importantly, Dodge chose to acknowledge only a narrow element of the Pueblo population. She saw only those members of the Pueblo who visited members of the Anglo arts community while maintaining the Pueblo's traditional mores. Members of the Pueblo who had assimilated into Anglo or Nuevomexicano life did not interest her, and she did not interest the numerous Pueblo residents who scorned any contact with Anglos. Yet Dodge drew no distinctions among various groups in the Pueblo. Because some Pueblo residents showed an interest in her, she decided that the entire Pueblo had accepted her. In Dodge's image of Taos, she fit right into the Indian community, and that is exactly the image she presented to her friends back East.

For Dodge, fitting in necessarily included frequent visits to Taos Pueblo, a few miles north of Taos village, where she and Sterne had settled. Taos Pueblo was a popular destination for artists and writers in large part because of its architecture. Many members of the Pueblo lived in tiers of adobe built one upon the other such that they visually echoed the mountains behind them. Taos was a large Pueblo whose residents spoke Tiwa, rather than Tewa, the language common to San Ildefonso and Tesuque, the Pueblos Sterne had previously visited. The people of Taos Pueblo also had a different relationship to visiting artists than did the people of Tesuque or San Ildefonso. In Tesuque, Sterne had had his notes confiscated when he tried to make small sketches of the Buffalo Dance; in San Ildefonso local artists were supportive of his endeavors, but he still encountered difficulty finding willing models. More than likely, the people of San Ildefonso were interested in making their own art, not in helping an itinerant Anglo artist make his. In Taos Pueblo, the locals had encountered visiting artists since the members of the Taos Society had first appeared in the 1890s. Sterne still found widespread reluctance among prospective models, but the people of Taos Pueblo were at least familiar with his request and comfortable with the social niceties of declining or accepting

his offers. That Dodge found some of the people of Taos Pueblo welcoming, then, is not entirely surprising. Those living at Taos Pueblo were accustomed to Anglo visitors, familiar with requests for models and pictures and picturesque behavior, and comfortable telling visitors to stay or go.[54] This is not to say that all members of Taos Pueblo welcomed and appreciated the artists who used Pueblo bodies and customs for Anglo artistic success, but many had reached some kind of conclusion as to how they would treat artists who came to visit.

At least one member of Taos Pueblo had a relationship with the Taos Society of Artists even before Dodge and her bevy of sculptors, painters, and set designers arrived. Tony Lujan, a drummer at Taos Pueblo, had appeared in a photo with the Taos Society of Artists sometime in 1917 or 1918, either before Dodge arrived or less than a year after he met her and her visitors from back East.[55] Lujan does not appear to have been interested in modeling for the TSA, but his participation in a photo with the society indicates that he was at least aware of the Anglo artists and their community in Taos. Lujan maintained his relationship with the artists' community through the winter of 1917–1918, visiting Dodge only a few days after she made her first trip to Taos Pueblo and found him drumming in his home.

Like Lujan, the local paper associated Dodge with the artists' community at Taos. The *Taos Valley News* had celebrated TSA activities since the paper's publishers had realized that art boosted tourism to the region, and they concluded that Dodge was just another addition to the artists' booster community. Soon, Dodge was appearing in a gossip column on the artists' community called "The Artist's Corner" that covered events surrounding the members of the TSA.[56]

Dodge wanted more than an invitation to TSA parties, though. She wanted her own identity in Taos, and she had her own aesthetic and social agenda for the region. The *Taos Valley News* charted her emergence as an independent actor in the New Mexico art community, introducing her first as part of the pair "Artist and Mrs. Sterne," then as "Mrs. Sterne," and, by June 1918, as "Mrs. Mabel Sterne," an evolution Dodge probably appreciated given her earlier satisfaction in replacing "Mrs. Edwin Dodge" with "Mrs. Mabel Dodge" during her marriage to her second husband.[57] Eventually, the paper would alternate between calling her Sterne and Dodge: a seesaw that reflected the community's own confusion over her marital and occupational status. She was clearly more than an artist's wife, but she was not an artist herself.

She shared the fascination of visiting artists with the landscape, the Pueblo Indians, and the Catholic traditions of the local Nuevomexicano community, but she distanced herself from the TSA. She promoted the area in a way pleasing to boosters, but she did so with a pen, not a brush, and she wrote erratically, praising the area to outsiders one day and relishing its distance from crowds and banal tourists the next. Whatever Dodge was, she was not the artist Taos locals had come to expect. As far as Dodge was concerned, her status as neither artist nor booster nor wife nor entrepreneur placed her in an ideal position to make Taos into the kind of art colony that she desired.

Crucial to Dodge's project were the social relationships she developed with the people she met at Taos Pueblo. Dodge actually did want to know the people of Taos Pueblo. She invited the people of the Pueblo to join her for horseback and auto outings as well as dinners and parties, just as she had invited Bill Haywood and members of the Wobblies to dine in her Fifth Avenue salon.[58] In fact, a salon atmosphere prevailed more and more at Dodge's Taos home, where her friends from the East mingled with the artists of Taos and Santa Fe and the people of Taos Pueblo.

Tony Lujan participated in most of these events, and he was by Dodge's side as she and her friends formed a new artists' community in Taos. Lujan often drove the group to surrounding dances, attended Dodge's parties, and, in May 1918, even accompanied a friend of Dodge's back to New York.[59] When Lujan returned, he involved himself even more deeply in the Dodge household. Dodge had become fast friends with John Young-Hunter, a portrait painter whom she met through Bert Phillips, a member of the TSA. Lujan persuaded Young-Hunter to build a home in Taos. Lujan oversaw the construction and employed many of his family members on the project. Before he had finished, he convinced Dodge that she, too, should have a house, and she purchased twelve acres adjoining Pueblo land for that purpose in June 1918.

The house Dodge and Lujan built together was the first of many projects they would complete as partners. Lujan oversaw the construction and Dodge set about decorating the interior. While they worked, they also took a series of walks, horseback rides, and camping trips to the surrounding area, including a long excursion to Blue Lake, a sacred site to Taos Pueblo Indians. Dodge was entranced with the landscape and increasingly enamored with Lujan, who brought her flowers on their trips and introduced her to the surrounding mountains. When not working on the house, Dodge spent her days in a teepee she bought for the trip to Blue Lake and later erected in her front

Ernest Knee, *Mabel Dodge Luhan's Los Gallos Residence*, 1938. (Courtesy of the Ernest Knee Photographic Trust.)

yard.[60] Eventually, Lujan began visiting her there, out of sight of the growing collection of friends and family living in Dodge's home.

Sterne, with growing apprehension, watched the relationship between Lujan and Dodge take form. He had always planned to return to New York in August 1918, but he was offended when he realized that Dodge was eagerly anticipating his departure. At first he withdrew into his work. While Dodge went camping with Lujan, Sterne spent hours molding a wax bust of a Taos Pueblo woman named Albidia Marcus. He emerged from his sessions with Marcus on more than one occasion to confront Dodge about her relationship with Lujan, but Dodge maintained (even in her memoirs) that she and Lujan did not acknowledge their feelings for each other or consummate the relationship until after Sterne had left Taos. Sterne himself did not give full vent to his anger until Lujan's daily visits to Dodge's teepee. Unable to alter the situation and dependent on Dodge's money, Sterne left in a cloud of frustration and anger that he released on his sculpture of Marcus. When the summer heat partially melted his work, he hacked the head to pieces and never returned to Taos.[61]

Sterne's departure distressed Dodge, but it also left her free to pursue her goals in Taos. Her relationship with Sterne had always been rocky, and, as her plans for New Mexico took form, she realized that she wanted more to be a presence in the local community than the wealthy wife of a sculptor. Dodge would maintain a connection with Sterne over the next few years, using him more and more as a contact in the art world of New York and less and less as an emotional companion. Her real project would be making Taos into the locale bohemians wanted to find, and for Taos to become such a place, she would have to have a strong connection to the Indian community. Lujan was that connection, and his relationship with Dodge would last until her death in 1962.

To achieve her ambitions for her Taos home, Dodge relied on her ability to promote the art of northern New Mexico in New York. Less than six months after Sterne's departure she was using him and her contacts at New York art galleries to promote work by Indian painters. Along with John Sloan, an artist who had helped Robert Edmond Jones with the Paterson Pageant and who regularly traveled from New York to Santa Fe, she arranged for two shows of paintings by children and adults from the surrounding Pueblos. "I want these things seen," she demanded of Sterne. "Also I want to be associated with the show in case anyone gets interested & wants to get some pictures & hear about them & I want the prestige of showing them." Dodge went on to outline just how much prestige she expected from the show when she asked that every painting carry the caption: "Sent by Mabel Dodge Sterne." "Because," she explained, "at the 1st big independent show I exhibited Gertrude Stein's 'portrait' & *launched her*."[62] In Dodge's mind, her involvement in New Mexican life would equal her involvement in the Armory Show, and, ideally, bring her the same level of fame and social importance. New York had not lost its centrality in Dodge's mind. It was now the showcase for the aesthetic riches that she intended to cull from her New Mexico art colony.

Dodge's effort to gain a New York audience received a boost when Alida Sims, writing for the *New York Times Book Review and Magazine,* caught the tenor of 1920s Taos for eastern readers. In a 1921 article titled "The Provincetown of the Desert," Sims quickly assured readers that "Taos is not Provincetown, nor another Gloucester, nor even a Greenwich Village of the West, as it has been called. And that is why it is so different. Because it is not at all what anyone would ever expect it to be." What made Taos even better than Provincetown was its relatively small sprinkling of tourists and the warm re-

ception of the locals. "Instead of a horde of tourists and students," the writer assured readers, "there is a comparatively small group of real notables, who have left their own peculiar impression upon a town distinctive for its scenic setting." Visitors to Taos may have been a highbrow crowd, but the *Times* asserted that Taos locals got more diversion out of watching the artists than they did "practically anything else." All of this led Sims to conclude that "Taos is wholly devoted to its artists, and the artists are wholly devoted to Taos. . . . Together [Taos and Santa Fe] represent a great stronghold for the development of the esthetic culture of the United States today."[63]

Dodge's Taos household may have held more aesthetic promise than the arts communities in Greenwich Village and Provincetown, but to match the energy of either of these artists' colonies Taos needed a political edge. Almost from her arrival, Dodge's efforts in Taos seemed to be focused on reviving the spirit of her New York salon, but her salon had been far more politically active. That artists in Taos and Santa Fe were slow to adopt any political causes is not entirely surprising. The war had led Dodge and many of her friends to abandon their hopes of finding a melding of art and politics in modernism, and Dodge's retreat to Croton had mirrored her retreat from political activity. When she arrived in Taos, she carried this despair with her, finding artistic interest in New Mexico's land and people but not political inspiration. Even when Sterne wrote Dodge about the political persecution of her friends in the nascent Red Scare of 1919, Dodge remained silent, seemingly oblivious to the harsh consequences of the political idealism she and her friends had embraced in the days of her salon.[64] Dodge does not even appear to have remarked publicly on women achieving national suffrage. Whether driven by a similar apathy, fear of their own persecution, or just the sheer distance between Taos and major political centers, most of Dodge's visitors steered clear of political involvement as well.[65] By the early 1920s, though, Dodge began to see her retreat from politics as a mistake and local Taos politics as her redeemer. Fortuitously, an issue that combined political activism, aesthetic appreciation, and Dodge's newfound love for Taos suddenly appeared.

John Collier's Place

What brought Dodge the fusion of place and politics she desired was a fight over a fence in Tesuque, the first Pueblo Sterne had visited when he came to New Mexico. On February 9, 1922, an Anglo settler named E. D. Newman found two miles of his new fence torn down and a group from Tesuque Pueblo claiming responsibility. The Tesuque Indians explained that Newman had built over their land. Newman insisted the land was his and that he would continue fencing. According to Martin Vigil, a member of the Tesuque group that had torn down the fence, Newman stated that he didn't "care . . . whether China-men, Nigger, any nationality tries to stop me, I won't stop."[1] Tensions escalated and, according to some reports, the conflict nearly came to blows. The Indian agent responsible for the northern Pueblos, which included Tesuque, took the Pueblos' side, insisting that the land indeed belonged to the Pueblo Indians. Newman was none too pleased and appealed to the U.S. commissioner of Indian affairs, the U.S. secretary of the interior, and the governor of New Mexico.[2]

Secretary of the Interior Albert Fall, a ranch owner from southern New Mexico, was already wrangling with the issue of disputed Pueblo land claims when Newman's appeal arrived. The U.S. government had twice changed its policy on whether Pueblo lands were open for non-Indian settlement, and the result was a series of land ownership disputes that showed no evidence of leaving the courts quickly. Fall had already commissioned a historical report on the issue from an attorney named Ralph Twitchell. When the Tesuque crisis came to a head, Twitchell drafted a bill with the hope of putting the land disputes to rest. Senator Holm Bursum of New Mexico introduced the bill to Congress on July 20, 1922.[3]

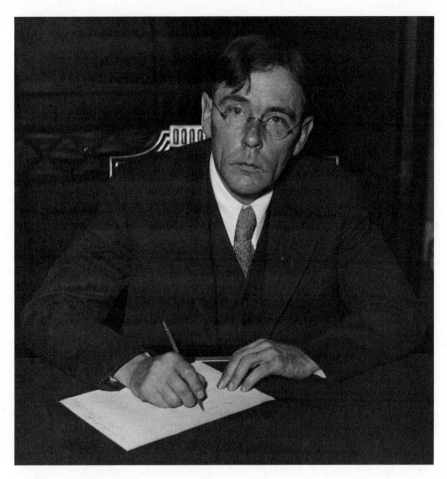

John Collier. (Library of Congress, Prints and Photographs Division, NYWT&S Collection [LC-USZ62–111222]; courtesy of Bettmann/Corbis.)

This legislation came to Dodge's attention through an old friend, John Collier. Collier had left a job at the People's Institute, where he had promoted immigrant culture on New York City's Lower East Side, had spent a brief time in North Carolina, and then moved to California. He had arrived at the ever-expanding Dodge compound in December 1920. Dodge had sent a deluge of invitations to Collier until she overcame all of his objections and finally convinced him to visit Taos with his family. The Colliers stayed in New Mexico until May 1921, when John returned to California and resumed work as a sociology professor at San Francisco State Teachers' College. Collier would later

write glowing accounts of his days in Taos and of his conviction that he found there the seamless whole of life and art that he had sought when working with immigrant and community groups in New York. His initial letters, though, reflected only a concern about Pueblo poverty and lack of health care. In the hope of improving the medical situation at the Pueblos, he contacted Californian Stella Atwood, chair and cofounder of the General Federation of Women's Clubs Indian Welfare Committee.[4] Through Atwood's assistance, Collier found a sponsor who allowed him to suspend his teaching work and return to New Mexico for research on the Pueblo Indians. He was preparing for his trip there when Atwood heard of the Bursum bill and concluded, quite rightly, that it would hurt Pueblo land interests.[5]

Collier's view of the Indians and of New Mexico would fundamentally change how Dodge and her visitors reacted to the region, how they presented it to a national audience, and most substantively, how people in the region itself understood land holdings. Collier had a particular image of New Mexico's inhabitants, an image strongly influenced by his work supporting immigrant communities' cultures in New York City and by his advocacy for communal living and artistic production. His outlook was further informed by an appreciation of nature that he had nurtured while he was in the North Carolina countryside during a hiatus from public service work. Dodge and others were quick to accept and expand Collier's vision. They imagined a place with ancient antecedents where artistic production, nature, and everyday life melded into a seamless whole. The Pueblo Indians, who were already popular symbols among other boosters of northern New Mexico, would become central to the image of the region that Collier and his allies presented to the nation and to the world.[7] At the same time, the Indians' land and how it was distributed would increasingly become an indication of how successful Collier had been in making his vision a reality.

That Collier's ally Stella Atwood was able to identify the consequences of the Bursum bill was remarkable given how enormously complicated land issues in New Mexico were, and, for that matter, continue to be. The land in question in the Bursum bill included approximately 60,000 acres of the region's more valuable land, to which Pueblo Indians and several thousand non-Indians all claimed title. Much of the land was irrigated acreage, making it particularly valuable in the drought-prone Southwest. Many of the non-Indian claimants were squatters, many were Nuevomexicanos, some had married members of the Pueblos, some were the children of such unions, some

(like Newman in Tesuque) were more recent Anglo immigrants to the state. Some of the Nuevomexicano claims to the land went back to the Spanish colonial and Mexican eras in New Mexico, and, although the U.S. government had agreed to honor these claims when it acquired New Mexico territory in 1848, finding proof of title for claims hundreds of years old proved difficult.[8] The thorniest problem, however, arose from the Supreme Court's seesaw approach to Pueblo sovereignty. In 1876 the Supreme Court had ruled that the Pueblos were not wards of the government and thus were free to sell their lands. In 1913, however, the Court reversed its ruling, throwing all titles to Pueblo land acquired since 1848 into doubt.[9]

The Bursum bill, although it was written by Twitchell, the Pueblo attorney at the time, resolved the issue by granting almost all of the land to non-Indians. Twitchell wrote the bill in consultation with the attorney for the non-Indian claimants, A. B. Renehan, and with Secretary of the Interior Albert Fall, whose record for honoring Indian ownership was far from spotless.[10] The plan Twitchell, Renehan, and Fall concocted gave every Anglo or Nuevomexicano settler title to the disputed land provided they could prove color of title before or after 1848. If the settlers could not prove color of title, they were *still* granted the land if they could prove continuous possession of it since 1900. And if the settlers could not prove color of title or continuous possession, they could *still* appeal the case to the secretary of the interior. In effect, the bill gave non-Indian settlers three opportunities to claim the land, and all of those opportunities were biased in the non-Indians' favor. Squeezing the Pueblos still more, the bill placed Pueblo water rights under the jurisdiction of the unfriendly state courts. To make up for the lost territory, the government was to compensate the Pueblos with public agricultural lands, many of which did not have accompanying water rights, or with cash, a process that almost inevitably underpaid native groups and left them destitute.[11] If the implications of the bill were confusing to an outsider, they were painfully clear to the Pueblos. Members of Laguna Pueblo met in Albuquerque with Commissioner of Indian Affairs Charles Burke to express their concern over the legislation even while Twitchell was drafting it, but Burke shooed them out of his office.[12] The overt injustice of the situation rankled Atwood and Collier to no end, and Collier temporarily abandoned his efforts on behalf of Pueblo health care to throw himself into the fight against the Bursum bill.

Dodge offered her money and her Pueblo and New York connections to the campaign, creating a coalition of artists, writers, activists, and locals that

revived the salon spirit of her New York days. California writer Mary Austin, who had visited Dodge's salon to talk about California's Indian population, had visited Taos in 1919 and was fortuitously in Santa Fe at the time of the campaign. She joined the effort and added her literary connections to Dodge's. D. H. Lawrence, who had arrived at Dodge's invitation shortly after Collier, was bewildered by the sudden flurry of activity and ambivalent about Anglo interference with Pueblo and Nuevomexicano life, but he wrote an article against the bill for the *New York Times.* Lawrence had a field day with the puns he pulled out of names like Albert Fall and the Joy Survey, the controversial basis for the non-Indian claims. Catching the infectious energy of Collier and Dodge, Lawrence lamented, "O Mr. Secretary Fall, Fall, Fall! Oh Mr. Secretary Fall! You bad man, you good man, you Fall, you Rise, you Fall!!! The Joy Survey, Oh Joy. No Joy, once Joy, now Woe! Woe! Whoa! Whoa Bursum! Whoa Bill, Who-a-a!"[13]

Meanwhile, the artists and writers in Santa Fe showed no sign of slowing down. Santa Fe *New Mexican* editor E. Dana Johnson, poet Witter Bynner, the Director of the Museum of New Mexico Edgar L. Hewett, painter Gerald Cassidy, his wife Ina Sizer Cassidy, and Coeditor of *Poetry Magazine* Alice Corbin Henderson all joined forces with journalist Elizabeth Shepley Sergeant and a woman named Margaret McKittrick to form the New Mexico Association on Indian Affairs. The association, along with Dodge, Austin, and Collier, milked every connection they had in the New York periodical world until the *New Republic,* the *Survey,* the *Nation,* the *New York World,* and the *New York Times* fairly burst with articles and editorials decrying the injustice of the Bursum bill.[14] The *New Republic* and the *Nation* brought the story to liberals, who found little to celebrate in the politically conservative climate of the 1920s, and the *Survey* kept the story in front of Collier's fellow progressives. The *New York World* ensured the issue a popular audience. It is likely that tens of thousands of readers at least heard of the legislation.[15] When the press failed to provide publicity, the group produced their own by widely distributing their broadside on the issue titled "Protest of Artists and Writers against the Bursum Bill."[16]

Because Dodge and her friends saw the artistic talents of the Pueblo Indians as the Pueblos' greatest strength, they hoped that publicity against the Bursum bill would revive the melding of art and politics that had been popular in Dodge's salon days. Not an article escaped the group that did not mention the artistic promise of the Pueblo Indians or their communal lifestyle. In

her article against the bill, Alice Corbin Henderson reminded readers that the Pueblo Indians were "artists in ceremonial dances, in music, in poetry, in pottery, in weaving, in silverwork; and in the art of pure design alone their continuing and developing achievement is superb, comparable to the early Greek and Etruscan art and far surpassing the most ambitious achievements of American artists in this direction—as the American artists themselves are the first to acknowledge."[17] For writers and artists such as Henderson, separating art from the political and material implications of the Bursum bill was unfathomable. [Politics and art were inextricable components of the same campaign to transform modern U.S. society for what they saw as the better.]

Although the players had shifted slightly, Dodge's circle in New Mexico employed cultural politics remarkably similar to those of her salon in New York. Collier's previous employer, the People's Institute, had been founded in part "to bring together the world of culture and labor to cope with the problems of social unrest."[18] Collier interpreted this mission by staging elaborate pageants that showcased the cultures of immigrant communities on Manhattan's Lower East Side.[19] His work did not end in New York. Just as he had celebrated the folk art of immigrant groups in New York and just as John Reed had written of the natural connection between people and expression in Mexico, Dodge's community now rejoiced in the artistic talents of the American Indian. Just as members of Dodge's salon in New York had pinned their hopes for a modernist melding of art and life on the groups they patronized on the East Coast, now the Anglo artists of Taos and Santa Fe deferred to the superior lifestyle of the Pueblo Indians. Dodge's salon had not changed all that dramatically. [She and her nascent art colony still sought salvation in artistic expression; they still hoped for grounding in a uniquely American, but ancient civilization, and they remained optimistic that some "primitive" group would provide a model to follow.] What had changed for Dodge and her friends in the Southwest was who and, more importantly, where that model was.

Collier, Dodge, and their allies clearly saw Pueblo Indians as the key to their utopian visions, but the Pueblos were vital because Dodge and her friends believed that Indians had a unique connection to the land. The land made the Pueblos, in Dodge's eyes, unquestionably American. The Pueblos' long tenure in the Southwest meant for Dodge and Collier that the Pueblo Indians had an ancient civilization, one that had never been separated from the land. That many of the landscape's natural features held sacred meanings for

Pueblo Indians only validated Dodge's and Collier's belief that a fruitful fu-
ture for the nation and for humanity lay in aesthetic appreciation of rural, nat-
ural beauty.

Collier's interest in combining nature, ancient civilization, and advocacy
on behalf of others was not new. His work at the People's Institute demon-
strated these interests, and only a few years before the Bursum bill struggle,
Collier had written Dodge a long letter describing what he saw as the trans-
forming natural beauty of the North Carolina countryside. Contrasting his
concerns with those that had preoccupied him in New York, he wrote: "There
are other interests here, the daily weather, on which just now a whole year's
comfort depends; the mistletoe that is capturing and will destroy a great oak
beside the house; the mystery of honey-dew which comes in dry weather on
walnut trees; the russet cow who wandered here, with udders sagging and
aching, from ten miles over the forested mountains by the Indian trail, day
before yesterday." Collier had left the city behind, but not his attraction to
what he found ancient and unchanging. "And the wind in these grasses and
bushes stirs every leaf with the slow force of the boundless river which it is,
flowing northeastward through the whole valley, through a hundred other val-
leys, around a thousand mountains; the south wind worldwide, the inconceiv-
ably ancient returning of spring."[20] Collier's sojourn in North Carolina took
place at the same time Dodge was singing the praises of her country home in
Croton-on-Hudson. That a place, particularly a rural place that followed sea-
sonal rhythms, might hold the key to what she and Collier sought never
seemed to be far from either of their minds.

The Pueblo Indians seemed to inhabit just such a place. Dodge and her
friends had always had an interest in Pueblo Indians, but the Bursum bill and
Collier's fight against it helped to develop that interest. Dodge and her fellow
bohemians wanted more than a people, they wanted a *place* that would pro-
vide the alternative aesthetic and way of life they had been seeking. Because
the Bursum bill threatened Pueblo land holdings, it jeopardized the basis of
the primitivism Dodge and her friends had come to embrace. Alongside the
aesthetic value of Pueblo Indian culture, the Bursum bill's detractors sought
to defend the land above all. As Collier's ally Elizabeth Shepley Sergeant put
it: "To the Pueblo land is life—not any land, but the piece north or south, east
or west, that he is bred on." She went on to ask rhetorically "Was this [the
Bursum bill] then, the reward of constant agricultural effort, industry, self-de-
nial, devotion to family and tribe, ceremonial dance to gods of rain and sun?

To lose in the twentieth century the whole of your heritage?"[21] In short, for Collier, Dodge, and others involved in their campaign, the Pueblos ceased to be ancient, spiritual, or natural without their land.[22]

Collier's most articulate and sophisticated expression of his primitivist faith in the Pueblo Indians and their connection to their land was an article titled "The Red Atlantis," which he began composing even before he was familiar with the Bursum bill and its effects. The article argued that with sufficient aid from non-Indian advocates, Indians could create a life that combined elements of their ancient communal traditions with such elements of "modern life" as advanced education and occidental medicine. "The pueblo is not primitive in the sense of being primordial," Collier clarified. "But it is primitive in that it has conserved the earliest statesmanship, the earliest pedagogy of the human race, carrying them forward. . . . From this statesmanship and pedagogy our present world needs to learn and tomorrow's world will learn if given the chance."[23] Whereas Dodge was less inclined to qualify what she meant by primitive and more likely to trap the Indians in a seemingly timeless world, Collier was more likely to believe that the Pueblo Indians carried a timelessness with them, one that carried great promise for white culture, if whites would only acknowledge and preserve it along with the land that made Pueblo culture possible.

Collier seemed to propose an exchange of Indian aesthetic forms for "modern" white contributions, particularly in medicine. That Collier saw white visitors to the Pueblos as aesthetically retrograde in comparison to their Pueblo hosts was apparent in "The Red Atlantis." Although the article reproduced art by Maurice Sterne and members of the Taos Society of Artists, Collier found that the work of the white "art colony" paled in contrast to that of the Pueblo Indians. "The Taos art which is steadfastly great is the Indian art," Collier asserted. He took the white art colony to task for "severe individualism." In contrast, the Pueblo Indian artists were, in his view, "intensely social. They are, indeed, the community itself consciously living in beauty."[24] In short, the Pueblo Indians offered the community of aesthetic creation that Dodge had begun to build in Greenwich Village and Croton and had hoped to revive in Taos. Collier reminded her and other readers how central Indians and Indian art were to such a vision.

Collier's enthusiasm for Indian art notwithstanding, he felt that whites would never have an opportunity to benefit from the Indians' aesthetic consciousness if whites did not first embrace their responsibility for the material

needs of the Pueblo Indians. Indeed, his primary concern throughout the
Bursum bill conflict was the health and economic standing of the Pueblos. In
his brief tour through the Pueblos and in his association with Stella Atwood,
Collier had been appalled by the living conditions on Indian land. Hunger
and disease were rampant. Even at Taos Pueblo, considered prosperous com-
pared to some of its southern neighbors, contemporary demographers meas-
ured per capita income at only $30 a year.[25] Economic opportunities were few,
and as early as 1922, when Collier published "The Red Atlantis," he worried
over the Pueblos' dependence on tourism.[26] Collier was particularly con-
cerned about Indian education. Most schools were understaffed and over-
crowded, and students were punished harshly when they resisted
assimilation to the norms of white behavior. Collier hoped to improve the
standard of living on reservations and Pueblos, expand religious and social
freedom for all native groups, and begin an entirely new education system,
goals that would continue to motivate him when he became commissioner of
Indian Affairs during the New Deal.[27]

Dodge shared these practical concerns, particularly Collier's efforts to im-
prove health care for the Pueblos, but she thought political, social, and aes-
thetic change could all proceed in a single movement. Collier's own
sympathies to such a vision led him to encourage her enthusiasm, but he
stressed that they would first "have to establish the right to dictate Indian pol-
icy, and build up a truly national movement, and get ourselves strong 'on top'
politically, before we can demand for the Pueblos the kind of thing you write
of."[28] Collier increasingly placed his faith in defeating the Bursum bill. He
felt that without successfully defeating the bill and establishing a political
coalition, none of his or Dodge's plans for the Pueblos could proceed.

In keeping with this strategy, he and Tony Lujan convinced the Taos
Pueblo Council to discuss the bill. First the Taos Pueblo Council and then
members from the entire Pueblo met over the course of several nights and
agreed that all of the New Mexico Pueblos should hear about the legislation.[29]
With Lujan serving as ambassador, Collier traveled to nineteen of the state's
Pueblos over the following weeks, a grueling trip even with Dodge's well-
equipped car.[30] The members of Isleta Pueblo responded strongly to Lujan
and Collier's visit and called an All-Pueblo Council. On November 5, 1922, 121
delegates met at San Ildefonso Pueblo in one of the first public acts of inter-
Pueblo cooperation since the Pueblo Revolt against the Spanish in 1680. The
council drafted an alternative measure for settling disputed land claims and

issued a statement against the Bursum bill titled "An Appeal to the American People." Many of its signatories agreed to form a delegation to Washington, D.C., and Collier volunteered to raise the necessary funds for the trip.

The All-Pueblo Council and the imminent trip to Washington delighted Collier, Dodge, and their friends because both events seemed to show their closeness to the Pueblo Indians, a proximity that carried a powerful cachet among their peers and many of the Indians' advocates. In his article summarizing the events, Collier called the All-Pueblo Council "the most picturesque gathering" and managed to mention the fact that he was the first white man allowed to enter San Ildefonso Pueblo "intimately." In keeping with his vision of an ancient culture preserved in contemporary Native American life, he called the Pueblo council meeting "the living, undiminished continuum of a democracy older than the Saxon folk-mote and probably older than the Athenian democracy."[31] Elizabeth Shepley Sergeant, writing of her experience at a Pueblo meeting, also felt obligated to point out that she was the "only white person present." Perhaps in an attempt to demonstrate her own intimate understanding of what she saw as an ancient culture, she wrote that "each fine head, and dark, lined face etched against the whitewashed wall, stands out for me like the head of some ancient ruler on an antique coin, highly individualized, yet sign and symbol too."[32] Collier's and Sergeant's articles made clear that the artists, writers, and activists fighting the Bursum bill advertised more than the bill's drawbacks when they wrote about the Pueblos. They also publicized their own supposedly unique access to the Pueblo Indians. They wanted the entire nation to take note of the Bursum bill, but they also wanted it clear that *they* were the Anglo emissaries of the Pueblo Indians.

For Dodge, utopian fantasies were more than subtext; they were the entire reason for her efforts against the bill. Dodge found what she called the "amelioration" and "reform" of Indian rights work tiresome, but she was excited about the mythic visions emerging from her friends' writings on the Bursum bill. Following the meeting at San Ildefonso, she wrote Collier excitedly about her plans to turn her house in Taos into a sort of social experimental center that would provide a "new world plan" modeled after Indian life. She explained that her house was an ideal venue for this effort because she believed she was "really in the indian current." To lend credence to her claim she noted that "Tony is a kind of symbol of my having gone over into an 'otherness,' as Lawrence would say. When I left the white people's world I really left it—it was no mental attitude or superficial sensational gesture. I am commit-

ted to the indians."[33] With Lujan as her lover, Dodge could claim even more persuasively than Collier and Sergeant that she understood Pueblo Indians intimately. More importantly, she could use this intimacy as the foundation for the new world plan she intended to spread throughout the nation.

Dodge's new world plan, with her house at its center, preoccupied her during the Bursum bill struggle. At one point, when Dodge feared that Austin was tiring from the effort of the campaign, she reminded Austin of the cascade of media attention and its importance for their visions of the future. "The country almost has seemed to go indian. . . . This publicity is invaluable. That it began in politics does not prevent its being channeled [sic] into aesthetics."[34] Dodge and even Collier, Austin, and Sergeant seem to have seen a clear connection between political and cultural activity, and Dodge at least was ready to volunteer her home—and its proximity to Taos Pueblo—for the cause.

Dodge's new world plan was fantastic, akin to her plan to bring a Pueblo family to Croton in its outrageousness, but she had accurately gauged the strength of the campaign. Indeed, she had also accurately identified the source of much of its appeal to many involved. Stella Atwood repeatedly reminded Francis Wilson, a New Mexico attorney who joined the New Mexico Association, of the Pueblos' picturesque charm. A typical letter read: "I feel that particularly in New Mexico, you people must realize that for the future those wonderful and picturesque Indians are one of your greatest assets. More and more as the facts about them are known, people are going to come to your country and make their acquaintance and find out what a fine state New Mexico is."[35] Similar letters poured into Congress and President Harding's office not just from writers and artists connected to New Mexico but also from the General Federation of Women's Clubs. While Dodge, Collier, and Austin bombarded the national press with articles and editorials, Atwood mobilized the federation's 2 million members, who were eager to show off their new voting rights. In an era of social conservatism and widespread racism, the General Federation of Women's Clubs and the coalition of artists and writers in New Mexico had created a national outcry over the status of the Pueblo Indians.[36]

Crucial, of course, to Dodge's vision for her house's future and the defeat of the Bursum bill was the Pueblo delegation to Washington, D.C. The group, which included Lorenzo Chavez of Zuni, Pablo Garcia of Acoma, Frank Paisano and Charlie Kie of Laguna, Santiago Peña of Santo Domingo, Jesús

Baca of Jemez, Martin Vigil of Tesuque, Sotero Ortiz of San Juan, Santiago Naranjo of Santa Clara, Tony Romero and Alberto Martínez of Taos, and José Alcario Montoya of Cochiti, left for the East Coast on January 10, 1923.[37] Dodge had dearly wanted to accompany the delegation, but the New Mexico Association feared that her relationship with Lujan would bring the entire campaign distracting publicity. Dodge's own fears that her presence would bring negative repercussions to the Pueblos finally convinced her not to go, and Atwood and Austin served as the group's publicity managers.[38] In Chicago, the delegation met Collier, who had recruited Harold Ickes, an Indian advocate who later became secretary of the interior during Franklin Roosevelt's administration, to arrange an appearance before the Cliff Dwellers, an organization of artists, businessmen, and bank presidents interested in Indian affairs. The appearance brought in little money (fund-raising was the primary focus of the Pueblo delegation), but it did win Ickes's political support.[39] The delegation went on to New York City for an appearance at the People's Institute, and then to Washington, D.C. During an interval between the Senate and House hearings on the bill, a portion of the group returned for a series of fund-raising events in New York, including an appearance at the New York Stock Exchange.[40]

The delegation's trip east satisfied many of Dodge's primitivist hopes, and Austin fed her satisfaction with detailed letters about the group's experiences. She wrote Dodge excitedly about the delegation's appearance at the New York Stock Exchange. "When the Indians stood up in the gallery and sang the Morning Song, the Exchange simply got up on its hind legs and howled."[41] Austin was particularly pleased with the financial contributions solicited from the stock exchange, but Dodge was probably more excited by the reaction the delegation received at Cooper Union, Collier's old stomping grounds from his days at the People's Institute. Austin wrote that she initially thought the appearance was a waste of time. After all, she explained, the group was "98 percent radical labor men, with no money and little influence," but then, according to Austin, as the delegation began to sing and dance, a curious change came over the assembly.

> As if for once they had truly discovered the brotherhood of man . . . as if the Heavens had opened and they had heard a Voice! At the last it seemed as if they simply couldn't let those Indians go. They crowded round, shaking hands over and over, with such simple expressions as 'Wish you luck

Boys,' and yet it was evident that there was a rapport established between them and the Indians that was of immense spiritual value to both.[42]

Whether the appearance at Cooper Union elicited a spiritual response or whether Austin just hoped that it did, Dodge must have been pleased that the working-class groups she and Collier had patronized in New York and the Pueblo Indians she patronized in New Mexico had finally come together.

The Bursum bill did not just change the lives of Dodge, Collier, and those who shared their particular vision. The Pueblo Indians had their own reactions to the bill, reactions that sometimes contradicted the image of New Mexico Collier and his allies had presented in their campaign. When members of the Pueblo delegation finally had an opportunity to present their own opinions to Congress, only one delegate chose to use the term "primitive."[43] Instead of trading on their popular image, the members of the delegation focused on the immediate danger of the legislation that they feared would limit their land. They insisted that they did not want charity. They requested aid in developing more modern agricultural and irrigation techniques so as to make the land as productive as possible. They expressed appreciation for the education of their children. They asserted their right to self-government. Most crucially, they repeated insistently that they had been deprived of their land through fraud and wanted their property restored.[44] The delegation was evidently willing to indulge Collier in their public presentations, but when it came time to make their case in Congress, they did so without the sensational trappings Collier and others had imposed.

Indeed, the delegation's most forceful member made his case not through performance but through skilled argumentation. Pablo Abeita of Isleta Pueblo was the only member who spoke before Congress when the delegation went east. The remainder of the delegates submitted written statements, but chose Abeita as their representative speaker. He had been educated at St. Michael's College in Santa Fe and spoke fluent Tiwa, Spanish, and English. At the time of his testimony, he was working as a judge in the Indian courts established by the federal government.[45] Dodge likely would not have chosen him to go east. As she wrote to Collier, "They always vote that the smart short-haired americanised [sic] ones shall go," she complained, "just the wrong ones."[46] As far as the delegates were concerned, Abeita was exactly the right one, and his performance before the subcommittee who heard his testimony soon proved them right.

Like his fellow delegates, Abeita focused on the Pueblos' achievements and their long history as a civilized people. In his prepared statement, he asserted that "way down in New Mexico civilization was in full bloom when Christopher Columbus's great-grandparents were murdering and massacring each other." Abeita implied that the Pueblos, as a people with a long, civilized tradition, were entitled to keep the land that they held for centuries. Under questioning, he would not yield his point. After reassuring one skeptical senator that he had, in fact, written his statement by himself, he answered a series of questions from Senator Bursum. His quick answers and ready wit demonstrated that it was political aptitude and intelligence, rather than an ancient, primitive essence, that drove Abeita's success. When Bursum demanded that Abeita express gratitude for government-sponsored schools, Abeita refused to be deferential. "Do you not think that the Government is doing something for you which is of lasting benefit in providing this education?" Bursum asked. "Yes," Abeita replied, "but nothing in comparison to what the Government has taken from us." Bursum insisted: "This Government has not taken anything whatever away from you. This Government has been giving to you." Abeita continued to hold his ground. "I cannot agree with you," he replied, "outside of what you mentioned as to schools; but as far as land is concerned, there is no man can convince me that he has given me this land." Bursum persisted: "All the title which you have now is by reason of what this Government and Congress have done. Is there any other title?" Abeita parried: "The Government has simply given us the papers, but the land was always ours." Abeita's response prompted a lengthy lecture on law, which Bursum concluded by returning to the issue of government-sponsored education. "Don't you think that is fine and liberal treatment on the part of the Government to do that?" he asked. "It is a fine thing that the Government is doing," Abeita replied, "and we are not complaining about what it has done. We are complaining about what it is trying to do." Succinctly, then, Abeita brought the questioning back to the issue of the legislation at hand.[47]

Abeita's performance in Congress was impressive, but even in its more colorful public presentations, the delegation made it clear that the bill was about more than publicity. Most immediately, the bill gave members of various Pueblos an opportunity to act in concert, an opportunity few Pueblo people had explored previously. Martin Vigil, one of the youngest members of the delegation, later remembered the trip as an "education." Vigil rode on a train for the first time, saw the cities of Chicago, New York, and Washington, D.C.,

spoke in front of the largest audience he had ever addressed, and responded to press accounts that were published in the *New York Times*. Vigil claimed that he was ignorant of the functions of U.S. government prior to the trip and used the experience to improve his English and to learn about how Indian people could influence federal policy. Unlike other members of the delegation, Vigil had not had an extensive education in an Indian boarding school, and he was unaccustomed to the idea of thinking of Indian people as a single group.[48] In an interview conducted in the 1970s, he remembered that his Pueblo shared some of their traditional clothes with other members of the delegation and had to instruct them in how to wear them. His exposure to other Pueblo people and to federal policy toward Indians led him to think of an Indian community beyond his own at Tesuque.

Later during the journey, after Vigil had spoken in front of a large group in New York, a white speaker told the story of the purchase of Manhattan for $24 in trinkets. The story was new to Vigil, and he repeated it years later as an indication of the effectiveness with which he had presented the Pueblo case in his speech.[49] When the delegation returned from the East, Vigil became more active in the All-Pueblo Council and eventually served as the chair. His experiences with the Bursum bill had helped to convince him of the effectiveness of inter-Pueblo cooperation, and had led him to identify with Indian people beyond Tesuque and even the Pueblo community. Throughout their trip east, the delegation found opportunities to strengthen pan-Pueblo and pan-Indian identity and action.[50]

Although the Pueblo delegation might have looked like Collier's and Austin's publicity tool, appearing in incongruous settings like the Stock Exchange and singing and dancing on command, in fact the group proved remarkably capable of working on the Pueblos' behalf. The delegates gave numerous interviews and managed to emphasize their opposition to the bill even when journalists seemed more interested in their reactions to the sights and sounds of urban New York.[51] Seemingly picturesque gestures, like the delegation's decision to bring the Pueblos' silver-topped Lincoln canes, served a political purpose as well. The canes had been presented to the Pueblos as a symbol of their sovereignty during the Lincoln administration and were a common feature in Pueblo dances that celebrated the transfer of power from one governor to the next. Because the first three sections of the Bursum bill gave more power to Indian agents at the expense of Pueblo governors and religious leaders, bringing the canes created a conversation about Pueblo sover-

eignty and allowed the delegation to explain how the bill threatened not only Pueblo land but also Pueblo governance.[52] By the time Congress dismissed the Bursum bill at the conclusion of the hearings, the delegation could proudly say it had been instrumental in its defeat.

By February 1923, then, Dodge's transformation of Taos into a politically active creative center seemed complete, and she owed much of that transformation to Collier. On a national level, Collier appeared to have found the success he sought. He had helped form a coalition of writers and artists engaged in a common political cause, and the group invoked not only political justice but also aesthetic potential in their writings about the Pueblo Indians. Behind every article on the Bursum bill lay a utopian vista where the United States could come into its own by embracing the landscape's natural beauty and the ancient harmonies Collier and his allies saw in Pueblo culture.[53] Newspapers across the nation publicized the names of the artists and writers who had stayed at Dodge's home and the Pueblo causes Collier had brought to their attention. Most dramatically, Collier had brought a group of Pueblo Indians east, and they had garnered Dodge the attention of the New York audience she so craved. Although the Pueblo Indians had different motives and a different understanding of the activities surrounding the Bursum bill, Dodge's goals, nonetheless, seemed to have been fulfilled. She had proven her cause worthy of national attention, and she was at the center of the community she believed would launch a new American era. Then, just as the campaign against the Bursum bill succeeded, the primitivism Dodge and Collier had nourished started to eat its own tail.

Nina Otero-Warren's Place

In February 1929, six years after Collier and Dodge threw themselves into the Bursum bill struggle, a man named José Chávez journeyed from his home in Chimayó to Santa Fe. His village was a beautiful one. As author and politician Nina Otero-Warren described it in her book celebrating the folk culture of New Mexico, *Old Spain in Our Southwest*: "The red cliffs which form the background for this village rise as monuments which no human being could erect or imitate, so beautifully has nature formed them. As the sun casts its rays on them and the shadows lengthen, they seem to assume shapes, now of cathedral towers, now of kneeling images, now of a fortress; always with coloring so intense that one realizes the Master hand has truly worked in this community."[1] If Chávez noticed the surrounding grandeur, it did not distract him from his mission. He was on his way to Santa Fe to sell a collection of santos, carved and painted wooden saint figures like those Dodge and her friends had collected when they first arrived in Taos. The figures were from the Chávez family chapel, and he was even considering selling the chapel itself, known throughout New Mexico as the Santuario de Chimayó.

The chapel, however, was not exactly private. Although the Chávez family did indeed own the structure, the santuario had served the community as a pilgrimage site and place of worship since 1816. Local tradition said that earth gathered from the sacristy had healing powers, and residents of the surrounding villages attributed miracles to the intervention of the Christ Child represented in a *bulto* housed in the church. Villagers considered this santo a member of the community. As one told Otero-Warren, "'During this time the Child Jesus did not sit in His niche in the church idly waiting for the Adoration

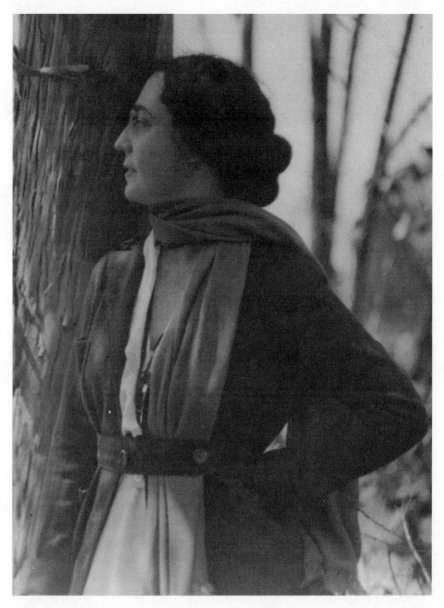

Nina Otero-Warren, n.d. (Bergere Family Photograph Collection, Image No. 21706. Courtesy of the New Mexico State Records Center and Archives, Santa Fe.)

of His people. Though the image itself was there, we felt His presence as He walked around in the community. . . . He was brown-eyed and His skin was tanned by the wind and the sun, like mine. . . . He runs and plays with the children of the poor and their laugh rings out as the brook that runs through this village, singing before it tumbles.'"[2] Given the tenderness with which Chimayó's villagers regarded the santos, Chávez's unilateral decision to sell them was an unpopular choice. A delegation from the village announced that Chávez had neither the right to sell the chapel nor the right to sell the objects within it. They descended on Santa Fe, reclaimed the santos Chávez had sold, and returned to Chimayó, where they restored the figures to the church.[3]

By the time the group returned to the village, yet another party was interested in the chapel. According to a 1990s interview with Chimayó resident Beniga Ortega Chávez, "a *gringa* [Anglo] from Santa Fe bought the *capilla* [chapel] and gave it to the church."[4] The gringa in question was not Mabel Dodge, but Mary Austin. Austin never actually bought the santuario herself, but she, a sculptor named Frank Applegate, and the soon-to-be-famous southwestern architect John Gaw Meem were instrumental in transferring the property to the Catholic Church. They felt that the santuario and the santos within it were safest in church hands, and they secured funds for the New Mexico archbishop with the understanding that he would buy the chapel and maintain its architectural integrity. In an outdoor public ceremony on October 15, 1929, Mary Austin pointed to the signature line as José Chávez, hat in hand, bent over the deed to the chapel property and signed it over to the waiting archbishop.[5]

At first glance, Dodge's and Collier's absence from the Chimayó affair seems conspicuous. After all, Dodge and Andrew Dasburg had spent their early days in Taos traveling the surrounding area collecting santos like those Chávez had hoped to sell in Santa Fe. In his early writings for *Sunset* magazine, Collier praised the entire region and extolled the charms of the "ancient" villages of local Nuevomexicanos. Moreover, the future of the santuario seemed a perfect cause for Collier and Dodge to embrace. According to Meem and others, the structure itself was architecturally significant, and the santos were a form of local folk art that represented the modernist aesthetic Dodge and her visitors cultivated. The significance of the structure to local Catholic tradition, in particular, might have appealed to the vision of New Mexico that held sway among Dodge's and Collier's allies in the Bursum bill fight.

The details of the Chimayó story, however, hold the key to explaining

Dodge's and Collier's absence, and, more significantly, the consequences of the primitivism that reached its apotheosis during the Bursum bill struggle. When Chávez made his decision to sell the santos from the santuario, he went not to Taos but to Santa Fe. When a gringa became involved, it was not Dodge, but Austin. Austin collaborated not with an activist like Collier, but with a sculptor and an architect—Applegate and Meem. By 1929, when Chávez and his neighbors argued over the fate of the santuario, the nature of Anglo patronage in northern New Mexico had fallen into a predictable groove. By 1929, Santa Fe, far more than Taos, served as the center of Anglo patronage of Nuevomexicanos. By 1929, Mabel Dodge had almost completely extricated herself from support for Nuevomexicanos. By 1929, too, New Mexicans frequently celebrated the triracial quality of the region, but rarely found opportunities to note the ties and conflicts among Anglos, Nuevomexicanos, and Indians. In popular presentations of the state, three races lived side by side in harmony.[6] Finally, by 1929, Santa Fe's Anglo patrons extended their patronage more often to the arts and to events celebrating the "Spanish" history of northern New Mexico than they did to political struggles over land such as the Bursum bill.[7]

What caused such changes? The struggle over the Bursum bill contributed significantly to the changed landscape of patronage by 1929. Certainly the proximity of Taos Pueblo to Taos contributed to the favoritism Anglo patrons in Taos showed to Pueblo Indians. Also, the relatively greater political, cultural, and economic power Nuevomexicanos held over Pueblo Indians in Santa Fe contributed to the emphasis on Nuevomexicano heritage there. Moreover, in a story well-told by several scholars, Anglos and Nuevomexicanos had, since the late nineteenth century, worked on forging a unique Spanish heritage to sell Santa Fe as well as the Atchison, Topeka, and Santa Fe Railroad to visiting tourists.[8] In addition, the battle over the Bursum bill transformed the nature of Anglo patronage in New Mexico. The positions Anglos took during the Bursum bill conflict clarified, amplified, and helped to cement the idyllic images used for promotion of the state.

For visitors to Dodge's house, those images increasingly applied only to Indians, not Nuevomexicanos. Among Collier, Dodge, and their allies, the Pueblo Indians' centrality came at the expense of New Mexico Spanish-speaking residents, and Indian land came at the expense of Nuevomexicano land. Collier and Dodge had made the Pueblo Indians and their land central to the ambitions of Anglo bohemian visitors to New Mexico. But the land in New

Mexico was finite, and gains for the Pueblo Indians were losses for the Pueblos' neighbors. Those neighbors were sometimes Anglo, but they were also Nuevomexicano. In later years, Nuevomexicanos would find more sympathetic patrons in the Anglo arts community of Santa Fe, and Anglo patrons in Taos would dedicate many of their efforts to insuring as picturesque a presentation of the Pueblo Indians as possible.[9]

This triethnic trap, as scholars have called it, did not mean that Nuevomexicanos were without their own primitivist portrait. Indeed, the fallout from the Bursum bill contributed to an emerging image of Nuevomexicanos possessing an authentic heritage deeply rooted in an imagined Spanish "fantasy past."[10] Since the turn of the century, elite Nuevomexicanos had increasingly laid claim to their Spanish heritage, a heritage inevitably presented as European and white, but also steeped in folk traditions like the carving and religious use of santos. Although most Nuevomexicanos had intermarried with Native Americans, claiming a Spanish heritage allowed Nuevomexicanos to distance themselves from Mexican Americans, who struggled against racism and skepticism of their loyalty to the United States. As Spanish Americans, elite Nuevomexicanos could claim a white American identity and could also engage in a colorful nostalgia for an authentic Spanish past. Anglos like Mary Austin played a prominent role in the formulation of northern New Mexico Spanish heritage, and, like Anglo patronage of Pueblo Indians, Anglo promotion of the state's Spanish past fueled its tourist economy.

Elite Nuevomexicanos enthusiastically furthered the image of a Spanish fantasy past, despite the fact that such a past did little to counter their increasingly marginal political and economic standing in the state. Their behavior may seem peculiar, but as historian John Nieto-Phillips has argued, what a Spanish heritage did bring Nuevomexicanos was a "collective identification with the land and with a historical discourse of conquest, settlement, and occupation."[11] Such an identification, although it encouraged Anglo tourism and privileged Anglo representations of New Mexico, also provided a source of what Nieto-Phillips calls "ethnic agency" in Nuevomexicanos' struggles to maintain political, economic, and cultural control over their lives. The conflict over the Bursum bill, then, rife with issues of land ownership and historical occupation, was an ideal opportunity for elite Nuevomexicanos to enhance and further their Spanish heritage. One of the people who seized the opportunity most enthusiastically was a woman named Adelina, or, as she sometimes preferred to be called, Nina Otero-Warren.[12]

Otero-Warren had a far more privileged past than most of the Nuevomexicanos on the land under dispute in the Bursum bill. She had attended a private school in St. Louis, married and divorced an Anglo, and was a cousin of former New Mexico territorial governor Miguel Otero.[13] She served for more than a decade as the superintendent of education of Santa Fe County and throughout her life was an ardent supporter of bilingual education.[14] Just as the Bursum bill was defeated, she sought a civil service position in the U.S. Department of the Interior from Commissioner of Indian Affairs Charles Burke. Burke hired her as an Indian inspector for New Mexico, Arizona, and southern California, but her primary job was to keep track of Collier and his work on Indian affairs. Otero-Warren seemed a good choice, given Burke's political bias. She had won the Republican nomination to run for U.S. Senate in the 1922 election (she was the first New Mexican woman to run for Congress), and she was head of the Public Welfare Committee for the New Mexico General Federation of Women's Clubs. As a Nuevomexicana, a politician, and a General Federation of Women's Club member, she was ideally situated to oppose Collier's plans.[15]

Otero-Warren based her opposition on a Spanish fantasy past. Just as Collier had celebrated the Pueblo Indians' connection to the land, their ancient antecedents in the area, and their presumably pure and authentic relationship to nature, Otero-Warren celebrated the Nuevomexicanos' connection to their land, their centuries-old occupation of the area, and their pure and authentic traditions. Although she would not publish *Old Spain in Our Southwest* until seven years after the events at Chimayó, by 1929 she had already contributed significantly to the romantic picture of the northern New Mexico villages that spurred Austin's involvement in the transfer of the church. Indeed, she wrote *Old Spain in Our Southwest* with encouragement from Austin herself. In short, Otero-Warren contributed to an image of Nuevomexicanos parallel to the image that Collier and his allies had helped to create of the Pueblo Indians.

In their support for the Pueblo Indians, Collier, Dodge, and their allies had made a critical error. They had forgotten that Nuevomexicanos, too, contributed to the region and its culture. Their mistake would lead to a split in the style of Anglo patronage in Taos and Santa Fe. This error would also highlight the inclination of Dodge's guests to think of race in binary terms, a tendency that would have cultural consequences far outside of New Mexico. Dodge and Collier had celebrated northern New Mexico as Pueblo Indian

land. They had fought the Bursum bill to win the Indians' land back from rapacious Anglos. But the struggle over land in New Mexico was not a simple struggle between whites and Indians. The racial landscape of New Mexico was more complicated than the Bursum bill publicity campaign made it seem. Otero-Warren's response to Collier's efforts points to the conflicts and consequences that accompany primitivist celebrations of a land and its people in a multiracial place.

Collier's success in defeating the Bursum bill at the close of 1922 obscured fundamental differences within his group of supporters about the role of race and land in New Mexico. When those differences came to light in the early months of 1923, his and Dodge's vision of New Mexico began to fracture. Albert Fall, who had been the Bursum bill's most vigorous defender, was no longer a problem, having announced his resignation from office as a result of the Teapot Dome scandal and the negative publicity he had received from the Bursum bill controversy.[16] The new problem facing Dodge's politically active guests was a compromise bill written by Francis Wilson, an attorney hired by the New Mexico Association, Collier, and Atwood. The new legislation, commonly called the Lenroot bill because it was introduced to Congress in February 1923 by Senator Lenroot of Wisconsin, gave significant concessions to the Pueblo Indians, but granted to a portion of the non-Indian claimants, most of them Nuevomexicanos, title to their lands, and the Pueblos were not compensated for the lost land and water rights. Wilson and many members of the New Mexico Association had always expected such an outcome. They sympathized with the Nuevomexicano families who had held the land for several years or even generations. Collier, however, was incensed that the Pueblos were not compensated and questioned the legality of many of the claims Wilson's plan granted. He wanted a plan that gave all the land to the Pueblos and offered financial compensation to the non-Indian settlers. Collier initially corresponded with Wilson privately about his discontent with the plan, but eventually the two men split over the issue, and their rancor spilled over into Collier's relationship with the New Mexico Association.

A split between Wilson and Collier had always been likely given the political and symbolic importance Collier ascribed to the Bursum bill struggle. Collier's vehemence was apparent in a series of letters he wrote Wilson through April 1923. In one, he stormed:

What I have stated was that a grave legislative—if you will, moral—prece-
dent was involved in such an act of confiscation and repudiation toward
Indians as is contained in the Substitute Bill [the Lenroot bill]. . . . Now,
there has never been such a public interest in an Indian controversy as in
this Pueblo one; nor has the moral issue ever been made clearer; and for
the *crusade* on behalf of the Pueblos (and of national honor) to eventuate
in the endorsement of confiscation and repudiation would constitute a
grave political and legislative precedent—would further extend the im-
plicit idea that Indians are innately lacking in property and personal
rights. That implicit idea is back of all the ruthless acts and legal sub-
terfuges which have made our record of dishonor toward the Indians.[17]

Although Wilson was committed to achieving a just and equitable settlement,
he had never matched Collier's fervor, nor was he interested in a national re-
framing of the U.S. government relationship with Indian people. Collier had
invested in the Bursum bill struggle his hopes and ambitions for all of Indian
affairs. He saw the struggle over the bill as a moral one, and loss in his "cru-
sade" would further the "record of dishonor toward the Indians" that he so ab-
horred. He was not interested in compromise.

Collier's recalcitrance exacerbated an already fraught partnership. The re-
lationship between Dodge, Collier, and the New Mexico Association had
never been stable. Collier criticized Elizabeth Shepley Sergeant's early public-
ity efforts, and Dodge herself felt that the group was too tentative in its pro-
nouncements against the bill.[18] Collier's zealous style also aggravated the
more staid members of the New Mexico Association and led some to worry
that he would alienate potential allies.[19] Most important, Collier had used the
early months of 1923 to form a new organization called the American Indian
Defense Association (AIDA). Ostensibly, AIDA acted as an umbrella organi-
zation encompassing representatives of the General Federation of Women's
Clubs, the New Mexico Association, the Eastern Association of Indian Affairs,
and several other organizations. In reality, Collier had created a new organiza-
tion with himself at the helm and his vision for Indian welfare as the organi-
zation's dominant philosophy. The members of the New Mexico Association
may well have had representation in Collier's new domain, but they were
clearly not in charge. Collier wanted AIDA to be the benefactor of the Pueblo
Indians; the members of the New Mexico Association wanted the honor for
themselves.

The New Mexico Association responded by repeatedly reframing their support for the Lenroot bill as the best course for the Pueblos. Implicit in much of their support was the sentiment that Collier's style of patronage poorly served the Pueblo Indians. The Lenroot bill was superior, the New Mexico Association believed, because it would provide a hasty resolution to the disputed land controversy, and because it fairly distributed land between Indians and non-Indians alike. As one of the association statements put it:

> To denounce [the Lenroot substitute], or the Senators or Congressmen who worked to produce it, is unfair, unwise, and impractical, to say the least. Such a course can only confuse the public and delay legislation. Worst of all, to hold out to the Indians, as a corollary of denouncing the Lenroot Substitute, promises of more land or of anything else they want, in excess of what they may justly be entitled to after a full hearing, is immoral, inflammatory, and dangerous. Wild promises to the Indians are just as wicked as the Bursum bill was when it attempted to give non-Indians almost anything without respect to the rights of the Indians.[20]

In many respects, the New Mexico Association held firmly to the image of New Mexico that Collier and his allies had presented in their public writings on the Bursum bill. New Mexico was a place of ancient, primordial settlements. What would best preserve such a place was best for all who lived there. In the view of members of the New Mexico Association, the compromise would preserve the image of New Mexico they had nurtured. Collier's "wild promises" were only a source of dangerous conflict between Pueblo Indians and Nuevomexicanos.

A significant undercurrent in the split between Collier's camp and the New Mexico Association was the varying racial definition of Nuevomexicanos. Many Anglos involved in the Bursum bill conflict could not seem to decide whether Nuevomexicanos were Indians. Indeed, when Newman's fence first hit the ground in Tesuque and kicked off the entire Bursum bill squabble, members of the Indian Rights Association called Tesuque's Nuevomexicano residents "penitente Indians."[21] Much like Dodge and her peers, the members of the Indian Rights Association had filled a single vessel with all they saw as authentic in New Mexico. Few penitentes, whose principal identification was religious, not racial, would have accepted a racial designation of themselves as "Indian," but that was beside the point for Anglo artist new-

comers.[22] Both penitentes and members of the Pueblo were fascinating to Anglo artists and writers; therefore both groups must be Indian. Mary Austin's friend Lou Henry Hoover expressed a similar sentiment when Austin appealed to her for help from her husband, Herbert Hoover, then U.S. secretary of commerce. When Austin first wrote Lou Hoover about the Bursum bill in 1922, Hoover responded that she had been looking into the bill herself and had spoken to a man in New Mexico who heartily supported the legislation. Hoover wrote that her informant had explained that there was little threat to the Indian lands because "there were only a few hundred of these old-time settlers and 'near Indians' whose right in equity should thus be recognized against the 19,000 Indians holding the community lands."[23] As Hoover's letter indicated, it was difficult for Collier and Austin to garner support for Indians when some of their potential allies perceived the Pueblos' Nuevomexicano adversaries as "near Indians."

Supporters of the settlers often used a similar argument, noting that many Nuevomexicanos descended from Pueblo Indians. In a speech to the League of the Southwest in Santa Barbara, California, in June 1923, A. B. Renehan, the attorney advocating for the settlers, argued that many Pueblo Indian people had been completely absorbed by their Nuevomexicano neighbors. Members of present-day Pojoaque Pueblo might be surprised to learn that in 1923, according to Renehan, "there remain[ed] but one full-blooded Pueblo Indian and nine or ten mixed-bloods. The rest," according to Renehan, had "been absorbed or disappeared." He concluded that "in all of the Pueblos, undoubtedly, some of the land holders, who consider themselves Spanish-Americans, are Indian descendants, at least in part."[24] Renehan argued further that as descendants of the original holders of the land, Nuevomexicanos deserved to own the property or had lawfully sold it to Anglo settlers. Renehan used the term *Spanish American* to refer to the Nuevomexicano settlers, but he too was advocating a vision of Nuevomexicanos as near-Indians.

That the claimants to the land were descendants of Indians was an argument offered during the congressional hearings on the legislation as well. Bursum pressed Pablo Abeita on just this point. When Bursum asked the "nationality" of those individuals who occupied disputed land near Isleta Pueblo, Abeita responded that they were "Mexican." "Are they part Indian?" Bursum asked. "Not that I know of," responded Abeita. "If you were to call them Indians they would probably beat you up." Senator Lenroot then entered the questioning. He ignored the racial conflict and complexity in

Abeita's response and pressed further. "Is there much mixed blood in your Pueblo?" he asked. "Very little," Abeita responded. "The mixed bloods are outside," Bursum concluded.[25] Bursum and Lenroot were pursuing Renehan's argument: Nuevomexicanos intermarried with Indians. Indeed, as Mexicans, they were part Indian. Any legislation settling the disputed land issue, the argument logically continued, would need to grant some of the land to Nuevomexicanos. After all, they were, according to the argument, practically Indians themselves.

As Abeita's response indicated, however, Nuevomexicanos and Pueblo Indians did not see the racial breakdown of New Mexico in the same way. Conflict between Pueblo Indians and Nuevomexicanos had existed for centuries and had generated a complex system of racial identification in New Mexico.[26] Many Nuevomexicanos resisted any racial designation that included them in a group with Indians. They might even, as Abeita suggested, beat up someone who suggested such an identity for them. By using the term *Spanish American* rather than *Mexican,* Renehan showed that he clearly understood such opinions. Indians, likewise, resisted any telling of New Mexico history that granted Nuevomexicanos an Indian identity. In August 1923, for example, members of several Pueblos in northern New Mexico sent lists of "trespassers" to the commissioner of Indian affairs, repeatedly identifying such trespassers not as "Indian," "near-Indian," or "white," but as "Mexican" or, in rare cases, "Spanish." The members of the Tesuque Pueblo even offered a history lesson explaining their relationship with those who had settled on the disputed land. "In early times these lands were given to us," they wrote.

> In these same early times different Mexicans and Spaniards married some of our women. We would not let these men live in our pueblo but allowed them to have land to use outside the pueblo. We did not sell them these lands. Neither did we give them the lands. We just let them live there. After they had lived there a while, as we are told by our ancestors, these people claimed the lands were their own and that they had a right to sell them and did sell them. We protested against these sales and the occupancy of these lands by others than Indians and, as early as [1876], we entered a suit against these intruders. The court was Mexican. The jury was Mexican. Our attorney was a Mexican. Of course, the judgment was against us though the judge said the settlers had no title to the land shown by any papers.[27]

Nuevomexicanos bristled at any indication that they might have Indian heritage. Pueblo Indians denied any inclusion of Nuevomexicanos into their communities. Hoover's friend, Senators Bursum and Lenroot, and Renehan all may have seen Nuevomexicanos and Indians as barely distinguishable, but within both Nuevomexicano and Pueblo communities in New Mexico, the differences were deep enough to prevent any easy resolution to the disputed land issues addressed by the Bursum bill.

The racial standing of Nuevomexicanos was further complicated by the moniker *Spanish American*. Nuevomexicanos increasingly used the term to shore up their standing as American citizens, an identity non–New Mexicans frequently doubted. For Nuevomexicanos intent on distancing themselves from Mexican immigrants and other Mexican Americans, the name had the added advantage of sounding more European and more "white."[28] For Nuevomexicanos coping with Anglos hostile to nonwhite people, a Spanish American identity could be the ticket to safety and social advancement. Moreover, for centuries throughout Latin America and the U.S. Southwest, "whiter" identities had been associated with higher social and economic standing.[29] For elite Nuevomexicanos, *Spanish American* was a self-identifying term that conveyed their sense of their own standing in local racial and ethnic hierarchies.[30] A variety of charged definitions, then, accompanied the phrase Spanish American.

Anglos who supported Nuevomexicanos employed each of these meanings. In his Santa Barbara speech, Renehan managed to evoke several connotations of the term:

> Do you realize that these people, now known among us as the Spanish Americans, among whom are many of Anglo-Saxon descent, sent to the Civil War more than their due proportion of soldiers in defense of the Union, and in the Spanish-American War contributed more than their quota of fighters against their mother country, Spain, and in the World War gave seventy-four hundred of their sons against seventy-six hundred of all other breeds and races who enlisted for the overthrow of the lawless Teuton?[31]

Spanish Americans, as Renehan described them, were citizens who fought for the United States. Some were "of Anglo-Saxon descent," and therefore white. They were even more permanently established in the United States

than immigrants from northern Europe. For each of these reasons, Spanish Americans seemed particularly deserving.

For members of the New Mexico Association, the racial identity of Spanish Americans posed problems. Many of the writers and artists of Santa Fe had invested as much patronage in the Nuevomexicano population as they had in the Pueblos.[32] They saw the Nuevomexicano settlers on the disputed land as descendants of Spanish colonists and the carriers of ancient and mystical traditions. Many in the association particularly supported the folk Catholicism and penitente practices of Nuevomexicano communities. As Alice Corbin Henderson put it in a 1928 pamphlet advertising the region: "If [the visitor] would enter into the composite spirit of the country, he must not only visit the Indian pueblos, where the contrast with modernity is most evident, but he must absorb the atmosphere of the small Mexican villages in the mountains and along the Rio Grande, where time has stood still for three centuries, and where Old Spain still exists in New Mexico."[33] As Henderson revealed, the vision of New Mexico she and other Anglo artists and writers in northern New Mexico had created relied on representations of *both* Pueblo Indians and Nuevomexicanos as authentic. The New Mexico Association, therefore, attempted a difficult balance. The members wanted to continue their support for the Pueblo Indians but also maintain their romantic image of Nuevomexicanos, all the while respecting elite Nuevomexicano communities by embracing the term *Spanish American*. To reconcile their various positions, the members of the association needed to distinguish Spanish Americans from Pueblo Indians so that the two groups could not claim the same land, retain their exotic portraits of Nuevomexicanos and Pueblo Indians so that they could continue to celebrate the region in primitivist terms, and portray Spanish Americans as fully contributing U.S. citizens so that they could retain their patronage of Nuevomexicanos. It was not an easy combination to maintain.

Surprisingly, Collier almost found himself in the same position. In Collier's early writing on the Bursum bill, he too embraced an idyllic vision of Nuevomexicano communities. Indeed, "The Red Atlantis," which had forged his reputation as an Indian advocate, started with a long and ruminating description not of a Pueblo but of the Nuevomexicano town of Córdova, a place he called "the most perfect of the dozen old Mexican towns on the Taos plateau." What made Córdova perfect was its age, "not very ancient," according to Collier, "only perhaps three hundred years old." Adding to its charm for

Collier was the beauty of the inhabitants and their homes, the slow pace of life, and the widespread use of the Spanish language.[34] Collier even wrote Dodge prior to publication of the article asking for illustrations that gave "an impression of the beauty of the old Mexican towns."[35] Written before the Bursum bill, before the San Ildefonso meeting, and before Collier had rallied the nation around the Pueblo Indians, "The Red Atlantis" indicated that Collier included Nuevomexicanos within the image of New Mexico he and the anti-Bursum bill coalition had cultivated. Nuevomexicanos were a part of the picturesque landscape, the ancient culture, even the natural beauty of the area.

As Collier's involvement with the Pueblos and the Bursum bill grew, however, Nuevomexicanos slowly disappeared from his writings. In his earlier articles on the bill, Collier referred to the "Mexican" and "white" settlers on the disputed land. Through such language, Collier gave a nod to those Nuevomexicano settlers with long-standing claims to the territory. In effect, he followed the logic offered by Bursum, Lenroot, and others, which granted some validity to Nuevomexicano claims. Collier's later articles, though, only referred to "white" settlers.[36] According to the logic of Collier and Anglo members of the New Mexico Association, if the settlers were "white," not "Spanish American," "Mexican," or "Indian," they must be recent arrivals and therefore could not have the ancient connection to the earth Dodge and her friends honored in the Nuevomexicano and Pueblo communities. As "white" settlers, Nuevomexicanos could hardly provide the idyllic image of northern New Mexico that Dodge and Collier wanted. By calling the Nuevomexicanos "white," Collier had effectively kicked them out of his plans for the future of New Mexico.

When Collier's visions were manifested in art shows and passionately written letters, the consequences for local New Mexicans were not especially severe, but when they meant the eviction of families from their ancestral homes, the stakes were much higher. Indeed, not even all members of Collier's camp felt comfortable with his position. Some of the dissent among Collier supporters was apparent in Adolph Berle, an attorney whom Collier hired after his final split with Wilson, and a major voice in Franklin Roosevelt's administration. After visiting several of the Pueblos, Berle voiced some of his concerns about the issue. Berle supported Collier entirely in his reasoning about the apportionment of the disputed lands, and wrote prospective legislation granting the land to the Pueblos and compensation to the settlers. Even in areas with relatively recent "encroachments," however, Berle lamented the

loss of the Nuevomexicanos' holdings. "It is no joke to evict the Mexicans," he wrote in his journal after visiting Picuris Pueblo. "They are humble people; working hard; their little houses are well cared for; it goes against my grain to throw out a family whose land is tilled and whose house is surrounded by hollyhocks and larkspur. No help for it, though. We must get them some compensation." Four days later, he was still troubled by the settlers' eviction. When he realized that new legislation would displace an entire Nuevomexicano community, its church, and its cemetery, he mused over "this strange business, this raising of Spanish ghosts long dead, to untangle present injustice."[37] Berle probably did not even notice that he had transformed the "white settlers" of Collier's articles first into Mexican families with gardens of hollyhocks and then into Spanish descendants. Berle never wavered in his support for Collier, and he never saw the Nuevomexicanos as Hoover had, as "near-Indians," nor does he appear to have adopted the moniker Spanish American for settlers on the disputed land. His journal indicates, however, that he saw their position sympathetically, and a portion of his sympathy came from his identification of the settlers as Mexicans with longstanding Spanish roots.

Whereas Berle restricted his worries to his private journal, members of the New Mexico Association chose the difficult balance of publicly supporting both Nuevomexicanos and Pueblo Indians. As Alice Corbin Henderson noted in a letter to an eastern ally of the New Mexico Association, "As if the majority of small Mexican farmers were not as much in need of defense and protection as the Indians!"[38] Interestingly, in the same letter, Henderson had gone to the trouble of marking out the word *white*, which she had used to describe the settlers. According to the position the New Mexico Association had adopted, the settlers on the land were never white. They were, in private correspondence, "Mexican," and in public pronouncements "Spanish American," but they were never "Anglo" or "white." In the association members' view, by supporting Spanish Americans, they were supporting a population equal in exotic appeal to the Pueblo Indians. Collier had attempted to erase the exotic appeal even he had seen among Nuevomexicanos by calling them "white." The members of the New Mexico Association never used the same language. Such an exotic population could not be white. As an equally exotic group, Nuevomexicanos were just as deserving of land as the Pueblo Indians.

Thus did the Lenroot bill prove to be the snake in the garden for the New Mexico coalition Collier had formed. The bill forced the Anglo artists and

writers of Santa Fe and Taos to make a choice. If the New Mexico Association supported the bill, the support meant, most importantly, that Anglo patrons favored some Nuevomexicano claims against Pueblo land. Furthermore, given the nature of the Anglo art community patronage, the association support meant that members of the association believed that Nuevomexicanos held as much artistic promise as the Pueblos, and that Nuevomexicanos had as much of a connection to the land as Pueblo Indians. Although the Pueblo Indians continued to hold appeal for members of the New Mexico Association, the group made an effort to show that Nuevomexicanos held appeal as well. The split between the association and Collier led each side to take interesting and contradictory stands on the racial identity of Nuevomexicanos. Collier, in an effort to portray Nuevomexicanos as trespassing newcomers to the region, called all the settlers "white." The association, in an effort to portray Nuevomexicanos as racial exotics with ancestral connections to the land of New Mexico, called them "Spanish American." As Spanish Americans, Nuevomexicanos could sell the utopian vision of New Mexico that had fueled the campaign against the Bursum bill, but they could not hold the same land as Pueblo Indians. If the Anglo artists of Taos and Santa Fe were to be patrons of Nuevomexicanos, some Pueblo land would have to be sacrificed. Most of the members of the New Mexico Association were willing to make such a sacrifice.[39] Collier was not.

The conflict between Collier and the New Mexico Association simmered throughout the first half of 1923 until it finally exploded at another All-Pueblo Council meeting in August at Santo Domingo Pueblo. Collier and Berle intended to present a revised version of a Pueblo land bill at the meeting, but the New Mexico Association had other plans. On behalf of the association, Margaret McKittrick, William Henderson, and Witter Bynner, a wealthy Harvard-educated poet recently moved to New Mexico from Berkeley, California, interrupted the meeting to complain that Berle's plan did not represent all the organizations interested in Indian welfare. After hearing Collier's defense of his resolutions, the association members stalked out.[40] In their absence, the Pueblo delegates accepted all of Collier's resolutions including those naming the American Indian Defense Association and the General Federation of Women's Clubs as the Pueblos' political advocates.[41]

The New Mexico Association met in a fury five days later in Santa Fe. Its members insisted that they wanted to help the Pueblos, but they did not agree with the Pueblos' choice to support Collier. A representative of Santo

Domingo Pueblo, Martin Herrera, was present at the meeting and repeatedly insisted that his Pueblo governor and those delegates present at the Santo Domingo meeting supported Collier, but the association broke with Collier anyway. Wilson countered that Collier could not achieve the land concessions he had promised the Pueblos, and that Pueblo Indians were under the false impression that Collier would retrieve property from railroads with lines running across Pueblo land.[42]

As the meeting progressed, however, the real objections of the association became clear. Wilson, McKittrick, and Bynner were genuinely concerned that Collier had promised the Pueblos legislative victories he could not attain, but they also believed Nuevomexicanos deserved a portion of the lands. Wilson throughout the meeting referred to the Nuevomexicano settlers as "natives" or "Spanish Americans," terms that justified the settlers' claims to the land more persuasively than did the names "Mexicans" or "whites." By the close of the meeting, McKittrick summarized the position of the association succinctly, calling the Nuevomexicano claimants "settlers" to buttress her argument. "We always stood for justice and equity for settlers and Indians," she explained, "but had a hard time to make some friends on the settlers' side believe that. We believe the proposals as laid out the other day were not just to the settlers, therefore we objected to them." McKittrick summarized the position of the New Mexico Association. It had always had the interest of long-term Nuevomexicano settlers in mind, but the association's strong opposition to the Bursum bill and Collier's articulation of that opposition had obscured their sympathy. Now, in the Lenroot bill, the members of the association saw their opportunity to make their lines of support clear.[43]

Equally important to their newly articulated position was the association members' anger over their exclusion from Collier's list of Indian benefactors. Because the resolutions Collier had presented at Santo Domingo named only the General Federation of Women's Clubs and the American Indian Defense Association as the Pueblo Indians' political patrons, the members of the New Mexico Association felt they were no longer included in Indian rights work. Wilson, still stinging over his conflicts with Collier in the spring, expressed the frustration of the Santa Fe members. "Now our organization here feels that we are just as much friends of the Indians, working just as hard for them—perhaps even harder," he complained. Wilson concluded his statements to the association with condemnation of Collier's statement as a "grave error and grave mistake and grave injustice to the Indians themselves and to

those who have given our time and thought to this great problem."[44] When it came to promotion of the Indians, the association members refused to play a secondary role.

The split between Collier and the New Mexico Association provided an opening for Nuevomexicano politicians involved in the Bursum bill struggle. Nina Otero-Warren seized it. First she traveled with Atwood to the annual meeting of the General Federation of Women's Clubs and did her best to sow doubt among the association members about Atwood's standing in the federation. Atwood held on to her seat as the head of the Indian Welfare Committee, but Otero-Warren must have been persuasive, because she managed to convince the president of the general federation, Alice Winter, to visit her in New Mexico. By the time Winter arrived, Otero-Warren had attended the Santo Domingo meeting and the subsequent New Mexico Association gathering. In her reports, Otero-Warren spoke warmly of the New Mexico Association and approved their support for the Lenroot bill. "From my observation and attendance at these meetings," she concluded, "the New Mexico Association is desirous of a constructive program [that] will do justice to the Indian and settler alike. They wish to retain for the Indians the friends already made in Congress and so are planning to give their full support to the Lenroot bill, with such minor amendments as can be settled in committee."[45] For Otero-Warren, as for the New Mexico Association, the critical goal was to ensure that any legislation affecting Pueblo lands also granted some of the land to Nuevomexicano settlers. Because the Lenroot bill gave some of the land to the settlers, Otero-Warren was satisfied, and she found ready allies in the New Mexico Association.

Otero-Warren found a particularly sympathetic audience among those members of the New Mexico Association who saw the Nuevomexicano population as the descendants of picturesque Spanish colonists who had a deep and inherent connection with the land of New Mexico. As a part of their vision of the area, many of the Santa Fe artists and writers viewed Nuevomexicanos as frozen in time, relics of an earlier, more ancient, and mystical past, with a connection to the earth more natural than that of Anglos. Otero-Warren did nothing to disabuse the members of the New Mexico Association of this opinion. Indeed, she supported it. When Alice Winter, the general federation president, finally arrived in October 1923, Otero-Warren took her on an extensive tour of northern New Mexico and arranged meetings with members of the Pueblos as well as with Anglo and Nuevomexicano settlers on the

disputed lands. Throughout her description of the trip, she called the settlers
on the disputed lands "Anglo-Americans" or "Spanish Americans" and ob-
jected strongly to Collier's use of the terms "squatters" and "common tres-
passers" to describe them. Later, when Otero-Warren wrote *Old Spain in Our
Southwest,* she described the relationship of Nuevomexicanos to the land in
terms that would have satisfied many in the New Mexico Association.

> These people, in their villages, were surrounded by the beauties of nature
> which became a part of them; they added unconsciously to the brilliant
> coloring by placing the red *chili* in strings, and the pumpkins and blue
> corn on the adobe houses. They did not constantly exclaim over the beauty
> of the sunset, or the golden leaves of the cottonwood trees, or the blueness
> of the bluebirds. That, to them, was not unusual and while apparently
> they were indifferent to it, it was actually a part of them. Their lives were
> lived close to the soil and to nature.[46]

As Spanish Americans who were close to nature, Nuevomexicanos were
everything that Anglo patrons wanted them to be.

Otero-Warren's appeal to the New Mexico Association vision of New Mex-
ico ended with a visit to one of the towns that had so charmed Collier. She
concluded Winter's trip with a stop in Santa Cruz, a Nuevomexicano town
north of Santa Fe, "in order," Otero-Warren explained, "that Mrs. Winter
might see the old mission which was established among the Pueblos about
three centuries ago and around which a very ancient Spanish settlement grew
up, typical of many such towns within Spanish grants."[47] Otero-Warren
seemed willing, to an extent, to accept the patronage of Santa Fe's Anglo
artists and writers if such support helped her secure lands for Nuevo-
mexicano settlers. If she could encourage others to see Nuevomexicanos as
Spanish Americans living in ancient villages granted by the Spanish crown,
their opinions would help her cause, and she eagerly presented Nuevomexi-
canos in the picturesque settings that would win Anglo support.

Otero-Warren's New Mexico was not all that different from Collier's. She,
too, presented New Mexico in colorful and idealistic terms. She, too, cele-
brated the connection between locals and the earth. She, too, saw in the rela-
tionship of local people to the land a chance at redemption for the nation at
large. But although Nuevomexicanos had occupied a hazy place in Collier's
writing, they were clearly and solidly at the center of New Mexico life in

Otero-Warren's presentations. In Otero-Warren's New Mexico, Nuevomexi-canos lived in harmony with nature and the land and had for centuries. They presented a romantic image to Anglo newcomers not out of artifice but natu-rally, just like the Pueblo Indians. In Otero-Warren's New Mexico, Nuevomex-icanos deserved the land on which they lived.

The New Mexico Association split with Collier, along with Otero-Warren's alliance with the New Mexico Association, put Dodge in an uncomfortable po-sition. Collier, of course, had come to Taos at Dodge's invitation, and Lujan had accompanied Collier on all of his trips to the surrounding Pueblos, in-cluding Collier's journey to encourage delegates to attend the August meeting at Santo Domingo. Collier could count on Dodge for generous contributions to AIDA. Moreover, during the Bursum bill publicity, Dodge had succumbed to pressure from Collier's enemies and married Lujan in order to lessen ru-mors that theirs was an illegitimate union.[48] But Dodge had her allies among the Santa Fe artists and writers as well. Her son, John Evans, had married the Hendersons' daughter shortly before Dodge married Lujan.[49] Dodge must have realized that accepting the Lenroot bill would have avoided friction be-tween Evans and his new in-laws. Of course, she must also have realized that such acceptance would have put her at odds with her new husband, Taos Pueblo, and Collier. If she supported Collier, Dodge risked losing her connec-tion to the arts community of Santa Fe, her status as a patron of local Nuevomexicanos, and her son's good standing with his wife's family. If she supported the New Mexico Association, Dodge risked alienating her husband and the Pueblo Indians, on whom she depended for her status as a patron.

Dodge simply did not know what to do. She spent most of the closing months of 1923 scrambling to maintain her friendships with the Anglo artists of Santa Fe while giving continued financial support to Collier and AIDA. Her divided feelings were apparent in a letter she wrote to Austin some time after the Santo Domingo meeting. She explained that Lujan's friend, Tony Romero, had arrived in a fury over the New Mexico Association and its poten-tial support for the Lenroot bill. When Dodge tried to get some information from members of the association in Santa Fe, however, she realized that she did not know whom she could trust "down there" in Santa Fe. Her doubts ex-tended to both parties in the conflict. In the same letter she continued, "Have you seen the Hendersons? Or Wilson? What can one's relationship turn out to be? How do you handle it?"[50] Dodge was in a bind, and at the close of 1923, she could see no way out.

She finally decided simply to leave. In November she packed up her household and moved temporarily to Mill Valley, California. She continued to write and give interviews on Indian rights, but her interest in the entire land issue had waned. Leaving a political crisis was not entirely unprecedented for Dodge, who had never had a long attention span for political affairs. Nonetheless, even leaving had its political consequences. She told Austin that everyone who had come with her to Mill Valley loved it. "We are all quite pleased we came & the community is interested & friendly over the 'return of the indians to Mt. Tamalpais,'" she wrote breezily as if the potential eviction of the Pueblo Indians from the disputed lands back in New Mexico was not an issue. "I've met some people I like," she continued, and their greatest attribute appeared to be that they did "*not* talk about the Lenroot bill."[51] She sent a final check for $300 to Collier, and in early 1924 he informed the AIDA board that Dodge had "retired from politics and no longer contributes."[52]

Though running away from problems had helped Dodge in the past, she was not as lucky when she fled from the Lenroot bill controversy. She never settled permanently in the San Francisco area, and in the summer of 1924 she returned to Taos. She came back primarily to welcome the Lawrences, who had been traveling since the previous spring. Although Lawrence had not been in New Mexico during the split between Collier and the New Mexico Association, he managed to cut to the heart of the conflict in his published writing. In "Indians and An Englishman," he called himself "a bumpkin in a circus ring, with the horse-lady leaping over my head, the Apache war-whooping in my ear, the Mexican staggering under crosses and bumping me as he goes by, the artist whirling colours across my dazzled vision, the highbrows solemnly declaiming at me from all the crossroads." Lawrence's description would have been an echo of Dodge's first impressions of the state had it not been for his ability to perceive the strikingly polarized sides in the Lenroot bill conflict. "One has to take sides," he explained in his article. "First, one must be either pro-Mexican or pro-Indian; then, either art or intellect; then, Republican or Democrat."[53] Lawrence had immediately identified the various factions in the Anglo arts community from the Taos Society of Artists to the "highbrows" who stayed at Dodge's to the New Mexico Association to Collier and his Pueblo allies to the political divisions that haunted the Bursum bill struggle. Lawrence's position as an outsider gave him a better vantage point from which to observe Dodge and her fellow patrons. As far as Lawrence was concerned, the most amusing attraction was Anglo artists and writers and

their ongoing war over who best represented the area's Nuevomexicanos and Pueblo Indians.

Even Lawrence, however, began to take sides as the conflict brewed. He and his wife had traveled to Mexico with Bynner, the poet who so opposed Collier, and Bynner's lover, Spud Johnson. By the end of their Mexican sojourn, both Lawrence and Bynner agreed that Collier's efforts on behalf of the Pueblos were more for Collier's benefit than that of the Indians. When Dodge wrote to apologize for the arguments they had had in Taos, Lawrence wrote back accepting her apology but chastising her for her continued support of Collier. "Don't trouble about the Indians," he began bluntly. "You can't 'save' them: and politics, no matter *what* politics, will only destroy them. I have said many times that you would destroy the Indians. In your lust even for a saviour's power, you would destroy them. The same with Collier. He will destroy them. It is his saviour's will to set the claws of his own white egoistic *benevolent* volition into them."[54] By February 1924, when Bynner had returned to Santa Fe, Lawrence was still on the side of the New Mexico Association. He wrote Dodge that Collier was "utterly out of balance. The Santa Fe crowd is perhaps seeking a little balance, in its own way. Learn to modify yourself."[55] Bynner probably disagreed with Lawrence's conclusion that politics could do nothing in New Mexico to help the Pueblos, but his violent rejection of Collier upon his return from Mexico suggests that he and Lawrence had discussed Collier's tactics. Like Lawrence, Bynner believed that Collier had cast himself as the Pueblos' foremost patron, and, like Lawrence, he felt such a stance would do the Pueblos more harm than good. Dodge, who often seemed desperate for Lawrence's approval, must have been vexed at losing his support.

Nonetheless, Dodge ultimately resolved her position by sabotaging her patronage of Nuevomexicanos in an article she wrote about santos for the *Arts* magazine. She and members of her circle had been collecting Nuevomexicano santos since they had first arrived in New Mexico. Andrew Dasburg had turned the collection and sale of santos into a profitable business, and Dodge had even sent a carved saint to her old friend from New York, Carl Van Vechten.[56] In light of the Lenroot bill, Nuevomexicano opinion hardly favored Dodge, and her article only hurt her local standing further. Dodge's first offense was probably her name. She published the article as "Mabel Dodge Luhan," one of the first times she used her revised spelling of Lujan's name. The slight to the Spanish language, however, was the least of the article's

insults. Dodge called Nuevomexicanos "twentieth-century primitives" and the "naïve" and "immature" products of a cruel Spanish colonialism. She attributed almost all Nuevomexicano architectural and artistic accomplishments to the Pueblo Indians' influence, but claimed that the santos were a rare exception in a long history of moral and economic stagnation. "We see the birth of an art in these Santos," she explained, "the first primitive impulse of the soul to picture itself into release. Had the impulse been strong enough, it might have carried our Mexican colonists out into freedom. But it lapsed within them and they became more inturned [sic] and lost to the outside world. For a brief period only they created, and from them we got these sensitive, suffering Santos: the curious offspring of a most cruelly inclined race of men."[57] Dodge's opinions were not entirely dissimilar to those of the New Mexico Association. They, too, gave most of their attention to santos and the Catholic folk customs of Nuevomexicanos in the state, and they, too, saw value in the "primitive" nature of Nuevomexicano art. The members of the New Mexico Association, however, had not opposed the Lenroot bill. Nor did they compare Nuevomexicanos unfavorably with the Pueblo Indians. Dodge's decision to pit the primitive qualities she saw in Native Americans against the primitive qualities she saw in Nuevomexicanos opened her to her first public attacks from Nuevomexicanos.

Local papers immediately took Dodge to task. The *Taos Valley News* published a critical editorial on Dodge's piece, and, although its editors did not comment on the new spelling of her name, they did choose to use the original spelling of "Lujan." With reference to the piece itself, however, the editors were more direct. The paper called Dodge's article a "very unattractive number" and noted that "the Spanish-American element, of which, especially, this immediate vicinity is mainly composed, is taking great exceptions to several uncomplimentary statements made therein." In particular, the editors were rankled by the hypocrisy of a newcomer like Dodge criticizing the Spanish for their colonialism. The piece concluded dryly by observing, "Even yet, what might be termed a foreign element, are entering N.M. And in many cases, can it not be said shedding an unwholesome influence upon both the Indian and the native?"[58] Dodge felt her local popularity decline as the *Taos Valley News* brought her opinions to light.

In addition to the *Taos Valley News* editorial, a Spanish translation of the article also ran in a local paper giving Spanish-speaking Nuevomexicanos an opportunity to decide their opinion of Dodge for themselves. Dodge's article

Marsden Hartley, *Santos: New Mexico,* 1918–1919, oil on composition board. Art historians have often speculated that the hand in this Hartley painting belongs to Mabel Dodge Luhan. (Collection of the Frederick R. Weisman Art Museum, University of Minnesota, Minneapolis. Bequest of Hudson D. Walker from the Ione and Hudson D. Walker Collection.)

was as poorly received among her Nuevomexicano neighbors in Taos as it had been in Santa Fe. Dodge's son wrote her in a tiff over the local community's reaction. "I mean that idiotic translation of the Santo article and the half-witted editorial," he began. "I would advise you to get somebody to translate the Spanish article back into English, and find out just how garbled a translation the spanish [sic] one is. They certainly are a dumb bunch up there, for as far as I could see the article was purely psychological."[59] However dumb a bunch the Taos community might be, it did not share Evans's tendency to attribute all behavior to Dodge's favorite social science, psychology, nor did it offer Dodge the privilege of reprinting the article in English. The exercise would have been beside the point. Even the English version of the article offended. Added to the controversy over the Lenroot bill, Dodge's article was enough to turn local Nuevomexicanos against her and her efforts to be their patron. Later that year Dodge gave her santo collection to the Harwood Museum in Taos, and she never sponsored another show of Nuevomexicano art.[60] Nuevomexicanos evidently had some say in who their patrons could be, and they chose to exclude Dodge from their list of benefactors.[61]

In contrast to Dodge's bungled efforts to remain a patron, Austin finessed her way through the Lenroot bill fallout with considerably more aplomb. Like Dodge, Austin also had allies on both sides of the Lenroot bill. On the one hand, she had a long-standing interest in the Spanish-speaking people of the Southwest, and early in her tenure in Santa Fe had conducted research in the Nuevomexicano community for the Carnegie Foundation Study of the Methods of Americanization.[62] On the other hand, she had stayed with Dodge on her first visit, and she was a fierce supporter of AIDA. She did not attend the New Mexico Association meeting when its members decided to split with Collier, and, later, when Dodge suggested some kind of compromise with the association, Austin dissuaded her. "Don't let anybody hurry you into a too early reconciliation with the N.M. Assn. Let [them] try out their strength awhile," she cautioned. "If they get back with us advantageously, they will make another break for power just when they think it will do us the most harm. Trust John," she continued confidently, "he is the least likely of any of us to make a mistake." In her correspondence with Collier, however, Austin was less supportive. She told him she thought he had "done an injustice to Mr. Wilson's motives." She explained further that they would have to give some credence to the claims of local Nuevomexicanos on the land. "I am quite sure, however, that even if we decide on an organization to stand out for your point of view,

we will eventually have to compromise on something like Wilson's," she chided.[63] Austin was caught between supporting the logic of the New Mexico Association and sharing the emotion of Collier's campaign; she spent the concluding months of 1923 stepping lightly between the two camps.

She proved adept at serving two masters. Austin continued her support for Collier and AIDA, but in a far less visible role. Although she and Collier would later clash over the establishment of an Indian Arts Fund, Collier would remember her as one of his few friends in New Mexico in his autobiography.[64] The New Mexico Association was less kind. New Mexico Association member McKittrick noted Austin's snub of the association's August meeting when it resolved to split with Collier, and Bynner concluded that she was "mad."[65] Austin proved more dexterous in her relationship with Otero-Warren. As Congress neared its final legislation on the Pueblo land question, a new controversy emerged regarding the morality of Pueblo Indian dances. Typically, Austin defended the dances as representative of the Pueblo Indians' deeper connection to nature and their comfort with their bodies and sexual expression. Otero-Warren, in contrast, sided with female moral reformers who sought to restrict the dances, believing them to involve inappropriate public expression and opportunities to exploit Pueblo Indian women. Otero-Warren even journeyed to the General Federation of Women's Clubs meeting in Los Angeles to speak against the dances.[66] Yet, Austin established a solid friendship with Nina Otero-Warren, and encouraged her to write *Old Spain in Our Southwest*.[67] Austin would also go on to help found, along with several other patrons, the Spanish Colonial Arts Society, a group dedicated to Nuevomexicano arts and their presentation as modern manifestations of the state's Spanish colonial past. Austin may have lost some of her friends in the Santa Fe community and she may have argued with Otero-Warren and others about what the community's priorities should be, but she never lost her status as a patron of both Indian and Nuevomexicano culture. When she decided the time had come to ensure the continued traditional role of the chapel at Chimayó, she was ideally placed to do so.

Moreover, Austin proved astute in her forecast of the outcome of the Lenroot bill. Although the Lenroot bill itself was defeated, Collier finally accepted a compromise. President Coolidge signed into law the Pueblo Lands Act in June 1924. The law granted property to non-Indian settlers who did not have titles but who had occupied their plots for thirty years, and to non-Indians who did have titles who had occupied their plots for twenty years. The Pueblo

Lands Board was to adjudicate claims, and the law provided compensation for Pueblos and non-Indian settlers who lost their property.[68]

Collier's compromise seems strange given his virulent opposition to the similar Lenroot bill, but a number of factors explain his change of mind. First, he lay ill in a hospital in California during the land act negotiation and lacked the immediate influence he had possessed in previous legislative battles. Second, he believed that the non-Indian settlers would be unable to prove that they had paid taxes continuously on their lands and the lands would therefore revert to the Pueblos. Finally, he hoped that he could influence the appointments to the Pueblo Lands Board. He was mistaken on all counts. In the years following passage of the bill, Wilson proved far more adept at securing sympathetic members of the board, and district courts interpreted the tax payment requirement to the benefit of non-Indian settlers. Collier would go on to battle the board's decisions in court, but he would not find success until he himself became Indian commissioner in 1933.[69]

The Pueblo Lands Board proved an inadequate solution at best and an economic curse at worst. Although the Pueblos eventually obtained up to 667,479 acres via the process begun in the campaign against the Bursum bill, under the board's adjudication the Pueblos ultimately lost large portions of their irrigated acreage to Nuevomexicanos and Anglos. Nuevomexicanos, meanwhile, lost much of their ranch land to Pueblos and Anglos. The Pueblo Indians, traditionally agriculturalists, found themselves without the natural resources to continue farming and turned increasingly to tourism. Nuevomexicanos, traditionally ranchers, found themselves without the natural resources to continue ranching and turned increasingly to migrant farm work. Though migrant labor had begun infiltrating the New Mexico economy several years before the Pueblo Lands Act, the board's decision exacerbated the suffering in an already impoverished area and left scant industry and tourism, a fickle and inequitable business, as the only salve for New Mexico.[70]

As Nuevomexicanos and Pueblo Indians shouldered the burden of a poorly managed, shifting economy, they may have occasionally cast a resentful eye toward their Anglo patrons. Although Collier, Dodge, Austin, and the members of the New Mexico Association had every intention of helping their Nuevomexicano and Pueblo neighbors, the compromise only drove Pueblos and Nuevomexicanos deeper into poverty and left them fewer economic alternatives. Tourism and migrant work may have enhanced Nuevomexicanos' and Pueblo Indians' picturesque standing among members of the New Mex-

ico Anglo arts community, but they did little to improve the quality of life for long-term residents of the state. The racial and ethnic tensions associated with land ownership had caused division in New Mexico ever since the Spanish had arrived in the area, but the arts community participation in the Bursum and Lenroot bills added a sheen of primitivism to the already fraught division and exacerbated the state's economic troubles. If, in succeeding years, the Nuevomexicanos and Pueblo Indians of New Mexico examined their fruitless lands and reflected bitterly on their Anglo patrons, they were not without cause.

By 1929, when Chávez left Chimayó to sell his family's santos, it was not at all surprising that he went to Santa Fe instead of Taos. In Taos, Dodge's and Collier's support for the Pueblo Indians had helped spring the triethnic trap in which Anglos presented such a romantic portrait of the Pueblos that Nuevomexicanos found themselves on the economic and political margins of the region. In Santa Fe, Anglos and Nuevomexicanos like Nina Otero-Warren cooperated to present a picture of Spanish Americans as authentic to New Mexico, a picture that hid conflicts between Nuevomexicanos and their Pueblo neighbors. In Taos, Pueblo Indians found patronizing support from the highbrows who visited Mabel Dodge and Tony Lujan, but they also found a conduit to Collier and his political advocacy for Indians across the United States. In Santa Fe, Nuevomexicanos found similar patronizing support from Anglo artists and writers like Austin, but, unlike in the case of New Mexico's Pueblo Indians, such patronage did not translate into political advocacy. Nuevomexicanos like Nina Otero-Warren, who had accepted the portrayal of New Mexico Austin, the Hendersons, and other Anglos had begun to nurture, worked to support Nuevomexicano interests in an arena limited almost exclusively to culture. Otero-Warren would go on to provide significant support for bilingual education in New Mexico, but she would never again be involved in a battle as political as the Bursum bill struggle. In her decision to foster a romantic image of New Mexico, Otero-Warren was able to win Nuevomexicanos a compromise on the Bursum bill, but she did so by trading on a primitivist presentation of her community. It was a presentation that limited, rather than encouraged, political action on the part of Nuevomexicanos, who struggled to hold onto their lands in the early decades of the twentieth century.

The problems of patronage and representation that Collier, Dodge, Austin, and the members of the New Mexico Association helped to foster sprang in part from their limited vision of racial identity in New Mexico.

When Collier and his allies had presented the Bursum bill as a struggle be-
tween recent white settlers and ancient Indians, it was easy for audiences
sympathetic to Indian people to choose to support indigenous people. When
the struggle became one between white settlers, pastoral Nuevomexicano
farmers, and ancient Indians, however, Anglo patrons looking for a cause
found the choice more difficult. When Nuevomexicanos and Pueblo Indians
themselves insisted on defining their own racial identity and standing, the
picture became more complicated still. New Mexico was a multiracial state
with many different groups claiming many different identities and many dif-
ferent connections to the land. The land was finite, but identification with the
land took on a dizzying number of forms.

The conundrums of a multiracial place occasioned by the struggles over
the Bursum and Lenroot bills were not resolved at the borders of New Mexico.
Mabel Dodge, John Collier, Mary Austin, Witter Bynner, Alice and William
Henderson—each had extensive connections to political and aesthetic worlds
outside of Taos and Santa Fe. As Dodge and Collier began focusing their ef-
forts on supporting Native Americans, and Austin, Bynner, and the Hender-
sons threw their weight behind the appeal of Nuevomexicanos, they all found
themselves sometimes in dialogue and sometimes in active competition with
white advocates of other nonwhite people. Key among these was Mabel
Dodge's old friend Carl Van Vechten, a supporter of African American writers
and artists, particularly those commonly associated with the Harlem Renais-
sance. His visits to Dodge's place and her visits to his would make their prim-
itivism a national affair.

Carl Van Vechten's Place

Back in New York City, Dodge's salon had competition. Dodge's old friend Carl Van Vechten was spending his time with a new hostess, Edith Dale. Dale was a fictional character invented by Van Vechten in his 1922 novel *Peter Whiffle: His Life and Works,* but she represented what Dodge's life had been and perhaps could have continued to be had she remained in New York.[1] At Dale's salon, ear-trumpet-bearing old ladies mingled with peculiar gossips. Visitors enjoyed chocolate ice cream along with lectures condemning the gap between the "aristocrat" and "proletarian" classes. Modern art and at least one "African primitive" carving constituted the décor. Hutchins Hapgood, Andrew Dasburg, Big Bill Haywood, and Emma Goldman were all visitors. As Van Vechten described it, "The groups separated, came together, separated, came together, separated, came together: syndicalists, capitalists, revolutionists, anarchists, artists, writers, actresses, 'perfumed with botanical creams,' feminists, and Malthusians were all mixed in this strange salad."[2] Edith Dale was Dodge's stand-in, and her salon was a thinly veiled version of Dodge's. In Van Vechten's novel, Dale mixed and mingled with real figures from Dodge's salon as well as fictional characters. A shop window display advertising the book took literary license to merge Dodge and Van Vechten themselves, using an Andrew Dasburg abstract portrait of Carl Van Vechten, probably a retitled portrait of Dodge from the series Dasburg had painted when he first began attending Dodge's New York salon.[3] Although her dedication to the Pueblo cause was strong, Dodge never lost her desire to appear avant-garde among her old New York friends. For the remainder of the decade, she insisted on

Carl Van Vechten and Mabel Dodge Luhan, ca. 1933. (Yale Collection of American Literature, Beinecke Rare Book and Manuscript Library, and Carl Van Vechten Trust. Photograph by Carl Van Vechten.)

visits from her Greenwich Village peers, and frequently returned to New York herself.

In addition to serving as Edith Dale's medium, Van Vechten provided another glimpse of what Dodge's life could have been. Van Vechten had been one of Dodge's first friends in New York City. Originally from Cedar Rapids, Iowa, he had made his way first to Chicago, and then to New York, as a theater critic. *Peter Whiffle* initially seemed like an homage to Dodge, but by the time it was published, Van Vechten's enthusiasm for Dodge had waned. By the early 1920s, he frequently made fun of Dodge in letters to Gertrude Stein, who had become a closer friend to him than she had ever been to Dodge.[4] He also shifted his interest from the Greenwich Village bohemian art scene to Harlem's African American culture. He regularly attended parties with African American artists and writers and frequented the cabarets above 125th Street. Elements of his interest in African art and African American dance and music had appeared in *Peter Whiffle*, but the subject received his full attention while Dodge was immersed in the Bursum bill.[5] In 1926, he published a work of fiction entirely dedicated to African American life titled

Nigger Heaven. The title, a reference to balconies in segregated theaters, received intense criticism from a broad spectrum of his readers and ruined several of Van Vechten's friendships with Harlem residents. Van Vechten's father begged, practically from his deathbed, that Van Vechten change the name, but the title remained. Van Vechten's only concession was an ironic footnote explaining that the offensive element of the title was in common usage among residents of Harlem, but deeply insulting when used by whites. In the novel, Van Vechten never explained that he himself was white. To do so would have been to deny the familiarity he claimed with Harlem life. Indeed, in renaming Harlem with a term supposedly common in Harlem itself, Van Vechten asserted an intimacy with African Americans not entirely dissimilar to Dodge's intimacy with Tony Lujan and the residents of Taos Pueblo.[6] Had Dodge remained in New York, could she have had a similar relationship with African Americans?

The idea must have crossed her mind. After all, when Sterne called her to New Mexico, he wrote: "That which . . . others are doing for the Negroes, you could, if you wanted to, do for the Indians."[7] Dodge may have thought of Sterne's words when she wrote a short story titled "Twelfth Night" based on a visit of Van Vechten's to Taos in 1927. The character she based on Van Vechten, Louis Vandercomp, is rude to her other guests, drinks to excess, and otherwise spoils the visit. Van Vechten's wife's character is portrayed in a ridiculous light as she artlessly attempts to perform a popular dance of African American origin called "the Black Bottom." There were a number of clues that Dodge adhered closely to life in her telling. In addition to the close approximation of Van Vechten's name, Vandercomp, like Van Vechten, lives in a fashionable and popular apartment in New York City, provides patronage for African American writers and musicians, and frequently invites African American guests to his home. Dodge also attached a newspaper clipping to the last page of the story that noted the recent visit of Van Vechten to New Mexico, recorded his stay with Dodge, and concluded by saying that "Mr. Van Vechten was disappointed in the Taos deer dance, given the sixth of January, not finding in it the emotional excitement which he feels is so great a force in the dances of Harlem."[8] Van Vechten was not the only one who could channel his interests into satirical fiction. Dodge could as well, and she did so specifically to mock Van Vechten's patronage efforts, which she herself had passed over in favor of patronizing Native Americans.

What were Dodge and Van Vechten doing? Why, if they cared so little for

each other, were they portraying one another in their fiction? Why were they mocking each other in their letters? Why did they take such interest in each other's efforts at patronage? The easy answer is that both were, by virtually all definitions, primitivists.[9] They thought that African Americans and Native Americans were more primitive than whites, but they also found this simpler, less civilized nature fascinating and praiseworthy. In their patronage, they congratulated themselves for aiding groups whom they asserted could not always help themselves. Like many primitivists, they often saw similarities between Native Americans and African Americans. Both groups were, in their eyes, authentic and pure and therefore worthy of interest. From this agreement came Van Vechten's decision to place an African mask in the fictionalized version of Dodge's salon as well as Dodge's repeated entreaties to Van Vechten to advocate on behalf of the Pueblo cause.[10]

More often than not, however, Dodge and Van Vechten found themselves contrasting the two racial groups they had chosen to patronize along with the places those racial groups called home. Dodge increasingly trumpeted the charm she saw in Native Americans and the magical inspiration she believed existed in Taos; Van Vechten responded in kind, denigrating her interests in letters to Gertrude Stein while celebrating his patronage of African Americans and the glories of Harlem. Both sometimes stepped into racist language when belittling the patronized group of their competitor. Both also employed the condescending language typical of patronage efforts when praising their favored group. Both sometimes doubted the choices they had made. In the course of their fictional jabs at one another and in their correspondence, Dodge and Van Vechten revealed that their respective brands of primitivism grew in dialogue with one another. To call them primitivists only partially conveys the nature of their patronage. Comparisons, contrasts, and competition shaped their behavior into a form particular to their time and respective places. "Competitive primitivists" more accurately describes them.

Given the propensity of both Dodge and Van Vechten toward hyperbole, it would be easy to dismiss their competitive primitivism as irrelevant and petty, but their competition extended to more than their fiction and even to more than their personal relationship. Most immediately, their patronage shaped the communities they patronized and of which they were a part. Both individuals were members of networks of artists, writers, patrons, activists, and intellectuals, and their interests spread and received notice in the correspondence, little magazines, and public performances that tied these networks to-

gether.[11] As prominent patrons of Native American and African American causes and art forms, the personal preferences of both Dodge and Van Vechten translated into financial and public support for Pueblo Indians and African Americans.

On a broader level, the primitivism of Dodge and Van Vechten offers a window into how those whom they patronized responded to the patronage they received. When Dodge, Van Vechten, and others clashed over the nature of their patronage, opportunities arose for Pueblo Indians and African Americans to recast the meaning of their financial support. These clashes and renegotiations suggest that primitivism in the early twentieth century was contested ground, with patrons and the patronized alike reshaping its contours as they attempted to serve their own interests and needs. Dodge and Van Vechten were more successful in shaping their own patronage than were those they patronized, but even those who were closely bound to support from Dodge and Van Vechten found oblique ways to make known their feelings regarding cross-racial patronage. Although such feelings are merely the subjective experience of those who received patronage, they demonstrated that even when sharply constrained, nonwhite people maintained their own visions of their art, their race, their communities, and their relationships with more powerful individuals.[12]

Finally, and perhaps most importantly, the complex tangle of Pueblo, African American, Nuevomexicano, and white interests that intertwined Dodge and her white peers in Taos forced anyone involved in either the Harlem Renaissance or southwestern patronage to think beyond binary notions of race. As many scholars have argued, categories of black and white did not apply in the Southwest, where Native Americans, Mexican Americans, and Anglos clashed and cooperated. Nor do the categories of white and nonwhite adequately describe such a world. Add the presence of African Americans, Asian Americans, and white ethnic groups such as Italians and Serbs, who often found themselves occupying a space between white and nonwhite categories, and the challenge of racial descriptions of the Southwest becomes clear.[13] The story of Dodge and Van Vechten's relationship makes this challenge especially evident. Not only were both patrons in places of extraordinary racial diversity—New York City and New Mexico—but their conversations, correspondence, and patronage brought those two communities closer together and brought the members of each community into conversation with each other. Taos and Harlem are not often grouped together, but visits to both

places are necessary to understand the racial attitudes that shaped artistic communities in the 1920s.[14]

Although Van Vechten had always had a sporadic interest in the art and social standing of African Americans, from the mid-1920s he focused his patronage efforts on supporting African American musicians and writers. In 1924, he announced to Gertrude Stein that "[t]here is always something in New York, and this winter it is decidedly Negro poets and Jazz pianists."[15] Throughout his private and published writing on the subject, Van Vechten demonstrated a deep desire to see an authentic American voice in African American music and poetry. Of particular concern to him was a debate between African Americans and white collectors of African American music as to whether African American blues should be considered a part of American "folklore." This was a consistent point in Van Vechten's reviews, and he returned to it repeatedly in his writing in the mid-1920s. He echoed the contention of African American writer James Weldon Johnson that the blues, like spirituals, should be considered folklore.[16] In "Hey, Hey," a review of several books discussing black spirituals, Van Vechten concluded that "if any race boasts a more interesting folklore than the American Negro," he did "not know what that race is."[17] African American music, particularly the blues and jazz, was in Van Vechten's opinion the epitome of folklore.

Van Vechten consistently backed this opinion with standards of primitivist thought. He insisted on the use of dialect in renderings of blues songs and spirituals, calling it "an integral part of the charm of these naïve songs."[18] He insisted, too, that only black people could perform blues, spirituals, and dances like the "Black Bottom." In an article arguing that more African Americans should turn to their own "heritage" in performances of music and dance, Van Vechten contended that "as any one knows who has sat through a Negro musical show, no one else can compete with a Negro in the intricate steps and loose-jointed movements of [the Charleston]."[19] Regarding music, he asserted baldly, "The fact of the matter is that Blues are well-nigh unplayable save by instinctive Negro performers."[20] Van Vechten also used the word "primitive" with some frequency, at one point calling attention to the fact that he had "on several occasions stated in print my belief that these moans of primitive Negro lovers far transcend the Spirituals in their poetic values while as music they are frequently of at least equal importance. There has been, however, little effort made to study them in their natural habitat."[21] In his magazine writing, Van Vechten's primitivism probably reached its

apotheosis in "A Prescription for the Negro Theater," published in *Vanity Fair* in October 1925. There he proposed a celebration of Harlem cabaret life on theater stages with reenactments of the club scene at Small's, street life on Harlem's "Striver's Row," and a black barbershop. The spectacle would end with "a wild pantomimic drama set in an African forest with the men and women as nearly nude as the law allows. There . . . the bucks, their assegais stabbing the sky like the spears of the infantry in Velasquez's Las Lanzas and their lithe-limbed, brown doxies meagerly tricked out in multi-hued feathers, would enact a fantastic, choreographic tragi-comedy of passion."[22] Van Vechten's transition to an African setting, his delight in the nudity of his potential performers, and his kaleidoscope of culturally indeterminate costumes all suggest that behind his substantive and sincere desire to aid African American artists lay a deep-seated primitivism.

Van Vechten's primitivism took on a precise form, however, the distinctiveness of which is apparent when one contrasts it with that of Dodge. Whereas Van Vechten's primary interest was in the city life of African Americans, Dodge's interest was in the country. Much of the Pueblo Indians' appeal to her stemmed from what she perceived as the Indians' natural connection to the earth. In later writing describing the turtle dance at Taos Pueblo, Dodge wrote that "the dancers seemed to be intensely aware of the sun and the earth and of their beauty and strength. They were the joyous sons of the morning. They were the dancing stars."[23] Dodge was hardly the first white American to see Indians as kin to nature, nor was she the last of her circle of friends and salon guests to draw specific parallels between the Pueblo Indians and the natural world.[24] Nonetheless, whereas Van Vechten's primitivism more often led him to visit Harlem's clubs, Dodge's primitivism was expressed as an affinity for rural life.

This difference was sharply articulated in Dodge's and Van Vechten's correspondence. After Van Vechten sent Dodge records by African American musicians, she replied, comparing African American and Indian music in terms she had learned in her psychoanalytic treatment.[25] Van Vechten showed that he had Dodge's interests on his mind as well. In a letter to Gertrude Stein regarding a prospective visit of Dodge to New York, he said Dodge was arriving with her husband, "Indian and all." When she returned to Taos, Van Vechten flippantly called it "a trip Indianward."[26] Van Vechten could not have been entirely unaware of the parallels to his own adventures in patronage. He did not just visit Harlem, he visited Harlem's black residents.

Harlem was not just a place; it was, in the words of James Weldon Johnson, "Black Manhattan."[27]

The contrast between New York and New Mexico and between Dodge's and Van Vechten's respective visions of each place was especially apparent every time Dodge tried to convince Van Vechten to visit her in Taos. When Dodge wrote excitedly about the Bursum bill, Van Vechten responded serenely about New York's "wonderful parties." He even included a dig about Dodge's old successes in her Greenwich Village salon. "New York is as brilliant almost as it used to be in the days when Edith Dale had a saloon," he wrote.[28] As early as 1923 he said firmly that he did not think that he would "ever leave New York again." "I love the place," he wrote fondly, "especially in the summer."[29] Two years later, Dodge was still trying to convince him to visit Taos. She wrote insistently, "I want to tell you about Taos, for seriously, I have a feeling it will put you right on your feet—& change your tempo—& clear up things."[30] Van Vechten was not persuaded. He stayed in New York. As Dodge and Van Vechten developed their primitivism in conversation with one another, they consistently showed that for their particular kinds of primitivism, place mattered.

No place was more important for Van Vechten than Harlem. Van Vechten's enthusiasm for "Negro poets and Jazz pianists" led him to be, in the words of one historian, a "midwife" to the Harlem Renaissance.[31] Van Vechten read the work of numerous African American writers working in Harlem, and encouraged his publisher, Alfred Knopf, to publish the work of Langston Hughes and other authors. But Van Vechten was also a constant presence in Harlem's nightspots. White visitors to New York City frequently requested tours of Harlem with Van Vechten, and by 1930, Andy Razaf's popular song *Go Harlem* immortalized Van Vechten's role by enjoining listeners to "Go inspectin' like Van Vechten." Van Vechten's hosts in Harlem were happy to return his visits, and he became well known for the diverse guests at his parties. An often-repeated story regarding Van Vechten's influence soon made its way into the pages of the fledgling magazine the *New Yorker*. The magazine reported: "One of the embarrassing moments which the tabloids have not yet recounted concerns a matron who, having been away from the city, returned, to be greeted at the Grand Central by one of the darker redcaps. 'How do you do, Mrs. S—,' he murmured, cheerily, and noting her amazement added: 'I guess you don't remember me, but I met you at Carl Van Vechten's!'"[32] Just as Pueblo Indians mingled with bohemian artists and

writers at Dodge's home in Taos, African Americans mingled with New York City's white society matrons at Van Vechten's apartment in New York. Every time Van Vechten declined an invitation from Dodge he made clear that the beauty of Taos and the appeal of the Pueblo Indians had nothing on Harlem, its cabarets, and Van Vechten's own place, full of what he saw as his own exotic guests.

Van Vechten often tried to take a dismissive tone toward Dodge's interests and her comparisons with his own, but his irony did not always hide his recognition that they were engaged in an ongoing comparison that bordered on competition. Once, after Dodge had visited and complained about the inebriated state of one of Van Vechten's friends, he wrote Stein and criticized Dodge in blunter terms than usual. "Mabel wrote me a letter saying she couldn't come to my house again, that she didn't like to see people in that condition. . . . Some people like to see him just as much as they like to see an Indian chauffeur, drunk or sober—so I just haven't answered Mabel's letter— I can't think of anything to say."[33] Van Vechten's phrasing—"some people like to see him just as much as they like to see an Indian chauffeur" suggested that he saw Dodge's relationship with Lujan as a public one designed to bring her attention. Moreover, he suggested that his parties played a similar role, bringing him as much attention as they brought many of his guests.

Dodge's and Van Vechten's patronage worlds came into the sharpest contrast in March 1925 when Dodge was visiting New York and asked Van Vechten to entertain Lujan. Dodge's friends from New Mexico, Witter Bynner and his lover Spud Johnson, were also in town, and Van Vechten took the entire entourage to Small's, one of Harlem's hotspots. The *New York Daily News* society columnist, Bernadine Szold, caught word of the outing and reported it in her Sunday column. According to Szold, "Tony was thrilled and that is a great achievement, for nothing has ever been known to disturb his passiveness. His two long braids, bound tightly in sky blue ribbons, began to sway back and forth as the primitive rhythm of the negro music finally penetrated his stolid exterior." As the evening wore on, Lujan apparently was overwhelmed by his own enthusiasm. Szold told readers:

> The elemental surge in Tony that had been roused by the tom-tom of the music broke all bounds. When the floor cleared after a dance, he suddenly leaped from his chair, while the startled spectators stared in excitement, ran over to the orchestra, seized a small drum, made one grotesque bound

to the center of the floor, and to the intense delight of his enraptured audience, began thumping out a Navajo war dance, which he accompanied with the wailing and undulating chant which the Indians sing while they dance.

Lujan had such a good time, according to Szold, that Van Vechten, Bynner, and Johnson did not get him home until 5:00 in the morning.[34] The evening may have been nothing more than a frivolous boys' night out, but the effect was to put the crown jewel of Dodge's patronage—Tony Lujan—in immediate contrast with Van Vechten's patronage of African American culture.

Szold did not react to the juxtaposition of Native American and African American cultures as Dodge and Van Vechten did. Szold blurred Native American and African American music into a single spectacle. The "primitive rhythm of the negro music" became the "tom-tom of the music" and somehow easily allowed Lujan to play a "Navajo war dance." As a society columnist, Szold could meld Lujan, a Taos Pueblo Indian, Navajos, and the African American musicians at the club into a single nonwhite group. Such a conclusion was probably typical of most white Americans at the time.[35] Even Dodge and Van Vechten had subscribed to such a view when Dodge had her New York salon. Both seemed to hold the opinion, common among many advocates of modern art, that all the people they considered primitive, from Pacific Islanders to Native Americans to Africans, were instinctively modern artists.[36] Indeed, it was just such a grouping of "primitive" people and their art that allowed Van Vechten to place an African carving at Edith Dale's salon, Sterne to assume mistakenly an innate connection between the Balinese and the Pueblo Indians whom he met, and Dodge and some of her peers to believe initially that there was no difference between Nuevomexicanos and Pueblo Indians.

By the mid-1920s, however, the patronage efforts of Van Vechten and Dodge made such a conclusion impossible for each of them. Although they both condescended to members of both races and considered themselves authorities on each race, neither could say that both races were the same. They had each invested too much time in asserting the differences they saw in each racial group. Taos was not the same as Harlem. African American music was not the same as Native American dancing. African American poetry was not the same as Native American art. In short, their efforts in patronage had led them to think beyond the binary terms of white and nonwhite when they con-

sidered race. Such thinking did not make them any less condescending in their choice of language or in their treatment of the groups they patronized, but it did make the nature of their patronage and their relationship with one another more complicated.

The evening at Small's seemed to bring the complicated dance in which Dodge and Van Vechten were engaged to a climax. Their particular reactions to the evening remain a mystery. Soon after Lujan's adventure at Small's, Dodge sent Van Vechten her letter comparing the psychological profiles of Native Americans with African Americans. Van Vechten, meanwhile, sent a clipping of Szold's column to Stein. Both Dodge and Van Vechten appear to have seen the evening as some sort of turning point. Van Vechten, although anxious during Lujan's antics, still felt that the evening would be of interest to Stein. Whatever Dodge thought of the evening, afterward she began to change her approach toward Van Vechten. Her frequent visits to New York suggest that the city still held appeal for her, and Van Vechten had made it clear that Harlem and its ferment of artistic, literary, and musical activity was a vital part of the city. Dodge was not willing to give up on forging a creative center in Taos, but she recognized the attraction of the creative activity that Van Vechten supported. Soon after Van Vechten took Lujan to Harlem, Dodge began to look for ways of bringing Harlem to New Mexico.

Just a few months after Lujan's outing, Dodge found an opening. In the winter of 1923–1924, Dodge visited New York and attended a lecture about the teachings of famed mystic George Gurdjieff. Gurdjieff had founded a spiritual center in Fontainebleau, outside Paris, called the Institute for the Harmonious Development of Man. Gurdjieff's teachings, which continue to inspire followers today, are imprecise and seem particularly opaque to skeptics, but they appeal to those who find modern life fractured into disparate elements. In brief, Gurdjieff taught that a combination of physical, intellectual, and emotional exercises would allow his followers to integrate all aspects of their lives, thereby attaining universal consciousness. His followers at Fontainebleau sought what Gurdjieff called the "permanent I" through ritual dances, gymnastics, communal chores, and fasting. His philosophy attracted many Europeans and Americans who felt that the war had left the world in shambles.[37] Gurdjieff's work appealed particularly to Dodge, who had never fully faced her frustration and depression over the war.

In November 1925 Dodge met one of Gurdjieff's most intriguing disciples, a young writer named Jean Toomer. Toomer had helped kick off the

Harlem Renaissance in 1923 with the publication of his book *Cane,* a combination of poetry and prose that followed African Americans from the rural South to northern urban centers. In the foreword to the first edition, social critic Waldo Frank wrote that *Cane* was a "harbinger of a literary force of whose incalculable future I believe no reader of this book will doubt."[38] *Cane* shook Toomer personally as well as creatively. Writing the book forced Toomer to grapple with his mixed-race heritage in a way he had previously avoided. His maternal grandfather, P. B. S. Pinchback, though light-skinned enough to pass for white, claimed a black heritage and parlayed his racial identification into a relatively successful political career in late nineteenth-century Louisiana. Toomer attended both black and white schools while growing up in Washington, D.C., but not until he visited Georgia and began writing *Cane* did he fully understand the limitations placed on African Americans in the United States in the 1920s.

Toomer's own heritage and his experiences working on *Cane* led him to deny the praise he received as a "Negro writer." Toomer claimed instead that he was a representative of a new "American" race that was neither black nor white. He explained this in a letter to James Weldon Johnson after Johnson requested a sample of his work for an anthology titled *The Book of American Negro Poetry.* "My view of this country sees it composed of people who primarily are Americans, who secondarily are of various stocks or mixed stocks. The matter of descent, and of divisions presumably based on descents, has been given, in my opinion, due emphasis, indeed overemphasis. I do not see things in terms of Negro, Anglo-Saxon, Jewish, and so on. As for me personally, I see myself an American, simply an American."[39] Toomer went on to explain that he did not see each race in the United States creating literature and art unique to their race. He claimed instead that he devoted his energies to fostering a life that supported all creative people. Toomer's racial claims were controversial and did not always engender sympathy among other writers and artists of the Harlem Renaissance. Nonetheless, Toomer maintained his opinions. As he moved away from the explorations of race that marked *Cane,* he ceased writing fiction and turned instead to the comforting philosophies of Gurdjieff.

Though Dodge had already begun to form an interest in Gurdjieff, she did not cement her commitment to the mystic until she heard Toomer speak about his experiences at Fontainebleau. Dodge, like many women who heard Toomer speak, was strongly attracted to him. She deepened her support for

Gurdjieff in an attempt to bring Toomer closer to her. She soon invited Toomer to visit Taos, and after he spoke about Gurdjieff to several artists and writers in Santa Fe in the winter of 1924–1925, she wrote several letters praising Gurdjieff's method in effusive terms and asking Toomer for a deeper and more intimate relationship. In one letter she wrote:

> I hardly could look towards you for fear of starting something psychologically bad in Tony—yet more & more as time went on I felt with you & in a relationship that was positive & wonderfully refreshing. I am not mistaken, am I? You do feel it too, don't you? I don't have to say how much I wish we can start something here—& that you will be the one. . . . Wasn't it interesting that Tony said he would like to see how the real people of New Mexico would take it? And wasn't it remarkable that Tony got it? For he did—as I found from talking afterwards. He said he understood it all— tho' not some of the words. They really want it. And as Willy Henderson said—more would come—from all over—this is a magnetic, an attracting centre.[40]

Dodge was simultaneously concerned that her attraction to Toomer would hurt Lujan and delighted that Lujan believed Gurdjieff's methods potentially beneficial to the people of northern New Mexico. Her behavior seems contradictory, but her sentiments were consistent with her desires. She assessed, probably correctly, that the way to Toomer was through Gurdjieff. By expressing her enthusiasm for Toomer in one breath and Lujan's enthusiasm for Gurdjieff's methods in another, she hoped to bring a center like the one in France to New Mexico, a center that Toomer would no doubt establish. Such a center would validate her claims, and those of artist William Henderson, that northern New Mexico attracted creative and spiritually attuned individuals.[41] Dodge potentially could have it all: New Mexico would become a destination for the creatively and spiritually inclined, the center would have the imprimatur of a Taos Pueblo Indian as well as other "real" New Mexicans, and Dodge would have Toomer nearby.

In another letter, Dodge was even more explicit about her attraction to Toomer and her desire to live near him. "I feel something for you I have never felt before—it is that passionate admiration feeling—I have never had it for a man as man," she wrote, "I've had it for something in some men while despising them. But it is you, Jean, I have this feeling for. I have it when you

talk—when you talk to me or to the group when all of you is focused together
& directed. Then I have that very thing you spoke of last night—that sense of
tremulous wonder—half believing half incredulous—that there you are—that
real man." Dodge suggested that she was even considering leaving Lujan to
win Toomer's affections. "I need you," she insisted, "*Need* to love you the way
I do." Toomer did not respond with the same ardor, but managed to secure
from her a $14,000 loan for Gurdjieff. Dodge hoped that Gurdjieff would use
the money to open an institute in Taos and bring Toomer closer to her.
Toomer's intentions were never as clear. Gurdjieff never opened an institute
in Taos, though Toomer claimed he was considering it, and Dodge never saw
her $14,000 again. In the early 1930s, Toomer grew disillusioned with Gurd-
jieff, whose drinking and relationships with various women seemed to con-
tradict his teachings. In 1934, Toomer wrote Dodge an apology accounting for
the money she had lent and explaining that he did not have the means to re-
pay her. Dodge's flirtation with Gurdjieff and with Toomer had come to an
end.[42]

Dodge never cited Toomer's race as the basis of her attraction to him, but
she must have given his racial identity some thought. One of her first articles
referring to her relationship with Lujan had been titled "A Bridge between
Cultures."[43] Dodge believed that her marriage with Lujan brought white peo-
ple into contact with a culture necessary for humanity's survival. Only by in-
corporating an Indian worldview, she believed, could whites undo the harms
of civilization. Dodge's ruminations on the differences between Native Amer-
icans and African Americans may have led her to wonder if a liaison with an
African American would offer her insights similar to those her marriage with
Lujan had provided. That Toomer himself was divided over how to identify
himself racially, and that he came from a racially mixed background, probably
only encouraged Dodge to believe they held similar opinions on Americans'
need for interracial communication and interaction. Toomer already consid-
ered himself a representative of an "American" race; Dodge believed her rela-
tionship with Lujan would usher in an age of interracial understanding. She
may have wondered if a relationship with Toomer could be as powerful.

Dodge did actively compare the two men, even in her love letters to
Toomer. At one point, she wrote to Toomer:

> Its wonderful to find someone who seems manly where I've had nothing
> but sons in my life & not sons of god either Except Tony. He is a man but

I cannot communicate consciously with him. Or hardly. He gets me out of the air—& he gets me up to a certain point. And it is he who awakened my heart & my altruism & who has kept it alive so that it is alive for good—& he made me maturer & stronger—but there is a something beyond where I meet you & where I bring him & my love & compassion that he awakened & with them join on to another thing.[44]

Elsewhere in her correspondence, Dodge expressed reservations about how Lujan would respond and had responded to her desire for a relationship with Toomer. Repeatedly, she claimed that Lujan had prepared her for a deeper relationship, which she believed that she should have with Toomer. In her desire to "awaken" her "altruism," Dodge found herself promising money and devotion to Toomer even at the cost of losing Lujan's affections. That she did so at the same time Collier was expanding the American Indian Defense Association and in need of financial support from patrons like Dodge suggests both Dodge's fickleness and the material consequences of her primitivism.

Whatever Dodge, Toomer, and Lujan felt about the racial implications of their relationships they kept to themselves, but observers of the married couple may have been less discreet. Van Vechten and Bynner both may have shared their opinions with one of the young poets of Harlem, Langston Hughes. Hughes had never met Dodge; he had never been to Taos; and he was unimpressed with Toomer's efforts to convince Harlem's residents to follow Gurdjieff.[45] Nonetheless, in 1927, he published a poem titled "A House in Taos" that appeared to address Dodge's relationship with Toomer directly. Hughes submitted the poem to a competition overseen by Witter Bynner and won. He would later claim that the poem was not based on Dodge at all, but the text, reproduced in full, seems to suggest an alternative interpretation.[46] It appeared in *The Weary Blues* as follows:

> *Rain*
> Thunder of the Rain God:
> And we three
> Smitten by beauty.
>
> Thunder of the Rain God:
> And we three
> Weary, weary.

Thunder of the Rain God:
 And you, she, and I
 Waiting for nothingness.

Do you understand the stillness
 Of this house
 In Taos
Under the thunder of the Rain God?

Sun
That there should be a barren garden
About this house in Taos
Is not so strange,
But that there should be three barren hearts
In this one house in Taos—
Who carries ugly things to show the sun?

Moon
Did you ask for the beaten brass of the moon?
We can buy lovely things with money,
You, she, and I,
Yet you seek,
As though you could keep,
This unbought loveliness of moon.

Wind
Touch our bodies, wind.
Our bodies are separate, individual things.
Touch our bodies, wind,
But blow quickly
Though the red, white, yellow skins
Of our bodies
To the terrible snarl,
Not mine,
Not yours,
Not hers,
But all one snarl of souls.
Blow quickly, wind,

Before we run back
Into the windlessness—
With our bodies—
Into the windlessness
Of our house in Taos.[47]

Hughes claimed later that the red, white, and yellow skins referred to the colors of sacred corn and that the poem was a commentary on those who sought enlightenment in the southwestern desert. Hughes may well have seen the poem as a criticism of Dodge and her visitors in Taos. The references to buying "lovely things," the three individuals "smitten by beauty," and "the unbought loveliness of moon," certainly evoke Dodge's ever-changing household of guests and their penchant for buying up the landscape and its inhabitants on their quest for aesthetic and spiritual fulfillment.

The pronouns "you," "she," and "I," along with the implication of romantic conflict, however, seem too close an approximation of Lujan's, Dodge's, and Toomer's relationship to be a generic comment on bohemians in New Mexico. It is possible to read Hughes's poem as a comment on those who patronized Native Americans and African Americans. In bringing Dodge, Toomer, and Lujan together in a single poem and commenting on their racial differences, the emptiness that marked their relationships, and the place that Dodge called home, Hughes highlighted the complexity of racial relationships like those generated by competing primitivists. Van Vechten probably thought about more than the relationship between whites and blacks when he patronized black writers. Dodge probably thought about more than the relationship between Anglos and the Pueblo Indians when she patronized members of Taos Pueblo. Hughes probably thought about more than sacred corn when he wrote "A House in Taos." · reading to much into it?

Hughes appears to have recognized the inequities of cross-racial patronage. Nonetheless, he made his commentary while directly benefiting from the patronage of Van Vechten. Poetry was one way he could make his feelings regarding patronage known, but it was not powerful enough to win him independence from the patron who had inspired him. Hughes's poem provides only a trace of how patronized people responded to patronage from primitivists. As such, it is illustrative both of the widely varying perspectives of patrons and patronized peoples and of the enormous power that patrons wield in defining the terms of their support.[48]

Whatever record remains of Van Vechten's response to Hughes's poem or

Dodge's relationship with Toomer is obscured by the furor generated by *Nigger Heaven*. Van Vechten had published the book a year before Hughes published "A House in Taos," and it immediately generated a flurry of reviews and sales. The book follows the relationship between two black lovers: an innocent and pure librarian who works on 125th Street and a young rake who cannot reconcile his ambitions with the limited options available in segregated and racist New York. The novel is an awkward combination of Van Vechten's breezy ironic style and his serious intent to address the problems of race in Harlem.[49] Van Vechten saw the book as an effort to portray the authentic folk culture of urban Harlem. Critics saw the title as a gross insult and the book as a lurid and unseemly description of Harlem's underbelly. The book probably would not have received the attention it did had it not been for its title, but the title was enough to make Van Vechten the center of debate in Harlem's intellectual circles.

In fact, Van Vechten rapidly became a tool in the battle over intellectual freedom between Harlem's older intellectuals and its younger literary aspirants. The Chicago *Defender* called the book "smut," and W. E. B. Du Bois described it as "an affront to the hospitality of black folk and to the intelligence of white," but the members of a younger generation in Harlem found Van Vechten a useful rallying point for challenging their elders. Wallace Thurman suggested that blacks erect a statue in Van Vechten's honor on 135th Street not as a monument to the novel but to "comment upon the fickle and superficial nature of black critical response to the novel and its author." Langston Hughes, who had written lyrics for some of the songs in the novel, and James Weldon Johnson similarly invoked Van Vechten and his book to champion artistic freedom. In his autobiography, Hughes even compared Van Vechten's title with the title of his second collection, *Fine Clothes to the Jew,* as proof that Van Vechten intended the title not as an insult but as ironic commentary. Thurman, Hughes, and Johnson shared Van Vechten's interest in Harlem's less elite residents, and they pursued similar themes in their own work, themes their elders found inappropriate. Their support for Van Vechten and his novel did not stem primarily from their views of him or his writing, but from their desire to uphold their own artistic freedom.[50]

Van Vechten may well have been shrewd enough to realize the attention his book had brought his African American friends, but the controversy appears to have wearied him. His own father wrote to say that he did not like the title and that it disguised Van Vechten's good intentions. "If you are trying to

help the race," his father patiently explained, "as I am assured you are, I think every word you write should be a respectful one towards the black."[51] Van Vechten's father died seven months before the novel was published, but his words must have echoed in his son's mind as the author faced criticism from some of Harlem's most elite circles. However he felt about the controversy, Van Vechten evidently did not want to see it out in New York. A month after publication of his book, he and his wife went to Europe. As soon as he returned in January 1927, he promptly set off again on a trip to Hollywood. Along the way, he stopped in New Mexico, where, in the pages of Dodge's prose, he took on the name Louis Vandercomp.

Dodge had finally won a visit from Van Vechten, but she may have been a little uneasy seeing him in the wake of his novel's popular success. She told Van Vechten that it was one of the best he had written. "You seem to have lifted the environment right out & put it into your novel," she gushed. "This is much more done in this book than in any others of yours. You really were identified with those people, weren't you?"[52] Whether Dodge was conscious of her decision, she had carefully laid out the basis of their competition: she also wanted to lift the environment of New Mexico right out and put it into a novel, either of her own or of some visiting luminary. More than any other message such an effort would convey, she wanted others to realize that she was really "identified" with Pueblo Indians. As Van Vechten's visit approached, she may have wondered if she could impress him with her connection to the Pueblo Indians, and convince him that such a connection was better than the one he had formed in Harlem with "those people."

If she harbored such desires, she was not successful. Van Vechten had a perfectly pleasant stay, but Dodge did not enjoy the visit. Dodge and Lujan both came down with pneumonia, and Andrew Dasburg came up from Santa Fe to entertain Van Vechten. Dodge felt that Dasburg had ruined the entire venture. She was not alone in her opinion. Dorothy Brett, a painter who had accompanied the Lawrences to New Mexico, complained enough about Van Vechten's visit to elicit a reply from D. H. Lawrence himself. He told Brett that the time she described with Van Vechten and Dasburg sounded "horrid" and that there was "a certain impotence about modern men, which runs to smuts. But no good bothering. The poor things have prurient itch."[53]

Lawrence, despite his protests, did bother. In unfortunate racist language, he cut to the core of the relationship between Dodge and Van Vechten. "One likes to cherish illusions about the race soul," he wrote, "the eternal Negroid

soul, black and glistening and touched with awfulness and with mystery. One is not allowed. The nigger is a white man through and through. He even sees himself as white men see him, blacker than he ought to be."[54] Lawrence had his own relationship to nonwhite people, and he also turned to them on occasion to tap into an authentic identity. Nonetheless, he succinctly noted the primitivism that motivated both Van Vechten and Dodge, and he even gestured toward the pressure such attitudes placed on African Americans to perform the identity patrons like Van Vechten and Dodge imagined for them. Lawrence did not stop there, however. Having called Van Vechten on his sensationalism, he went on to question Van Vechten's motivations. He told Spud Johnson that he had "slapped [Van Vechten]" in the review and had called the novel "a false book by an author who lingers in nigger cabarets hoping to heaven to pick up something to write about and make a sensation—and, of course, money."[55] Van Vechten's motives were probably more generous than Lawrence suggested, but Lawrence had noted the fundamental flaw in the book. Readers were more likely to come away with a sensational vision of Harlem than they were the complex and varied portrait of African American culture Van Vechten had intended. Van Vechten's primitivism had overcome his genuine desire to paint a full portrait of African American life.

Van Vechten probably had not read Lawrence's review by the time he visited Dodge, but he might well have picked up on Dodge's competitiveness and Brett's animosity. He referred to his trip to Taos as a trip to "Mabel Dodge and the Indians," and complained to Stein that Dodge was "just the same (and I think should be a little different by now.)"[56] Van Vechten was neither inspired by his brush with the Pueblo Indians nor convinced of Dodge's superior connection to them. It would seem that Dodge had failed.

But Dodge did not see the visit in the same light. As she reflected on Van Vechten's stay, her competitive drive began to shift. Just after Van Vechten left, she continued to compare his passion for African Americans to hers for Native Americans. She wrote that she had received "the negro records" he had sent and that she had not commented on them because "they were so *sad*. Such *dolor*. With the indians it is all light & allegro. They have hardly any dolor & do not feel hopeless. They have no sense of inferiority—for a very good reason. Their religion—all of love & joy & the sun & growing things fills them constantly, *daily*, with wonder & worshipful delight." Van Vechten may have thought Dodge was continuing their old competition, but her focus had changed. In the same letter she told Van Vechten that she was "nervous"

about his announcement that he would write a book about Taos. "You didn't really see the real Taos," she complained. "An alien thing was going on when you were there, quite commonplace & familiar in the world but not to Taos as Tony & I have it generally." She enjoined Van Vechten to "be careful when you write about Taos & leave out that commonplace aspect that does not belong to *it,* but to those who brought it there for a few days. I could show you such beauty there," Dodge boasted, "so free & really gay & without the dolor that was there with those 'parties.'"[57] Dodge was still comparing her brand of primitivism with Van Vechten's, but her letters after his visit indicated that she had decided for herself who had won. Whereas she had previously left room for Van Vechten's interests, after his visit Dodge claimed her style of patronage and her Taos as superior. If Van Vechten was not willing to follow along, then she did not want him writing about her home.

Dodge's and Van Vechten's competitive primitivism had reached an impasse. Van Vechten would not yield his interest in African Americans, and Dodge would not hand him material on the Pueblo Indians. Over the next few years, they would let the subject drop. Not even a subsequent visit by Van Vechten to Taos in 1933 was enough to get them riled up again. Without their rivalry, they had little to say to one another, and they had no contact until 1950.

As was her custom, however, Gertrude Stein had the last word on the entire affair. After Van Vechten's trip to Hollywood, Stein wrote Van Vechten confidently and in her typically elliptical style. "I know why you like niggers so much. [Paul] Robeson and I had a long talk about it," she began. "[I]t is not because they are primitive but because they have a narrow but a very long civilisation behind them. They have alright, their sophistication is complete and so beautifully finished and it is the only one that can resist the United States of America. Of course Mabel and her Indian business is wrong because they were an undeveloped people and the Indians learn but the niggers don't which is their problem."[58] It is difficult to extract a coherent opinion from Stein's account of her conversation with singer and actor Paul Robeson, and it is excruciating to imagine Robeson's reactions to her language, let alone her conclusions. Nonetheless, the conversation and Stein's account of it suggest the important role the interplay between Dodge's support of Pueblo Indians, Van Vechten's support of African Americans, and Stein's support of modern art had in each of their articulations of primitivism. Stein claimed to reject the notion of African Americans as "primitive," but her characterization of black

culture as a "narrow" civilization was not so different from Dodge's claims of the Pueblo Indians' spiritual superiority. Whether Stein was willing to call it primitivism, that was exactly what she, Dodge, and Van Vechten were practicing. That Stein suggested she had the approval of an African American, Robeson, for her opinions suggests how much she and Van Vechten had invested in their primitivism. Dodge had decided that "her Taos" was the answer to modern American problems, whereas Stein had decided that an interest in black culture like Van Vechten's was the key to Americans' modern angst. Each turned to their specific brand of primitivism and pronounced it triumphant, and they did so while actively comparing and vying for approval from the groups they patronized.

By the time Stein commented on Van Vechten's vexed relationship with Dodge, Dodge herself had traveled far from her Greenwich Village salon, and her interests appeared to have radically shifted. At their root, however, all three individuals continued to engage in the primitivism that had marked their activities before World War I. Stein continued to support the work of artists such as Pablo Picasso, who used so-called "primitive" African carvings as his inspiration. Van Vechten continued to celebrate African American culture, particularly in juxtaposition with "white" cultural forms. In fact, he and Stein collaborated on the 1934 production of *Four Saints in Three Acts*, a modernist opera by Stein and Virgil Thomson, which starred an entirely black cast.[59] Dodge continued to try to bring together artists, writers, and activists on behalf of people she found authentic, pure, close to nature, and therefore worthy of her patronage. Their efforts and their continued contact with one another meant that all three informed one another. Stein discussed Native Americans with Paul Robeson. Van Vechten talked about Toomer and Gurdjieff with Langston Hughes. Dodge listened to music by African Americans after visiting dances by Pueblo Indians. Primitive modernism drove all three individuals. Competitive primitivism drove them to discuss, compare, and contrast their interests with one another. Their efforts and discussions informed modernist work, shaped Dodge's financial contributions to the causes that occupied her, led those they patronized to reconsider their position vis-à-vis their patrons, and complicated even further the racial landscapes of Harlem and Taos.

Witness to these efforts was Tony Lujan. It was he who figured in the gossip Van Vechten shared with Stein. It was he who traveled back and forth across the country when Dodge desired the pleasures of the city. It was he

who jumped to the stage at Small's. It was he who suffered as Dodge considered a romance with Toomer. Lujan was central to every one of Dodge's projects in New Mexico and farther afield. Her place in Taos would never have been secure without him. His place among the aesthetic, political, and personal agendas that drove Dodge and her visitors is an amorphous one. To find it requires a return to Toomer's lecture and a visit to a Santa Fe hotel room.

Tony Lujan's Place

Dodge had never been a woman to hide her feelings. After he realized her attraction to Toomer, Lujan protested her behavior. When, following Toomer's lecture, she did not return to their hotel room in Santa Fe until after midnight, Lujan confronted her. She had entered the hotel more than an hour earlier, he said. Where had she been? Dodge refused to argue, but Lujan kept her awake all night as he tossed in bed. Finally, at 6:00 A.M., he announced that he was going home. "He will not ride with you behind him in the car," Dodge reported to Toomer. "He will not be 'a shield' for me. He will not have the world laugh at him nor let me make a fool of him." Lujan threatened to tell Dodge's son and her mother about her behavior with Toomer. He was not only upset over Dodge's possible infidelity and his own potential role as a cuckold but also felt that Dodge had betrayed the particular gifts he had given to her. "He tells me it is true that ten years ago when I came here I did not know how to live—but now I know—I do not need any teacher," she told Toomer. Lujan's threats became more extreme. He told Dodge that "the white people are all going down & later the dark people will step on them & maybe he will hit me with a hammer—for the white people turn to stone—& will be used as 'foundations.'"[1] If Dodge had cheated on Lujan, she had betrayed him in every way she could. He was no longer her partner, her teacher, or her exotic showpiece.

While reading Dodge's letter to Toomer in the archive, I had a thought I often had when reading statements Dodge attributed to Lujan. "Did he really say that?" I wondered. "Or did Dodge invent their conversation to garner more attention from Toomer?" Her letter to Toomer and Hughes's cryptic

Tony Lujan leading two horses up trail. (Yale Collection of American Literature, Beinecke Rare Book and Manuscript Library.)

poem are the only documents related to the alleged triangle between Dodge, Lujan, and Toomer. Toomer appears never to have returned Dodge's affections. Their correspondence is extremely limited. Could Lujan possibly have had such an extreme reaction to a single appearance of a charismatic potential rival? Did Dodge just make it up? Although she was prolific, she was not an original writer. Most of her books are composed of published correspondence and meandering recollections. Was she capable of imagining such a conversation? Or did it really happen? If it did, did Lujan forgive Dodge? They never separated. Did he just let the incident go and continue to serve as Dodge's pawn in her personal and public relationships?

Some members of Taos Pueblo certainly thought so. In 1949, years after Dodge's supposed affair with Toomer, a member of the Pueblo wrote a letter to the editor protesting a recent article Dodge had written, and taking the opportunity to make a swipe at Lujan as well. Dodge had, typically, called readers to return to simpler living. "Can't We Let the Indians Find Their Own Way Home?" she titled the article. Modernizing trends at Taos Pueblo were having a deleterious effect on the Pueblo's residents, she argued, calling attention to World War II veterans who wanted "conveniences." "Soon plumbing, electricity and gas stoves, little shops and even restaurants may spring up in the Indian village, and this," she concluded scornfully, "will be called Progress by some." She reserved her greatest disappointment for those at Taos Pueblo who had lost touch with the appeal of more simple living. "For who understands the basis for the old ways," she reflected, "the dirt floor, the open fireplace for cooking, the river water for their needs, new corn and wheat every year sown by themselves for bread, the fresh ventilated houses with no glass panes, the need to hunt for meat?"[2] What Dodge saw as a beautiful life, however, some Taos locals saw differently. In a letter to the *Taos Star,* an angry veteran of fourteen World War II battles tackled Dodge's arguments only a few days after they appeared: "My name is J. R. Martinez," he began. "I was born at Taos Pueblo and I live at Taos Pueblo. How would you like to exchange places? Say I live at your house, you live at mine. You can have all the horse[s] and buggies you want and I'll have your nice new cars. You drink muddy water which came down from the mountains . . . and my five children will drink nice clean water from your faucets." Martinez argued that maybe Dodge herself had caused members of Taos Pueblo to look toward modern conveniences. "Maybe since you moved to Taos 30 years ago and married one of our people, you have made us think how much better it is to ride in an automo-

bile than a horse and buggy. Maybe you are the one to blame for what you say is the 'end of Taos Pueblo.' You have to understand that we are humans and want to live like human[s], not like animals . . . we are tired of being fed by you writers and artists, with peanuts . . . Mrs. Dodge," Martinez concluded. "Take your peanuts somewhere else. We have quit being monkeys at Taos Pueblo, we are men now."[3] Martinez may have been the only one who held such a view, but the paper's decision to print his letter along with one from an Anglo woman expressing similar views suggests that in the eyes of at least some Taos residents, Lujan was a trained monkey who "played Indian" for Dodge's benefit.

Placing Lujan in the story of Dodge's years in Taos is more difficult than placing any of her other guests. As a native of one of the oldest settlements in the area, he had greater claim to northern New Mexico than any of the other figures in this story. Nonetheless, his uncertain place in the hierarchy of power in Dodge's household makes his the trickiest story to tell. Lujan was functionally illiterate. He left no correspondence or published writing. Although he appears repeatedly in the photographs and literature created by Dodge's guests, he did not create any art or literature of his own. He appears in Dodge's own writing again and again as a voice of the land. In her vision of Taos, he understood the climate, the agriculture, the animals, the mountains, and harmonious ways of living with the natural world. But, as Lujan's nephew Alfred Lujan reminded me: "That's her story."[4]

What was Lujan's place? What is his story? Was he a man smitten with the lively, if difficult, Dodge? Was he a teacher and gentle guide who taught one woman and her illustrious guests to appreciate the natural world of Taos, New Mexico? Was he a wronged subaltern, who could only fantasize about a day when "dark people" rose up to challenge the power white people held over them? Was he Dodge's pet, a man who served as an accessory to the public presentation Dodge showed the world? Did every photograph and literary allusion to him and the Taos Indians whittle away at his power until he was merely an empty vessel for the fantasies of visiting white modernists? Or did he challenge Dodge, like he is said to have done that night in Santa Fe, noting the benefits his knowledge and local identity had brought her, demanding a say in how their relationship and his public persona would develop? Although he is ever-present in the documents that chart Dodge's years in Taos, his is a muffled and perhaps even imagined voice. How he felt about his years with Dodge is almost entirely impossible to uncover.

Given how highly mediated accounts of Lujan are, I was tempted initially to write as little about him as possible. Then an uncomfortable irony revealed itself. Were I to avoid writing about Lujan, he would remain a cipher, fulfilling the stereotype of the "unknowable Indian" Dodge herself and others had perpetrated in their depictions of Lujan. Moreover, as I thought more about the history of Lujan, I realized that all of my sources are mediated. Although Dodge could be a fickle and flighty person, her correspondence and published writing present her as a woman moving smoothly from a life of excessive modernity to one of organic simplicity. Although Collier's relationships with indigenous people were driven by his own assumptions and priorities as much as his desire to help others, his writing presents him as an unflagging servant of those in need. Although Otero-Warren appears to have sacrificed the real needs of Nuevomexicanos in favor of a distorted romantic vision of New Mexico, her career in public service and her devotion to bilingual education suggest that she did so with a sincere desire to help her peers. Even Van Vechten, whose breezy style might suggest that he had no desire to be taken seriously, so thoroughly masked his intentions that it is almost impossible to assess what impact he intended to have. Why then exclude Lujan from analysis? Sources document his participation in Dodge's household. They suggest some of the impact artistic and literary modernist movements had on the people and the land of northern New Mexico. Although it is easy to dismiss him as Dodge's pet or to embrace him as her romantic soul mate, it is much harder, and much more necessary, to recognize Lujan's common humanity and modernity. Lujan too has a place of his own. Despite how often Dodge and some of her guests may have treated him as one, he was not a character. He, too, was seeking his place in Taos.

The first possible role one can consider for Lujan is the one Dodge ascribed to him: translator of the natural world. Dodge's private letters and musings are relatively silent on her relationship with Lujan, but her public writing constantly brought her sense of place together with Lujan. In her memoirs and books published in the early 1930s, Dodge frequently celebrated the beauty she saw in the landscape, but only when Lujan had introduced her to a particular place or when he was present. Particularly in *Winter in Taos*, arguably the best of Dodge's published writing, Lujan continuously serves as Dodge's entrée into the Taos landscape. He guides her through the Taos mountains, picks her flowers, teaches her to appreciate the moon, and calms her when a winter storm threatens. In her public work, at least, the

land was as much Dodge's lover as Lujan, and together they successfully wooed her. Anyone who questioned Dodge's presence in New Mexico had only to look to this love story between Anglo, Pueblo Indian, and the land, to find Dodge's response.[5]

Reality, of course, was a bit different than Dodge's memory. Where *Winter in Taos* carried Dodge snugly through a winter's day, complete with jam preserves, sleigh rides, and fond recollections of previous seasons, the real winters in Taos made Dodge decidedly uncomfortable. Most of her correspondence with Mary Austin over the winter of 1923–1924 involved her hope that Lujan would choose to spend winters at Croton. She begged Austin to join them in the hopes that Austin's presence would make Lujan feel more at ease. "Please be prepared to come out next Wednesday P.M. & stay for Thanksgiving dinner. I count on you to help acclimatise [*sic*] Tony so he will stay contentedly & so that I may therefore stay," she explained.[6] Lujan's precise feelings about Croton never appear in Dodge's letters, but he delayed coming to Croton in fall 1923, pleading that his crops kept him in Taos. Dodge frequently found Taos enchanting, but her struggle with Lujan over where to spend winters suggests that not every winter in Taos was as serene as the one she portrayed in her writing.

Whatever private disputes existed between Lujan and Dodge, though, remained private, and visitors came away with the impression that Lujan had an unimpeded and special relationship with the Taos landscape. Willa Cather, who stayed briefly in Dodge's house, may have based the character of Eusabio in *Death Comes for the Archbishop* on him. Cather wrote that "traveling with Eusabio was like traveling with landscape made human."[7] Shortly after Van Vechten's trip to Taos in 1927, he attributed his pleasurable moments at Dodge's house to "Tony who makes a beneficent atmosphere." Almost all of Dodge's visitors specifically remembered Lujan in their closings, and frequently asked for his opinion about them. To know Lujan was to know the place, and Dodge's friends desperately wanted a connection to the place. A full twenty years after Dodge had settled in Taos, conductor Leopold Stokowski summarized the opinions of many of her friends and guests:

> I feel that Taos is one of the great magnetic centers of the world. . . . I feel confident that some individuals will carry along the sacred fire at Taos. One sees how in Benares, Athens, Egypt, Peiping, Rome there are still a few individuals who carry within them the spirit of these places when they

were at their height. Perhaps it is too much to expect great numbers of people to hold this spirit. Perhaps the sacred fire will always be carried by a few individuals. Tony is one of these.[8]

Lujan, no doubt, did know Taos well. Nonetheless, the comments of Dodge's visitors suggest that they saw Lujan as Taos embodied.

Did Lujan see himself in the same terms? If we take Dodge at her word, he did. Upon his first visit to Dodge's house in Taos, he told her that the fire spoke to him. He told Dodge that fire was "alive. He feel. He is my friend. I know what he say." When Dodge asked if the fire understood Lujan in return, he replied: "Of course. Natcherel!" [9] When Lujan first showed her the property that she would buy in Taos, he said: "The field and the apples go with this last house. That why I like it."[10] In Dodge's memoirs, Lujan regularly criticizes white people for their acquisitiveness and their distance from the places they live and the food that they eat. When, shortly after meeting him, Dodge praised the sparseness of his home, he replied: "White people have *things,* but God give the Indians just what grows on the mountains. . . . God give white people things and Indians watch them go under them. You know. Wheel turning. . . . So many things carry the wheel down, with the white people underneath. Pretty soon Indians come up again. Indians' turn next."[11] If the real Lujan shared these sentiments, which Dodge ascribed to him in her memoirs, then he did identify with the land and he did see it as his role to teach white people the errors he saw in their way of life, particularly in their relationships with nature.

Perhaps because, among Dodge and her friends, intimacy with Lujan meant intimacy with the countryside, many of Dodge's female guests commented more openly than they might have otherwise upon their attraction to him. In *Lorenzo in Taos,* Dodge remembered her and Lujan's first meeting with D. H. Lawrence and his wife, Frieda. Dodge wrote: "The Lawrences seemed to be intensely conscious of Tony and somehow embarrassed by him. I made out, in the twinkling of an eye, that Frieda immediately saw Tony and me sexually, visualizing our relationship."[12] Dodge may have imagined Frieda's reaction, but Frieda did comment on Dodge's relationship with Lujan. She seemed to covet Dodge's connection to the Pueblo community more than she did any personal feeling between Dodge and Lujan, and years later she wrote bluntly that "had Tony & the Indians been my show, I would have gone Indian whole hog."[13] Frieda Lawrence expressed a primitivist pull

toward Lujan, but other women confessed a more physical attraction. Shortly after Lujan had passed through Chicago on a trip east, Lucy Collier, John Collier's wife, wrote about how compelling she found him. "Seeing Tony in the office yesterday cut the dreariness of Chicago like a thunderstorm on a humid day. How do Indians vitalize the atmosphere?" she queried, but then hurried on:

> I could hardly bear to let Tony disappear. . . . It is strange—because I do not feel any sex or personal pull to Tony—I don't want to possess him or impress myself upon his personality—I only want to have my being in the atmosphere he creates. Of course there is one strong personal pull—With Tony as with no other human being—all that is violent—combative in me fades out—In that sense I feel a warm flow and support rapport with him—and yet it's all utterly impersonal. Well! He is the only element in another's life I have ever really envied—of all your gifts and rare opportunities I feel he is the real enduring one—[14]

Collier's protests to the contrary, she appeared to find Lujan sexually attractive, an attraction compounded by her perception of Indians as inherently spiritual and calm. Few of Dodge's visitors expressed their fascination with Lujan as openly as Collier did, but the frequency with which he appeared in their correspondence and their art suggests that Collier was not the only individual who envied Dodge her marriage.

Indeed, Lujan's most lasting imprint on the archival record is his image. Lujan regularly posed for photographs. A tall, dignified, and attractive subject, Lujan looks out from myriad photographs by eminent photographers including Ansel Adams and Edward Weston. His gaze is usually to one side of the viewer, and he generally looks composed. Dodge used his image frequently in her published works. Of the sixteen photos that comprise the illustrations in *Winter in Taos,* thirteen are landscapes and only three include people. One, by Van Vechten, is of an unidentified Taos girl, a second, titled, "Going Fishing," is of Dodge and Lujan with fishing gear, and the third is a portrait of Lujan, wearing a tie and a Pueblo blanket draped over his forehead. In the book, Lujan is the only named Taos Indian who receives a place alongside the land in the images meant to convey the spirit of Taos to Dodge's readers. Not only did Lujan's relationship with the physical world attract Dodge and her friends, so also did his physical self.

That Lujan held both spiritual and physical attraction for her female
guests became cause for concern for Dodge in the summer of 1929. Dodge's
doctor found fibrous tumors in her uterus in June, and she returned to Buf-
falo in July for a hysterectomy. Her distance from Taos, along with the emo-
tional turmoil brought on by the operation, left her highly vulnerable. When
word came that Lujan was sleeping with his first wife, she fell into a spiral of
suspicion and despair that no amount of reassurance from home could dis-
pel. She grew suspicious even of her own guests, and, increasingly, her accu-
sations fell on artist Georgia O'Keeffe, who, at Dodge's invitation, was
spending her first extended stay in New Mexico at Dodge's house. Dodge con-
vinced herself that O'Keeffe had seized upon her absence to pursue an affair
with Lujan.

Even when her other friends attempted to defend O'Keeffe, Dodge's suspi-
cions did not fade. A year later Dorothy Brett was still assuring her that the
greatest intimacy O'Keeffe and Lujan shared was friendship. "This is all about
Georgia," Brett wrote in 1930, affecting a labored tone that suggested this was
not the first time she and Dodge had gone over the matter.

> I feel somehow that you haven't got the right hunch about her. She isn't a
> vamp, she isn't a snatcher, or any of these things. . . . She has all her life
> sacrificed a great deal for her painting, and she has an enormous zest for
> life, that zest has been transmuted to paint, but she still has it, much as
> Lorenzo had it, and most of it went to Stieglitz. It is that that swept her off
> her feet last year, just that zest, going out to life; she didn't vamp Tony, he
> was part of a great new experience, part of life, and when Georgia goes out
> to life she goes out with all sail on.[15]

Brett, for all her kind words, probably did not help matters. Over the sum-
mer of 1929, Dodge was threatened not only by O'Keeffe's proximity to Lujan
but also by the deep connection O'Keeffe felt with the New Mexico landscape.
Whereas Dodge had previously been able to claim a connection to Taos as a
home through Lujan, now O'Keeffe threatened to seize that connection both
through her relationship with Lujan and through her ardent love for the
place. That Brett celebrated O'Keeffe's devotion to her work and her zest for
life probably made Dodge even more uncomfortable when she compared her-
self with her imagined rival.

Unwittingly, O'Keeffe fed Dodge's suspicions with glowing letters about

her days in Taos. Lujan had, at Dodge's insistence, taken Rebecca Strand, wife of artist Paul Strand, and O'Keeffe on several horseback rides and a camping trip, and both women had formed a strong liking for him. After a particularly pleasant outing, O'Keeffe wrote Dodge, "As for your Tony, I feel like saying, I take off my hat to him. If he were mine, and had gone through these days with someone else as he has with us, and I could watch every detail of it, I would be very proud of him. I can not tell you, no I can not tell you at all, you must know without my telling, it is a rich, rare thing, a great trust you have."[16] Dodge had shared some of her fears of Lujan's infidelity with O'Keeffe (though not her specific fears about O'Keeffe herself), and O'Keeffe intended her letter to allay Dodge's anxiety. She even closed by insisting that Dodge "must feel right about Tony." O'Keeffe's own warm, enraptured accounts of her days with Lujan, though, only exacerbated Dodge's fears.

The more O'Keeffe defended Lujan, the more Dodge convinced herself O'Keeffe had betrayed her. O'Keeffe's rich, sensual letters about the landscape worsened Dodge's worry. In one she described her recent horseback riding trips with a member of the Pueblo named Pete. "We rode till after nine both nights—grand starlight after sunset—I didn't ask if I could ride your horse. I just started, and it seems the first time I have really felt close to the sage brush and hills and little trees—close till I hugged them like I hug you sometimes. . . . I really had a wonderful time."[17] That O'Keeffe was having a wonderful time riding Dodge's horse on midnight adventures during which she "hugged" the land hardly put Dodge's fears to rest.

Dodge's anxieties over O'Keeffe expanded to encompass her connections to Taos. One of her guests wrote her in late June to assure her that she should harbor no fears about her connections to Taos. "Do not feel afraid of anything. This place *belongs* to you, & you can be happy in it. I don't really think that the Pueblo is hostile; not as a body. I think the influences are more in the place itself. You need to make a centre in it."[18] Whether Dodge's fears stemmed from her concern over her relationship with Lujan or from some conflict with the Pueblo is unclear, but there is no question that she spent the summer of 1929 anxiously mulling over her relationship with her husband and whether she belonged in Taos.

Dodge's anxiety suggests that Lujan may have had more power in his relationship with Dodge than is immediately apparent. Lujan may have posed for photographs at Dodge's request, and he may have served as chauffeur and tour guide for her many guests. He may also have become dependent on her

for the luxuries she provided him such as expensive boots and the cars that
were so vital to their explorations in the countryside. Nonetheless, he appears
to have chosen his own friends among her visitors and to have chosen his
own sexual partners. Dodge biographer Lois Rudnick notes that Lujan not
only slept with his first wife after his marriage with Dodge, he also briefly had
an Anglo mistress in Carmel during the 1930s and a Nuevomexicana mis-
tress during the 1940s and 1950s.[19] Dodge's wealth had bought her the free-
dom to choose her sexual partners, a freedom many women did not have at
the time. Nonetheless, even while Lujan was tied to Dodge inequitably, she
had little control over his sexual behavior.

Lujan's infidelities suggest that he used Dodge for her connections and
wealth, but his affection for her appears to have been sincere. It is worth re-
membering that he pursued her avidly in their courtship. Dodge may have in-
tended *Edge of Taos Desert*, the volume of her memoirs that records her arrival
in Taos, as a love story. It records their first meetings, their longing for one
another when Lujan visited New York with one of Dodge's friends, Lujan's
first present to Dodge—a scented pouch she wore inside her dress, and their
ultimate decision to leave their respective spouses so they could be together.
In the book, Dodge notes that she not only dreamt of Lujan's face before visit-
ing New Mexico, but that he had dreamed of her as well. Dodge concludes the
book by repeating the conversation in which they committed themselves to
one another: "'Tony! You know if we come together now there's no turning
back. Do you feel that?' 'Yes.' He nodded. 'I know this not play. This for-
ever.'"[20] Throughout *Edge of Taos Desert*, Dodge reconstructs Lujan's language
in a dialect that emphasizes his otherness. Nonetheless, this particular ex-
change suggests that, at least in Dodge's memoirs, Lujan wanted their mar-
riage as much as she did.

That Lujan made significant sacrifices for his marriage to Dodge suggests
that she did not entirely imagine his commitment in the pages of her pub-
lished writing. Because of his involvement with Dodge, Taos Pueblo banned
Lujan from its more private ceremonies. Lujan's nephew, Alfred Lujan, told
me that Tony Lujan was "ousted" from the Pueblo because he had left his first
wife.[21] Dodge may have believed that she had become the ultimate insider
when she married Lujan, but several members of the Pueblo believed instead
that she had transformed Lujan into an outsider. The people of Taos Pueblo
were not in a position to tell Tony Lujan what he could and could not do in his
personal life, but they were in a position to control Lujan's access to Pueblo

events.[22] The community reaction clearly did not favor the match, and Lujan suffered as a result. Lujan, however, persevered, and he and Dodge remained married until her death in 1962. His does not appear to have been a passing attachment.

Glimpses of Lujan's own wishes, then, appear in his marriage to Dodge as well as in his infidelities, but his will is most apparent in the role Dodge and Lujan played in the Taos community. As wealthy residents, the two employed many members of the local community. As connected political actors, the two played an ongoing role in Indian affairs. As an interracial couple from dramatically different backgrounds, the two provided wanted and unwanted guidance for local people negotiating the spaces where Anglos and native people interacted. Repeatedly, Lujan and Dodge both helped and hindered the people of Taos as the community negotiated its relationship with the modern world.

Of course Pueblo people had been engaged in such negotiations for hundreds of years. Pueblo people had encountered Spanish colonists as early as the sixteenth century, and members of Taos Pueblo had participated in regular trade and political negotiations with white settlers from the United States beginning in the early nineteenth century. Dodge certainly believed that the people of Taos Pueblo lived in an authentic, unchanging, primitive world, but Taos Pueblo had been negotiating the changes that accompanied newcomers for hundreds of years. Whereas Dodge saw the modern world in skyscrapers and mechanization, however, members of the Pueblo and other local Taoseños often saw Dodge herself as a symbol of the modern world. Her rapid trips back and forth across the country, her cars, her assumption that she could communicate with her widespread circle quickly and efficiently, her connections to patrons who paid handsomely for Indians' art, and even the tourists who followed in her wake were all symbols of what modernity meant in northern New Mexico in the 1920s and 1930s. When people in the Taos community and members of Tony Lujan's family looked to Dodge for employment, transportation, money, medical advice, patronage, and aesthetic judgment, they were making short-term decisions about their lives, but they were also deciding how they were going to live in the modern world. Lujan was a critical negotiator between Dodge and local people, and, as such, he was one of the intermediaries between Taos locals and what they saw as modernity.

Throughout these negotiations, Lujan appears to have had some influence in his marriage and his public presentation of himself. Some members of the

Pueblo appear to have seen Lujan's role similarly. Twelve years after Dodge's and Lujan's marriage, Taos Pueblo's *cacique*, a religious and political leader, welcomed Lujan back to the Pueblo. As the cacique gave his long-delayed blessing, he attributed the changes in Lujan's life to God's will. "God has done this. He sent you the white woman so we would send you away, because on the outside you could do so much more for us, but now since you have labored so well, God has sent you back to us and we receive you with great joy."[23] Although Lujan and Dodge lived less than twelve miles from Taos Pueblo, Lujan's association with Dodge, Collier, and her other guests had taken him to the "outside." When he had an opportunity to return to the Pueblo, he did so with every intention of helping his peers, and some of them, in turn, recognized the contributions he had made.

Dodge and Lujan probably made their greatest contribution to Taos as employers. Juan and Jimmy Suazo, nephews of Tony Lujan, credit Dodge and Lujan with giving jobs to members of the Pueblo as well as to "Spanish people" who performed agricultural and construction work on land Lujan and Dodge owned. Alfred Lujan recalls that a number of women from the Pueblo, including his mother, a sister-in-law to Tony Lujan, performed housework in Dodge's and Lujan's house. Juan Suazo believes that Nuevomexicanos and Native Americans in Taos today understand the benefits Dodge and Lujan brought as employers. "They know how it is, you know, when you're poor— it's really hard," Suazo observed. Dodge and Lujan, in his opinion, "just put [locals] to work to help their families and talk to them about their problems. That's how they were, helping." As Alfred Lujan responded when I asked about the wages Dodge and Lujan paid, "At that time money was good."[24]

Dodge and Lujan were a source of income in a financially strapped area, but they were not the only source of income. When Lujan employed Nuevomexicano and Taos Pueblo people, he sometimes paid his agricultural laborers with a portion of his harvest.[25] Alfred Lujan was more critical of his uncle when he remembered Lujan's and Dodge's payment in goods. Alfred Lujan recalled that when Dodge bought a threshing machine, his father, Tony Lujan's brother, worked the machine but was not given a portion of the grain. When Taos Pueblo bought its own machine, Tony Lujan's brother began working for the Pueblo instead because it was more profitable. Alfred Lujan also recalls a Pueblo woman who performed housework for Dodge but was unhappy with her position. When the wealthy Standard Oil heiress Millicent Rogers arrived in Taos and began looking for household help, the woman left

Dodge's house to work for Rogers.[26] Locals certainly saw Dodge and Lujan as potential employers, and therefore as assets to a community where wage work was scarce. As participants in a wage-labor system, however, Dodge and Lujan were not unique, and the people of Taos used the same methods to challenge their employers as did other wage laborers elsewhere in the country. Lujan may have been a frequent employer, but that status did not protect him from criticism from members of the Pueblo or the town of Taos.

Negotiations over wage labor, although certainly well established in Taos by the time Dodge arrived, were one of the ways the people of Taos responded to what seemed to be a rapidly modernizing world. A modern convenience far more prevalent in the memories of Lujan's niece and nephews, however, was Dodge's car. Jimmy Suazo, Juan Suazo, Alfred Lujan, and Gilbert Suazo, governor of Taos Pueblo at the time of our conversation, all stressed in their interviews how rare automobiles were in Taos at the time Dodge arrived, and how novel and helpful Dodge's car proved to be for the Pueblo. Tony Lujan regularly drove and repaired Dodge's cars, and almost all of her guests remembered that he had served as a chauffeur during their visits. Lujan also employed his relatives. Jimmy Suazo, his brother Lupé, and Alfred Lujan all drove for Dodge, an occupation that not only brought them wages but often allowed them to take advantage of the transportation Dodge's cars offered.

Dodge's car and Lujan's driving were also critical during the Bursum bill struggle. Remembering what he had heard of Dodge's earliest days in Taos, Alfred Lujan recalled, "At the time the tribe had no transportation whatsoever. They had no bank accounts or any kind of things they have today. She helped a lot by transporting the delegates to Albuquerque, Santo Domingo, and so on." The Suazos similarly remember that Dodge's car was vital in the Pueblos' protest of the Bursum bill.[27] Contemporary observers particularly noted Lujan's role as driver. One wrote the commissioner of Indian affairs in 1924 that Lujan had been criticizing him at Santo Domingo and then had "crossed the river to Cochiti, delivered his message, and like Paul Revere of old, rode on to San Felipe, Sandia, Isleta, and possibly Jemez to spread the news."[28] Members of Tony Lujan's family seemed to place her car almost in the same light as they place John Collier. Both were vital to the Pueblos' influence on federal political relations, and both came into regular contact with the Pueblo via Mabel Dodge and Lujan.[29]

As sources of employment, transportation, and political contacts, Dodge and Lujan had a modernizing influence on the entire community of Taos, but

they also had a specific influence on the lives of their individual family members, particularly in the realm of education. Tony Lujan, for example, discouraged his nephew Alfred Lujan from attending school, insisting instead that Alfred remain in Taos to do agricultural work.[30] Alfred Lujan was certainly not the only young man in the 1930s who vacillated between performing agricultural work at home and pursuing an education away from his family, but for him, Tony Lujan became a central figure in the choice. Tony Lujan might have been influenced in his opinion by the experience of another of his nephews, Tony Archuleta. Archuleta wrote to Dodge and Lujan throughout his life, beginning with his experiences in the mid-1920s in boarding school at Santa Fe. Early in his education he explained in a letter to Dodge and Lujan that Indian students were punished if they spoke their native languages. "And one thing about school," he told Dodge and Lujan, "The school children do not talk Indian. When anybody talk Indian work in school house for one week. I am afraid to talk Indian."[31] Lujan may have had less influence over Archuleta's educational choices than he did Alfred Lujan's, but in both cases he was a source of information and opinion for the two young men about how to balance the demands of their life at the Pueblo with the contingencies of increasing Anglo influence.

Archuleta not only consulted Lujan and Dodge regarding his education but he also consulted them on matters of health. By the mid-1930s, Archuleta was suffering from tuberculosis, and he sought treatment in Santa Fe and Albuquerque. At one point doctors recommended an operation, and Archuleta mulled over whether to agree to the procedure. He believed his parents and Tony Lujan would not approve of the operation, but over time he became convinced of its necessity, and appealed to Dodge to convince his family to approve it. "I want you folks to act now and talk it over as I want to accept the ribs operation as soon as possible," he wrote her. "Nothing can be done without you knowing it. I have to see you first as I love you all and am anxious to get well so I can be with you. Of course I know Uncle would object and disagree about this ribs operation, same way with my dad and the rest. But at the same time how glad you would be when you see me get well."[32] Archuleta never mentioned what his family's objections to the operation were. Nonetheless, his appeal to Dodge to mediate with his family suggested that the household Dodge and Lujan had built together was one of the places where members of the Pueblo could discuss the hazards and benefits of Western medical care.

Because Lujan brought members of the local community, particularly members of the Pueblo, the benefits of employment, transportation and conversations about medical care, one might assume that he followed Dodge's wishes and successfully brought her into the Pueblo. None of Lujan's family members remember her in that way, however. Alfred Lujan, who has read Dodge's books *Edge of Taos Desert* and *Winter in Taos,* recalled that "she said in her stories how she came here and found Tony. And then she felt that this is it. This is my place. This is where I belong. That's her story." Lujan, however, was careful to point out that the story was Dodge's, not necessarily his own or that of other people from the Pueblo. Although Dodge made a point of distinguishing herself and other artists in her circle from members of the Taos Society of Artists, Alfred Lujan links her to the society in his memories. "She had really, really, special particular persons that were really good to her like the Art Society people," he remembered, "like . . . John Hunter, and the old artists, like Higgens the old time artists . . . those were her best associates."[33] Dodge may have seen Taos as the place where she belonged, but Alfred Lujan saw her role differently and was careful to point out that Dodge seemed to belong among the Taos Society of Artists, not in Taos as a whole or in Taos Pueblo.

Even the Suazos, who remember Dodge and Tony Lujan warmly, drew a distinction between the contributions Dodge made to the community and her membership within it. When I mentioned that some historians believe Dodge was "trying to be an Indian," and I asked if they believed that she was "trying to be an Indian," all of them responded "No." Instead, Jimmy Suazo stressed that Dodge loved the land and culture in northern New Mexico. "What she saw in Taos: the mountains, the people, the culture, the three cultures, Indian, Spanish, and then there's some mixed you know . . . she liked that. When she saw everyone get together, like in parties, you know, when she saw that, she liked that. And then like I said she fell in love with our grandfather [Tony Lujan]. I think mostly it was . . . our culture, what she saw . . . she liked that and the land." Jimmy Suazo spoke fondly of Mabel Dodge, but he also drew a distinction between her "trying to be an Indian" and her loving the place, his uncle, and the diversity of cultures she found in Taos.[34] Tony Lujan's family was willing to see Dodge as a contributor to the community, as a local enthusiast, and even as a family member, but they do not appear to have seen her as a member of the Indian community.

Lujan himself never appears to have told Dodge she had "become an Indian" or was "like an Indian." Indeed, he seems to have relished their

differences and enjoyed the challenge of reeducating Dodge according to the values that he thought she wanted to acquire. When, at the end of *Edge of Taos Desert*, Dodge and Lujan commit to one another, Dodge insists that Lujan cease using peyote. Ever since a disastrous "peyote party" she hosted in New York, Dodge had feared the drug, and did not want Lujan to use it even for religious reasons. Lujan responded to her plea: "'I guess you not makin' a bargain with me,' he replied as though announcing a fact. 'No. We not makin' a trade together. I always goin' to do things because that help you, make you happy, make you feel life good. You goin' to do the way I want because you want to make the life good. No need to bargain, us!'"[35] Dodge admitted she was ashamed at Lujan's reply. She was asking him to make a sacrifice, when she was not willing to sacrifice anything in exchange. Lujan, ultimately, did give up peyote at Dodge's request, but his reply to her demand is interesting because he does not promise her everything she wants. He promises instead to aid their relationship by doing things that "help" her and make her "happy." By doing so, he suggests, he will make their life together "good." He never promises to bring her into the Pueblo. He never promises to make her into an Indian. Indeed, if anything, her writing suggests how distant from Indian life she seemed both to herself and to him. Lujan appears to have genuinely loved Dodge, but he also appears to have been most inspired by their differences, not their similarities.

Lujan offered Dodge a link to the Pueblo life she could never completely have. Upon hearing Jimmy Suazo's list of the attractions Dodge found in Taos, Gilbert Suazo responded: "She probably would have liked Taos for all the reasons that Jimmy has given but that in itself might not have been enough to keep her here. She could always have come back to visit but the fact that Tony was here, that's what kept her here. I guess my perception is that if it weren't for Tony she probably may not have stayed as long as she did," he told me. "Tony was the influence that kept her in Taos. If it weren't for Tony she probably would have moved away again." Dodge completely dedicated herself to Taos. She gave the area the bulk of her resources and devoted her peculiar talents for assembling prominent artists and writers. Were it not for Lujan, it is likely that she would not have done so. In that lay Lujan's influence in his relationship with Dodge and much of his power in the community.

What was Lujan's place? He was a farmer, an employer, a chauffeur, a political activist, a messenger, and a family leader. He was an adulterer, an erratic boss, a kept man, a political naïf, and a fearful traditionalist. He was

Dodge's companion and betrayer. He was her teacher and her pet. Reading his reported words in his fight with Dodge that night in Santa Fe, it is difficult not to feel sympathy for him. Dodge was clearly not an easy person to know, let alone marry. Moreover, she turned his words so quickly to her own advantage that it is impossible to tell if one hears his voice or hers.

A few years later, though, she repeated his words again. Following Van Vechten's visit to Taos, Lujan sent him a letter to apologize for failing to show him Taos at its best. He had been sick during Van Vechten's visit, and had been unable to serve as host. Dodge transcribed his words with her typical rendering into Hollywood dialect. "We are very busy around here working, planting all kinds of things," Lujan, ever the watchful farmer of an arid land, explained. "We still have lots of snow. . . . Wish you'd been a little bit longer round here, you didn't see much. . . . I remember we once had a good time with you & your wife in Harlem. Sometime again I go to New York & I'll see you again. I don't know when."[36] In brief, Lujan had summarized the source of his authority in his relationship with Dodge, in their household, and in Taos, and he had done so in a letter to Dodge's most sharp-tongued rival and peer. As a farmer, Lujan knew the land and the seasons. He saw it as his place to educate Dodge's visitors in how to pay attention to both. As a local, he had repeatedly shown Dodge's guests the best side of Taos and the region. He knew, had he been healthy, that Van Vechten's visit would have been different. Finally, he knew that he was Dodge's tie to Taos. Someday, he might return to New York to visit, but his home, and therefore Dodge's home, was in Taos. Dodge might have written Lujan's words, and she might have even made her power known by recording his faltering syntax. The words themselves, however, suggest that Lujan was aware of the opportunities and restrictions that came with his position in Dodge's life. Whether Van Vechten came again to New Mexico or whether Lujan returned to New York, Lujan's place in Taos was secure.

Mary Austin's Place

When Dodge still lived in New York City and held her salon, long before Lujan solidified her connections to the Southwest, she visited El Paso with her lover John Reed. Reed journeyed to the region to cover the Mexican Revolution, and Dodge, seemingly blind to the chaos the revolution had brought to the U.S.–Mexico border, decided to join him. She did not enjoy the visit. She found the area dusty and boring, and its art incapable of brightening her mood. While Reed dove into Mexico and eventually shadowed Pancho Villa, Dodge returned east. As she wrote to Van Vechten, "I'm afraid the West is a man's world and that woman's sphere is in New York."[1]

A decade later, Dodge's opinion had changed dramatically. Her participation in the campaign against the Bursum bill, her collection of local Nuevomexicano and Pueblo art, her struggle to force Van Vechten to admit the appeal of New Mexico, and her relationship with Tony Lujan all showed her commitment to the region and the power of her claim that she belonged in Taos. Dodge had made Taos her realm, in part through her house, a place many at the time would have considered a "woman's sphere." Dodge, with typical exuberance, made her house large and extravagant. She bought property and began construction less than a year after arriving in northern New Mexico, and she acquired seven other homes over the next four decades. She oversaw the construction or renovation of most of her houses herself, and she sited several of the structures on the property she had first purchased in Taos. During most of the construction she remained in the house Lujan and his crew had built for her in 1918. With its eclectic collection of Italian chaise lounges, New York avant-garde art, and Nuevomexicano santos, Navajo rugs,

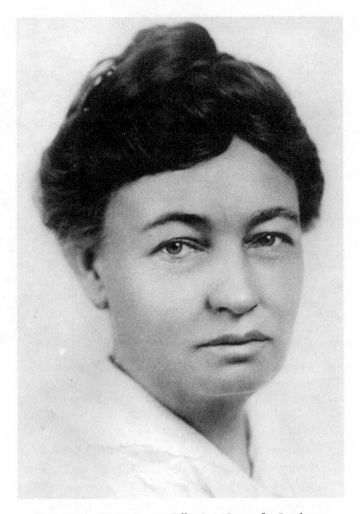

Mary Austin. (T. M. Pearce Collection, Center for Southwest Research, University Libraries, University of New Mexico, Albuquerque.)

and Pueblo pottery, the house made a comfortable headquarters from which to plan further building. By 1926, the new houses included five structures Dodge and her friends called the Tony House, the Pink House, the Two-Story House, the St. Teresa House, and the Young-Hunter house. By the time Georgia O'Keeffe came to visit in 1929, Dodge had also added a studio, a place she eagerly promised to visiting artists. Control: obey nature

Ernest Knee, *Taos Mountains*, 1938. Dodge reproduced *Taos Mountains* for her book, *Winter in Taos*. She captioned the photo "From My Window," suggesting her strong attachment to the view of the landscape. (Courtesy of the Ernest Knee Photographic Trust.)

Dodge counted her greatest successes, though, when her visitors began to call Taos home. She encouraged artists and writers to see Taos as the place they belonged by including sprigs of sage in her Christmas cards, a small gift that made her guests recall the Taos mountains.[2] If the smell of the high desert did not prompt visitors to return, Dodge counted on her descriptions of the landscape and the comforts of her house. She wrote to everyone of the glowing aspens and the clear air, promising peaceful mornings for concentrated work and lively evenings for scintillating discussion.[3] When successful, Dodge inspired attitudes like that of her old friend theater designer Bobby Jones. Although he spent only two winters in Taos, he wrote Dodge longingly, "It is time Mabel, dearest Mabel, that the halcyon days should come again for all of us who feel what the word halcyon means, and should stay for ever and ever without end amen."[4] When struck by a particularly haunting landscape in Europe, Jones would write Dodge a postcard that said, simply, "Taos?" In

less poetic moments Jones expressed the sentiments of many of Dodge's guests and wrote that he was homesick for New Mexico.[5] Jones was in good company. Russian artist Nicolai Fechin, who visited in 1927, established a home there. He shared his first visit with members of Alfred Stieglitz's circle, Paul and Rebecca Strand. The two later separated, and Rebecca Strand, renamed Rebecca James, eventually settled permanently in the area. Leo Stein, on his first visit, considered buying a house in the area, and called the country "good medicine." [6] Mary Foote, a portrait artist who had known Dodge for years, spoke continuously of her yearning for Taos and called returning to it "coming home."[7] Even Mary Austin, who rarely shared credit for any of her decisions with anyone, attributed part of her decision to live in northern New Mexico to Dodge's home in Taos.[8]

Indeed, even more than Dodge, Austin strove to make of northern New Mexico a "woman's sphere." Originally from Illinois, Austin had migrated with her family to California in the late 1880s. There, she had met her husband and moved to the Owens River Valley. She found herself captivated by the landscape, and it led her to write her first book, *The Land of Little Rain*. After she and her husband divorced, Austin endured a peripatetic existence as she searched for a literary life and livelihood. While working in New York, she befriended the author Willa Cather and participated in Dodge's salon. Austin was one of Dodge's early visitors in Taos, but when she decided to settle permanently in northern New Mexico herself, she chose Santa Fe.[9] Austin began building her home in September 1925, and it too hosted the foremost artists and writers of the day. A large collection of Pueblo pottery, jewelry, and Nuevomexicano santos soon adorned the walls and *nichos* (small niches in the walls where Nuevomexicanos often place art) of Austin's house, and she photographed the entire interior for posterity. That she cared deeply about her house was apparent in the name she chose for it: Casa Querida—beloved house.[10] Austin shared Dodge's pride in owning a home and hosting visiting artists, but she reserved her greatest satisfaction for the influence her house had on her as a woman writer.[11]

Indeed, as a woman writer Austin most fiercely defended the place she had chosen to call home. In spring 1926, Austin saw her refuge come under attack. The Texas Federation of Women's Clubs had proposed a summer chautauqua, alternately called a culture colony, in Santa Fe.[12] The federation proposed that Santa Fe artists, writers, and scholars offer seminars and lectures, and that the club women consider buying summer homes in the Santa

Fe area. Although not so different from Austin's own daily life in Santa Fe, the club women's plan rankled her. She threw herself into the campaign against it.

She was not alone. A large contingent of artists and writers contributed to an outcry that eventually defeated the endeavor, and scholars have suggested a number of explanations for the vehemence of their response. The plan was proposed at a time when alliances within Santa Fe's arts community were shifting, and the chautauqua was one of many casualties that resulted from the ensuing conflicts.[13] Many of the more recently arrived Anglo artists and writers may have seen the culture center as a threat to one of their causes: support for northern New Mexico's rural Nuevomexicanos as romanticized American folk. A culture center filled with Texas white women would hardly have been a conducive environment for fostering Nuevomexicano culture, particularly the idealized culture Anglo artists such as Austin had begun to champion.[14] This last reason may have contributed to the objections of two Nuevomexicano organizations in town as well.[15] Still other recent arrivals in Santa Fe may have recognized their tenuous status as experts on the region, and may have seen a large number of club women seeking education in Southwest culture as a threat to their claim as authorities on the area.[16] Finally, scholars have noted that many of the objectors to the center were sincere in their elitism. They truly believed their own interpretation of creative expression superior to that provided in more institutional environments, and they objected to a plan that stood to lessen Santa Fe's image as a center of bohemian and sophisticated creative endeavors.[17]

Although all of these factors were at play for Austin, what may have motivated her most were ideas about home and gender. In both her private and public life, Austin had claimed Santa Fe as her home, and she had consistently done so by noting how conducive the land and culture were to writers and artists. In the 1920s, the idea of home—even an artists' home—was completely intertwined with ideas about women's roles. Like Dodge and many of Dodge's female peers, Austin challenged many norms regarding women's behavior. She was divorced. She had not dedicated her life to motherhood. Her daughter, Ruth, had mental disabilities, and Austin had placed her in an institution until Ruth's death from pneumonia in 1918. Unlike Dodge, however, Austin did not have any independent wealth, and she struggled to support herself with her writing. She also gave considerable thought in her writing, her public announcements, and her patronage to the role of women in mod-

ern society. For her, the culture colony was threatening not only because it represented a different way of engaging art but also because it challenged the persona she had built for herself as a woman artist. The women who proposed the culture colony were not dissimilar from Austin herself. Austin may have feared that the distinctiveness of her identity as a woman artist would disappear in the atmosphere of cultural appreciation and summer seminars the colony's proponents endorsed. Austin's struggle against the culture colony reveals much about the meaning of the Southwest for white women who came to northern New Mexico to work as artists and writers. For many, Santa Fe and Taos appear to have acquired near-mystical status because these women believed there they could successfully be both women and artists.[18] Austin, Dodge, and other women in their acquaintance had found for themselves a woman's sphere in the West. It is hardly surprising that Austin was loathe to cede such a place.

The Texas Federation of Women's Clubs was a branch of the General Federation of Women's Clubs, the same federation that had proven unflagging in its support of Collier in his campaign against the Bursum bill. The Texas federation was involved in many of the general federation's endeavors, including child welfare legislation, education legislation, and the establishment of the first national art gallery, but the Texas branch also chose to focus on causes of particular interest to Texas area members.[19] Of special concern to the Texas federation women was a national campaign called the Better Homes Movement, begun in 1922 by a household magazine, which promoted home ownership, home maintenance, and home decoration. President Coolidge served as honorary chair of the Advisory Council of Better Homes in America, and then Secretary of Commerce Herbert Hoover helped form the organization and served as president of its board of directors.[20] Sally Katherine Martin of Dallas, a Texas federation member, was particularly involved in the Better Homes Movement.[21] She served as a representative of the Home and Community Committee of the American Farm Bureau, which participated in the Advisory Council of Better Homes. Martin also visited and publicized a better homes demonstration in Cleburne, Texas, and she broadcast information about the Better Homes Movement on Dallas radio stations. In addition to Martin's involvement, the Texas federation had an American Home Department divided into three sections called "Home Economics, Teaching, and

Thrift Education," "Extension," and "Home Making."[22] Elements of this last endeavor—home making—had particular resonance with ideas regarding home espoused by Austin and her peers in Santa Fe.

Overlapping the Texas federation's members' commitment to "home making" was their commitment to cultural and artistic expression. Reports from the federation Fine Arts Division showed the club women's interest in expanding the study of art, literature, music, and drama in Texas, supporting pageants, recitals, and exhibitions, and providing study programs on European, American, and Texan art. A central goal in all of these endeavors was to support home life through artistic expression. At the federation statewide convention, one Fine Arts Division report noted, "'Fine Arts' are great factors in the making of happy homes. What would home be without music and literature and art? These are the things that lift us out of the material, everyday existence into a finer, more spiritual atmosphere."[23] Meanwhile, the *Texas Federation News* argued that "art in the home brings beauty; presents personality; it embodies dignity and peace; it adds joyousness; it develops discernment and appreciation; it creates thoughtfulness; it introduces the presence of great minds."[24] In keeping with the bonds Texas federation members saw between the home and art, the Art Division and the American Home Department combined efforts to promote the purchase of sculpture and art by federation members' families, an effort the federation called "education by ownership."[25] Better homes meant zoning restrictions, home building, and home ownership to Texas federation women, but it also meant home decoration and art appreciation.[26]

The Texas federation women initially encountered a ready welcome among Anglos in Santa Fe. At the helm of this community was Edgar L. Hewett, a former president of New Mexico Normal College in Las Vegas, New Mexico, and an archaeologist. Hewett engaged in archaeological investigations in the area surrounding Santa Fe as well as cultural and fine art promotion. He headed both the Museum of New Mexico and the School of American Archaeology, and by 1920 he was at the center of a Santa Fe community of archaeologists, architects, and a small number of artists.[27] Hewett and his allies were keen on promotion of northern New Mexico's charms to tourists. Via argument, experimentation, and cooperation, they developed the unique architectural style that continues to dominate national perceptions of Santa Fe buildings, and they contributed to the image of Santa Fe as an exotic wonderland with Anglos, Nuevomexicanos, and Indians offering their unique cultural assets.[28] Hewett's

timing was key. His activities corresponded with a surge in visitors to the Southwest that began with the completion of the Atchison, Topeka, and Santa Fe railroad line through the Southwest in 1881 and exploded with the development of the Harvey House restaurant and hotel chain. Although the railroad did not take visitors to the Santa Fe city limits, the Harvey Houses promoted arts and crafts associated with Santa Fe and provided auto tours to Santa Fe.[29] Hewett contributed to the market for goods with Santa Fe themes by providing patronage for both Anglo and Native American artists, particularly under the auspices of the Museum of New Mexico. Although many of Hewett's allies saw value in cultural expression for its own sake, most were happy to link promotion of the arts with promotion of the city.

Alongside and sometimes even within Hewett's coalition had grown the group of artists, writers, and activists that included Alice Corbin Henderson and her husband William Henderson, Witter Bynner, and Mary Austin. Like Dodge and her visitors, many in the Santa Fe Anglo arts community had arrived during the final years of World War I seeking a place where they believed they could be free from the evils of modernity. More through example than active promotion, this second community presented a public image of Santa Fe as an oasis of artistic activity, healthful contemplation, and natural beauty.[30] This second group included a large number of independent women with activist backgrounds.[31] Many of the women were single, and most had professional or social reputations forged independently of their husbands, fathers, and sons. Their numbers included philanthropists, arts patrons, ethnologists, writers, and artists. Some were veterans of the struggle for suffrage for women, and most had been involved in activism targeted at increasing workers' wages and improving social programs. Several, like Dodge or through Dodge, had connections to the bohemian community of Greenwich Village.

Austin and many of her peers in the independent-minded community of Anglo women in Santa Fe particularly idealized Native American women. Many Anglo women of the Santa Fe arts community believed that Pueblo women had equal standing in their homes and that the seamless melding of art and life they believed existed in Pueblo houses guaranteed women's equality. To support Pueblo women artists, Dodge, Austin, Elizabeth Shepley Sergeant, and Alice Corbin Henderson all joined the Indian Arts Fund (IAF), an organization that got its start, not surprisingly, at a domestic affair, a dinner party at Sergeant's Tesuque home in 1922. The IAF gave significant attention to Pueblo pottery, an art form largely generated by Pueblo women.

Through support of Pueblo potters, Dodge and her friends hoped Pueblo women would preserve their roles in Pueblo society and thus provide a model for Anglos like themselves who wanted to make their homes artistic and cultural centers.[32]

For several of the Anglo women in the modernist community of northern New Mexico, support for local artists translated directly into support for northern New Mexico as a place.[33] Sergeant, a writer who had moved to New Mexico in 1920, explained to John Collier her desire to write a book about the Pueblos that focused on the appeal of New Mexico as a place. The book would give, Sergeant contended, "the look and feel and meaning of the country the Pueblos live in, the country that has produced their civilization." This, Sergeant continued, would be her "best contribution—if I have any gift in writing it is in making places and people live and if one did not do that in this case the book would, indeed, be a dead thing."[34] Sergeant was not alone in her contention that northern New Mexico had political and aesthetic significance. Alice Corbin Henderson seemed to feel similarly, and concluded her article on Pueblo dances by singing Santa Fe's praises. "Vachel Lindsay, who visited Santa Fe and the Pueblos several years ago, intuitively proclaimed Santa Fe as the 'spiritual center of the United States.' We took his natural flamboyance with a grain of salt, but his vision may have been more prophetic than we thought."[35] A few years after the culture colony struggle, Austin herself briefly enumerated Santa Fe's attractions, and the landscape was foremost among them. "It is a mountain country, immensely dramatically beautiful; it is contiguous to the desert with its appeal of mystery and naked space, and it supplies the element of aboriginal society which I have learned to recognize as my proper medium."[36] As a nature writer, it is not surprising that Austin would dwell on the beauty of the land, but across the Anglo arts community of northern New Mexico, artists and writers linked their specific style of aesthetic expression and their specific political interests with the region they had adopted as their home.

This trend resonated most with the women of the Anglo arts community, in part because they sincerely loved the landscape, in part because they had promoted such ideals before coming to New Mexico, and in part because of gender norms linking women with the home. In their public and private writings, the women of the Anglo arts community again and again asserted the importance of their houses and their homemaking skills to their artistic identities.[37] Embracing the assumption that women's place was in the home, the

women of the Anglo arts community recast the home as the wider space of northern New Mexico. Rather than a limited sphere of influence, women in the Anglo arts community crafted a home that encompassed a vast amount of space as well as what they saw as the highest aesthetic and political expression.

Most articulate in her reliance on her house as a site of inspiration and authority was Sergeant. She established her own home in New Mexico in the summer of 1921 when she and a female friend renovated a house in Tesuque, just north of Santa Fe. Sergeant described the whole experience in a series of articles published in *Harper's Magazine* between March and June 1922. Sergeant titled the series "The Journal of a Mud House," and started her first article with the unusual claim that "a taste for the Southwest is as hard to analyze as a taste for drink."[38] The New Mexico landscape, she implied, had addictive qualities.

Sergeant thought women attained power in the northern New Mexico landscape, and she emphasized the sexual equality she believed she witnessed in Tesuque. She thrilled to the idea that a neighboring Anglo girl "at nineteen can fully and freely choose her woman's destiny in this underfeminized land," and she boasted of the abilities of her wealthy, half-Nuevomexicana, half-Anglo neighbor, whose shoulders "could lift a hundred-pound sack of grain like a strong man's." Sergeant assured her readers that her neighbor's son was "proud of his mother's masculine capacity, her fearlessness," and Sergeant was clearly proud of her own masculine capacity as well. She blithely ignored an Anglo man who informed her that two women should not build a house together, and that her friend was sorely in need of "a man to boss her." Tesuque was wonderful, in Sergeant's eyes, in part because there she felt women could be as free, as strong, and as independent as men. [39]

Sergeant wanted to transform herself into one of the strong, independent women she had met in Tesuque, but she had no intention of sacrificing her identity as a woman writer in the process. Her particular vision of herself emerged one afternoon when she and several of her female friends unexpectedly hosted the Tesuque *mayordomo,* a local official who managed the communal irrigation ditches. When he lingered in the front yard, Sergeant noticed, "He just sat there, his large black orb wildly roving from one to the other of these four ladies in riding breeches engaged in unknown rites. . . . Tesuque is used enough to American farmers' wives, but finds us a remarkable species." Sergeant's dismissal of farmers' wives might have offended some of her neighbors, but she was willing to risk the offense if she could call

herself a remarkable species. For all her efforts to feel at home in New Mex-
ico, Sergeant seemed most satisfied with her identity in the Tesuque land-
scape when she was uniquely situated as a woman writer.[40]

Ultimately, though, Sergeant was most gratified by the sense of individual
inspiration she drew from her home in New Mexico. In later years, when she
had returned east, she wrote to Mabel Dodge that she needed the "freedom of
space of the S.W.," and that Dodge's stories of Taos made her "homesick."[41]
Over time she began to see the house as a part of herself and an expression of
her inner thoughts. Twelve years after she rebuilt the "mud house" and re-
turned to its walls, she wrote to Dodge: "I am deeply *in* this piece of life—re-
viving this little house which has been asleep behind its cottonwoods and in
me for so long. *Right here,* whatever the rest of Tesuque, everything is just as it
was 12 yrs ago—the new unspoiled . . . the color of sky & mountains exquisite
& refreshing."[42] Sergeant melded her vision of her house with a wider notion
of New Mexico as her creative home. Like her colleagues in the area, her vi-
sion of home brought her a sense of independence and sexual equality, pride
in her work as a writer, and, finally, the hope that in Tesuque she revitalized
herself and awoke her own spirit.[43]

Sergeant was not the only woman who saw an extension of her creative
home in the New Mexico landscape. Alice Corbin Henderson similarly
blurred the lines between her creative and residential homes. In addition to
participating in local art events, Henderson and her husband supported
Pueblo and Nuevomexicano artists and craftspeople. Henderson's husband,
an artist and part-time architect, designed several of the area homes and
buildings in the style popularized by Hewett's set, and Henderson herself
contributed to a local campaign to change their street name from the utilitar-
ian Telephone Road to the more romantic Camino del Monte Sol. The
Camino, as local artists called it, soon became a kind of artists' enclave and
the first stop for artistically inclined newcomers. Henderson further added to
the appeal of her home and of the Camino by holding poetry readings at her
house. She memorialized the sense of place she had helped to create on the
opening page of her edited collection, *The Turquoise Trail,* an anthology of po-
etry written in and about New Mexico. She dedicated the book to "the poets
included in the collection, and offered to them as a record of companion-
ships—the covers of the book now taking the place of the low-roofed adobe
houses within whose walls most of the poems have, at one time or another,
been shared in manuscript form."[44] Henderson sought a union of home and

art in her poetry and in its presentation. She seemed most satisfied when the home she built between the covers of her anthology overlapped the one she had built with her husband along the Camino.

Like Sergeant and Henderson, Austin cast the wider space of New Mexico and of the Southwest as her home. For Austin, the Southwest was the nation's heart of creativity. In *Land of Journey's Ending*, she proposed that the region between "the Rio Colorado and the upper course of the Rio Grande" was the seedbed of the nation's greatest cultural wealth. There, she believed, the union of land and culture would produce a new human race, one that would rival the artistic and social accomplishments of ancient Greece and Rome.[45] Like most of Dodge's visitors, Austin celebrated the ancient inhabitants and contemporary native people of the Southwest in the language of primitivism. In Austin's view, Native Americans were more pure, more natural, more peaceful, and more creative than white Americans, and they were therefore better. One of their most valuable traits was their appreciation for the places they called home. In her description of the ancient cliff dwellings now a part of Bandelier National Monument, Austin claimed that visitors learned "shut in there with the purling creek, the feathery pines between whose tips one looks out from the great ceremonial cave, the cool air and the warm sun, the magpie flying over, and the faint gobble of turkey cocks from the potreros, to correct impressions of cave-dwelling man, to discover the shy, home-loving, beauty-worshiping animal man was. Never in the cliff period so harried and hate-ridden as in this civilized age of ours."[46] Throughout *Land of Journey's Ending*, Austin carefully noted her own love of home and worship of beauty. In the most lyrical chapter, "Sacred Mountains," she recalled that it was along the "Rio Santa Fé, between the straight white aspen boles, with the sunlight shattered overhead by the glinting gold of the leaves," that she saw "all the secrets of ancient Greece . . . the unattainable Cup of the soul's adventure." She concluded with a Navajo prayer about walking "in beauty."

Intensely conscious of her own identity as a creative worker, Austin claimed New Mexico as her natural home, but she did so while seeing home as "woman's sphere." During the course of World War I, Austin had increased her commitment to women's suffrage and, upon attaining the right to vote, gave full voice to her theories that women's experiences gave them unique insights into social organization. Her house represented the culmination of several years of effort during which she equated the necessity of a home for raising children with the necessity of a home for creative work. She

explained her theories in an interview with the *Brooklyn Eagle* right before leaving the East Coast to live permanently in Santa Fe. "Hardly anybody realizes that the one institution which our civilization prizes most—the home— is simply the outgrowth of our realization that woman needed a special kind of environment in which to conduct her business of bearing and bringing up children," she preached. "When we realize that the contribution of creative ideas is entitled to a naturally helpful background the problem will be solved. That . . . is the reason I am going to Santa Fe to live, because I can there have the best background for a creative life at the least cost to myself."[47] For Austin, her house was physical proof that women's homes were sites of work and creative activity. A beautiful home in the Southwest was a place to host the artists and writers she admired, but it was also a workplace, and it was in her written work that she took her greatest pride.

In her respect for women's creative work within their homes, Austin echoed some of the sentiments of the Texas federation. She, too, believed that women's work at home deserved greater praise, and she, too, linked women's work with domestic aesthetic expression. Indeed, Austin had long harbored the opinion that women brought unique talents to political and social realms that could only be fully employed if they were fully recognized. In her advice manual to newly enfranchised women, *The Young Woman Citizen,* Austin stressed what she saw as the unique organizational powers of women, and implored readers to recognize great women "as women" and to ask of "woman . . . the definite light thrown on our general problem from her high specialization."[48] Women had unique powers, according to Austin, which derived from their essential natures.

Austin suggested the connection she saw between women's unique powers, their homes, and their creative activity in an interview with *American Pictorial* in 1922, two years before she built her own house in Santa Fe. The article was titled "Wife Has Right to Boss Home, Says Mary H. Austin; Noted Novelist Thinks Sacrifices Earn This Reward." Austin actually proposed a more complicated critique of home life, and advanced her notion that homes should be sites of creative development. She felt that families both in Europe and in the United States had turned away from the example of ancient Roman families, who, she argued, made home "the intellectual and cultural centre of the family." She went on to explain that she felt some mothers were more successful in their families and the workplace if they worked outside the home, but she also believed those women who dedicated themselves to

home life should be rewarded. "Suppose a woman has given up her life plans, her dreams and ambitions, to make home her objective. If she stays at home, raises the family, and sacrifices her own desires to make a success of life, don't you think her husband should be fair enough to recognize her as the one having more authority around the house?" In an ideal world, Austin seemed to propose, the home would be a site for intellectual and cultural development and a center for creative and productive activity, all overseen by a woman who had dedicated herself to such a place.[49]

In their presentations of their homes, the Anglo women artists and writers of Santa Fe insistently denied any tourist identity for themselves. As consumers of Pueblo jewelry and Nuevomexicano carving and as individuals who often relied on romantic presentations of the Southwest for their livelihoods, the women in the Santa Fe Anglo art community often mimicked the behavior of tourists or boosters. But they were quick to deny both of those identities and the stereotypes of feminine consumerism that went with them. Early in her series, Sergeant explained that her homeownership in Tesuque was a far cry from her previous adventures as a visitor to the area. After buying a well bucket and groceries, she proclaimed herself no longer an outsider. "Nothing could better mark our advance from the stage of tourists to that of insiders than this sudden leap from a sleeping car into household economics," she wrote triumphantly.[50] Sergeant suggested that the productive work she put into building her home meant that she belonged in New Mexico. In the years following the culture center controversy, Austin deplored tourists and what she called their "innumerably badly chosen souvenirs."[51] Both women consistently invoked their own productive labor in their own homes as creative workers to deny the tourist label. They repeatedly made clear in their public and private writings that they saw New Mexico as their home—a home to which they were uniquely entitled because they were productive artists.

The idea of an artist's home was one both men and women in the Santa Fe art community used to justify their presence in the area. Nonetheless, for Anglo women in Santa Fe, the idea of an artist's home carried the added benefit of expanding their authority as artists. Women artists felt they belonged in New Mexico because they were artists, but they also believed they understood the ideas of belonging and homemaking better than their male peers because they were women. In embracing their homes as sites of liberation, in using their homes as sites of creative work, in implying that homes were women's domain, and in presenting the home as a potential site for women's

John Sloan, *Indian Detour,* 1927, etching on paper. Sloan caricatured tourists and their enthusiasm for Pueblo dances in this work. Mary Austin particularly decried what she perceived as the "middlebrow" nature of tourist interest in northern New Mexico. (Cleveland Museum of Art, Cleveland, Ohio, 1951.50.)

advancement, the Anglo women of the Santa Fe art community seemed willing, to an extent, to embrace the notion of home as a woman's place. The home they described, however, did not end at the boundaries of their individual property but extended to the city of Santa Fe, the wider region of northern New Mexico, and, at times, the entire Southwest.

The club women targeted this domain for their culture center. The club women had toyed with the idea of a chautauqua as early as 1922, and they had passed a formal resolution in 1923 asking a committee to investigate potential sites designed not just for the Texas federation but for the Southwestern Federation of Women's Clubs, encompassing general federation members in

Texas, Kansas, Arkansas, Louisiana, Missouri, Colorado, Arizona, Oklahoma, New Mexico, and Mississippi. The Texas federation, however, remained the primary contact for the club women's chautauqua plan, and Martin, the Texas federation woman so committed to the Better Homes Movement, became the central force behind finding a location for the culture center. Martin organized a series of committees to investigate potential sites and, when the Santa Fe Chamber of Commerce showed an interest in the plan, Hewett traveled to the Texas federation annual convention to sing the praises of the city. Hewett was excited to see wealthy potential tourists and a committed group of potential students who could take advantage of the adult summer school he had long hoped to connect to the School of American Archaeology and the Museum of New Mexico. By April 1926, the club women had settled on Santa Fe as the site for their proposed community, incorporated as the Culture Center of the Southwest. [52]

Even before the federation had decided on Santa Fe as its site, however, members had begun to articulate their expectations of the culture center in terms that recalled Austin's, Sergeant's, and Henderson's public and private writings about their homes in Santa Fe. The Texas federation made clear that it did not want a tent-covered religious revival, a common stereotype of chautauquas. What the members wanted was sort of a summer camp for adults, with classes in the arts and in art appreciation. "The chautauquas, which were originally sponsored by religious organizations, have become more and more an expression of the desire for a combination of wholesome recreation for the body and cultural advantage for the mind," the *Texas Federation News* proclaimed. "We ourselves, looking forward during the past few years, have created this very demand in the Southwest. We need more art centers, and we want them. Women, since they were first organized in club work some fifty years ago, have made a systematic and concerted effort toward these very things."[53] Not only did Texas federation members see the culture center as an opportunity to celebrate women's promotion of the arts, they also saw it as an opportunity to expand the place they called home. As Martin explained to the *Dallas Morning News,* the club women did "not want to pioneer. They are eager for cool weather, beautiful scenery, and association [with] other women, but they want these things in conjunction with the conveniences of home. . . . It is planned that women interested in the Chautauqua will eventually buy their summer homes there, contributing in that way to the support of the Chautauqua."[54] Though not quite as intent on calling Santa Fe home, the club

women had united their interest in women's roles, art promotion, and domestic space in similar ways to those of Austin, Sergeant, and Henderson. The club women wanted a domestic space in which to explore creative expression.

The parallels between the Anglo women of the Santa Fe art community and the club women became even more apparent when the Texas federation settled on Santa Fe as its desired location. In its report recommending Santa Fe as the culture center site, the visiting committee made clear that its members had thoroughly absorbed popular presentations of the city. The committee report called northern New Mexico "a land of mystery and romance, of flaming color and wistful charm, of the ancient religious rites and little known customs of a great and vanished people." To make clear its overwhelming endorsement of Santa Fe, the committee concluded that "there can be many great cities, but only one Santa Fe, and it is here amidst scenic wonders and natural and man-made beauties that inescably [sic] allure and hold, that we Committee members recommend for the establishment of a Southwestern Chautauqua, or Creative Centre of Art and Culture." The committee went on to note as the city's best attributes the presence of an art colony in Santa Fe and the desire of still more artists to make in Santa Fe "their permanent home." The report concluded on the basis of the Santa Fe climate, cultural activities, and history that it was an ideal choice for the federation endeavor.[55] In their praise for Santa Fe and their fascination with its presumably "ancient" culture, the club women echoed the words of Hewett and those of the Anglo women who had made of northern New Mexico their artists' home.

It was with some surprise, then, that the club women witnessed the reaction of their prospective hosts. Santa Fe erupted. Upon learning of the Southwest federation incorporation of the plan, an organization dubbed the Old Santa Fe Association immediately formed, dedicated to controlling growth in Santa Fe in such a way as to avoid sacrificing the city's "unique charm."[56] Leading the charge of the association were Dana Johnson, editor of the Santa Fe daily paper, the *New Mexican*, Witter Bynner, and Austin. The three leaders responded with a similar flurry of activism to the culture colony as the Santa Fe art community had responded to the Bursum bill. Publishing editorials in the *New Mexican*, the *New Republic*, *Bookman*, *TIME*, and the *New York World*, the association and its sympathizers initiated a national campaign against the culture center, but the Santa Fe Chamber of Commerce and Hewett stood their ground against what they saw as the artists' collective temper tantrum.[57]

But the artists of Santa Fe were in earnest. Passions grew so heated that Johnson felt compelled to resign as director of the chamber of commerce.[58] Meanwhile, Old Santa Fe Association members continued to call the center a chautauqua despite its formal incorporation as a culture center, and played up the stereotype of chautauquas as carnival environments populated by overzealous proselytizers. They repeatedly insisted that the uniqueness of Santa Fe—particularly the culture of its Spanish-speaking residents—was at risk if 3,000 club women arrived to talk about art. Two associations of Spanish-speaking residents, La Unión Protectiva and El Centro de Cultura, objected to the plan, lending a patina of authenticity to the artists' cries that the "natives" did not want a cultural center. Whenever possible, the association referred to the women as midwesterners or as Texans, playing up regional animosities and emphasizing what the association characterized as the "main street" nature of the center proposal.[59] The author of *Main Street*, Sinclair Lewis, finally weighed in himself announcing that "as one who has seen the unspoiled beauty of Santa Fe I believe that it would be nothing but a ghastly misfortune to hand the town over to the hordes of seekers for predigested culture—to change it from a dignified and distinguished city, admired by all the world, into a flimsy fairground."[60]

In addition to Austin and Alice Corbin Henderson, three other women in the Santa Fe Anglo art community also strenuously fought the culture center. They were Amelia Elizabeth White, her sister Martha White, and Margretta Dietrich, all three art patrons with college ties to Elizabeth Shepley Sergeant. Elizabeth White (as she was always called) privately confessed to a friend that she feared Santa Fe would vanish before "a swarm of locusts," and Dietrich and Martha White mocked the effort later that year in a city parade by riding in a vendor's cart with signs reading "Dr. Quack's Remedies for the Uncultured" and "Magic Chautauqua Balm."[61] Many of these women seemed to object particularly to the fact that the "culture seekers" in question were women. Although men signed a statement to the club women stating that the culture center was not welcome in Santa Fe, women chose to travel to Dallas to deliver the letter to the club women in person.[62] In a later meeting of the Old Santa Fe Association, one of the female members of the association referred to federation rivals as "these women."[63] In a private letter on the matter, Elizabeth White remarked scornfully, "You can imagine what a Chattauqua [*sic*] of Texas and Oklahoma club women would be," and Austin in an article for the *New Republic* tried to remedy the misconception on the part of "a vast

majority of Americans, particularly American women . . . that 'culture' is generated in 'courses' and proceeds as by nature from the lecture platform."[64] None of these women articulated why the gender of the culture center promoters mattered, but the fact that they made a point of mentioning women in their remarks suggests that for them the gender of the participants was important.

Austin's further writing on the matter suggests why it was important. In an "Open Letter to Club Women and Business Men," Austin laid out all of her objections to the culture center plan. She insisted first that artists, not chautauqua groups, should dictate the cultural future of the region. Her peers, she explained, were "creative workers" who came to the area to produce art. In contrast, the women's club members were a "cultural group" who came to the Southwest only to consume lectures and classes about art. No one who observed both groups "can help knowing that the two can not exist together in the same town," she insisted. "This has been tried many times, with the same result. The creative type is immediately driven away to seek some other locality." As far as Austin and her friends were concerned, the chautauqua was a threat to the lifestyle they had journeyed to the Southwest to find.[65]

For Austin, the artists were uniquely qualified to promote the area because they were productive members of the community who created high-quality work and were devoted to New Mexico as a home. Austin insisted at the beginning of her letter that the creative workers in Santa Fe were "the most important artist group not only in the Southwest, but probably west of the Mississippi." More important for Austin, though, was the commitment of the artists' community to New Mexico. She cited the efforts of Anglo artists to promote Native American and Nuevomexicano arts as proof of their devotion to the region. She explained that she and her peers had dedicated themselves "to discover and create and distribute works of art," and she clearly saw collecting Native American and Nuevomexicano arts as a part of this agenda. According to Austin, these efforts combined to prove that the Anglo artists' "loyalty to the home of their adoption has been outspoken and unquestioning." By serving New Mexico artistically, Austin felt she and her peers had established and justified their place in the region.[66] Ultimately, it was this appeal to New Mexico as an artists' home that carried Austin's argument against the club women's culture colony. By making Santa Fe a productive artists' community, Austin felt that she and her friends had earned the right to stay. "We have built our homes here, created the conditions necessary to

Andrew Dasburg, *Coordinated Explosions 1914: Portrait of Carl Van Vechten*. Dasburg's cubist portrait of Van Vechten may be a retitled portrait of Mabel Dodge that he completed shortly after he began attending her Greenwich Village salon. (Regis Collection, Minneapolis, Minnesota.)

Marsden Hartley, *Still Life No. 1*, 1912. While painting in Europe, Hartley was inspired in part by Native American artifacts in European museums. (Columbus Museum of Art, Columbus, Ohio; gift of Ferdinand Howald 1931.184.)

Marsden Hartley, *Indian Fantasy,* 1914. Hartley also painted abstract compilations of Indian imagery before he visited Taos. (North Carolina Museum of Art, Raleigh; purchased with funds from the North Carolina Museum of Art.)

José Aragón (active ca. 1820–1835), *San Ramón Nonato,* painted
wood. (Harwood Museum of Art, University of New Mexico; gift of
Mabel Dodge Luhan.)

Marsden Hartley, *El Santo,* 1919, oil on canvas. Along with Dasburg, Dodge assembled a significant collection of Nuevomexicano santos, carved and painted saint figures. They served as inspiration for some of Hartley's work. (Collection of the New Mexico Museum of Art; anonymous gift of a friend of Southwest art, 1919.)

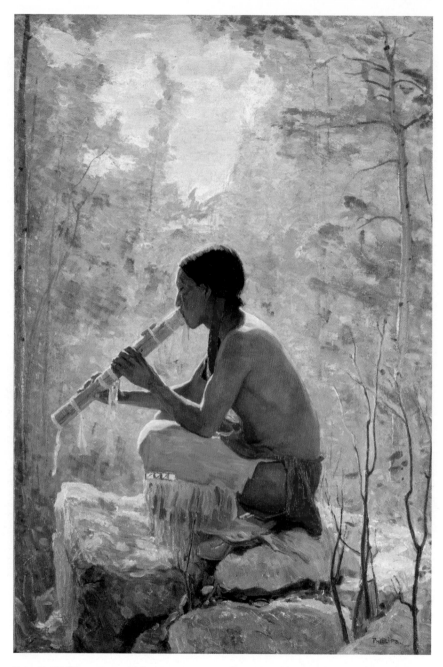

Bert G. Phillips, *Song of the Aspen*, ca. 1926–1928, oil on canvas. Phillips and other members of the Taos Society of Artists were more likely to paint in a realist style than were the modernist painters who visited Mabel Dodge Luhan. (Courtesy of the Eiteljorg Museum of American Indians and Western Art, Indianapolis, Indiana.)

Georgia O'Keeffe, *From the Faraway, Nearby*, 1937, oil on canvas. One of the most popular images used by the Santa Fe Chamber Music Festival in their posters. The image helped to cement O'Keeffe's connection to the region in the popular imagination. (Metropolitan Museum of Art, New York, Alfred Stieglitz Collection, Metropolitan Museum of Art/Art Resource.)

Awa Tsireh [Alfonso Roybal], *Green Corn Ceremony at Santo Domingo*, San Ildefonso Pueblo, ca. 1922. Anglo patrons in both Santa Fe and Taos supported the work of Pueblo painters. Awa Tsireh was one of the most admired and successful of those who received Anglo patronage. (Museum of Indian Arts and Culture, Laboratory of Anthropology, New Mexico Department of Cultural Affairs, 24018/13. Photography by John Frank.)

The Greenwich Village Murals, 1994. Both New York City and Taos publicly remember Mabel Dodge Luhan today. A mosaic in a Greenwich Village subway station depicts Mabel Dodge and many of her guests. A street sign in Taos (shown in the epilogue) carries Dodge's name. (Copyright © Lee Brozgol, Christopher Street–Sheridan Square, 1 line. Commissioned and owned by Metropolitan Transportation Authority Arts for Transit. Photograph by Rob Wilson.)

good work," Austin explained. "We have as individuals—for we are in no sense a 'colony'—done our share as citizens of our community and our State." As far as Austin was concerned, colonies did not produce art. Places, particularly places artists called home, produced art. "We are very much dependent for the quality of our work on the sort of conditions we have found and created here in Santa Fe," she pleaded, "Our homes are here, our capital invested."

Where did that leave club women seeking cultural enlightenment? Austin, at least, felt they should stick to their own homes in Texas. There, they could start the kind of intellectual and cultural inquiry they sought in Santa Fe. Austin regretted the potential costs to the city of Santa Fe, but she felt the loss to art would be even greater if the club women came. "I should be sorry to deprive the Chamber of Commerce of the money they are anticipating from the Federated Clubs," she wrote, "but I should be sorrier to rob the other states and towns of the native energy of acculturation residing in their women, by transporting them to Santa Fe. The arts, like charity, *must* begin at home. When they try to begin on other roots than their own they succeed only in being 'arty.'"[67] Anyone could easily have accused Austin and her friends of straying far from their roots and into the realm of the "arty," but Austin chose not to recognize herself in the portrait she painted. Instead, the entire chautauqua conflict became a platform for her vision of home as the site of cultural development and Santa Fe as the ultimate expression of that vision.

In her open letter, Austin as a "creative worker," and as someone deeply invested in her home, objected to the culture center. Her comments suggest she objected to the chautauqua in part as a woman artist. Statements by other women in the Santa Fe art community suggest Austin seemed to have allies in the identity she had chosen to defend. Had the culture colony appeared, artists and tourists alike might have mistaken the women who had objected to the culture center for club women. Women in the Santa Fe Anglo art community regularly attended poetry and prose readings, supported local art, and purchased jewelry and pottery for their own use. In many ways, their daily activities were like those of club women in search of cultural stimulation. On the surface, the women of the Santa Fe art community seemed to confirm popular stereotypes linking women with unproductive consumption. Yet, they saw themselves as engaged in a higher endeavor—one that required an artistic sensibility. The chautauqua battle allowed such women to make clear that they were not the kind of women who only patronized art. Instead, they

were artists themselves, and if a woman's place was at home, then their place was in Santa Fe.

The club women who had proposed the chautauqua, needless to say, were not pleased with their reception. Undoubtedly, many took Austin's letter as a slap in the face after the general federation had supported the fight against the Bursum bill. Some club members, too, pointed out that they had provided financial support for artists in the past when the benefits of promoting art had been less lucrative. "But really now," one woman protested, "there is some excuse for the club women. . . . For years they had been exhorted to support art, exploit art, encourage poor downtrodden unappreciated artists. . . . Time was when they were honored, much-sought 'patrons.' How could they know that they had degenerated into mere hangers-on and sychophantic [sic] climbers in art colonies?"[68] Writing with a level of sarcasm that would have made even Austin proud, at least one woman protested the club women's newly circumscribed position as pariahs of the art community. Ultimately, though, the charge of hypocrisy failed. The club women initially ignored the statements by the Old Santa Fe Association and insisted that the invitation from the Santa Fe Chamber of Commerce was still valid.[69] Nonetheless, federation interest appears to have waned after encountering so much resistance. Although the club women never formally stated their reasons for withdrawing, the Culture Center of the Southwest was never built, and in later years federation members gave their efforts to constructing a headquarters in Texas.[70]

Dodge remained largely silent during the culture colony controversy, but she, too, evoked the idea of an artist's home when conceiving her own estate in Taos. Dodge was never as far from the realm of commercial tourism or ventures like the culture colony as she liked to think. Between 1924 and 1925, her son ran a curio shop called the Spanish and Indian Trading Company along with his mother's friends Andrew Dasburg and Witter Bynner, just the place tourists needed for the "innumerably badly chosen souvenirs" Austin scorned.[71] Four years later, Dodge advertised her home as a dude ranch, complete with a Pueblo guide—none other than Tony Lujan. She may have rationalized her participation in the northern New Mexico tourism industry by distancing her home in Taos from those of her friends in Santa Fe. Even by the late 1920s, Taos still required a long difficult day's journey from the train station in Lamy, and it hosted fewer tourists than the more popular Santa Fe. Dodge may have seen her home as outside the tourist circuit and her ven-

tures in inn keeping as a temporary commercial venture into the tourist realm. In her correspondence, at least, she saw no hypocrisy in her criticism of tourists. She even wrote to Sergeant in the fall of 1929 that "Santa Fe is gone! But Taos—outside the plaza—is still real. The plaza is rotton [sic] with tourists though."[72] Dodge apparently maintained a delicate balance between her scorn for tourists in Santa Fe and on Taos plaza and her invitations to tourists to visit her own home.

Ultimately, though, the idea of an artist's home drove Dodge to drop the idea of using her house as a tourist stop. "The house wouldn't lend itself to be a 'dude ranch'," Dodge explained to Austin. "It fought hard & is battered but triumphant! Isn't it queer?" She continued, "From now on it must be its own kind of place, sincere & real & no smiles of profiteering!" She explained by recounting an argument she had had with her son over the issue. "John said: 'You'd have to smile like a landlady!' 'Never,' I answered 'Well if you take their money you'd have to. Naturally you sell yourself with the house' . . . so our argument went."[73] Dodge, draped in the silver and turquoise jewelry many tourists collected, wanted famous artists and writers to come to Taos, and she wanted to be an expert guide, but she hardly wanted to taint the whole experience with worries over money and the niceties of service work. Rather than bow to the tastes of middlebrow tourists or admit any desire for tourist money, Dodge claimed her house would decide what kind of place it should be.

The house, with a fair amount of prompting from Dodge, eventually chose to be a home for creative work. Dodge explained to Austin that she was "determined to get back to my original ideal of having this place a creative centre." Dodge did not want to run a hotel or smile graciously at guests. Instead, she wanted "not just a place for people to retreat into or to go to sleep in or to barge in for just a good time. . . . I want people to use it freely but for creative purposes."[74] Dodge wanted a place in which artists felt comfortable, and where they gave birth to their greatest work. She wanted a place in which her visitors felt no obligation to see the sights or imbibe local culture, but where the sights and local culture inspired artists and writers to creative expression. She wanted a place that gave rise to great art but that let guests feel at home.

Dodge had chosen the right correspondent when she wrote to Austin about the inclinations she ascribed to her house and home. Austin, too, had worked hard to make her house and the city of Santa Fe places she and others could call artists' homes. Austin, too, had been motivated by her adoration of the landscape, her commitment to art, and her belief that women were

entitled to places to call their own. Austin, too, had scorned the tourists, particularly the women tourists, who had tried to claim a part of New Mexico for themselves. That such a stance smacked of hypocrisy did not seem to bother either woman much. If they ever worried over such inconsistencies, they appear to have resolved them by insisting that the place itself had chosen its role. They had merely served as handmaidens for the land's destiny. For Austin and Dodge, Santa Fe and Taos were not just artists' homes, they were natural artists' homes.

Such an outlook did not always sit well with the Anglo men who also tried to make of Santa Fe and Taos a place for themselves. Many of Dodge's and Austin's male peers were not accustomed to finding inspiration in "woman's sphere." Although they found the landscape of northern New Mexico equally inspiring, to call it home meant ceding some of the power to women. They made such acknowledgments with great reluctance, if they acknowledged women's roles in the forging of the Anglo art community at all. Witter Bynner and Jean Toomer both chafed against the control Dodge, Austin, and other women held in the Anglo art community. The man who would most challenge the authority women asserted over the artists' home of New Mexico, however, was D. H. Lawrence.

D. H. Lawrence's Place

Traveling by bus in Italy in January 1921, D. H. Lawrence mused about Sardinia, a place that had confounded him, delighted him, angered him, and, at least for a moment, completed him. "Life was not only a process of rediscovering backwards," he surmised. "It is that, also: and it is that intensely. Italy has given me back I know not what of myself, but a very, very great deal. She has found for me so much that was lost: like a restored Osiris. But this morning in the omnibus I realize that, apart from the great rediscovery backwards, which one *must* make before one can be whole at all, there is a move forwards. There are unknown, unworked lands where the salt has not lost its savour. But one must have perfected oneself in the great part first." Humans had made of Italy a "conscious genius" in Lawrence's eyes.[1] The question before him was whether he could effect the same change elsewhere. Could he find the unknown lands that would allow a move forward? More importantly, had he perfected himself such that he could elicit the same genius from another place? He knew his task was daunting. His adversary in this quest was the entire modern age. Sardinia's appeal came, in part, from its resistance to what Lawrence saw as the forces of modernity. "The spirit of place is a strange thing," he concluded. "Our mechanical age tries to override it. But it does not succeed. In the end the strange sinister spirit of place, so diverse and so adverse in differing places will smash our mechanical oneness into smithereens, and all that we think the real thing will go off with a pop, and we shall be left staring."[2]

What did Dodge think upon reading such words? She, too, had mused about the spirit of place. Although she did not find the same satisfaction in

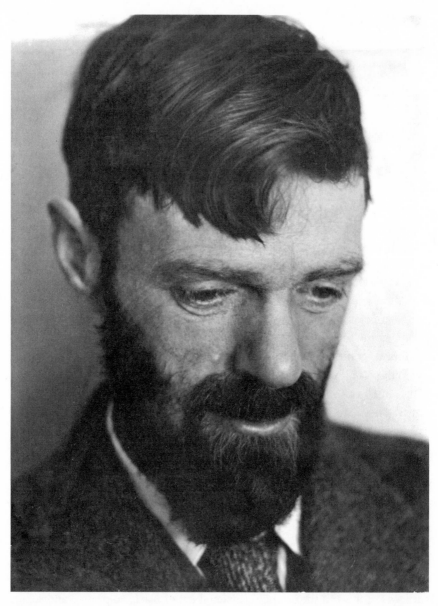

D. H. Lawrence. (Yale Collection of American Literature, Beinecke Rare Book and Manuscript Library.)

Italy as Lawrence did, she, too, had gone in search of those places that held their flavor by resisting the forces of homogenization. She, too, had imagined a confrontation between the authentic and the modern in which the former emerged triumphant. She, too, located such authenticity in a place. Taos had been everything for Dodge that Italy had been for Lawrence. Indeed, Dodge believed it had been more.

Filled with doubt over her own ability to convey the spirit of Taos in print, but convinced of the need to spread the insight that in Taos a modern nation might redeem itself and more sure of her ability to convince guests to visit her, Dodge invited Lawrence to New Mexico. "Here is the only one who can really *see* this Taos country and the Indians, and who can describe it so that it is as much alive between the covers of a book as it is in reality," Dodge recalled herself thinking. In *Lorenzo in Taos,* a book-length letter to the poet Robinson Jeffers (whom she would also invite to Taos in an effort to capture the place in writing), Dodge remembered her decision: "For Taos had something wonderful in it, like the dawn of the world. . . . It was after reading *Sea and Sardinia* that I wrote to him to come to Taos," she explained to Jeffers. "He gives the feel and touch and smell of places so that their reality and their essence are open to one, and one can step right into them. . . . I wrote him a long letter. I told him all I could about Taos and the Indians—and about Tony and me."[3] Dodge had decided that Lawrence would be the emissary of her vision. She had completed her New York show of Pueblo Indian and Nuevomexicano art. She was about to throw herself into the Bursum bill struggle. Her romance with Lujan was in full flower. She was in the process of building the houses on her elaborate grounds. But Dodge was an energetic woman, and she was willing to struggle on many fronts. If art, politics, love, and homemaking did not succeed in making Taos the creative center and national inspiration she believed it was, then perhaps literature might.

Dodge had chosen, in the words of her and Lawrence's mutual friend Leo Stein, a literary "lion."[4] In addition to *Sea and Sardinia,* Lawrence had published *Sons and Lovers* as well as *Women in Love* by the time he arrived in Taos. Although his work met with controversy in England, he had established a sufficient reputation that he was able to support himself and his wife with his writing. Nonetheless, the pair had struggled financially, and an invitation from a potential patron like Dodge was enticing. Dodge's offer found Lawrence and his wife, Frieda, in Italy, where they had been living since 1919. Although both of the Lawrences felt a strong attachment to Italy, the war had

soured them on Europe, and Lawrence frequently expressed hope in the United States as a savior for the modern soul. Nonetheless, the Lawrences traveled first to Ceylon and then to Australia before arriving in the United States. Lawrence's first reaction to New Mexico must have pleased Dodge beyond measure. Remembering it later, he wrote, "I think New Mexico was the greatest experience from the outside world that I have ever had. . . . The moment I saw the brilliant, proud morning shine high up over the deserts of Santa Fe, something stood still in my soul, and I started to attend."[5]

New Mexico enthusiasts regularly quote Lawrence's words, but they gloss over fundamental differences between Lawrence's and Dodge's visions of Taos. Indeed, their radically contrary approaches to New Mexico prevented Lawrence from writing the book Dodge wanted and in turn precluded her from eliciting the conscious genius of Taos that he wanted. The two clashed on two significant points. Lawrence refused to accept the "woman's sphere" Dodge, Austin, and other Anglo women had crafted in northern New Mexico. Indeed, like other men in the Anglo art communities of Taos and Santa Fe, he repeatedly tried, both literally and figuratively, to undermine Anglo women's power. Lawrence also objected, however, to Dodge's vision of the Pueblo Indians. He never accepted the kind of primitivism that governed her relationship with Lujan and with other Pueblo Indians, and he actively mocked Dodge, Austin, and other women for romanticizing their Pueblo neighbors. Lawrence's vision of Pueblo Indians was a complex one; he, too, engaged in primitivism, but it was a dark and disturbing primitivism. His most engaged writing about New Mexico celebrated the land but expressed ambivalence about the Pueblo Indians. Intent on picking at Dodge's greatest weakness, her primitivism, Lawrence refused to accept her vision of Taos. Angered by Lawrence's misogyny, Dodge refused to examine her primitivist outlook and never fostered in Taos the kind of community Lawrence wanted. Dodge and Lawrence repeatedly fought over seemingly trivial issues, but at the heart of their discord were core differences over the meaning of a place like Taos and the people who called it their own.

Even before D. H. Lawrence arrived in Taos, there was evidence that he and Dodge would clash over the meaning of his presence in her home. After reading *Psychoanalysis and the Unconscious*, Dodge concluded that Lawrence had the ability to "understand the invisible but powerful spirit that hovered over the Taos Valley." Yet, she herself was divided over whether the spirit had infused the Pueblo Indians or whether the Indians gave rise to the spirit. She

explained her confusion by repeating a conversation she had held with Lujan. "The white people like Taos and call it *'climate,'*" Lujan told Dodge, "'Do they know what *climate* is? Do they know why the sun is better in Taos and why they feel happy in it?' But I did not know, really," Dodge reflected, "whether they were responsible for the spirit of the place or whether there was over and above them all a consciousness that permeated all that place, that possessed it and called it Home. Anyway, I believed that Lawrence was the only person living . . . who could penetrate and define that magic—the laughing, aloof, genius of Taos." Dodge's refusal to acknowledge an origin for the inspirational qualities of the area allowed her to attribute to the land and the Indians the same qualities. Evidently, Lujan had questioned the imprecision of her thinking. Did she know why she felt better in the sun in Taos than she did elsewhere? Dodge had considered the question, but contented herself with a vague answer—maybe the Indians, maybe the place itself. She would leave Lawrence to figure out the difference. Lawrence, however, did not rise to the challenge eagerly. In a letter he sent before he arrived, he wrote: "I too believe in Taos, without having seen it. I also believe in Indians. But they must do *half* the believing: in me as well as in the sun."[6] Lawrence did not dismiss the prospect of writing about the Indians, but he did not accept the Indians unequivocally as a part of the place.

Lawrence's doubts about the wisdom of writing about New Mexico continued until his arrival. In July 1922, he wrote his agent, Robert Mountsier, that he would like "to write a New Mexico novel with Indians in it." After he arrived, however, Lawrence was less optimistic. He told a friend that Dodge had lent them "a very charming *adobe* house which she built for us because she wants me to *write* the country up. God knows if I shall." By October he had started a book with Dodge. He told his agent that he was "doing a M. Sterne novel of *here:* with her Indian." Dodge must have been thrilled that Lawrence had chosen her relationship with Lujan as the centerpiece of his Taos work, but her delight was short-lived. Frieda Lawrence objected when Dodge invited Lawrence to work on the rooftop that formed a patio to Dodge's bedroom. Dodge refused to work at the cottage where the Lawrences were staying. Eventually, she became too meddlesome a hostess, and the Lawrences moved to a ranch north of Dodge's home. There, Lawrence gave up the plan for a book about Dodge and Lujan. He told Mountsier that if he wrote the "M[abel] S[terne] novel, and the Indian, it would be just *too* impossible. Might make me also *too* sick. But," he concluded optimistically, "I think I'll do a novel out here."[7]

That Lawrence called Lujan Dodge's "Indian" indicated the broader dis-
trust he harbored of nonwhite people and of Dodge's proprietary relationship
to Taos and its environs. Before his arrival in Taos, he had written Dodge
from Ceylon that he was hesitant to arrive in Taos because of the artists and
the Indians. "I still of course mistrust Taos very much, chiefly on account of
the artists," he explained, "I feel I never want to see an artist again while I
live. The Indians, yes: if one is sure that they are not jeering at one. I find all
dark people have a fixed desire to jeer at us: these people here. They jeer be-
hind your backs. But heavens, I don't see much in them to admire, either. . . .
No, no, these little darkie people don't impress me, upon actual contact."[8]
Lawrence would prove more respectful of the indigenous people he encoun-
tered in the U.S. Southwest and later in Mexico, but his racism might well
have deterred him from writing a book about Taos and the Pueblo Indians.

Indeed, his first published writing about the Southwest vacillated between
his fascination and his distaste for the southwestern Indians he encountered.
Upon his arrival in Taos, Dodge immediately sent him to observe an Apache
dance. Lawrence's article about the dance, "Indians and an Englishman" re-
veals how overwhelmed and excluded he felt at the event. When an Apache at
the dance explained that Lawrence could not join a group of men receiving re-
ligious instruction, he claimed he never wanted to be invited anyway. "It was
not for me, and I knew it," he wrote somewhat bitterly, but then continued,
"Nor had I any curiosity to understand." Lawrence insisted he had no interest
in Apache religion because he believed it part of humanity's primordial past.
He concluded the article by ruminating on his civilized distance from the
Apaches he observed. "I know my derivation. I was born of no virgin, of no
Holy Ghost. Ah, no, these old men telling the tribal tale were my fathers. I
have a dark-faced, bronze-voiced father far back in the resinous ages. My
mother was no virgin. She lay in her hour with this dusky-lipped tribe-father.
And I have not forgotten him. But he, like many an old father with a
changeling son, he would like to deny me. But I stand on the far edge of their
firelight, and am neither denied nor accepted. My way is my own old red fa-
ther; I can't cluster at the drum any more."[9] Lawrence claimed his own way,
but this meant that he would remain an outsider and an observer, a difficult
stance from which to write the kind of psychological novel on which he had
based his reputation.

When Lawrence returned from the Apache dance to Taos, he appeared to
have a similar reaction to the Pueblo Indians. Again he found the Indians for-

eign, and, again, his feelings showed in his published work. In his piece "Taos," he continued to cast himself as an outsider. He dedicated half the article to a description of the white interlopers at a Pueblo maypole dance. When an Indian contradicted a white man directing a crew of volunteers raising a maypole, Lawrence claimed to have stayed out of the conflict and "just gave a hand steadying the pole as it went up, outsider at both ends of the game." Still later when a white doctor was denied entrance to the Pueblo's Catholic church, Lawrence claimed to have observed in the Pueblo Indians the "same almost jeering triumph in giving the white man—or the white woman—a kick. It is the same the whole world over," he observed wearily, "between dark-skin and white. . . . For my own part, I have long since passed the stage when I want to crowd up and stare at anybody's spectacle, white man's or dark man's."[10] Lawrence wrote about systems of exclusion and inclusion in England, and feeling he was left out of something significant was nothing new to him. Nonetheless, the way Lawrence wrote about his exclusion from the Indian dance was different. The Indians who excluded Lawrence were indistinguishable from each other. Lawrence did not even distinguish them from other nonwhite people. As long as Lawrence felt excluded from Pueblo Indian life, he excluded the Pueblo Indians as individuals from his writing. They appeared instead only as strange spectacles in an unfamiliar landscape.

By spring 1923, Lawrence had failed to make any real progress on a book about New Mexico, and he and Frieda had also decided to leave the United States for a trip to Mexico.[11] Dodge and Lawrence had repelled each other. Their different opinions of the Pueblo Indians played a significant role, but so did his personal approach to Dodge and her household. Lawrence insisted Dodge wear tight-waisted dresses with aprons and perform household chores like cleaning the floors and cooking.[12] Although Dodge followed neither suggestion for long, it was not an auspicious beginning to a cooperative venture. Once Lawrence left her household, Dodge found it even more difficult to influence him and his writing. She refused to host him for Christmas, and by spring the Lawrences had invited Witter Bynner and Spud Johnson to join them on their trip to Mexico.

In Bynner and Johnson, Lawrence found comrades in his frustration with Dodge. In particular, Bynner and Johnson chafed against the control she exerted over the men in the Anglo art community of Taos and Santa Fe. Bynner expressed his frustration with Dodge more openly than did Johnson. He could do so because he had greater financial resources and a more established

reputation in the world of arts and letters. Johnson, who would break from Bynner following their trip to Mexico with the Lawrences, found his relationship with Dodge and other women of the Anglo arts community more fraught. Following his split with Bynner, Johnson worked for Dodge, and he frequently relied on her for financial support. Although in later years he made a better reputation through his little magazine the *Laughing Horse* and as a writer for the *New Yorker,* he continued to depend on Dodge and her household for the literary and artistic companionship that most pleased him. Both men, then, were in a position to sympathize with Lawrence's frustration.

Indeed, six years after his trip to Mexico with the Lawrences, Bynner would channel his anger at Dodge into a play entitled *Cake: An Indulgence.* Anticipating advances in absurdist theater, *Cake* confused many of its watchers. Throughout, a wealthy, oft-married woman identified only as "the Lady" harasses her manservant, a unicorn, as she seeks "experience" in various exotic locales. Most viewers called it dull, pointless, meaningless, and poorly written, but at least one attendee felt comfortable explaining the work to others: "The play is a clever satire on the modern American woman with millions of dollars who goes in and out of the divorce court, who travels from country to country seeking adventure, romance, pleasures, and happiness. The play was intended to hold up to ridicule these much married and much divorced women." Many readers of *Cake* have not had difficulty seeing in it criticism of Anglo women in the northern New Mexico art colony, most notably Mabel Dodge.[13]

The misogyny in the play ran deep. At its outset, the Lady identifies herself as "a modernist," and meets briefly with a psychoanalyst who tells her she has a "frontier libido." Seeking an outlet for her sexual energy and "experience," the Lady journeys to Paris, where she is the object of an elaborate practical joke; to China, where she is nearly buried alive after seducing a Mandarin; and to India, where a man rips out all her hair in a barely concealed rape scene. Bynner may have been reprimanding Dodge for her thoughtless exploitation of nonwhite people and her ceaseless self-gratification. Still, one wonders if *Cake's* real indulgence was its punishment of a woman wealthy and driven enough to seek emotional and sexual satisfaction.

If Johnson shared Bynner's feelings regarding wealthy women, he did not express them publicly. In fact, many critics believed the unicorn a stand-in for Johnson. Throughout the play, the unicorn carries his own horn, a subtle unmanning that Johnson never publicly protested.[14] Instead, Johnson puzzled

over his relationship with women in the privacy of his journal. "I see practically nothing of anyone but women," he wrote years after the journey to Mexico with the Lawrences, "which irritates me beyond measure, & in pretending that I enjoy them I am being hypocritical and false to my true feelings & inclinations. But how can I manage to see less of women & more of men? Even so, I think I'd better do it. Avoid them, even at the additional financial cost of paying for more meals at the hotel instead of going out for dinner when invited! And staying home more instead of going to the hotel in the evening etc."[15] Johnson's ambivalent relationship with women derived not only from the nature of his sexual desire but also from the demands of his pocketbook. As a gay man with limited financial resources, Johnson had to keep his feelings about women to himself, a restriction Bynner did not face.[16]

In 1923, however, Johnson had yet to seek employment with Dodge, and Lawrence might have found sympathetic listeners in him and in Bynner. In *Cake*, the Lady ends the play with a husband, but she never settles in one particular place. No one in Paris or China or India will have her. She never belongs. Her homelessness stands in striking contrast to Dodge's sense of place in Taos. Like Bynner, Lawrence seethed over Dodge's self-indulgence and her penchant for the exotic. And, like Bynner, Lawrence struck at Dodge in his writing. Lawrence also sought to deprive Dodge symbolically of her sense of place. Early in *Lorenzo in Taos*, Dodge remarks:

After he came, [Lawrence] got me to really doing things, washing floors and making bread and wearing aprons for a while. . . . I told him how in that place a woman would come to the door and stand smiling towards the Sacred Mountain, after she put her cake into the oven. For it was like that. The mountain and the fields were not separate from one's life. One did not go *out* to things, one was part of them. The mountain, if anything, came to one, came into the house; one ate it with the cake. At least it seemed that way to me. Yet afterwards, when he'd been there awhile, he was the one that upbraided me for being too cluttered up by things, and he wrote a poem that began: Let us unhouse the women.[17]

Symbolically depriving Dodge of her wealth and her house, however, did not actually remove Dodge from Taos, and the Lawrences sought escape with Bynner and Johnson in Mexico.

If Bynner and Johnson initially left with the impression that Lawrence

owed his dissatisfaction with New Mexico to Dodge, they must have discovered quickly they were mistaken. Lawrence was difficult both as a man and traveling companion. In his memoirs from the journey, Bynner described Lawrence's frequent temper tantrums and intimated that Frieda Lawrence suffered both physical and emotional abuse from her husband. Bynner never openly confronted Lawrence regarding his ill treatment of his traveling companions or his wife, but he often considered some kind of interference. Johnson apparently enjoined Bynner to keep his opinions to himself, and the two men endured Lawrence's outbursts in silence.[18]

The Lawrences, meanwhile, despite inviting the couple along, appeared discomfited by traveling with gay men. Frieda wrote to friends of hers that Bynner and Johnson were "both nice, but Bynner is an old lady and Johnson a young one." Lawrence, who some critics believe engaged in homosexual relationships himself, seemed unfazed by Bynner's and Johnson's romantic relationship but felt that Bynner was a stifling mentor for his younger companion.[19] While the group was in Mexico, he wrote his U.S. publisher, Thomas Seltzer, to see if he could offer Johnson a more prestigious position. "He's very reliable and does good work," Lawrence explained. "I think he ought to have a proper job, not be just Bynner's amanuensis."[20] A job far from Taos obviously would have upset Johnson's relationship with Bynner, but Lawrence apparently thought he knew what was best for Johnson.

Lawrence might have interfered even further with the relationship between Bynner and Johnson if Dodge's activities back in New Mexico had not distracted him. In April 1923 Dodge once again attracted Lawrence's attention when she and Lujan decided to marry. He wrote to friends of Dodge's in Taos, friends almost certain to report back to Dodge, "Mabel married Tony, I hear—why?"[21] Lawrence did not appear to see the match as a good one, and he wanted Dodge to know of his disapproval. As in his published writing about American Indians, however, Lawrence matched his distaste with fascination. In other correspondence he appeared preoccupied with Dodge's decision. Shortly after writing to Dodge's friends in Taos, he wrote Seltzer to ask if he had heard of Dodge's marriage. "She is now Mrs. Antonio Lujan," Lawrence explained. "It gives me a sort of end-of-the-world feeling. Mexico does that too. It feels like the end of the world."[22] Frieda Lawrence voiced a similar opinion. She wrote to a mutual friend of hers and Dodge's that "your world must have come tumbling about your ears, your whole world when you heard that Mabel had married Tony—In my *head* I say: why not, but somewhere else

it's *so* impossible." She went on to report that she had heard "the Indians dont like the marriage, and the Taos people dont, but they have something to talk about and that they *do* like."[23] Like the people of Taos, the Lawrences seemed fascinated by Dodge's and Lujan's marriage. Whether they approved, they could not seem to stop thinking about it.

Indeed, Dodge's marriage appears to have helped her reconcile with the Lawrences. Dodge's relationship with Lujan allowed her to keep D. H. Lawrence's attention, and eventually to secure his blessing. By the fall he finally told Dodge that Lujan had always had his "respect and affection," and that her marriage with him "may even yet be the rounding of a great curve; since certainly he doesn't merely draw you back, but himself advances perhaps more than you advance, in the essential onwards."[24] As was typical of Lawrence's and Dodge's interactions, neither of them clarified what they meant by "a great curve" or "the essential onwards," but his letter reflected a new warmth toward her, Lujan, and the Pueblo Indians.

Lawrence's new attitude eventually brought him back to Taos in spring 1924. As was typical of their peripatetic life, the Lawrences traveled extensively before returning to the Southwest. After leaving Mexico, they bounced around the United States, separated for several months when their marriage became particularly strained, then reunited in England toward the close of 1923.[25] Once there, D. H. Lawrence began recruiting members for a utopian community that he called "Ranamin," which he hoped to found back in Taos. He was largely unsuccessful, and when the Lawrences reappeared in New Mexico in spring 1924, they had only one recruit, artist Dorothy Brett. Brett and the Lawrences immediately settled in Dodge's son's house, north of Dodge's own. The property bordered the ranch they had rented the previous year, and the Lawrences found their new home comfortable and familiar. Dodge was delighted with the Lawrences' return, and brought her entourage back from a sojourn in San Francisco to greet them. Soon thereafter she offered her son's ranch to the Lawrences as a gift. Frieda Lawrence insisted on repaying Dodge and gave her the manuscript of *Sons and Lovers*. The Lawrences had joined Dodge's household again.

Dodge not only gave Lawrence the only home he ever owned, she also attempted to be the kind of woman he liked. As her biographer Lois Rudnick has explained, she even wrote a lengthy poem entitled "The Ballad of the Bad Girl," in which she renounced feminism and insisted that mothering was a sufficiently powerful role for any woman. Although the poem seems comic in

retrospect, Dodge meant it seriously and even told Van Vechten that it was "an earnest appeal to women to leave off trying to steal the world away from men."[26] In 1929, Lawrence took up the theme of "The Ballad of the Bad Girl" himself in an allegory titled "Cocksure Women and Hensure Men," in which he condemned to "nothingness" those women who tried too strenuously to control the world around them.[27] In an unpublished essay titled "Women Are So Cocksure," Lawrence explored the theme again, this time condemning women at age fifty who had asserted too much control over their own lives. "If you have been making a grand mistress of your destiny, all triumphant, the clock of years tolls fifty, and the play is over," he warned middle-aged women. "Now you must go, out into the common night, where you may or may not have a true place of shelter."[28] Dodge had found her writer, and she apparently was willing to renounce much of her previous behavior as well as her aspirations in order to keep him.

Briefly, Dodge's and Lawrence's wishes seemed harmonious. Even Lawrence's writing appeared to match Dodge's expectations. After returning to Taos, Lawrence wrote a new piece describing a spring dance at Santo Domingo Pueblo. The article, "Dance of the Sprouting Corn," conformed closely to the image of New Mexico Dodge wanted to publicize. Lawrence restricted himself primarily to description, and for the first time the New Mexico landscape emerged as a prominent element of his writing about the Southwest. Like many in the Dodge circle, Lawrence acknowledged the land as ancient. He wrote that driving to the Pueblo was like driving through "the bed of a great sea that dried up unthinkable ages ago, and now is drier than any other dryness, yet still reminiscent of the bottom of the sea, sand hills sinking, and straight, cracked mesas, like cracks in the dry-mud bottom of the sea." Lawrence also softened his descriptions of the Pueblo Indians. He had previously portrayed southwestern Indians as alien, but in "Dance of the Sprouting Corn," they appeared as a part of the earth itself. When the dancers formed a group, Lawrence described them as a "forest." When they spread into a line, they were "straight as rain," and when a dancer stooped downward, he brought his life "down, down, down, down from the mind, down from the broad, beautiful shaking breast, down to the powerful pivot of the knees, then to the ankles," until it plunged "deep from the ball of the foot into the earth, towards the earth's red center, where these men belong."[29] Lawrence appeared to have forgotten his previous sense of alienation and instead seemed reassured by the Santo Domingo ceremony. He still saw the

Pueblo Indians as primordial, but in his second round of writing on New Mexico, he found their supposedly ancient ties to the land appropriate and comforting. As important as Lawrence's attention to New Mexico mesas and dusty roads was his implication that the Pueblo Indians were human manifestations of the land. Dodge had long presented Pueblo Indians as the emissaries of an authentic country. Lawrence now appeared to be endorsing her view that New Mexico was the heart of that authenticity and the Pueblo Indians the key to unlocking the nation's artistic and spiritual potential.

The harmony on Dodge's grounds, however, was short-lived. Over the next several months, Lawrence came tantalizingly close to creating the kind of writing about Taos Dodge wanted, but then, at the last moment, snatched her prize away. After finishing "Dance of the Sprouting Corn," Lawrence wrote two more pieces that echoed the terms of Dodge's enthusiasm for New Mexico.[30] By the beginning of summer, however, he had turned his attention to two different pieces, "The Woman Who Rode Away" and *St. Mawr*. Characters based on Dodge appear in both stories, and the landscape described in "The Woman Who Rode Away" bears a striking resemblance to that surrounding Taos. But Lawrence set both stories in Mexico, not New Mexico. Dodge wanted Lawrence to write something that proved she had found the authentic center of her country, but Lawrence had yet to deliver.

"The Woman Who Rode Away," in particular, seemed to be an attack on Dodge and her approach to the Southwest as well as the Pueblo Indians. In its broad outlines, "The Woman Who Rode Away" is something of a tribute. Before his death Lawrence told Frieda, "'The Woman Who Rode Away' is Mabel's story to me."[31] In the story, a thirty-three-year-old woman travels three days in the desert of Mexico before a group of Native American men abduct her, drug her, hold her in their village, then sacrifice her in a ritual designed to regain the power and land they had lost to white settlers. If Dodge felt honored by her savior's role, she must have been somewhat discomfited by the dislocation and abuse her fictional self endured. Moreover, Lawrence removed his story from the New Mexico landscape and placed it, instead, in Mexico. Although the cave Lawrence described bore a remarkable resemblance to one Dodge had shown the Lawrences in New Mexico, Dodge did not even have the satisfaction of seeing her home acknowledged as inspiration for the story. As if that were not enough, Dodge then watched her character lose herself in the desert, endure abduction, and finally die. Lawrence appeared to punish Dodge for the power she wielded over her home and her

friends, and he did so by denying her character any security in the landscape she called home.

"The Woman Who Rode Away" may have been Lawrence's most vigorous effort to punish his hostess, but Dodge rejected its message. Dodge never wrote another capitulation after "The Ballad of the Bad Girl," and she ceased trying to convince Lawrence to write a book about her. She even recognized "The Woman Who Rode Away" as a vindictive attack. While wintering at Croton, she wrote to Leo Stein that Lawrence was "too damn mean—that's the trouble. He has satisfied his sadism in a story called 'The Woman Who Rode Away.' . . . It was about a white woman whom he makes sacrifice herself voluntarily to the indians who finally cut out her heart up in that cave above Arroyo Seco."[32] Dodge would not agree to be a sacrificial lamb or the docile acolyte she had described in her ballad or even a housekeeper for one of her guests. If Lawrence rejected a woman's role in the place she had embraced, then she would reject Lawrence.

Dodge's increasing animosity did not deter Lawrence from continuing to use her in his writing. In October, the Lawrences, accompanied by Brett, returned to Mexico, and by November Lawrence had begun revising a novel he called "Quetzalcoatl." Eventually published as *The Plumed Serpent,* the book described an interracial love triangle between a European woman and her European and Indian lovers, a theme not far from Dodge's personal experience. After reading *The Plumed Serpent,* Bynner wrote Lawrence to tell him Dodge had had too much influence on the book's conclusion. After praising the first half of the novel, Bynner launched a critique. "I resented . . . a presence of weakness, after your own presence had been strong," he said of the second half of the novel. "It almost seemed as though you had dropped the pen . . . and let Mabel take it up and proceed to impose upon your pages her idiotic bunk about Tony's spiritual qualities and to infuse into your magnificent vision her queasy female notions generally."[33] Biographer Lois Rudnick sees Kate, the female protagonist of *The Plumed Serpent,* as an amalgam of D. H. Lawrence, Frieda Lawrence, and Dodge. Kate holds herself above Mexican and Indian peoples as did D. H. Lawrence, embraces sensuality as did Frieda Lawrence, and pursues authentic experience as did Dodge.[34] Nonetheless, the elements of Dodge's character that entered the book opened Lawrence to attacks from people like Bynner, who appears to have embraced the author in part because Lawrence articulated a misogynist critique of Dodge. In no other piece of writing would Lawrence be as generous to Dodge. *The Plumed Ser-*

pent was, at best, a portrait of what might have been had the two been able to collaborate.

The Plumed Serpent came closest to the novel Dodge had always wanted from Lawrence, but it was not close enough. Lawrence set *The Plumed Serpent*, like "The Woman Who Rode Away," in Mexico. Dodge's plans suffered even further when Lawrence's editor suggested that he publish a selection of his essays about the Americas as a book. Lawrence dedicated the book to "Mabel Lujan," but it was titled *Mornings in Mexico.*[35] Lawrence had finally "written the country up," just as Dodge had wanted. What she had failed to foresee was that he would call the country "Mexico."

Dodge was not so offended by Lawrence's slights to her and her vision for the Southwest that she ended their relationship, but she did not exactly encourage their friendship in the years that followed. When Lawrence returned from Mexico in spring 1925, he was suffering from tuberculosis. Dodge barely saw him while he was recuperating at the ranch, and their correspondence was limited after the Lawrences decided to return to England in September. In fact, after "The Woman Who Rode Away" was published in the summer of 1925, Dodge and Lawrence did not see each other ever again. They would later exchange letters about publishing the first volume of Dodge's memoirs, but they held each other at a distance. Although Lawrence frequently mentioned that he was considering a return to New Mexico, ill health kept him in Europe. He died in March 1930 without ever returning to Taos.

Dodge's and Lawrence's long history of personal conflict helps to explain the cooling of their relationship, as does competition between Dodge and Frieda for Lawrence's attention, but Lawrence's vision of New Mexico also differed fundamentally from that of Dodge. Some of their differences had been apparent as early as December 1923, when Dodge was caught up with the Bursum bill. After their first major split, Dodge told Leo Stein that Lawrence "was a dismal failure as a visitor or appreciator of the whole thing." The "whole thing" in Dodge's nomenclature meant the campaign for Indian rights and her efforts to form a community of intellectuals and artists in Taos. She claimed that he "hated & feared the indians. They, too, [like Dodge] were 'evil'—'destructive' & 'like these mountains, full of a patient unwearying & eternal *opposition*.'"[36] Alice Henderson echoed Dodge's objections and told her that Lawrence's writing about the Pueblos made her "sick . . . as sick as he says the Indians *make him*."[37] Both women's images of northern New Mexico

necessarily included an idyllic description of Pueblo Indians, a description Lawrence was unwilling to yield. When Lawrence finally did write essays that pleased Dodge, like "Dance of the Sprouting Corn," the enthusiasm he expressed for Pueblo Indians stemmed from his pleasure in the landscape. Lawrence absolutely refused to cast himself as the Pueblo Indians' savior, and he refused to cast the Indians as the ambassadors of an authentic nation.

Moreover, Lawrence repeatedly attacked the premise that Anglo women had a unique connection with the Pueblo Indians, and therefore the land of New Mexico. He expressed his anger with this idea most articulately in a comic play fragment titled "Altitude," which Johnson later published in the *Laughing Horse*.[38] The play opens with Mary Austin chanting "Om" in the doorway of Dodge's kitchen. She muses to herself, "This country is waiting. It lies spell-bound, waiting. The great South-West, America of America. It is waiting." After Johnson arrives for breakfast, she tells him: "It is a Woman Mediator you are pining for. The Woman Redeemer!" Johnson ignores her, but throughout the play Austin persistently announces that a white woman will learn to understand the Indian way of life and thereby redeem the land of the Southwest, even suggesting at one point that she herself is the woman redeemer. Dodge meanwhile attempts to convince each arriving guest of the superiority of the Pueblo Indians. "They have *life*, where we have *nerves*," she tells her assembled guests. Austin's and Dodge's words stand in stark contrast to their actions, however. They are hapless in the kitchen without Dodge's cook, and they both periodically interrupt themselves to give orders to a Pueblo Indian character named Joe and to Tony Lujan. Lawrence did not just reject Dodge's style of primitivism in his writing, he actively mocked her expression of it, and he did so in terms that questioned the unique connection to northern New Mexico that Dodge, Austin, and other women claimed as a result of their gender.

When Lawrence was not spending his energy attacking Dodge's perspective, he turned his creative efforts to celebrating the landscape of New Mexico. The enthusiasm and creative energy Dodge had wanted Lawrence to extend to the Pueblo Indians, he directed instead toward his writing about the land. His descriptions of New Mexico landscapes in some ways paralleled his earlier writing about the Southwest Indians. He seemed both fascinated and terrified by the mountains surrounding his home north of Taos, and he could not seem to decide whether beauty or danger best defined the place. In *St. Mawr*, which eventually grew into a short novel, he described a landscape similar to

that near his ranch as "beauty, beauty absolute, at any hour of the day: whether the perfect clarity of morning or the mountains beyond the simmering desert at noon, or the purple lumping of northern mounds under a red sun at night." "The landscape," according to Lawrence, "lived, and lived as the world of the gods, unsullied and unconcerned. The great circling landscape lived its own life, sumptuous and uncaring. Man did not exist for it." Lawrence tried to distance himself from the effects of the sublime place he described by giving his fears to a female character in *St. Mawr*. Even as her love for the ranch turns into a "certain repulsion," however, one can see Lawrence negotiating his own fears of "the spirit of place: the crude, half-created spirit of place, like some serpent-bird forever attacking man, in a hatred of man's onward struggle towards further creation."[39] When Lawrence wrote about Pueblo Indians he held his distance, but when he wrote about the land in which they lived, he was overwhelmed.

The depth of Lawrence's faith in the land appeared again in his writing after he left New Mexico for the last time. While in Italy, he was overcome with nostalgia for his ranch, and wrote a short piece for Johnson's *Laughing Horse* describing his feelings. He called the piece "A Little Moonshine with Lemon," after his drink of choice on cold Rocky Mountain evenings. The article followed Lawrence through an evening back at his ranch. More than any of his other writing about New Mexico it reflected the satisfaction and pleasure he had drawn from having his own home with its own responsibilities. In describing the grounds, he lingers along the snow-covered alfalfa field to admire the moonlight over Ranchos de Taos. He looks with pleasure at his iron tools; he checks on his chickens, his horses, and his cow; he lights his stove. Until the realities of his new life on the Mediterranean intervene, he is lost in the memory of his ranch. He imagines himself waking in his bedroom to see the pine tree outside his bedroom "like a person on guard, and a low star just coming over the mountain." For a brief moment, Lawrence revealed his affection for New Mexico, unfettered by his fears for the future of civilization or his prejudice against the Pueblo Indians. He simply loved his home in the "wonderful, hoary age of America, the continent of the afterwards."[40]

Lawrence never matched the calm and appreciation he produced in "A Little Moonshine with Lemon," but he did write one more article about the place he had called home. "New Mexico" appeared in *Survey Graphic* in March 1931, a year after Lawrence's death. Lawrence had written the article at Dodge's request, and it has the feel of an article demanded of him. Lawrence had not

lost his knack for finding a community's weakest element. The article antici-
pated later complaints about tourism in the Southwest, and mocked those
who came to see "the picturesque reservation and playground of the eastern
states, very romantic, old Spanish, Red Indian, desert mesas, pueblos, cow-
boys, penitentes, all that film stuff." Unlike earlier pieces, however, Lawrence
left off ranting and turned to a lovely rumination on the beauty he saw in New
Mexico. He even spoke in a more complimentary fashion about the Pueblo
Indians and predicted that their religion, "the oldest religion, a cosmic reli-
gion the same for all peoples," would soon revive not only among the Pueblos
but also throughout the United States. In terms remarkably similar to the
kind Austin and Dodge used, he concluded triumphantly, "The skyscraper
will scatter on the winds like thistledown, and the genuine America of New
Mexico will start on its course again."[41] Lawrence had finally done it. Here,
preserved in his writing, was what Dodge had wanted: the genuine America
of New Mexico.

Even Dodge must have recognized, however, that her victory was a hollow
one. Lawrence's one article in *Survey Graphic* hardly outweighed the collective
effect of his first articles about the Southwest Indians, "The Woman Who
Rode Away," *St. Mawr, The Plumed Serpent, Mornings in Mexico,* and "A Little
Moonshine with Lemon." If Lawrence's body of work suggested a central
theme about New Mexico, it was hardly the positive triumph of Indian reli-
gion in the "genuine America of New Mexico." The tenet of his writing that
emerged was the role of the land in marking New Mexico as a distinct place.
The land, not the Indians, made New Mexico unique in Lawrence's eyes, and
gave him hope in the cultural and spiritual future of the United States.

"New Mexico" ended on a positive note, but it did not begin to overcome
the tone Lawrence set. "Let me make a reservation," he started. "I don't praise
the Red Indian as he reveals himself in contact with white civilization. From
that angle, I am forced to admit he *may* be thoroughly objectionable. . . . But
also I know he *may* be thoroughly nice, even in his dealing with white men.
It's a question of individuals, a good deal, on both sides."[42] For all his roman-
tic conceptions of Indian religion and his racism against Indians, Lawrence
ultimately saw the people of the New Mexico Pueblos as individuals. They
were not a part of the earth. The Indians and the land, in Lawrence's concep-
tion, were separate.

Dodge could not follow Lawrence's leanings. Her marriage to Lujan, her
financial support for Collier, her letters celebrating the Pueblos, her publicity

of the Bursum bill issue, and her rejection by the Nuevomexicano community all combined to deepen her belief that the Pueblo Indians and the landscape were of a piece. She could not, given her social and political position in northern New Mexico and her angling for power in the arts community of New York, simply announce that she had been wrong. Like almost all of the New Mexico art colony members who interacted with Lawrence, she later celebrated her connections to him. He had, after all, written "New Mexico" at her request. But she had never harnessed Lawrence's creative energies to serve her own needs. In her comparisons of the Pueblo Indians with Nuevomexicanos, in her quest to prove the Pueblo Indians the most deserving of New Mexico people, and in her ongoing passion to prove New Mexico the heart of U.S. modernism, she connected the Pueblo Indians irrevocably to the land. They were more than New Mexico emissaries; they were the place in human form. When Lawrence refused this conception of New Mexico and its indigenous peoples, Dodge's relationship with her most famous guest crumbled.

By attacking Dodge's primitivism, Lawrence hit her weakest point. His frustration that a woman, particularly a woman as difficult as Dodge, exerted so much power in the place he wanted to call his own led him to fight her image of New Mexico. His criticisms were incisive and scathing. They are, perhaps, the best contemporary critique of Dodge's vision for Taos and the Pueblo Indians, and they anticipated the criticisms of later scholars who took Dodge and others to task for failing to see the condescension and narcissism of the primitivism they practiced. Nonetheless, by framing his picture of New Mexico as a rejoinder to the artist's home Dodge, Austin, and other women had cultivated, the image of New Mexico his collective writings sketch leaves no role for people. The Pueblo Indians are distasteful. The Anglos are lost in their own visions. Nuevomexicanos are almost nonexistent. Even Lawrence himself subscribed to primitivism in *The Plumed Serpent*. Everyone is subject to Lawrence's mockery, and no one has the potential to realize the genius of the place.

In *Studies in Classic American Literature,* Lawrence wrote "Every continent has its own great spirit of place. Every people is polarized in some particular locality, which is home, the homeland. Different places on the face of the earth have different vital effluence, different vibration, different chemical exhalation, different polarity with different stars: call it what you like. But the spirit of place is a great reality."[43] Lawrence had moved across the entire globe searching for that great reality. He had plumbed his own depths seeking the

perfection of self he thought necessary to find a homeland. But none of Dodge's guests, in his view, not even Lawrence himself, had perfected themselves such that they could find the spirit of the place. In the end, the great reality eluded them all.

Epilogue:
Georgia O'Keeffe's Place

Walk through the tourist centers of New Mexico—downtown Santa Fe and Taos, the Albuquerque airport, gift shops scattered throughout the state—and you will probably see a poster of a black and white photograph of Georgia O'Keeffe on the back of a motorcycle. She is not driving, but one gets the impression that she could be. She sits behind a man, and she is turned toward the back of the vehicle, smiling. A pair of goggles sits atop her head, and she has rolled up her jeans almost to the knees. Piñon trees dot the land around her. A mesa rises in the distance. Sometimes the poster tells you that you are "Entering O'Keeffe Country." Other times, along with the image of O'Keeffe, are the words: "Women Who Rode Away."[1] The phrase is reminiscent of Lawrence's story, but nothing about the image suggests a woman on her way to a ritual sacrifice. O'Keeffe is vibrantly alive in the photograph, and she appears to be inviting viewers to come along with her. Lawrence may have condemned to death the woman who rode away, but in the annals of popular culture, O'Keeffe has written a new ending. New Mexico is where women ride away, but they ride toward creative inspiration.

How O'Keeffe's vision managed to supplant Lawrence's is a story worth investigating. Her images are probably the most widely recognized representations of New Mexico. In the story of Dodge's years in Taos, O'Keeffe is also an important figure. Although she did not spend a significant amount of time at Dodge's home, far more than any of Dodge's other visitors, or even Dodge herself, O'Keeffe successfully transformed northern New Mexico's reputation into what Dodge most desired. Through the promotion of both her work and

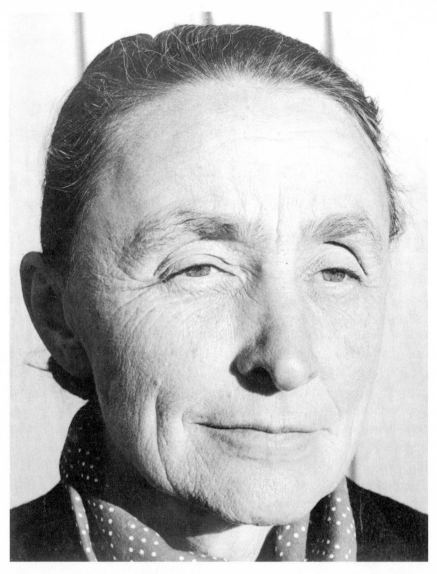

Georgia O'Keeffe. (Yale Collection of American Literature, Beinecke Rare Book and
Manuscript Library.)

herself, O'Keeffe came to symbolize modern art in northern New Mexico, the
region's ties to New York cultural institutions, the area's austere and primor-
dial beauty, and the promise that in the northern New Mexico landscape
women could be creative, independent, and at home. O'Keeffe furthered the

image of northern New Mexico as a place worth visiting, a place worth recording, a place outside of modernity, indeed, a place outside of time. Most of all, she claimed it as her place.

Beginning in the 1970s, large numbers of New Mexicans began claiming her as well. Local shows honored O'Keeffe's work. Local museums began seeking O'Keeffe pieces. Promotional material for artistic events in the state began using her images. In their efforts to claim O'Keeffe, northern New Mexicans reiterated much of what O'Keeffe had said about the region. They also used a language that mirrored that of Dodge and her visitors. Increasingly, in promotional material about the region, northern New Mexico was a place apart, a place of extraordinary, almost unreal beauty, and a place of ancient traditions. By the time of her death in 1986, O'Keeffe had literally become the New Mexico poster girl, and the image of the region as a world apart had been cemented.

O'Keeffe was certainly not the last of Dodge's visitors, nor was she the last artistic figure Dodge pursued. Throughout the 1930s, Dodge continued to host writers and artists in Taos. Artist Maynard Dixon, writer Aldous Huxley, dancer Martha Graham, photographer Edward Weston, and conductor Leopold Stokowski all spent time in Dodge's home and found inspiration in the landscape and the indigenous cultures they explored. Although the visit did not yield what she wanted, Dodge even invited poet Robinson Jeffers to write of the landscape what Lawrence had failed to deliver. Into the 1940s, Dodge continued to cooperate with creative figures, including the photographer Laura Gilpin and another luminary of New Mexico literature, Frank Waters. Dodge even briefly revived her salon in New York City, but the experiment was short-lived.[2] Although Dodge significantly limited her activities in the decade before her death in 1962, she never gave up on making her Taos household into an artistic and creative center.

Nonetheless, no figure who visited after O'Keeffe had the painter's level of impact on the region. The year 1929, when O'Keeffe first visited Dodge's household in Taos, was the last year Dodge's guests consisted primarily of visitors from her New York days. O'Keeffe returned to New York so enlivened by her stay that she held a triumphant show in 1930, two-thirds of which had been inspired by her time in Taos. In the ongoing cultural dialogue between Taos and New York, O'Keeffe was one of the most articulate participants.

Most significantly, O'Keeffe represents the power Dodge's household held over the U.S. image of the northern New Mexico landscape. O'Keeffe's vision

of New Mexico vaulted the region into the national consciousness, and provides an ongoing inspiration to creative women seeking places in which to nurture their self-expression. But O'Keeffe's presentation of northern New Mexico also affirms impressions of the region as an untouched wilderness and a place outside modernity. As the preceding pages have shown, the troubles accompanying such an image are manifold. In present-day political contests, Native Americans continue to encounter the language of primitivism that flowered in Dodge's household when John Collier first visited and during the Bursum bill struggle. New Mexicans continue to battle endemic poverty, despite (or, as some have argued, because of) an extensive tourism industry based on the reputation of the region as timeless, a reputation nurtured in part by Nina Otero-Warren's response to Collier's campaign. Some artists continue to trade in primitivist stereotypes, and the creative networks that tie New Mexico and New York together continue to place promoters of such stereotypes, such as Carl Van Vechten, and objects of such stereotypes, such as Tony Lujan, in an uneasy relationship with each other. Anglo women continue to seek homes for creative activity in northern New Mexico as Mary Austin did, and they continue to encounter men such as D. H. Lawrence who mock them for their selfish consumerism. Each of these problems has various roots, but they are unlikely to find resolution until we complicate presentations of the area such as O'Keeffe's. Because she was one of the main ties between New York's modern art world and New Mexico, because she is probably the best known of Dodge's guests, because her presentation of New Mexico encapsulated the representations of the region nurtured in Dodge's household, and not least because the power of O'Keeffe's work is an indication of the power art holds to change circumstances for the better, O'Keeffe is a logical endpoint for the story of Mabel Dodge Luhan, her New York guests, and their quest for a place in which they could belong.

Georgia O'Keeffe and her friend and fellow artist Rebecca Strand arrived in Taos almost serendipitously. Dodge, while visiting New York in January 1929, had invited Stieglitz and O'Keeffe to visit. By then, O'Keeffe and Stieglitz had built a substantial artistic reputation for O'Keeffe. Since he had first received charcoals by O'Keeffe from one of her classmates in 1916, Stieglitz had continued to show her work at his 291 gallery and, in subsequent years, at the Anderson Galleries, the Intimate Gallery, and An American Place, his last New York exhibition space. Her greatest admirer and advocate, Stieglitz promoted O'Keeffe's work assiduously. The two married in

1924, and they split their time between New York City and Stieglitz's family home at Lake George, New York. When Dodge invited them to New Mexico, poor health kept Stieglitz at home, but O'Keeffe arrived with Strand some months later.[3]

The two women were initially reluctant to stay with Dodge, but she was persistent. She cornered them at a Pueblo dance, and, when they insisted they were staying elsewhere, Dodge informed them that she had already sent their trunks on to her estate. They were quickly installed at the Pink House, and Dodge also offered O'Keeffe the studio. The two women rapidly overcame their reluctance to stay and delighted in their freedom from their husbands along with the unscheduled days of Dodge's home. O'Keeffe even began taking driving lessons, an exercise Stieglitz had long discouraged. Although O'Keeffe's reputation in the New York art world was well established by the time she visited Taos, she had a disappointing exhibition earlier in 1929. Her trip to Taos revitalized her and her creativity.[4]

Over that summer, O'Keeffe worked her way through the standard paintings of santos, Ranchos de Taos church, and Taos Pueblo itself, but hints of her later work appeared as well. Particularly in a series of paintings of penitente crosses against a backdrop of a southwestern night sky, O'Keeffe illustrated the spiritual inspiration she found in the New Mexico landscape. Perhaps the best-known painting from the summer, however, is "The Lawrence Tree." Because Dodge was in Buffalo recovering from a hysterectomy in summer 1929, O'Keeffe described the painting to her. "I had one particular painting that tree in Lawrence's front yard as you see when you lie under it on the table with stars it looks as tho it is standing on its head—I wanted you to see it."[5] Whatever Dodge thought about the painting, she did not record, but the work shows O'Keeffe's sensual appreciation of New Mexico as well as her engagement with Lawrence's writing. Lawrence had described the tree himself in *St. Mawr*, and Lawrence's work remained in O'Keeffe's library throughout her life. Although Lawrence, typically, saw the tree with some ambivalence, O'Keeffe made it entirely her own. In the painting, the tree reaches up and seems to kiss the sky, much as O'Keeffe herself once said she wanted to do.[6]

Although Dodge remained ambivalent about O'Keeffe and suspicious of her relationship with Lujan, she did not hesitate to include O'Keeffe in her presentation of northern New Mexico. Indeed, Dodge was, arguably, O'Keeffe's first New Mexico booster. Dodge made sure to note in her memoirs that she

had been one of the first to see O'Keeffe's work at Stieglitz's 291 gallery, and in 1931 she wrote a glowing article about her guest for *Creative Arts*. If anything, Dodge exaggerated O'Keeffe's connection to New Mexico in an attempt to advertise her own home and her vision of Taos. She started breathlessly. "Take an exquisite sensitive mortal like Georgia O'Keeffe who is so specialized that she is like no one else . . . and suddenly lift her from sea level to the higher vibrations of a place such as Taos and you will have the extraordinary picture of her making whoopee! She doesn't make whoopee like other people do, but she makes it just the same." Dodge made sure to explain that Taos itself had caused such a fascinating transformation in one of the country's best artists. "And when her spirit soared up into the mystical strange fastnesses of that strangest of American places called Taos, it came back with the partial vestiges of her experience that we know as her Art, and we can trace there somewhat of her benefit, her added life and her joy, so that we know it did her what is called good and thus we share somewhat in her fate." Of course, for those readers who wanted to share in O'Keeffe's fate beyond a mere glance at her paintings, Dodge opened the possibility that O'Keeffe just might be in Taos again. She ended the article with some sharp words to O'Keeffe's husband: "You had better let her come again, Stieglitz."[7] Dodge did not explain what would happen if he didn't comply, but she had already made her point. O'Keeffe's work represented exactly the vision of Taos Dodge had long been seeking, and Dodge was perfectly willing to use it to advertise her own home. Dodge never was completely comfortable with O'Keeffe, and she might well have prompted O'Keeffe's settlement west of Taos in Abiquiu. Nonetheless, she never missed an opportunity to claim O'Keeffe belonged to Taos.

Dodge had nurtured many women artists and writers at her home, but O'Keeffe's presence in summer 1929 seemed to magnify the creative inspiration women found there. Rebecca Strand promised a hint of what other women would find when they visited the Taos that O'Keeffe popularized. Just days before she departed Taos, Strand wrote to Dodge that her time in New Mexico was "the first time I have been so completely myself, so well, so happy."[8] Strand would later divorce her husband, the photographer Paul Strand, remarry, take her new husband's last name, James, and move permanently to his home, New Mexico. It seems likely that Dodge chose to capitalize on O'Keeffe's and Strand's experiences in Taos. Where the two women found freedom in driving lessons, long horseback rides, and evening jaunts in the mountains, Dodge may have promised freedom to female visitors look-

ing for liberation from constraining marriages and jobs. In her celebration of Tony Lujan, O'Keeffe threatened Dodge at her most vulnerable, but Dodge managed to recover and even take a bit of O'Keeffe with her in the process. O'Keeffe's visions of the landscape too closely matched Dodge's own for the patron to ignore them. O'Keeffe, after all, saw New Mexico as spiritually satisfying, individually liberating, and a unique home for those who could find art in the land.

Although O'Keeffe was enormously productive in her first summer at Dodge's estate, she did not always enjoy the atmosphere that prevailed when Dodge was at home. The following summer, she seems to have resented the gossip and intrigue that had always marked Dodge's households. For the most part, she focused instead on her work. O'Keeffe did work at the studio on Dodge's estate, but she took her meals elsewhere and eventually moved to a hotel. By spring 1931, when she returned to New Mexico again, she chose to stay in the tiny community of Alcalde, between Santa Fe and Taos. She maintained her relationship with Dodge, but O'Keeffe had decided to embrace northern New Mexico independently of her Taos hostess.[9]

By 1940, O'Keeffe had purchased a home at Ghost Ranch, New Mexico, and in 1945 she bought a second piece of property in Abiquiu from the Catholic Church. O'Keeffe had become entranced with a doorway in the Abiquiu home, and she badgered church officials until they agreed to sell. When O'Keeffe acquired the property, the structure was near ruins, but Maria Chabot, who had become an assistant to O'Keeffe and would later photograph her riding away on a motorcycle, agreed to supervise renovation of the buildings. After three years of settling the estate of Stieglitz, who had died in 1946, O'Keeffe moved permanently to northern New Mexico, and from Ghost Ranch and the Abiquiu house continued to make excursions into the desert seeking inspiration for her paintings.[10]

O'Keeffe's southwestern paintings transformed popular images of the region in three significant ways. First, through her paintings of animal skulls, O'Keeffe made animal bones symbols of transcendence, whereas previously in U.S. art, they had represented tragedy, particularly that associated with American Indians. Second, autobiographical elements in her landscape paintings placed her, and by extension, the figure of the woman artist, in the center of a distinctly American place. Finally, by using elements of abstraction instead of more realist depictions like those popular in regionalist schools, O'Keeffe made modern art the dominant mode of representation for visual

images of the Southwest. Critics and art historians have thoroughly investi-
gated O'Keeffe's southwestern work and have noted each of these transforma-
tions, but they bear repeating here because each change was in keeping with
the image of northern New Mexico Dodge had always promoted. O'Keeffe
and Dodge may not have gotten along personally, but in their representations
of northern New Mexico, they drew from the same wellspring.

Art historian Wanda Corn has written eloquently of how O'Keeffe trans-
formed the meaning of animal bones in U.S. western art. When O'Keeffe
first showed her paintings of animal bones suspended against fields of color
or the blue of the sky and the red and pink hills of New Mexico, critics were
baffled. Corn notes they mistakenly looked to the symbolism of European art
instead of that of the American West for O'Keeffe's inspiration. By the turn of
the century, buffalo skulls, which many Americans associated with the pacifi-
cation of Indian peoples, had become a popular motif among western artists,
including Frederick Remington. By the early twentieth century, Anglo artists
who painted western themes frequently used animal skulls in the décor of
their studios as did dude ranch proprietors seeking a touch of authenticity for
their venues. O'Keeffe had probably encountered animal skulls in the studios
of members of the Taos Society of Artists, who painted in a vein more similar
to Remington's than to hers, and at Ghost Ranch. O'Keeffe's paintings seized
the associations most Americans made with animal skulls in the western
landscape and provided a new script. Instead of loss and tragedy, the skulls,
in O'Keeffe's hands, came to represent austere beauty, the solitude and peace
of the desert, and transcendence. Expansive and primordial, they reach
across time and space. If viewers continued to associate the skulls with Na-
tive Americans, Indian people were more likely to appear as having an an-
cient connection to a starkly beautiful place than as a vanishing people whose
way of life had been destroyed. Such a connection was particularly likely in
Red, White, and Blue, a striking painting of a cow's skull against the epony-
mous colors. O'Keeffe later claimed the painting was her effort at "the Great
American Thing," the much-sought representation of American culture she
and other members of Stieglitz's circle pursued throughout their careers.[11]
Ancient, primordial, spiritual, and American—each word was a mainstay of
the primitivism Dodge had cultivated in her household. O'Keeffe probably
did not intend to further any of Dodge's goals, but her paintings of animal
skulls did so.

O'Keeffe's southwestern landscapes not only transformed western art but

also transformed her role as an artist. Throughout her career, O'Keeffe occu-
pied a highly gendered position. Through her relationship with Stieglitz, as
the only woman within the circle of artists whom he patronized, O'Keeffe's
identity as a woman received constant attention. O'Keeffe's intense, oversized
images of flowers magnified this identification. Many critics assumed she
painted flowers because she was a woman artist. When O'Keeffe began paint-
ing bones, however, critics did not know what to make of the subject matter.
There were no easy associations between women and bones. By shifting the
composition in her work, O'Keeffe transformed herself as well. Art historian
Sharyn Udall has argued that in *Rams Head—White Hollyhock—Little Hills,
New Mexico,* the first painting in which O'Keeffe suspended an animal skull
above the New Mexico landscape, O'Keeffe represented her own creative re-
birth following a long and difficult chapter in her professional life and in her
relationship with Stieglitz. The broad stretch of the ram's horns, commonly
associated with goddess imagery, and a hollow space shaped like a female
form at the mouth of the ram's skull both suggest O'Keeffe painted the work
with her own creative resurgence in mind. As Udall writes, "It is as if art—the
act of painting—allows the woman artist to give birth to herself."[12] O'Keeffe
painted land, bones, and women artists as an inextricable whole, each element
starkly beautiful, austere, and spiritually whole. In many ways, she fulfilled
the goal of Mary Austin to make of New Mexico an artist's home for women.

 Although the autobiographical elements of O'Keeffe's work made it
deeply personal, her success as a painter meant that her mode of expression,
abstraction, became the classic manner of depicting northern New Mexico.
Most of O'Keeffe's landscapes are not pure abstractions, but they do represent
the land and the bones she frequently suspended above it in forms not en-
tirely real. Moreover, she worked deeply within a tradition of abstraction influ-
enced by modernist painting in Europe and New York. In her efforts to
capture the allure of New Mexico landscapes, O'Keeffe had many options. She
painted many of her southwestern landscapes in the 1930s, at the same time
that such regionalist painters as Thomas Hart Benton and Grant Wood en-
gaged in a similar effort to create a distinctly American art. Benton and others
criticized Stieglitz and his circle for promoting Manhattan as the center of
American expression when, they contended, New York City suffered too
much from European influence. Regionalists insisted that an authentic
America could only be found in small communities and among local folk.
Although she did not paint in a regionalist style, O'Keeffe did paint in a small

community among what many people considered to be "local folk." O'Keeffe drew from both Indian and Nuevomexicano sources for inspiration.[13] The preference audiences have shown for her landscapes has overshadowed this inspiration, but it persevered in her work nonetheless. The modernist style that had inspired Dodge's involvement in the Armory Show had led O'Keeffe to her unique take on the Southwest. As her work rose in prominence, modernism became the northern New Mexico aesthetic.

The power of O'Keeffe's paintings alone may have solidified her vision of northern New Mexico in the popular imagination, but O'Keeffe also engaged intently in self-promotion that linked her with the land she painted. Although O'Keeffe complained about the invasiveness of public attention and misinterpretations of her work, she and Stieglitz both worked hard to put her work before a wide audience. After Stieglitz's death, O'Keeffe repeatedly claimed northern New Mexico as her domain when she promoted her work and herself as an artist. Although the art world turned away from work by Stieglitz's circle in the 1950s as abstract expressionism ascended, a major retrospective show at the Whitney Museum in 1970 brought O'Keeffe back into the public eye. As one of her biographers has written, O'Keeffe had "outlived her own aesthetic obsolescence."[14] By the early 1970s, feminist interest in women artists had also begun to garner O'Keeffe significant attention, and a growing number of young visitors appeared, without invitation or notice, on O'Keeffe's doorstep, hoping to gain an audience with the iconic figure.[15] O'Keeffe did not always appreciate the attention, but she furthered it through two ventures: a book of her paintings with accompanying text she had written herself and a documentary about her life and art.

The book, published by Viking Press in 1976, included 108 reproductions of O'Keeffe's paintings accompanied by her text. In every regard, the book appeared to be O'Keeffe's effort to shape her own reputation as an artist, and she did so by repeatedly linking herself with the land she painted. In her description of *Ram's Head,* O'Keeffe emphasized the physical effort necessary to produce her paintings: "I had looked out on to the hills for weeks and painted them again and again—had climbed and ridden over them—so beautifully soft, so difficult. (Sometimes I pulled the horse, sometimes the horse pulled me.)" Alongside one of the many paintings she had made of the patio door at her Abiquiu home, she noted "That wall with a door in it was something I had to have. It took me ten years to get it—three more years to fix the house so I could live in it—and after that the wall with a door was painted many times."

For a 1941 painting titled *Red Hills and Bones,* she quoted from the exhibition catalog of an earlier show:

> Then when I paint a red hill, because a red hill has no particular associa-
> tion for you like the flower has, you say it is too bad that I don't always
> paint flowers. A flower touches almost everyone's heart. A red hill doesn't
> touch everyone's heart as it touches mine and I suppose there is no reason
> why it should. Badlands roll away outside my door—hill after hill—red
> hills of apparently the same sort of earth that you mix with oil to make
> paint. All the earth colors of the painter's palette are out there in the many
> miles of badlands. The light Naples yellow through the ochres—orange
> and red and purple earth—even the soft earth greens. You have no associ-
> ations with those hills—our wasteland—I think our most beautiful coun-
> try. You must not have seen it, so you want me always to paint flowers.[16]

Through the labor of her artistic endeavors, her perseverance in acquiring a domestic space in Abiquiu, and her recognition of the earth's "naturally" artistic qualities, O'Keeffe asserted her place in northern New Mexico.

The 1977 documentary about her life reinforced the message that New Mexico was O'Keeffe country. Throughout, O'Keeffe appears dressed in black and white, almost a work of art herself against the rolling hills outside her Ghost Ranch home. O'Keeffe was in the final stages of the book when the documentary was filmed, and, at times, she appears to have quoted directly from the pages of the Viking volume. "When I got to New Mexico, that was mine. That was my country . . . it fitted to me exactly," she asserts as the film begins. After waxing lyrical about the region's beauty, however, she steps back. "I shouldn't say too much about this," she realizes. "Other people may get interested and I don't want them interested." As in her book, O'Keeffe de- scribes the difficulty of painting in the surrounding desert and how in earlier years she would spend the entire day hiking or driving in the desert. In the film, made as O'Keeffe approached ninety, she is spry and able, climbing lad- ders on her property and wandering the hills with the filmmakers. When an interviewer says that it was "nice of Stieglitz" to let her go to New Mexico every summer, she shoots back: "He didn't let me go. I just went." As in her book, O'Keeffe is a formidable, independent figure who clearly made her own way in the art world. The culmination of her life as an independent woman artist is her celebration of the northern New Mexico landscape. Combined,

the book and documentary deliver such a powerful message that most viewers were likely to see northern New Mexico in the terms O'Keeffe had set.[17] Northern New Mexico was an artist's home. O'Keeffe, by virtue of the power of her work, belonged.

New Mexican celebrations of O'Keeffe coincided with the writing of her book and making of the documentary, and gathered intensity over succeeding years. In 1975, O'Keeffe's paintings made up the inaugural exhibition of the Governor's Gallery, a space in Governor Jerry Apodoca's reception room, which he turned over to the public with the expectation that it would educate New Mexicans and tourists about the artistic heritage of the state. In a curatorial echo of Dodge's first promotional efforts for northern New Mexican art, Clara Apodoca, the governor's wife, showed O'Keeffe's paintings alongside paintings by Indian children, but did not show any work by Nuevomexicano artists.[18] In 1976, *New Mexico Magazine* reproduced several of the pages from O'Keeffe's Viking book as a "special Christmas treat,"[19] and in 1984 the New Mexico Fine Arts Museum, now the New Mexico Museum of Art, finally acquired its first O'Keeffe painting of a southwestern landscape, *Desert Abstraction*. The museum already held a painting of Lake George Rebecca James had bequeathed in 1968. The fine arts museum director concluded the painting's "significance to the collection is a major one, for O'Keeffe played a prominent role in the development of modernist painting in New Mexico."[20] At the time of O'Keeffe's death in 1986, *New Mexico Magazine* reprinted a 1973 interview and article segment as a tribute. The article concluded with O'Keeffe's reflection: "I'm lucky to have found my time—not everyone does." The author of the article added, "And her place, New Mexico."[21] Obviously, a promotional publication like *New Mexico Magazine* would choose to accent O'Keeffe's New Mexico ties, but O'Keeffe gave promoters a verbal as well as a visual vocabulary with which to celebrate the state. Repeatedly, she called the place "hers." Many New Mexicans were willing to acknowledge her ownership if it meant attaching O'Keeffe's paintings to popular presentations of the state.

The medium that ensured O'Keeffe's association with New Mexico, however, was the poster. O'Keeffe's work can be found in museum collections across the United States, and museum audiences have eagerly purchased reproductions of her work. A New Mexican arts organization, however, played an especially significant role in popularizing O'Keeffe posters. In 1973 the newly formed Santa Fe Chamber Music Festival sent a very politely worded letter to O'Keeffe requesting permission to use one of her works as the pro-

gram cover for the premier year of the festival. The festival organizers had in mind O'Keeffe's abstract *Music in Pink and Blue* as well as the conviction that O'Keeffe's life and work "exemplify that idealism and discipline which the musician shares with the truly great visual artist."[22] Their correspondence did not mention New Mexico.

By 1975, however, it did. In that year the festival, in consultation with O'Keeffe, chose for the program cover and promotional posters *From the Faraway, Nearby,* one of O'Keeffe's most spectacular skull paintings. In it, an enormous multipronged elk skull dwarfs the delicate pink hills below it. O'Keeffe frequently signed her letters with the words "From the Faraway, Nearby." If she, in fact, did inscribe herself in her landscape and skull paintings, *From the Faraway, Nearby* makes O'Keeffe the mediating figure between the familiar and the distant. She, the woman artist, brings the land to the viewer. Whether audiences felt that O'Keeffe had given them a piece of "her" New Mexico is impossible to gauge, but they loved the poster. The festival director reported to O'Keeffe:

> The 1975 Festival poster has been a spectacular success: over 500 were sold from our box office in Santa Fe alone, and another 200 have been sold to museums and galleries around the country. . . . We have had requests for the posters from all parts of the country, and from such individuals as Mrs. Pablo Casals, Governor Apodaca, Nancy Hanks, the Chairman for the National Endowment for the Arts, the head of the Martha Baird Rockefeller Fund for Music, from the directors of the Edinburgh Festival, and the BBC, the office of the Archdiocese of New Mexico, directors of State Arts Commissions throughout the western states, and many others.[23]

Festival organizers had always been excited about the prospect of cooperating with O'Keeffe, but the success of *From the Faraway, Nearby* appears to have secured their commitment to the partnership.

The success of that poster also appears to have led the festival directors to look specifically to O'Keeffe's New Mexico paintings. In November 1975 the festival director wrote O'Keeffe to ask if they could use *White Shell with Red* for the following year. "The drama of *White Shell with Red* is, I believe, an incredible image for the 1976 Festival poster, it seems to me to speak of everything: music, New Mexico, and is, of course a remarkable painting which I

know would excite people as much as *From the Faraway, Nearby* has in this past year."[24] The inspirational quality of the New Mexico landscape would continue to be a theme in O'Keeffe festival posters for twenty years. Although festival organizers used O'Keeffe's flowers and abstractions as well, landscapes, and those paintings that tie O'Keeffe to New Mexico, have been popular choices. The 1981 poster featured *The Lawrence Tree*. The 1984 poster depicted *Summer Days,* another of O'Keeffe's dramatic bone paintings and the image used for the cover of her Viking book. The 1987 poster showed one of her penitente cross paintings. The twenty-fifth anniversary poster used *In the Patio VIII,* one of the many paintings O'Keeffe rendered of her Abiquiu house. Perhaps more than any other source, posters have led the public to view New Mexico as O'Keeffe country.

The posters, at first glance, have little to do with Mabel Dodge Luhan or her other guests. Dodge did not live to see the inaugural season of the Chamber Music Festival, and she probably would have expressed ambivalence about the tourists who have been inspired by the posters. Moreover, when the Georgia O'Keeffe Museum opened in 1997, it opened in Santa Fe, not Taos. If one looks closely at O'Keeffe's career, however, the links between her and Dodge's household become hard to miss. Charles Collier, John Collier's son, taught O'Keeffe to drive and first introduced her to Ghost Ranch. O'Keeffe and Jean Toomer carried on romantically charged correspondence in the early 1930s. Via Carl Van Vechten, O'Keeffe made arrangements to deposit her and Stieglitz's correspondence with the Beinecke Library, the same repository Dodge chose for her collection. Of course, Dodge and O'Keeffe continued to play a role in the cultural scene of New York City even after they chose northern New Mexico as their home. These are minor coincidences, but they speak to a larger cultural milieu that led both Dodge and O'Keeffe to New Mexico and that led both women to celebrate the region in similar terms. The posters that show O'Keeffe's work today bring that celebration to an ever-widening audience. Buy a poster and you, too, can ride away to a world apart.

Except that northern New Mexico is a real place. One has only to look at the physical and social landscape of northern New Mexico to see how one place changed when influential outsiders decided it was their personal world apart. Nuevomexicanos and Pueblo Indians continue to wrestle with land settlement claims associated with the Bursum bill. People of all races and ethnicities throughout northern New Mexico face limited job options because of the suffocating effects of the tourism industry, which relies on romantic and primi-

Mabel Dodge Lane, Taos, New Mexico, 2007. (Photograph by Gary Haug.)

tivist images of Nuevomexicanos and Native Americans. The racial and ethnic makeup of New Mexico changed, in part, as a result of the appealing image of northern New Mexico that Dodge, Austin, Lawrence, and O'Keeffe broadcast to others throughout the country. The desire of many outsiders today to own a home in northern New Mexico as well as the high cost of homes in northern New Mexico spring, in part, from the aesthetic of belonging that accompanied the notion of an artist's home. Each of these issues derives from more than the activities of Dodge and her guests, but her house is a good place to start if you want to understand how northern New Mexico acquired its present image.

As a real place and as a modern one, New Mexico is a critical, not an optional, part of the history of U.S. modernism. Too many scholars are content to end discussions of modernism with the advent of World War I or within the confines of large cities such as New York and Chicago. The history of U.S. modernism is incomplete without a history of the material consequences of its ideas. Historians have explained well how New York and Chicago gave form to modernist ideals, but not how those ideals were imprinted on the landscapes of places throughout the United States and the world. One of those places was northern New Mexico, and it deserves a role within discussions of modernism not least because to deny that role is to reproduce the errors of modernist thought by perpetuating the fiction that there is such a place as a world apart.

But the recognition of northern New Mexico as a part of the modern world cuts both ways. Not only should outsiders to New Mexico recognize the state's modernity, New Mexicans should as well. As I gathered information for this project I realized how, as a New Mexican, I relished the state's reputation as a world apart. I had an innate suspicion of events, people, and objects that originated from outside. I was reluctant to express my enthusiasm for O'Keeffe, choosing instead to identify local artists as my favorites. I felt an obligation to tell outsiders and newcomers that New Mexican artistic traditions preceded the arrival of those from the New York and California art worlds. Just as I have done here, in this book's introduction, I hastened to preempt any suspicion of my New Mexican credentials, and would, without hesitation, tell a new acquaintance I had deep roots in the Southwest. I always took guests to restaurants far from Santa Fe's plaza, choosing instead more "authentic" places, distant from tourist attractions. If, upon returning after a long absence, my breath caught when I saw the Sangre de Cristo mountains or when I smelled a passing rainstorm or when I edged past long-standing adobes, I told myself that I felt the special joy of belonging.

As I've concluded this book, I've considered what northern New Mexicans have to gain from it, and I have been surprised to find I think they might gain as much as people from outside the state. In the stories of Dodge's years in New York City, I believe New Mexicans can find an understanding of U.S. modernism that will allow them to better negotiate the cultural and political expectations of newcomers, and thus to negotiate a better present in New Mexico. Moreover, they may find invitations to cultural arenas far from home. New Mexicans might also find models for responding to modernity in the experience of Nuevomexicanos and Pueblo Indians who learned from African Americans and other patronized groups how to negotiate the terms of patronage. As New Mexicans relish the beauty of the state, they might raise their consciousness of what that beauty hides and shows—the aridity, the history of poverty, the ties to cities far away, the people's deep connection to the land. For New Mexicans who, like me, are in the habit of dismissing Dodge and her peers as rich Anglo interlopers, the story of Dodge and her guests in Taos might have some useful lessons after all.

Learning those lessons would truly bring the faraway nearby for those both outside and within northern New Mexico. For outsiders, the faraway would no longer be a primal landscape of authentic experience; the nearby would no longer be artificial. For New Mexicans, the faraway would no longer

be the congested and electric big city; the nearby would no longer be without opportunity. For outsiders, the faraway would include urbane conversation and urban grit; the nearby would include the most ancient histories. For New Mexicans, the faraway would include natural beauty and the promise of belonging; the nearby would be cosmopolitan. To mix the local and the distant requires effort, but, for locals and outsiders alike, ultimately promises great reward.

Notes

Introduction

1. Francis X. Clines, "Coming to Terms with Ground Zero Terror in a World Apart," *New York Times*, 4 November 2001, 1B, 9.

2. The terms used to describe people of Spanish and Native American descent in northern New Mexico have changed over time and are fraught with political meaning. I have followed the lead of scholars A. Gabriel Meléndez and John Nieto-Phillips, using "Nuevomexicano." "Hispanic" and "Hispano," I think, disguise the indigenous roots of many Nuevomexicano people. "Chicano" seems anachronistic because it was not used in the early twentieth century. See A. Gabriel Meléndez, *So All Is Not Lost: The Poetics of Print in Nuevomexicano Communities, 1834–1958* (Albuquerque: University of New Mexico Press, 1997) and John Nieto-Phillips, *The Language of Blood: The Making of Spanish-American Identity in New Mexico, 1880s–1930s* (Albuquerque: University of New Mexico Press, 2004).

3. Studies that have explored the links between promotion of New Mexico and California include Phoebe Kropp, *California Vieja: Culture and Memory in a Modern American Place* (Berkeley: University of California Press, 2006), Charles Montgomery, *The Spanish Redemption: Heritage, Power, and Loss on New Mexico's Upper Rio Grande* (Berkeley: University of California Press, 2002), and Chris Wilson, *The Myth of Santa Fe: Creating a Modern Regional Tradition* (Albuquerque: University of New Mexico Press, 1997).

4. Dodge's volumes of autobiography include Mabel Dodge Luhan, *Intimate Memories: Background* (New York: Harcourt, Brace, 1933), *European Experiences: Volume Two of Intimate Memories* (New York: Harcourt, Brace, 1935), *Movers and Shakers: Volume Three of Intimate Memories* (New York: Harcourt, Brace, 1936), *Edge of Taos Desert: An Escape to Reality: Volume Four of Intimate Memories* (New York: Harcourt, Brace, 1937). Biographies of Dodge include Emily Hahn, *Mabel: A Biography of Mabel Dodge Luhan* (Boston: Houghton Mifflin, 1977), Lois Rudnick, *Mabel Dodge Luhan: New Woman, New Worlds* (Albuquerque: University of New Mexico Press, 1984), and Winifred Frazer, *Mabel Dodge Luhan* (Boston: Twayne, 1984). Of these, I rely most extensively on Rudnick's work, the most comprehensive.

5. I have been influenced particularly by Margaret Jacobs, *Engendered Encounters: Feminism and Pueblo Cultures, 1879–1934* (Lincoln: University of Nebraska Press, 1999), Molly H. Mullin, *Culture in the Marketplace: Gender, Art, and Value in the Ameri-*

can Southwest (Durham, N.C.: Duke University Press, 2001), Maureen Reed, *A Woman's Place: Women Writing New Mexico* (Albuquerque: University of New Mexico Press, 2005), and Sherry Smith, *Reimagining Indians: Native Americans through Anglo Eyes, 1880–1940* (New York: Oxford University Press, 2000).

6. The historical literature on utopian communities in the United States is extensive. For general analyses of eastern nineteenth-century communal and utopian communities, see Rosabeth Moss Kanter, *Commitment and Community: Communes and Utopias in Sociological Perspective* (Cambridge, Mass.: Harvard University Press, 1972) and Mark Holloway, *Heavens on Earth: Utopian Communities in America* (New York: Dover, 1966). For the specific experience of art communities in California, see Robert V. Hine, *California Utopian Colonies* (New Haven, Conn.: Yale University Press, 1953), Kevin Starr, *Americans and the California Dream, 1850–1915* (New York: Oxford University Press, 1973), and Michael Orth, "Ideality to Reality: The Founding of Carmel," *California Historical Society Quarterly* 48 (1959): 195–210. For the establishment of art communities in northern New Mexico, see Arrell Morgan Gibson, *The Santa Fe and Taos Colonies: Age of the Muses, 1900–1942* (Norman: University of Oklahoma Press, 1983) and Chris Wilson, *The Myth of Santa Fe: Creating a Modern Regional Tradition* (Albuquerque: University of New Mexico Press, 1997). Various members of Dodge's group and individuals connected to them also found bohemian creative communities in Oregon (particularly among those individuals who associated with C. E. S. Wood) and in Provincetown, Massachusetts (particularly after the establishment of the Provincetown Players). See Adele Heller and Lois Rudnick, eds., *1915, the Cultural Moment: The New Politics, the New Woman, the New Psychology, the New Art and the New Theatre in America* (New Brunswick, NJ: Rutgers University Press, 1991).

7. Christine Stansell notes the appeal of the "new" in *American Moderns: Bohemian New York and the Creation of a New Century* (New York: Metropolitan Books, 2000), 1–2.

8. T. J. Jackson Lears coined the term "antimodern" in *No Place of Grace: Antimodernism and the Transformation of American Culture, 1880–1920* (New York: Pantheon, 1981). Lears identifies a sense of weightlessness and dissatisfaction among elite white northeasterners in the late nineteenth and early twentieth centuries. He argues convincingly that the disaffection with the United States and bourgeois society historians had previously associated with the years following World War I in fact began as early as 1880.

9. For theoretical discussions of the concept of authenticity and its role in U.S. culture and history, see Lears, *No Place of Grace*, Lionel Trilling, *Sincerity and Authenticity* (Cambridge, Mass.: Harvard University Press, 1972), and Miles Orvell, *The Real Thing: Imitation and Authenticity in American Culture, 1880–1940* (Chapel Hill: University of North Carolina Press, 1989).

10. Stansell, *American Moderns*, 39. Stansell argues that, far from feeling the sense of weightlessness Lears identifies in an earlier generation of intellectuals, Greenwich Village bohemians were "immersed in the palpable things of the world."

11. Smith, *Reimagining Indians*, 205.

12. Ibid., 208.

13. It also seems necessary to understand the artists and writers who visited Dodge's salon and Taos home as participants in the aesthetic trends that drove their work and their views of the larger world. Artistic and literary modernism seems sufficiently broad to encompass the practices of those who visited Dodge's homes. See David Singal, "Towards a Definition of American Modernism," *American Quarterly* 38 (Spring 1987): 7–26.

14. W. Jackson Rushing, "Modern by Tradition," in Bruce Bernstein and W. Jackson Rushing, *Modern by Tradition: American Indian Painting in the Studio Style* (Santa Fe: Museum of New Mexico Press, 1995), 27–74. The phrase "modern by tradition" comes from Dorothy Dunn, the art teacher at the Santa Fe Indian School from 1932 to 1937, and the individual most responsible for the surge in Pueblo painting and drawing in the 1930s. Rushing explores more fully the impact of Native American art on New York artists who visited New Mexico in *Native American Art and the New York Avant-Garde: A History of Cultural Primitivism* (Austin: University of Texas Press, 1995).

15. A significant exception to the primitivism that prevailed in Dodge's household was Elsie Clews Parsons, who applied modernist ideas nurtured in New York City to her work as an anthropologist among the New Mexico Pueblo Indians, but who was more adept at celebrating native culture without resorting to patronizing terms. See Desley Deacon, *Elsie Clews Parsons: Inventing Modern Life* (Chicago: University of Chicago Press, 1997).

16. Contemporary academics regularly acknowledge primitivism as a part of modernism. I have been led to my conclusions here by Philip Deloria's books *Playing Indian* (New Haven, Conn.: Yale University Press, 1998) and *Indians in Unexpected Places* (Lawrence: University Press of Kansas, 2004), Marianna Torgovnick, *Gone Primitive, Savage Intellects, Modern Lives* (Chicago: University of Chicago Press, 1990), Michael Taussig, *Mimesis and Alterity: A Particular History of the Senses* (London: Routledge, 1993), and Walter Benjamin, "On the Mimetic Faculty," in Peter Demetz, ed.; Edmund Jephcott trans., *Reflections, Essays, Aphorisms, Autobiographical Writings* (New York: Harcourt, Brace, Jovanovich, 1978), 333–336.

17. Torgovnick, *Gone Primitive*, Nathan Huggins, *Harlem Renaissance* (New York: Oxford University Press, 1971), Jane Becker, *Selling Tradition: Appalachia and the Construction of an American Folk, 1930–1940* (Chapel Hill: University of North Carolina Press, 1998), David Levering Lewis, *When Harlem Was in Vogue* (New York: Penguin, 1997), and Benjamin Filene, *Romancing the Folk: Public Memory and American Roots Music* (Chapel Hill: University of North Carolina Press, 2000).

18. Deloria, *Playing Indian* and *Indians in Unexpected Places*.

19. Barbara Babcock and Marta Weigle have both argued presentations of the Southwest parallel orientalist discourse. Barbara Babcock, "'A New Mexican Rebecca': Imagining Pueblo Women," *Journal of the Southwest* 32, no. 4 (Winter 1990): 400–437; and Marta Weigle, "Southwest Lures: Innocents Detoured, Incensed Determined," *Journal of the Southwest* 32, no. 4 (Winter 1990): 499–540.

20. Leah Dilworth tells this story particularly well in *Imagining Indians in the Southwest: Persistent Visions of a Primitive Past* (Washington, D.C.: Smithsonian Institution Press, 1996).

21. On the Harlem Renaissance, see Huggins, *Harlem Renaissance* and Lewis, *When Harlem Was in Vogue*. Within New Mexico, see Babcock, "New Mexican Rebecca," Weigle, "Southwest Lures," Dilworth, *Imagining Indians*, Rushing, *Native American Art*, and Charles Briggs, *The Wood Carvers of Córdova, New Mexico: Social Dimensions of an Artistic "Revival"* (Knoxville: University of Tennessee Press, 1980).

22. My thoughts on place and the idea of belonging have been strongly influenced by Yi Fu Tuan, *Topophilia: A Study of Environmental Perception, Attitudes, and Values* (Englewood Cliffs, N.J.: Prentice Hall, 1974), Lucy Lippard, *The Lure of the Local: Senses of Place in a Multicentered Society* (New York: New Press, 1997), and J. B. Jackson, *The Necessity for Ruins and Other Topics* (Amherst: University of Massachusetts Press, 1980) and *A Sense of Place, a Sense of Time* (New Haven, Conn.: Yale University Press, 1994). In many ways, this project had its genesis in the Site Santa Fe inaugural exhibition, "Longing and Belonging: From the Faraway Nearby" in 1995. See *Longing and Belonging: From the Faraway Nearby* (Santa Fe: Site Santa Fe, 1995).

23. Babcock, "New Mexican Rebecca," Dilworth, *Imagining Indians*, Jacobs, *Engendered Encounters*, Mullin, *Culture in the Marketplace*, Nieto-Phillips, *Language of Blood*, Marta Weigle and Kyle Fiore, *Santa Fe and Taos: The Writer's Era, 1916–1941* (Santa Fe: Ancient City Press, 1982), Montgomery, *Spanish Redemption*, Wilson, *Myth of Santa Fe*, and Hal Rothman, *Devil's Bargains: Tourism in the Twentieth-Century American West* (Lawrence: University Press of Kansas, 1998), 84–98.

Chapter 1: Mabel Dodge's Place

1. Lois Rudnick, *Mabel Dodge Luhan: New Woman, New Worlds* (Albuquerque: University of New Mexico Press, 1984), 31–42, 57.

2. For the location of the village and a comprehensive discussion of the village as a state of mind representing the center of the American avant-garde, see Christine Stansell, *American Moderns: Bohemian New York and the Creation of a New Century* (New York: Metropolitan Books, 2000), 11–45.

3. Hutchins Hapgood, *A Victorian in the Modern World* (New York: Harcourt, Brace, 1939; reprinted with an introduction by Robert Allen Skotheim, Seattle: University of Washington Press, 1972), 137–143, 277–278. Hapgood's articles on the Lower East Side were collected in *The Spirit of the Ghetto: Studies of the Jewish Quarter in New York* (New York: Funk and Wagnalls, 1902).

4. Mabel Dodge Luhan, *Movers and Shakers* (New York: Harcourt, Brace, 1936; reprinted with an introduction by Lois Palken Rudnick, Albuquerque: University of New Mexico Press, 1985), 80–81.

5. Although the Armory Show played a significant role in the Dodge salon's involvement in modern art, I do not want to suggest that it "brought" modern art to the United States. For a discussion of the inaccuracies and exclusions that accompany a linear narrative regarding modern art in the United States, see Serge Guilbaut, *How New York Stole the Idea of Modern Art: Abstract Expressionism, Freedom, and the Cold War* (Chicago: University of Chicago Press, 1983), Francis Franscina and Charles Harrison,

eds., *Modern Art and Modernism: A Critical Anthology* (London: Harper and Row, 1982), and Janet Wolff, *AngloModern: Painting and Modernity in Britain and the United States* (Ithaca, N.Y.: Cornell University Press, 2003).

6. Dodge to Stein, 24 January 1913, in Patricia Everett, ed., *A History of Having a Great Many Times Not Continued to Be Friends: The Correspondence between Mabel Dodge and Gertrude Stein, 1911–1934* (Albuquerque: University of New Mexico Press, 1996), 59.

7. Jean-Jacques Rousseau, *A Discourse on Inequality*, trans. Maurice Cranston (New York: Penguin, 1984 [1775]), 67.

8. The idea of a racial group being suspended in time is not new to this work. I draw my interpretation from Marianna Torgovnick, *Gone Primitive: Savage Intellects, Modern Lives* (Chicago: University of Chicago Press, 1990), Phil Deloria, *Playing Indian* (New Haven, Conn.: Yale University Press, 1998), and from predominantly literary studies of colonialism and imperialism, including the notion of "anachronistic space" advanced in Anne McClintock, *Imperial Leather: Race, Gender, and Sexuality in the Colonial Context* (New York: Routledge, 1995); the analysis of the power of imperial myths in Renato Rosaldo, "Imperialist Nostalgia," *Representations* 26 (Spring 1989): 107–122; Ann Stoler's discussion of deviance in *Race and the Education of Desire: Foucault's History of Sexuality and the Colonial Order of Things* (Durham, N.C.: Duke University Press, 1995); and the classic analyses of the role of primitivism in popular understandings of the American West: Richard Slotkin's *Regeneration through Violence* (Middletown, Conn.: Wesleyan University Press, 1973) and *Gunfighter Nation: The Myth of the Frontier in Twentieth-Century America* (New York: Atheneum, 1992).

9. Melvyn Dubofsky, *We Shall Be All: A History of the Industrial Workers of the World* (Chicago: Quadrangle Books, 1969), 49–55, 173–197, 227–262.

10. Dodge Luhan, *Movers and Shakers*, 188.

11. Robert Rosenstone, *Romantic Revolutionary: A Biography of John Reed* (New York: Vintage, 1975), 7–98.

12. John Reed, "War in Paterson," *Masses*, undated clipping in scrapbook volume 10, Box 3, Scrapbooks, Mabel Dodge Luhan Papers, Yale Collection of American Literature, Beinecke Rare Book and Manuscript Library, hereafter cited as MDLP.

13. Unidentified and undated newspaper article, clipping in scrapbook volume 10, Box 3, Scrapbooks, MDLP.

14. Hutchins Hapgood, "The Strikers' Pageant," undated clipping in scrapbook volume 10, Box 3, Scrapbooks, MDLP.

15. "The Power of Presentation," *New York Evening Sun*, undated clipping in scrapbook volume 10, Box 3, Scrapbooks, MDLP.

16. A reproduction of the program is in Martin Green, *New York, 1913: The Armory Show and the Paterson Pageant* (New York: Scribner's, 1988).

17. The most comprehensive biography of Pancho Villa is Friedrich Katz, *The Life and Times of Pancho Villa* (Palo Alto, Calif.: Stanford University Press, 1998). For a discussion of the relationship between Reed and Villa, see Jim Tuck, *Pancho Villa and John Reed: Two Faces of Romantic Revolution* (Tucson: University of Arizona Press, 1984).

18. John Reed, "With Villa in Mexico," *Metropolitan* (February 1914): 72.

19. Ibid., 72. Reed's articles are collected in John Reed, *Insurgent Mexico* (New York: International, 1969 [1914]).

20. Reed, "Francisco Villa: The Man of Destiny," *Metropolitan* (June 1914): 13.

21. Reed, "Francisco Villa," 68.

22. Reed, "With Villa," 72.

23. Reed, "With La Tropa," *Metropolitan* (April 1914): 12.

24. Reed, "With La Tropa," 74.

25. Robert Rosenstone traces the remainder of Reed's life in *Romantic Revolutionary*.

26. Stansell, *American Moderns*, 313–314.

27. On Reed, see Rosenstone, *Romantic Revolutionary*. On Hapgood and Boyce between 1914 and 1920, see Stansell, *American Moderns*, 282–284; Neith Boyce, *Intimate Warriors: Portraits of a Modern Marriage, 1899–1944*, ed. Ellen Kay Trimberger (New York: Feminist Press, 1991) and "The New Woman and The New Sexuality: Conflict and Contradiction in the Writings of Neith Boyce and Mabel Dodge," in Adele Heller and Lois Rudnick, eds., *1915, The Cultural Moment: The New Politics, the New Woman, the New Psychology, the New Art, and the New Theatre in America* (New Brunswick, N.J.: Rutgers University Press, 1991), 98–116. Hapgood and Boyce lost their first son, Boyce Hapgood, a friend to Mabel Dodge's son John Evans, to the influenza epidemic of 1918–1919. Boyce Hapgood was in New Mexico at the time of his death. Both parents were reluctant to visit the area afterward. See Neith Boyce, *The Modern World of Neith Boyce: Autobiography and Letters*, ed. Carol DeBoer-Langworthy (Albuquerque: University of New Mexico Press, 2003) and Neith Boyce to Mabel Dodge, 28 December [1919], MDLP. On the impact of the war on artist Marsden Hartley's travel, see Townsend Ludington, *Marsden Hartley: The Biography of an American Artist* (Ithaca, N.Y.: Cornell University Press, 1992), 130–150. On Dasburg, see Van Deren Coke, *Andrew Dasburg* (Albuquerque: University of New Mexico Press, 1979) and Sheldon Reich, *Andrew Dasburg: His Life and Art* (Lewisburg, Ohio: Bucknell University Press, 1989), 37–43.

28. Dodge Luhan, *Movers and Shakers*, 345.

29. Ibid., 346.

30. Maurice Sterne, *Shadow and Light: The Life, Friends, and Opinions of Maurice Sterne*, ed. Charlotte Leon Mayerson (New York: Harcourt, Brace, 1952), 3–95.

31. Joyce Kilmer, "Develops His Art in Savage Bali: Maurice Sterne, Young American Painter, 'Finds Himself' during Three Years in East Indian Archipelago," *New York Times Magazine*, 21 March 1915, 16–17.

32. Ibid., 95.

33. George Biddle cited in Sterne, *Shadow and Light*, xxiv.

34. Dodge to Sterne, 12 December 1917, Maurice Sterne Papers, Correspondence, Box 3, Series I, Yale Collection of American Literature, Beinecke Rare Book and Manuscript Library, hereafter cited as MSP.

35. Dodge Luhan, *Movers and Shakers*, 534.

36. Ibid., 534.

37. Lois Rudnick interprets Dodge's memoirs according to this arc as well, arguing that Dodge was part of a long tradition of literary autobiography that charted a progression from imperfection to perfection. For Dodge, this was not only a personal journey but also a national one as she hoped to convince others of the emotional vacuity of the Victorian era and the need for alternative cultural models for an American identity. See Rudnick, *Mabel Dodge Luhan*, 255–256.

38. Dodge to Sterne, 24 November 1917, MSP, and Sterne to Dodge, 30 November 1917, MDLP.

39. Sterne to Dodge, 5 December 1917, MDLP.

40. Sterne to Dodge, 16 November 1917, MDLP.

41. See Deloria, *Playing Indian*.

42. Mabel Dodge Luhan, *Edge of Taos Desert: An Escape to Reality* (New York: Harcourt, Brace, 1937; Albuquerque: University of New Mexico Press, 1997), 8–16.

43. See Arrell Morgan Gibson, *The Santa Fe and Taos Colonies: Age of the Muses, 1900–1942* (Norman: University of Oklahoma Press, 1983), 10. Gibson remarks on the varied responses of artists to the light in New Mexico, but implies that artists grew accustomed to the light over time. Many artists never did. Stuart Davis visited Santa Fe briefly in 1923 and explicitly mocked artists' love for the New Mexico light in his work.

44. Dodge Luhan, *Edge of Taos Desert*, 17–21.

45. On the Hendersons, see T. M. Pearce, *Alice Corbin Henderson* (Austin: Steck, Vaughn, 1969) and Marta Weigle and Kyle Fiore, *Santa Fe and Taos: The Writer's Era, 1916–1941* (Santa Fe: Ancient City Press, 1982). Alice Corbin Henderson published poetry under the name Alice Corbin. The Hendersons' daughter, also named Alice, later married John Evans, Mabel Dodge Luhan's son. To distinguish Alice Corbin Henderson from her husband and daughter, I will refer to her as "Henderson" or "Corbin" as needed.

46. Dodge Luhan, *Edge of Taos Desert*, 17–24.

47. Sterne to Dodge, 28 November 1917, MDLP.

48. Sterne to Dodge, 8 December 1917, MDLP. Sterne's memoirs state that Dodge learned of Taos from someone in New York, and that Sterne never liked it. I think the more likely story is that he was initially as interested in Taos as Dodge, suggested the visit to her in his letter of 8 December, and then changed his mind upon arriving. See Sterne, *Shadow and Light*, 137.

49. For Dodge's opinion of the Taos Society of Artists, see Dodge to Sterne, 27 November 1917, MSP.

50. Mabel Dodge Luhan, "Taos Solves the H.C. of L. for Many," *Taos Valley News*, 3 March 1918.

51. Andrew Dasburg to Grace Mott Johnson, 15 January 1918, Reel 2044, Archives of American Art, Smithsonian Institution, hereafter cited as AAA.

52. Letter from Mabel Dodge Luhan to Neith Boyce, 21 April [1918], Hapgood Family Papers, Personal Correspondence, Series I, Box 5, Yale Collection of American Literature, Beinecke Rare Book and Manuscript Library, hereafter cited as HFP. All misspellings in original.

53. On ethnic identification among New Mexico's Spanish-speaking population,

see Charles Montgomery, *The Spanish Redemption: Heritage, Power, and Loss on New Mexico's Upper Rio Grande* (Berkeley: University of California Press, 2002), and John Nieto-Phillips, *The Language of Blood: The Making of Spanish-American Identity in New Mexico, 1880s–1930s* (Albuquerque: University of New Mexico Press, 2004).

54. On the evolving relationship between the artists of Taos and local residents, see J. J. Brody, *Pueblo Indian Painting: Tradition and Modernism in New Mexico, 1900–1930* (Santa Fe: School of American Research Press, 1997), Leah Dilworth, *Imagining Indians in the Southwest: Persistent Visions of a Primitive Past* (Washington, D.C.: Smithsonian Institution Press, 1996), Charles Eldridge, Julie Schimmel, and William Truettner, eds., *Art in New Mexico, 1900–1945: Paths to Taos and Santa Fe* (Washington, D.C.; New York: Smithsonian Institution Press/Abbeville Press, 1986), Gibson, *The Santa Fe and Taos Colonies,* Dean Porter, Teresa Hayes Ebie, and Suzan Campbell, eds., *Taos Artists and Their Patrons, 1898–1950* (Notre Dame, Ind.: University of Notre Dame Snite Museum of Art, 1999), Sylvia Rodríguez, "Art, Tourism, and Race Relations in Taos: Toward a Sociology of the Art Colony," *Journal of Anthropological Research* 45, no. 1 (1989): 77–99, and Edna Robertson and Sarah Nestor, *Artists of Canyons and Caminos: Santa Fe, the Early Years* (Salt Lake City, Utah: Gibbs Smith, 1982).

55. Porter, Ebie, and Campbell, *Taos Artists and Their Patrons,* 39.

56. *Taos Valley News,* 30 April 1918–8 August 1918.

57. *Taos Valley News,* 30 April 1918–31 December 1918.

58. *Taos Valley News,* 7 May 1918, 13 August 1918, and 31 December 1918 for the comings and goings of Dodge's guests and their interactions with members of the Pueblo.

59. *Taos Valley News,* 7 May 1918.

60. Dodge Luhan, *Edge of Taos Desert,* 205–335.

61. Sterne, *Shadow and Light,* 145.

62. Dodge to Sterne, [1919], MSP, emphasis in original.

63. Alida Sims, "Provincetown of the Desert," *New York Times Book Review and Magazine,* 25 December 1921, in scrapbook volume 11, Box 4, Scrapbooks, MDLP.

64. See Sterne to Dodge, 14 June 1919 and 27 January 1920 in MDLP. Dodge's political apathy was probably the primary reason she didn't engage Sterne's letters on the Red Scare, but she might also have been reluctant to discuss John Reed with Sterne, whom she believed to be extremely jealous of her relationship with Reed.

65. Elizabeth Shepley Sergeant and Mary Austin were major exceptions. Both were involved in the campaign for women's suffrage in the late 1910s.

Chapter 2: John Collier's Place

1. Charles Burke to E. D. Newman, 31 March 1923, Box 1, Northern Pueblos Agency (1904–1937), 86, in Correspondence, Reports and Other Records Relating to the Pueblo Lands Board, 1918–1932, Records of the Bureau of Indian Affairs, Record Group 75, National Archives and Records Administration, Rocky Mountain Region, Denver, Colo., hereafter cited as NARA, RMR; and interview with Martin Vigil con-

ducted by Dennis Stanford, Tapes 645, 646, 754, 764, American Indian Oral History Collection, Pueblo Interviews, Reel 11, Center for Southwest Research, University of New Mexico, AIOHC. I find it tempting to speculate that Vigil's experience led him to identify Pueblo Indians with other nonwhite people. Vigil remembered Newman's statement in two separate interviews, almost fifty years after the argument over the fence occurred. Vigil did not mention how he felt about the statement, however, making it a provocative scrap of information on how Pueblo people felt toward other nonwhite groups in the early twentieth century. I explore the connections between Pueblo people and other nonwhite groups more fully in Chapters 4 and 5.

2. See letter from Horace Johnson to Ed Newman, 1 March 1922, Albert B. Fall Papers, Henry E. Huntington Library, San Marino, California, hereafter cited as AFP.

3. *An Act to ascertain and settle land claims of persons not Indian within Pueblo Indian land, land grants, and reservations in the State of New Mexico*, U.S. Senate, 67th Cong., 2nd sess., S. 3855. For further analysis of the Bursum bill introduction, see Lawrence Kelly, *The Assault on Assimilation: John Collier and the Origins of Indian Policy Reform* (Albuquerque: University of New Mexico Press, 1983), 141–254, Kenneth Philp, *John Collier's Crusade for Indian Reform, 1920–1954* (Tucson: University of Arizona Press, 1977), 26–54, and Joe S. Sando, *Pueblo Nations: Eight Centuries of Pueblo Indian History* (Santa Fe: Clear Light Publishers, 1992), 114–122.

4. Atwood had cofounded the Indian Welfare Committee with Gertrude Bonnin, also known as Zitkala-Sa, who was affiliated with the Indian Rights Association of Philadelphia. See Kelly, *Assault*, 126.

5. Collier described his interest in the legislation and the Pueblos' land holdings in a letter to Francis Wilson. See Collier to Wilson, 21 September 1922, Francis C. Wilson Papers, New Mexico State Records Center and Archives, hereafter cited as FWP.

6. Another link between Pueblo land holdings and Pueblo culture is the Pueblo dance controversy, which involved a Bureau of Indian Affairs restriction on traditional Pueblo dances. For an investigation of this link, see Tisa Wenger, "Land, Culture, and Sovereignty in the Pueblo Dance Controversy," *Journal of the Southwest* 46, no. 2 (Fall 2004): 381–412, and Margaret Jacobs, *Engendered Encounters: Feminism and Pueblo Cultures, 1879–1934* (Lincoln: University of Nebraska Press, 1999), 106–148.

7. The history of tourists' images of northern New Mexico and the role of Indians within it has been explored often. See Leah Dilworth, *Imagining Indians in the Southwest* (Washington, D.C.: Smithsonian Institution, 1996), Arrell Morgan Gibson, *The Santa Fe and Taos Colonies: Age of the Muses, 1900–1942* (Norman: University of Oklahoma Press, 1983), Jacobs, *Engendered Encounters*, Molly H. Mullin, *Culture in the Marketplace: Gender, Art, and Value in the American Southwest* (Durham: Duke University Press, 2001), Chris Wilson, *The Myth of Santa Fe: Creating a Modern Regional Tradition* (Albuquerque: University of New Mexico Press, 1997), Marta Weigle and Kyle Fiore, *Santa Fe and Taos: The Writer's Era, 1916–1941* (Santa Fe: Ancient City Press, 1982), Edna Robertson and Sarah Nestor, *Artists of the Canyons and Caminos: Santa Fe, the Early Years* (Santa Fe: Ancient City Press, 1976), and Hal Rothman, *Devil's Bargains: Tourism in the Twentieth-Century West* (Lawrence: University Press of Kansas, 1998).

8. Some historians have argued that much of the encroachment on the northern

Pueblo lands began in the late nineteenth century and was well advanced by the time of the Bursum bill struggle. See Alvar Carlson, "Spanish-American Acquisition of Cropland within the Northern Pueblo Indian Grants, New Mexico," *Ethnohistory* 22, no. 2 (1975): 95–110 and Sando, *Pueblo Nations*, 113–114.

9. Although the Sandoval decision addressed the sale of alcohol on Indian land, the Court explicitly recognized the implications for Pueblo landholding and concluded that "We are not unmindful that in *United States v. Joseph*, 94 U.S. 614, there are some observations not in accord with what is here said of these Indians, but as that case did not turn upon the power of Congress over them or their property, but upon the interpretation and purpose of a statute not nearly so comprehensive as the legislation now before us, and as the observations there made respecting the Pueblos were evidently based upon statements in the opinion of the territorial court, then under review, which are at variance with other recognized sources of information, now available, and with the long-continued action of the legislative and executive departments, that case cannot be regarded as holding that these Indians or their *lands* are beyond the range of Congressional power under the Constitution." See *United States v. Sandoval*, 352 (1913) and *United States v. Joseph*, 94 U.S. 614 (1876). The cases placed the Pueblo Indians in a particularly tight position. Although *Sandoval* granted them lands they stood to lose to non-Indian settlers and squatters, it did so on the premise that the Indians were "wards" of the U.S. government, and incapable of complete self-governance. Such a position was nothing new for Indian people, but that made their quandary no less difficult to navigate. On the contradictory nature of Indian policy, particularly its paternalism, see Sando, *Pueblo Nations*, 114, Frederick Hoxie, *A Final Promise: The Campaign to Assimilate the Indians, 1880–1920* (Lincoln: University of Nebraska Press, 1984), and Fergus M. Bordewich, *Killing the White Man's Indian: Reinventing Native Americans at the End of the Twentieth Century* (New York: Anchor, 1996).

10. Twitchell's role in the Bursum bill is interesting because his initial report on the disputed land claims favored the Pueblos, although he had never been the Pueblo advocate he should have been as Pueblo attorney. For Twitchell's conversion and the political wrangling behind the bill writing as well as Fall's record on relations with native peoples, see Kelly, *Assault*, 163–212 and Philp, *John Collier's Crusade*, 30–32.

11. Kelly, *Assault*, 163–212 and Philp, *John Collier's Crusade*, 32.

12. "An Appeal by the Pueblo Indians of New Mexico to the People of the United States" in scrapbook volume 17, Box 5, Scrapbooks, Mabel Dodge Luhan Papers, Yale Collection of American Literature, Beinecke Rare Book and Manuscript Library, hereafter cited as MDLP.

13. *New York Times*, 24 December 1922.

14. See Kelly, *Assault*, 217, Elizabeth S. Sergeant, "Last First Americans," *Nation* (29 November 1922): 570, Alice Corbin Henderson, "Death of the Pueblos," *New Republic* (29 November 1922): 11–13, *New York World* (29 November 1922), "Pueblos United in Petition," *New York Times*, 7 November 1922, 6, Elizabeth S. Sergeant, "Big Powwow of Pueblos," *New York Times*, 26 November 1922, 69, John Collier, "Plundering the Pueblo Indians," *Sunset Magazine* (January 1923): 21–25, 56, John Collier, "The Pueblos' Last Stand," *Sunset Magazine* (February 1923): 19–22, 65–66, John Collier,

"The Pueblos' Land Problem," *Sunset Magazine* (November 1923): 15, 101, John Collier, "Our Indian Policy," *Sunset Magazine* (March 1923): 13–15, 89–93, John Collier, "No Trespassing," *Sunset Magazine* (May 1923): 14–15, 58–60, Stella Atwood, "The Case for the Indian," *Survey* (October 1922); 7–11, 57, John Collier, "The Red Atlantis," *Survey* (October 1922): 15–20, 63–66, and John Collier, "The American Congo," *Survey* (August 1923): 467–476.

15. On the history of periodicals in the 1920s, see David Seideman, *The New Republic: A Voice of Modern Liberalism* (New York: Praeger, 1986), James Playsted Wood, *Magazines in the United States* (New York: Ronald Press, 1971), and Theodore Peterson, *Magazines in the Twentieth Century* (Urbana: University of Illinois Press, 1964).

16. "The Protest of Artists and Writers against the Bursum Bill," scrapbook volume 17, Box 5, Scrapbooks, MDLP.

17. Henderson, "Death of the Pueblos," 11–13.

18. People's Institute Director Charles Sprague-Smith as cited in Kelly, *Assault*, 24.

19. John Collier, *New York Press,* 15 March 1914, untitled clipping in scrapbook volume 13, Box 4, MDLP. For descriptions of the East Side Pageant of Nations, which Collier organized, see John Collier, "Caliban of the Yellow Sands: The Shakespeare Pageant and Masque Reviewed against a Background of American Pageantry," *Survey* (1 July 1916): 342–350, "Tenement Dwellers to Give Pageant of the Peoples," *New York Times Magazine* (24 May 1914): 53, "Pageant of Nations Reviewed by 15,000," *New York Times,* 7 June 1914, IV, 5.

20. Collier to Dodge, 23 April [n.d.], MDLP.

21. Sergeant, "Big Powwow of Pueblos," 69.

22. On the political, social, cultural, and economic investment in primitivism among Anglo patrons of Pueblo Indians, see Dilworth, *Imagining Indians,* Barbara Babcock, "'A New Mexico Rebecca': Imagining Pueblo Women," *Journal of the Southwest* 32 (Winter 1990): 499–539; and Sherry Smith, *Reimagining Indians: Native Americans through Anglo Eyes, 1880–1940* (Oxford: Oxford University Press, 2000). As I argue here and in the next chapter, the primitivist discourse propagated by Collier and his allies in New Mexico relied on linking the nonwhite people of northern New Mexico with the land and with representations of the landscape. This link between New Mexico nonwhite residents and the land led those Anglos who adopted this primitivist stance simultaneously to embrace aesthetic modernism and reject modern technology and economic development. Such a position was consistent with the political and cultural advocacy work Collier, Dodge, and others had done in New York City but, as I argue in the next chapter, proved challenging to maintain in the face of the ethnic tensions of northern New Mexico. On the presentation of all native people as inherently "natural," see Shepherd Krech, *The Ecological Indian: Myth and History* (New York: W.W. Norton, 1999).

23. Collier, "Red Atlantis," 18.

24. Ibid., 16.

25. For the economic status of the Pueblos in the early 1920s, see Philp, *John Collier's Crusade,* 44.

26. See the last photograph in Collier, "Red Atlantis," 29.

27. Some scholars have taken Collier to task for implementing his own brand of paternalism, beginning with the publication of "The Red Atlantis." See E. A. Schwartz, "Red Atlantis Revisited: Community and Culture in the Writings of John Collier," *American Indian Quarterly* 18, no. 4 (1994): 507–531.

28. Collier to Dodge as quoted in Kelly, *Assault*, 228–229. For Collier's broader plans for federal Indian policy, see Kelly, *Assault*, 103–140, 163–294, and Philp, *John Collier's Crusade*, 26–70.

29. The sequence of events I describe here comes from Collier's account of the Pueblo's activities in "American Congo," 472–473. Pueblo sources from the campaign against the Bursum bill are scarce, an unfortunate gap in the record given the romanticized version of events Collier, Dodge, and others propagated in the national media.

30. As we shall see in Chapter 5, the importance of Dodge's car to the fight against the Bursum bill is still remembered today among Tony Lujan's relatives. As Philip Deloria has argued, Indians have often used automobiles to respond to representations of themselves as technologically backward and incapable of modern development. That cars were a crucial element in Collier's campaign against the Bursum bill suggests the complicated and hypocritical process by which Collier, Dodge, and others negotiated their own responses to technological modernity by insisting on the primitive nature of their Indian drivers, and, in Dodge's case, her Indian spouse. See Philip Deloria, *Indians in Unexpected Places* (Lawrence: University Press of Kansas, 2004), 136–182.

31. Collier, "American Congo," 473.

32. Elizabeth Shepley Sergeant, "The Principals Speak," *New Republic* (7 February 1923): 274.

33. Mabel Dodge Sterne to John Collier, 21 November [1922], John Collier Collection, Yale University, Manuscripts and Archives Division, hereafter cited as JCC.

34. Letter from Mabel Dodge Sterne to Mary Austin, 1922, Mary Austin Papers, Henry E. Huntington Library, San Marino, California, hereafter cited as MAP.

35. Stella Atwood to Francis Wilson, 24 October 1922, FWP.

36. On women's club work generally, see Anne Firor Scott, *Natural Allies: Women's Associations in American History* (Urbana: University of Illinois Press, 1991), and Karen J. Blair, *The Clubwoman as Feminist: True Womanhood Redefined, 1868–1914* (New York: Holms and Meier Publishers, 1980).

37. Unidentified newspaper clipping in scrapbook volume 17, Box 5, Scrapbooks, MDLP.

38. See Margaret McKittrick to Collier, 29 December 1922, Collier to McKittrick, 2 January 1923, Mabel Dodge to Collier, 29 December 1922, Collier to Mabel Dodge, 2 January 1923, and Mabel Dodge to Collier, 4 January 1923 in JCC for the controversy over whether Dodge should accompany the delegation.

39. Ickes and Collier would both go on to become rival candidates for the position of commissioner of Indian affairs in the Franklin Roosevelt administration. For the chronicle of Roosevelt's selection of Ickes as secretary of the interior and Ickes's decision, in turn, to push for Collier as commissioner of Indian affairs, see Lawrence Kelly, "Choosing the New Deal Indian Commissioner: Ickes vs. Collier," *New Mexico Historical Review* 49, no. 4 (1974): 269–284.

40. "Pueblo Indians on 'Change,'" *New York Times*, 26 January 1923, 26. The delegation members were also guests of the Architectural League. See "Social Notes," *New York Times*, 24 January 1923, 13.

41. Letter from Austin to Dodge, 27 January [1923], MDLP.

42. Letter fragment from Austin to Dodge, n.d. [1923], MDLP.

43. The Bursum bill itself had been dismissed by the time the delegation was allowed to speak before Congress, but substitute legislation was introduced before the delegation returned home. During hearings on the subsequent legislation members of the delegation submitted their statements.

44. Senate Subcommittee of the Committee on Public Lands and Surveys, Bills Relative to the Pueblo Indian Lands: Hearings on S. 3865 and S. 4223, 67th Cong. 4th sess., 23 January 1923, 189–202.

45. Joe S. Sando, *Pueblo Profiles: Cultural Identity through Centuries of Change* (Santa Fe: Clear Light Publishers, 1998), 41–9.

46. Mabel Dodge Sterne to John Collier, 21 November [1922], JCC. Three of the members of the delegation had visited Washington, D.C., before the Bursum bill trip, and Antonio Romero of Taos had met Presidents Roosevelt and Taft. See unidentified clipping in scrapbook volume 17, Box 5, Scrapbooks, MDLP.

47. Senate Subcommittee of the Committee on Public Lands and Surveys, Bills Relative to the Pueblo Indian Lands: Hearings on S. 3865 and S. 4223, 67th Cong. 4th sess., 23 January 1923, 193–194.

48. For the creation of a pan-Indian identity within Indian boarding schools, see David Wallace Adams, *Education for Extinction: American Indians and the Boarding School Experience* (Lawrence: University Press of Kansas, 1995), 336. Vigil did attend St. Catherine's School in Santa Fe, New Mexico, until the third grade, but he remembers having as many Nuevomexicano classmates as he did Indian ones, and all conversation was in Spanish. St. Catherine's might have been an experience in pan–New Mexican identity, but for Vigil, at least, it was not an extensive exposure to pan-Pueblo or pan-Indian sentiments.

49. Abeita had also mentioned the sale of Manhattan in his testimony before the Senate subcommittee. Perhaps Vigil misremembered his source or heard it at both gatherings.

50. Interview with Martin Vigil conducted by Dennis Stanford, Tapes 645, 646, 754, 764, American Indian Oral History Collection, Pueblo Interviews, Reel 11, AIOHC.

51. See "City Too Cramped for Pueblo Indians," *New York Times*, 15 January 1923, 28.

52. Many articles about the delegation included references to the canes. See the *New York Times*, 15 January 1923, 28, Collier's articles for *Survey* and *Sunset*, and Sergeant, "Big Powwow of Pueblos." For Fall's frustration with the press attention given the canes, see the statement against the bill from the Economic Club of New York and Fall's response to the statement, 3 February 1923, in AFP.

53. I take the phrase "utopian vista" from Lois Rudnick, *Utopian Vistas: The Mabel Dodge Luhan House and the American Counterculture* (Albuquerque: University of New Mexico Press, 1996).

Chapter 3: Nina Otero-Warren's Place

1. Nina Otero-Warren, *Old Spain in Our Southwest* (New York: Harcourt, Brace, 1936; reprint, Chicago: Rio Grande Press, 1962), 149.

2. Otero-Warren, *Old Spain,* 151.

3. Frank Applegate to Mary Austin, 20 February 1929, Mary Austin Papers, Henry E. Huntington Library, San Marino, California, hereafter cited as MAP.

4. Beniga Ortega Chávez as cited in Don Usner, *Sabino's Map: Life in Chimayo's Old Plaza* (Santa Fe: Museum of New Mexico Press, 1995), 185.

5. See Album 296, folder 3, (80), MAP for photograph of signing ceremony.

6. On local celebrations and their use for local promotion, see Chris Wilson, *Myth of Santa Fe: Creating a Modern Regional Tradition* (Albuquerque: University of New Mexico Press, 1997) and Charles Montgomery, *The Spanish Redemption: Heritage, Power, and Loss on New Mexico's Upper Rio Grande* (Berkeley: University of California Press, 2002), 128–157.

7. Montgomery, *Spanish Redemption,* John Nieto-Phillips, *The Language of Blood: The Making of Spanish-American Identity in New Mexico, 1880s–1930s* (Albuquerque: University of New Mexico Press, 2004), and Richard L. Nostrand, *The Hispano Home-land* (Norman: University of Oklahoma Press, 1992). Both Montgomery and Nieto-Phillips note that the creation of a "Spanish" identity on the part of Spanish-speaking people in New Mexico covered over political and economic inequalities from which Spanish-speaking people suffered.

8. On the use of the "Spanish" heritage of New Mexico in the state's promotion of tourism, see Montgomery, *Spanish Redemption,* Nieto-Phillips, *Language of Blood,* Wil-son, *Myth of Santa Fe,* and Sarah Deutsch, *No Separate Refuge: Culture, Class, and Gen-der on an Anglo-Hispanic Frontier in the American Southwest, 1880–1940* (New York: Oxford University Press, 1987), 189–196.

9. I describe here what anthropologist John Bodine has called the "triethnic trap." John Bodine, "A Tri-Ethnic Trap: The Spanish-Americans in Taos," in June Helm, ed., *Spanish-Speaking People in the United States* (Seattle: University of Washington Press, 1968), 145–153. I believe the positions taken by Anglo members of the Santa Fe and Taos art communities during the Bursum bill struggle helped to spring the triethnic trap. I do not feel, however, that Anglos were the only actors in creating and springing the trap. Nuevomexicanos and Pueblo Indians participated as well for complicated rea-sons that both restricted and protected their power.

10. The term "Spanish fantasy heritage" comes from Carey McWilliams, who used it in reference to the imagined past Anglos created in California in the early twentieth century. Montgomery has applied McWilliams's idea to New Mexico, although noting the differences that distinguish the California and New Mexico experiences. See Carey McWilliams, *Southern California Country: An Island on the Land* (New York: Duell, Sloan, and Pearce, 1946), 70–83 and Montgomery, *Spanish Redemption.*

11. Nieto-Phillips, *Language of Blood,* 8.

12. Ann Massmann has discussed the varying benefits Otero-Warren gleaned from using various permutations of her name. Ann Massmann, "Adelina 'Nina' Otero-

Warren: A Spanish-American Cultural Broker," *Journal of the Southwest* 42, no. 4 (Winter 2000).

13. Miguel Antonio Otero II, the first native territorial governor of New Mexico, was Otero-Warren's father's cousin.

14. On Otero-Warren, see Charlotte Whaley, *Nina Otero-Warren of Santa Fe* (Albuquerque: University of New Mexico Press, 1994) and Elizabeth Salas, "Ethnicity, Gender, and Divorce Issues in the 1922 Campaign by Adelina Otero-Warren for the U.S. House of Representatives," *New Mexico Historical Review* 70, no. 4 (1995): 367–382. On Otero-Warren's use of a romanticized, whitened version of New Mexico's past in her writing, see Genaro M. Padilla, *My History, Not Yours: The Formation of Mexican American Autobiography* (Madison: University of Wisconsin Press, 1993), 20, 203.

15. For Otero-Warren's hire, see Lawrence Kelly, *The Assault on Assimilation: John Collier and the Origins of Indian Policy Reform* (Albuquerque: University of New Mexico Press, 1983), 279.

16. For the most succinct account of the effect of the Bursum bill on Fall's resignation, see Kenneth Philp, "Albert Fall and the Protest from the Pueblos, 1921–1923," *Arizona and the West* 12, no. 3 (1970): 237–254.

17. John Collier to Francis Wilson, 20 April 1923, Box 41, Francis C. Wilson Papers, New Mexico State Records Center and Archives, hereafter cited as FWP.

18. See John Collier to Elizabeth Shepley Sergeant, 23 October 1922, Sergeant to Collier, 24 October 1922, Collier to Sergeant, 31 October 1922, and Sergeant to Collier, 30 November 1922, all in John Collier Collection, Yale University, Manuscripts and Archives Division, hereafter cited as JCC.

19. See, for example, Alice Corbin Henderson to Roberts Walker, 31 December 1922, Alice Corbin Henderson Collection, Harry Ransom Humanities Research Center, University of Texas at Austin, hereafter cited as ACHC. Collier's zealotry would continue to interfere with his relationships with other officials while he was commissioner of Indian affairs. The skills that had served him well as an activist did not always do so when he was forging policy.

20. Margaret McKittrick, Gustave Baumann, Witter Bynner, Wm. P. Henderson, Sara McComb, Francis C. Wilson, Executive Committee, New Mexico Association on Indian Affairs, "Start From Here, Platform of the Indian Affairs Association," 4 October 1923, Box 41, FWP.

21. Herbert Welsh, Indian Rights Association to Albert Fall, 21 March 1922, Albert Fall Papers, Henry E. Huntington Library, San Marino, California, hereafter cited as AFP.

22. An ally of Alice Corbin Henderson, Roberts Walker, also used the term *penitentes* to refer to Nuevomexicanos. See Roberts Walker to Alice Corbin Henderson, 21 December 1922, ACHC.

23. Lou Henry Hoover to Austin, 17 December 1922, MAP.

24. A. B. Renehan, "Laws and Equities Affecting the So-Called Settlers on Pueblo Indian Land Grants," address given to the League of the Southwest, Santa Barbara, California, 9 June 1923, Box 41, FWP.

25. Senate Subcommittee of the Committee on Public Lands and Surveys, Bills

Relative to the Pueblo Indian Lands: Hearings on S. 3865 and S. 4223, 67th Cong. 4th sess., 23 January 1923, 196.

26. On the origins of the New Mexico racial system of identification, see James Brooks, *Captives and Cousins: Slavery, Kinship, and Community in the Southwest Borderlands* (Chapel Hill: University of North Carolina Press, 2001), Ramón Gutiérrez, *When Jesus Came, the Corn Mothers Went Away: Marriage, Sexuality, and Power in New Mexico, 1500–1846* (Palo Alto, Calif.: Stanford University Press, 1991), Adrían Herminio Bustamante, "Los Hispanos: Ethnicity and Social Change in New Mexico" (Ph.D. diss., University of New Mexico, 1982), Ross Frank, *From Settler to Citizen: New Mexican Economic Development and the Creation of Vecino Society, 1750–1820* (Berkeley: University of California Press, 2000), and Nieto-Phillips, *Language of Blood*, 13–50.

27. Statements by members of northern Pueblos, 24 March 1922, Box 2, Northern Pueblo Agency (1904–1937), 86; Correspondence, Reports and Other Records Relating to the Pueblo Lands Board, 1918–32 (Section 308), Records of the Bureau of Indian Affairs, Record Group 75; National Archives and Records Administration, Rocky Mountain Region, Denver, Colo., hereafter cited as NARA, RMR. The original statement reads "as early as 1776," but because in 1776 New Mexico was Spanish territory, I suspect the date is a typographical error, and the authors meant 1876, when the territory would have been American, but judges may have been Nuevomexicano.

28. Montgomery, *Spanish Redemption*, especially 54–88, and Nieto-Phillips, *Language of Blood*, especially 51–104.

29. Nancy P. Appelbaum, Anne S. Macpherson, and Karin Alejandra Rosemblatt, *Race and Nation in Modern Latin America* (Chapel Hill: University of North Carolina Press, 2003).

30. Montgomery, *Spanish Redemption*, 54–88, and Nieto-Phillips, *Language of Blood*, 51–104.

31. Renehan, "Laws and Equities Affecting the So-Called Settlers," Box 41, FWP.

32. Montgomery, *Spanish Redemption*, Chapters 4–6.

33. Alice Corbin Henderson, "Old Spain in New Mexico," in *They Know New Mexico: Intimate Sketches by Western Writers*, issued by the Passenger Department, Atchison, Topeka, and Santa Fe Railway (Chicago: Rand McNally, 1928), 11 (filed in ACHC Box 20).

34. John Collier, "The Red Atlantis," *Survey Graphic* (October 1922): 15.

35. Collier to Dodge, 22 May 1922, Mabel Dodge Luhan Papers, Yale Collection of American Literature, Beinecke Rare Book and Manuscript Library, hereafter cited as MDLP.

36. See John Collier, "Plundering the Pueblo Indians," *Sunset Magazine* (January 1923): 21–25, 56 and John Collier, "The Pueblos' Last Stand," *Sunset Magazine* (February 1923): 19–22, 65–66, in which he uses the term *Mexican* at the outset of the article but switches to the all-encompassing *white* later. Also see John Collier, "The American Congo," *Survey Graphic* (August 1923): 467–476, in which he only uses the term *white*.

37. Adolf A. Berle, *Navigating the Rapids, 1918–1971: From the Papers of Adolf A. Berle*, eds. Beatrice Bishop Berle and Travis Beal Jacobs (New York: Harcourt, Brace, Jovanovich, 1973), 17.

38. Alice Corbin Henderson to Roberts Walker, 4 January 1924, ACHC.

39. Elizabeth Sergeant even forecast such an outcome when she wrote "Many Indians holding individual sections of Pueblo land . . . sold or bartered or gave pieces of land to Spanish-American settlers. The descendants of such settlers . . . have equal rights in equity, if not in law, with the Indians." See Sergeant, "The Last First Americans," *Nation* (29 November 1922): 570.

40. Berle, *Navigating*, 17–18 and Adelina (Nina) Otero-Warren, Report on the Santo Domingo Council, 11 September 1923, Box 85, General Services Files 45918, 013-1921, Box 85, Record Group 75, National Archives and Records Administration, Washington, D.C., hereafter cited as NARA, D.C.

41. See Kelly, *Assault*, 282–283.

42. New Mexico Association of Indian Affairs, meeting minutes, 30 August 1923, included in Otero-Warren, Report on the Santo Domingo Council, 11 September 1923. NARA, D.C.

43. New Mexico Association of Indian Affairs, meeting minutes. The terms *non-Indian* and *settlers* included Anglo and Nuevomexicano settlers, but the concern of many in the New Mexico Association of Indian Affairs appears to have been that Nuevomexicano settlers particularly would have lost their claims.

44. New Mexico Association of Indian Affairs, meeting minutes.

45. Otero-Warren, Report on the Santo Domingo Council, 11 September 1923. NARA, D.C.

46. Otero-Warren, *Old Spain*, 51.

47. Nina Otero-Warren, Report on the Visit of Mrs. Thomas G. Winter, President of the General Federation of Women's Clubs, 22 November 1923. Box 85, General Services Files 45918, 013–1921, Record Group 75, NARA, D.C.

48. The pressure came from Ralph Twitchell, the attorney who had originally drafted the Bursum bill. See A. R. Manby to Charles Burke, n.d., and attached newspaper clipping, Box 85, General Services Files 45918, 013–1921, Record Group 75, NARA, D.C. and Collier to Dodge, n.d., MDLP. For Austin's and Collier's involvement in the decision, see Kelly, *Assault*, 275–276.

49. See William Henderson to Alice Corbin Henderson, 1922, Box 3, 1918–1923, uncatalogued letters of William Penhallow Henderson and Alice Corbin Henderson, Archives of American Art/Smithsonian Institution, hereafter cited as AAA.

50. Dodge to Austin, n.d., MAP. Errors in original.

51. Dodge to Austin, 2 November, MAP. Errors in original.

52. As cited in Kelly, *Assault*, 276.

53. Kelly, *Assault*, 276.

54. D. H. Lawrence to Dodge, 8 November 1923, *The Letters of D. H. Lawrence*, vol. 4, *June 1921–March 1924*, ed. Warren Roberts, James T. Boulton, and Elizabeth Mansfield (Cambridge: Cambridge University Press, 1987), 527.

55. D. H. Lawrence to Dodge, 10 February 1924, in *The Letters of D. H. Lawrence*, vol. 5, *March 1924–March 1927*, ed. James T. Boulton and Lindeth Vasey (Cambridge: Cambridge University Press, 1989), 577.

56. Van Vechten to Dodge, 16 May 1920, MDLP.

57. Mabel Dodge Luhan, "The Santos of New Mexico," *Arts* 3, no. 3 (March 1925): 127–137.

58. *Taos Valley News,* undated clipping in scrapbook volume 17, Box 5, Scrapbooks, MDLP.

59. Evans to Dodge, n.d., MDLP.

60. The number of late eighteenth-century and early nineteenth-century santos available for sale also declined in the late 1920s. Without such santos available, Dodge may have decided she was no longer interested in being a collector. Still, the animosity of members of the local Nuevomexicano community must have contributed to her shift in patronage from 1925 on. For the decline in sales of older santos, see Andrew Dasburg to Alfred Dasburg, 2 February 1922, Reel 2045, AAA.

61. My intent is to show the historical causality behind the anthropological findings Bodine describes (Bodine, "Tri-Ethnic Trap," 145–153). Bodine argues that in Taos specifically the Anglo arts community's favoritism of the Pueblo Indians trapped Nuevomexicanos between the prejudice they endured from the wider Anglo community and the secondary status accorded them by Anglo artists and patrons. As neither "white" members of the community nor "picturesque primitives," Nuevomexicanos fell into the least economically, socially, and politically valuable strata of the areas' trio of ethnicities. In addition to historicizing Bodine's theory, I feel the experiences of the Dodge circle vis-à-vis the New Mexico Association also explains why Nuevomexicano artists have received more support from the Anglo art community of Santa Fe than the Anglo art community of Taos. Some Nuevomexicanos, rather than accept the "triethnic trap" in Taos, appear to have chosen to participate in a wider system of patronage, one that included the Anglo art community of Santa Fe. Although such conclusions may seem self-evident, the fact that Dodge and many of her visitors briefly supported Nuevomexicanos and Nuevomexicano art suggests that Anglo patrons' favoritism for Pueblo Indians over local Nuevomexicanos in Taos was not a foregone conclusion.

62. Mary Austin, *Earth Horizon* (New York: Literary Guild, 1932), 340.

63. Mary Austin to Mabel Dodge, n.d., MDLP and Austin to Collier as cited in Kelly, *Assault,* 259.

64. John Collier, *From Every Zenith: A Memoir; and Some Essays on Life and Thought* (Denver, Colo.: Alan Swallow, 1963), 155.

65. Kelly, *Assault,* 285 and New Mexico Association of Indian Affairs, meeting minutes, 30 August 1923, included in Otero-Warren's Report on the Santo Domingo Council, 11 September 1923. NARA, D.C.

66. Margaret Jacobs describes the gendered terms in which white female moral reformers and feminists who shared Austin's views staked out territory in the Pueblo Indian dance controversy in *Engendered Encounters: Feminism and Pueblo Cultures, 1879–1934* (Lincoln: University of Nebraska Press, 1999), 106–148. Other treatments of the dance controversy include Kelly, *Assault,* 300–348, Kenneth Philp, *John Collier's Crusade for Indian Reform, 1920–1954* (Tucson: University of Arizona Press, 1977), 55–70, and Tisa Wenger, "Savage Debauchery or Sacred Communion? Religion and the Primitive in the Pueblo Dance Controversy" (Ph.D. diss., Princeton University, 2002).

67. Whaley, *Nina Otero-Warren of Santa Fe,* 130 and Otero-Warren, *Old Spain.*

68. On the conclusion of Collier's involvement in the Pueblo Lands Act, see Kelly, *Assault*, 213–292.

69. Ibid., 213–292.

70. For a full discussion of the effects of the Pueblo Lands Board adjudication on the New Mexico local economy and its apportionment of natural resources, see Suzanne Forrest, *The Preservation of the Village: New Mexico's Hispanics and the New Deal* (Albuquerque: University of New Mexico Press, 1989), 56–61 and Emlen Hall, "The Pueblo Land Grant Labyrinth," in Charles L. Briggs and John R. Van Ness, eds., *Land, Water, and Culture: New Perspectives on Hispanic Land Grants* (Albuquerque: University of New Mexico Press, 1987), 117–126. Sarah Deutsch charts the economic choices Nuevomexicanos made as their land base shrank over the turn of the century in *No Separate Refuge*. Alvar Carlson argues that Pueblo Indians began making the transition to ranching and Nuevomexicanos to farming before the Pueblo Lands Act. Alvar Carlson, "Spanish-American Acquisition of Cropland within the Northern Pueblo Indian Grants, New Mexico," *Ethnohistory* 22, no. 2 (1975): 95–110. William deBuys argues that Nuevomexicanos would benefit if their historic claims to lands in New Mexico were granted the same protections given to Pueblo Indians. He notes that following Collier's advocacy for the Pueblos 667,479 acres were returned to Pueblo ownership and that Collier's endeavors set the stage for the creation of the Indian Claims Commission in the Franklin Roosevelt administration in 1946. deBuys calls for a similar Hispanic land claims commission. William deBuys, *Enchantment and Exploitation: The Life and Hard Times of a New Mexico Mountain Range* (Albuquerque: University of New Mexico Press, 1985), 311.

Chapter 4: Carl Van Vechten's Place

1. Van Vechten devoted a chapter to a description of Dodge's salon. See Carl Van Vechten, *Peter Whiffle: His Life and Works* (New York: Knopf, 1922), 121–145.

2. Ibid., 145.

3. Patricia Everett argues convincingly that the painting was originally one of three abstract portraits of Mabel Dodge. See Everett, "Andrew Dasburg's Abstract Portraits: Homages to Mabel Dodge Luhan and Carl Van Vechten," *Smithsonian Studies in American Art* 3, no. 1 (Winter 1989): 73–87.

4. Although Dodge provided Van Vechten's introduction to Stein, Van Vechten's and Stein's friendship flowered while Dodge's friendship with each of them waned. See Edward Burns, ed., *The Letters of Gertrude Stein and Carl Van Vechten, 1913–1946* (New York: Columbia University Press, 1986). Burns notes their mutual criticism of Dodge: "Stein and Van Vechten almost never indulge in literary gossip. Where gossip does surface, it is in their remarks about Mabel Dodge. . . . Dodge's marriages, particularly to the full-blooded Pueblo Indian Antonio Lujan (later changed to Luhan), her stormy relationship with D. H. Lawrence, and her volumes of memoirs all became grist for a gossip mill between Stein and Van Vechten, which at times during the 1920s and 1930s was wickedly insidious" (Burns, *Letters*, 8–9).

5. In *The Harlem Renaissance*, Steven Watson notes that Van Vechten's father had cofounded the Piney Woods School, the first school for African Americans in Mississippi, and that as early as 1914, Van Vechten had praised *Granny Maumee*, a play about African American life by a white author. Dodge recalled Van Vechten's interest in African American culture in her memoirs as well. She describes Van Vechten inviting two African American performers to her home for the first event held at her salon. Watson states that the performers were cast members of J. Leubria Hill's *My Friend from Kentucky*. Steven Watson, *The Harlem Renaissance: Hub of African-American Culture, 1920–1930* (New York: Pantheon Books, 1997), 98–99 and *Movers and Shakers* (New York: Harcourt, Brace, 1936; reprinted with an introduction by Lois Palken Rudnick, Albuquerque: University of New Mexico Press, 1985), 79.

6. Although Van Vechten's interest in African American culture may have seemed frivolous, it was sincere and long-lasting. In addition to his novel and the patronage he provided for Hughes and other figures of the Harlem Renaissance, Van Vechten took numerous photographs of Harlem's artists, writers, and performers. He also took photos of nude white and black men. James Smalls explores the power dynamics of these photographs in *The Homoerotic Photography of Carl Van Vechten: Public Face, Private Thoughts* (Philadelphia, Penn.: Temple University Press, 2006). Smalls contends, as others have argued regarding Van Vechten's writing, that the photos and their primitivist content helped Van Vechten to shore up his own identity as modern and avant-garde. Smalls also argues, however, that the photos were Van Vechten's attempt to present interracial and homosexual relationships in an equitable context (Smalls, *Homoerotic Photography*, 7). Many of Van Vechten's photographs are housed in the Carl Van Vechten Photographs Collection at the Library of Congress and in the Carl Van Vechten Collection, Beinecke Rare Book and Manuscript Library, hereafter cited as CVVC.

7. Maurice Sterne to Dodge, 30 November 1917, Mabel Dodge Luhan Papers, Yale Collection of American Literature, Beinecke Rare Book and Manuscript Library, hereafter cited as MDLP.

8. Mabel Dodge Luhan, "Twelfth Night," MDLP.

9. Marianna Torgovnick explores the difficulty of defining primitivism in her study, *Gone Primitive: Savage Intellects, Modern Lives* (Chicago: University of Chicago Press, 1990). I follow her lead in examining "conceptions of the primitive that drive the modern and postmodern across a wide range of fields and levels of culture" (21). I am not interested in defining actual primitive societies. I do not believe such societies exist. Rather, I think that they are creations of white modernists. This chapter charts both how Van Vechten's and Dodge's creations came into dialogue and conflict and how the objects of their primitivism responded to their creations.

10. As Torgovnick and others have argued, the similarities primitivists saw among the people they called primitive allowed them to shore up their own white identity. If so-called primitive cultures were remnants of an earlier time, close to nature and at peace with themselves, then white so-called civilized cultures were modern, distant from nature, and neurotic. Van Vechten and Dodge certainly appeared at least as interested in their own identities as they were in the identities of the people they patronized. Because Torgovnick and others have charted how primitivism affected modern

white identity, I do not duplicate their efforts here. Instead, I hope to build on their insights by showing how the contrasts Van Vechten and Dodge drew between African Americans and Native Americans were as influential in the formation of white modern identity as the similarities primitivists saw between the two groups. Moreover, I hope to call attention to how those people Van Vechten and Dodge patronized took advantage of the fissures between them to create and record their own responses to the patronage they received and the primitivism that they witnessed. In this endeavor I follow the lead of Tracy McCabe, who argues that one should read primitivisms as "sites of complex cultural struggles, in which diversely positioned subjects manipulate and are manipulated by competing political ends." Torgovnick, *Gone Primitive*, 11–18 and McCabe, "Resisting Primitivism: Race, Gender, and Power in Modernism and the Harlem Renaissance" (Ph.D. diss., University of Wisconsin–Madison, 1994), 20.

11. Van Vechten's influence has been charted in Burns, *Homoerotic Photography,* Emily Bernard, *Remember Me to Harlem: The Letters of Langston Hughes and Carl Van Vechten, 1925–1964* (New York: Knopf, 2001), Leon Coleman, *Carl Van Vechten and the Harlem Renaissance: A Critical Assessment* (New York: Garland, 1998), Nathan Huggins, *Harlem Renaissance* (New York: Oxford University Press, 1971), Bruce Kellner, *Carl Van Vechten and the Irreverent Decades* (Norman: University of Oklahoma Press, 1968), and Edward Lueders, *Carl Van Vechten and the Twenties* (Albuquerque: University of New Mexico Press, 1955). Van Vechten also appears as a tangential figure in writings on the 1920s and on the Harlem Renaissance. See, for example, Robert M. Crunden, *Body and Soul: The Making of American Modernism* (New York: Basic Books, 2000), Ann Douglas, *A Terrible Honesty: Mongrel Manhattan in the 1920s* (New York: Farrar, Straus, and Giroux, 1995), Frederick J. Hoffman, *The 1920s: American Writing in the Postwar Decade* (New York: Free Press, 1949), and David Levering Lewis, *When Harlem Was in Vogue* (New York: Penguin, 1997). Lewis calls Van Vechten "a salon primitivist" (98–99).

12. Although competitive primitivism may have provided opportunities for Pueblo Indians and African Americans in Harlem to act on their own behalf, I have found little evidence that they were powerful enough to do so frequently. Rarely also did Pueblo Indians directly challenge Dodge's behavior and its effects. I address some of Tony Lujan's agency in the following chapter, but I mean to draw a distinction between agency and subjectivity. Few if any of those who received support from Dodge and Van Vechten were able to act as agents, but such lack of action did not indicate a lack of thought. Langston Hughes's poem below suggests that those who benefited and suffered from the patronage of Dodge, Van Vechten, and others shaped their concepts of themselves in response to the patronage they received. They also countered what McCabe calls "hegemonic primitivism," which she notes as dominant in the 1920s United States, and which led many Americans to identify so-called primitive attributes such as spontaneity, emotionalism, and affinity for nature as negative and dangerous traits (McCabe, "Resisting Primitivism," 3).

13. Social histories of the multiracial nature of the American West include Tomás Almaguer, *Racial Fault Lines: The Historical Origins of White Supremacy in California* (Berkeley: University of California Press, 1994), Katherine Benton, "What about Women in the White Man's Camp? Gender, Nation, and the Redefinition of Race in

Cochise County, Arizona, 1853–1941" (Ph.D. diss., University of Wisconsin–Madison, 2002), Neil Foley, *The White Scourge: Mexicans, Blacks, and Poor Whites in Texas Cotton Culture* (Berkeley: University of California Press, 1997), and Natalia Molina, *Fit to Be Citizens? Public Health and Race in Los Angeles, 1879–1939* (Berkeley: University of California Press, 2006). Studies specifically of triracial relations in Taos include John Bodine, "A Tri-Ethnic Trap: The Spanish-Americans in Taos," in June Helm, ed., *Spanish-Speaking People in the United States* (Seattle: University of Washington Press, 1968), 145–153 and Sylvia Rodríguez, "Art, Tourism, and Race Relations in Taos: Toward a Sociology of the Art Colony," *Journal of Anthropological Research* 45, no. 1 (1989): 77–99.

14. In her study of turn-of-the-century Hispanas in northern New Mexico and southern Colorado, Sarah Deutsch notes, "In much the same way New York's avant-garde turned to Harlem in the 1920s, New Mexico's literati, clustered in their bohemian colonies in Santa Fe and Taos, turned to Spanish American and Indian arts." This chapter investigates that parallel development and how it built on the experiences of those who claimed membership in both New York's avant-garde and northern New Mexico's bohemian communities. See Sarah Deutsch, *No Separate Refuge: Culture, Class, and Gender on an Anglo-Hispanic Frontier in the American Southwest, 1880–1940* (New York: Oxford University Press, 1987), 190.

15. Carl Van Vechten to Gertrude Stein, 15 November 1924, in Burns, *Letters*, 109.

16. Carl Van Vechten, "Mean Ole Miss Blues Becomes Respectable," *New York Herald Books*, 6 June 1926.

17. Carl Van Vechten, "Hey, Hey," *New York Herald Books*, 31 October 1926.

18. Carl Van Vechten, "'The Book of American Negro Spirituals'—Review," *Opportunity* 3 (1925): 330.

19. Carl Van Vechten, "'Moanin' wid a Sword in Ma Han'," *Vanity Fair* (February 1926).

20. Van Vechten, "Mean Ole Miss Blues."

21. Ibid.

22. Carl Van Vechten, "A Prescription for the Negro Theatre," *Vanity Fair* (October 1925).

23. Mabel Dodge Luhan, "Una and Robin," unpublished manuscript, January 1933, Mabel Dodge Luhan Collection. Yale Collection of American Literature, Beinecke Rare Book and Manuscript Library, hereafter cited as MDLC.

24. Shepherd Krech, *The Ecological Indian: Myth and History* (New York: W.W. Norton, 1999).

25. Dodge to Van Vechten, 10 June 1925, CVVC. Kevin J. Mumford has noted the racialized conception of the id in 1920s popular psychological discourse. Kevin J. Mumford, *Interzones: Black/White Sex Districts in Chicago and New York in the Early Twentieth Century* (New York: Columbia University Press, 1997), 83. Because both Dodge and Van Vechten were turning to nonwhite people to find a purer, less inhibited, and more authentic version of themselves, it is likely Dodge engaged in her psychoanalytic treatment with ideas of racial difference in mind. Torgovnick notes that Freud himself in *Civilization and its Discontents* drew parallels among children, individual neurotics, and societies he deemed primitive (Torgovnick, *Gone Primitive*, 203).

26. Van Vechten to Stein, 15 July 1925 and Van Vechten to Stein, 18 January 1926, in Burns, *Letters*, 104, 125.

27. James Weldon Johnson, *Black Manhattan* (New York: Knopf, 1930).

28. Van Vechten to Dodge, 6 November 1922, MDLP.

29. Van Vechten to Dodge, 4 June 1923, MDLP.

30. Dodge to Van Vechten, 24 November 1925, CVVC.

31. Nathan Huggins argues that through his support for Johnson, Countee Cullen, Langston Hughes, Paul Robeson, and others, Van Vechten facilitated the creative development of those he patronized and aided their publishing opportunities. Huggins concludes that Van Vechten "acted as a kind of midwife to the Harlem Renaissance" (Huggins, *Harlem Renaissance*, 93). As many scholars have noted, "Harlem Renaissance" is a misnomer that fails to acknowledge the cultural activities of African Americans prior to the 1920s and in areas outside New York City. Because the following pages address Van Vechten's and Dodge's relationship with African American writers who did live in Harlem in the 1920s, I continue to use the phrase "Harlem Renaissance."

32. "Reunion," *New Yorker* (March 26, 1927).

33. Van Vechten to Stein, 8 September 1924, in Burns, *Letters*, 105.

34. Bernadine Szold, "About Town," *New York Daily News*, 22 March 1925, 46.

35. As Torgovnick notes, "Our culture's generalized notion of the primitive is by nature and in effect inexact or composite: it conforms to no single social or geographical entity and, indeed, habitually and sometimes willfully confuses the attributes of different societies. . . . Less professional discourses often unabashedly and irresponsibly mix attributes and objects from widely separate geographical locales" (Torgovnick, *Gone Primitive*, 22). Szold was certainly mixing "unabashedly" the qualities of several different groups she and others considered primitive.

36. Art historian W. Jackson Rushing has explored the relationship between Native American artists, their art, and advocates and practitioners of modern art in *Native American Art and the New York Avant-Garde: A History of Cultural Primitivism* (Austin: University of Texas Press, 1997).

37. Nellie McKay, *Jean Toomer, Artist: A Study of His Literary Life and Work, 1894–1936* (Chapel Hill: University of North Carolina Press, 1987), 187–193.

38. Jean Toomer, *Cane* (New York: Liveright, 1975 [1923]), ix.

39. Letter from Jean Toomer to James Weldon Johnson, 11 July 1930, Jean Toomer Papers, James Weldon Johnson Collection, Beinecke Rare Book and Manuscript Library, hereafter cited as JTP.

40. Mabel Dodge Luhan to Toomer, 8 January [n.d.], JTP.

41. William Henderson and his wife Alice Henderson remained in correspondence with Toomer and A. R. Orage until 1930. See Orage to Alice Henderson, 12 September 1928, in which Orage praises Santa Fe over California, and Toomer to Alice Henderson, 30 January 1926, in which Toomer asks if she has been holding group meetings. Both in Alice Corbin Henderson Collection, Harry Ransom Center for the Humanities, University of Texas–Austin, hereafter referred to as ACHC.

42. Mabel Dodge Luhan to Toomer, 8 January [n.d.], JTP, Mabel Dodge Luhan to

Toomer, [n.d.], JTP, Toomer to Mabel Dodge Luhan, 26 November 1932, JTP, Mabel Dodge Luhan to Toomer, 30 November 1934, JTP, Toomer to Mabel Dodge Luhan, 4 December 1934, JTP, and Lois Rudnick, *Mabel Dodge Luhan: New Woman, New Worlds* (Albuquerque: University of New Mexico Press, 1984), 227–230.

43. Mabel Dodge Luhan, "A Bridge between Cultures," *Theatre Arts Monthly* 9, no. 5 (1925): 297–301.

44. Mabel Dodge Luhan to Toomer, Monday, [n.d.], JTP.

45. Langston Hughes, *The Big Sea: An Autobiography* (New York: Knopf, 1940; reprinted with an introduction by Arnold Rampersad, New York: Hill and Wang, 1993), 241–243.

46. Hughes, *The Big Sea*, 260–262.

47. Langston Hughes, *Selected Poems of Langston Hughes* (New York: Vintage Books, 1959), 94–95.

48. I hope here to draw a distinction between subjectivity and agency. When I first encountered Hughes's poem, I was tempted to argue it was an instance of Hughes exerting his agency, which I defined as acting on his own behalf to counter the primitivism of Van Vechten and Dodge. Later, however, when I considered that Hughes denied any connection between the poem and the Lujan-Toomer-Dodge triangle and that the poem did nothing to counter the power Van Vechten and Bynner wielded over him in their support for his writing, I decided that *agency* was too strong a term for Hughes's action in this particular case. Instead, I would term the poem an instance of his subjectivity; that is, the poem allowed him an opportunity to consider the position of nonwhite people who received support and encouragement from condescending white elites. Because Hughes was in a similar situation himself, the poem also possibly enabled him to consider his own position vis-à-vis his patrons. The poem, then, allowed him to reconsider his subject position, but did not allow him to challenge those who held power over him.

49. As Huggins concludes: "Try as he might to illustrate that Negroes were much like other people, Van Vechten's belief in their essential primitivism makes him prove something else. It stands to reason, after all. Had he thought Negroes were like white people, he would not have adopted Harlem the way he did. His compulsion to be fair to the race while he exploited the exotic and decadent aspects of Harlem caused the novel to founder" (Huggins, *Harlem Renaissance*, 112).

50. Emily Bernard makes this argument in "What He Did for the Race: Carl Van Vechten and the Harlem Renaissance," *Soundings: An Interdisciplinary Journal* 80, no. 4 (winter 1997): 531–541. In fact, she proposes that had Van Vechten not existed, black authors might well have invented him. The quotes included in this paragraph are from Bernard's work.

51. As cited in Bruce Kellner, *Carl Van Vechten and the Irreverent Decades* (Norman: University of Oklahoma Press, 1968), 210–211.

52. Dodge to Van Vechten, 11 August [1926], CVVC.

53. D. H. Lawrence to Dorothy Brett, 9 February 1927, in *The Letters of D. H. Lawrence*, vol. 5, *March 1924–March 1927*, ed. James T. Boulton and Lindeth Vasey (Cambridge: Cambridge University Press, 1989), 639.

54. D. H. Lawrence, *Phoenix: The Posthumous Papers of D. H. Lawrence* (New York: Viking, 1936), 361–363. One of the unintended and unfortunate consequences of Van Vechten's title was that many critics and readers of the novel used the word "nigger" far more freely after the book's publication.

55. D. H. Lawrence to Willard Johnson, n.d., *Letters of D. H. Lawrence,* 652.

56. Van Vechten to Stein, 16 February 1927, in Burns, *Letters,* 140.

57. Dodge to Van Vechten, [n.d.], CVVC.

58. Stein to Van Vechten in Burns, *Letters,* 152–153.

59. Steven Watson, *Prepare for Saints: Gertrude Stein, Virgil Thomson and the Main-streaming of American Modernism* (Berkeley: University of California Press, 1995).

Chapter 5: Tony Lujan's Place

1. Mabel Dodge Luhan to Jean Toomer, [n.d.], Box 5, James Weldon Johnson Collection, Beinecke Rare Book and Manuscript Library, Yale University.

2. Mabel Dodge Luhan, "Can't We Let the Indians Find Their Own Way Home?" *Crepúsculo,* 26 May 1949, Articles and Printed Poetry by Mabel Dodge Luhan, Mabel Dodge Luhan Papers, Yale Collection of American Literature, Beinecke Rare Book and Manuscript Library, hereafter cited as MDLP.

3. J. R. Martinez, "We Are Men Now," *Taos Star,* [n.d.], Pamphlets and Newspaper Articles, MDLP.

4. Alfred Lujan, interview with the author, 13 March 2002, hereafter cited as Alfred Lujan interview.

5. Mabel Dodge Luhan, *Winter in Taos* (New York: Harcourt, Brace, 1935).

6. Mabel Dodge Luhan to Mary Austin, [1923 or 1924], Box 95, Mary Austin Papers, Henry E. Huntington Library, San Marino, California, hereafter cited as MAP.

7. Edith Lewis, *Willa Cather Living: A Personal Record* (New York: Knopf, 1953), 139–143 and Willa Cather, *Death Comes for the Archbishop* (New York: Vintage Books, 1971 [1927]), 132.

8. Van Vechten to Dodge, 25 January 1927, and Leopold Stokowski to Dodge, 6 January 1938, MDLP. Many of Dodge's other correspondents expressed similar sentiments.

9. Mabel Dodge Luhan, *Edge of Taos Desert: An Escape to Reality* (New York: Harcourt, Brace, 1937; reprint, Albuquerque: University of New Mexico Press, 1987), 105.

10. Ibid., 151.

11. Ibid., 197. Emphasis in original.

12. Mabel Dodge Luhan, *Lorenzo in Taos* (New York: Knopf, 1932), 37.

13. Frieda Lawrence to Dodge, [n.d.], MDLP.

14. Lucy Collier to Dodge, [1926], MDLP.

15. Brett to Dodge, [1930], MDLP.

16. O'Keeffe to Dodge, [n.d.], MDLP.

17. O'Keeffe to Dodge, [n.d.], MDLP.

18. Ella Young to Dodge, 29 June [1929], MDLP.

19. Lois Palken Rudnick, *Mabel Dodge Luhan: New Woman, New Worlds* (Albuquerque: University of New Mexico Press, 1984), 155.

20. Dodge Luhan, *Edge of Taos Desert*, 331.

21. Alfred Lujan interview and Gilbert Suazo conversation with the author, 13 March 2002.

22. Emily Hahn, *Mabel: A Biography of Mabel Dodge Luhan* (Boston: Houghton Mifflin, 1977), 171–172 and Rudnick, *Mabel Dodge Luhan*, 155 and 181–182. For Taos Pueblo's reaction to Tony Lujan's marriage, see Frank Waters, *Masked Gods: Navajo and Pueblo Ceremonialism* (New York: Ballantine Books, 1960 [1950]), 124.

23. *Rocky Mountain News*, 14 April 1935, as quoted in Rudnick, *Mabel Dodge Luhan*, 251.

24. Alfred Lujan, Juan Suazo, Jimmy Suazo, and Natividad Suazo, interview with the author, 13 March 2002, hereafter cited as Suazo interview. Interestingly, the Suazos and Alfred Lujan stressed the role Dodge and Lujan played as employers but said little about Dodge's purchase of large amounts of land in the Taos area. Alfred Lujan remains distressed to this day because he believes he should have inherited land that went to the Suazos, but he did not suggest that Dodge took advantage of Juan Trujillo when she bought his land as the site of her house.

25. Alfred Lujan interview. Lujan stated that Tony Lujan paid others, but not Alfred Lujan's father, with portions of his harvests.

26. Alfred Lujan interview.

27. Suazo interview.

28. C. J. Crandall to Commissioner Burke, 25 April 1924, Box 2, Northern Pueblo Agency (1904–1937), 83 General Correspondence File (1911–1935), Administration and Control (Section 120–121, 054.1-076), Records of the Bureau of Indian Affairs, Record Group 75; National Archives and Records Administration, Rocky Mountain Region, Denver, Colo., hereafter cited as NARA, RMR.

29. On representations of native peoples and automobility, see Philip Deloria, *Indians in Unexpected Places* (Lawrence: University Press of Kansas, 2004), 136–182.

30. Alfred Lujan interview.

31. Tony Archuleta to Lujan and Dodge, 3 March 1924, MDLP.

32. Archuleta to Dodge, 19 October 1935, MDLP.

33. Alfred Lujan interview.

34. Suazo interview.

35. Dodge Luhan, *Edge of Taos Desert*, 332.

36. Mabel Dodge Lujan to Carl Van Vechten, 14 April 1925, Carl Van Vechten Collection, Beinecke Rare Book and Manuscript Library.

Chapter 6: Mary Austin's Place

1. Mabel Dodge to Carl Van Vechten, 12 December 1913, Carl Van Vechten Collection, Beinecke Rare Book and Manuscript Library, Yale University, hereafter cited as CVVC.

2. Austin to Dodge, 12 January [1923], and Elizabeth Duncan to Dodge, 7 May 1936, Mabel Dodge Luhan Papers, Yale Collection of American Literature, Beinecke Library, Yale University, hereafter cited as MDLP.

3. Dodge to Austin, 28 May 1923 and 12 July 1923, Mary Austin Papers, Henry E. Huntington Library, San Marino, California, hereafter cited as MAP.

4. Robert Edmond Jones to Dodge, 1923, MDLP.

5. Robert Edmond Jones to Dodge, 1922, MDLP.

6. Copy of letter from Leo Stein to D. H. Lawrence included in letter from Stein to Dodge, 9 November 1921, MDLP.

7. Mary Foote to Dodge, 23 August 1944, MDLP. Mary Foote, a portrait painter, is not to be confused with the famous illustrator Mary Hallock Foote.

8. See letters from Austin to Dodge, 29 April 1923 and 10 May 1923 in MDLP.

9. On Austin's biography, see Augusta Fink, *I-Mary: A Biography of Mary Austin* (Tucson: University of Arizona Press, 1983) and Esther Lanigan Stineman, *Mary Austin: Song of a Maverick* (New Haven, Conn.: Yale University Press, 1989).

10. Photos of Austin's home are in album 296, MAP.

11. I have been strongly influenced in my analysis of Austin by Maureen Reed's study of women writers in New Mexico and by her idea of "homesickness," which she defines as "a gnawing feeling that the home that is supposed to be there doesn't quite exist." Maureen Reed, *A Woman's Place: Women Writing New Mexico* (Albuquerque: University of New Mexico Press, 2005), 1.

12. The only other scholarly work of which I am aware that addresses the federation's perspective on the culture center is Kay Hilliard, "The Texas Federation of Women's Clubs and the Santa Fe Culture Colony" (Southern Methodist University, 1996, photocopy). A copy of the paper is available in Texas Federation of Women's Clubs Collection, Mss 32, Texas Woman's University, Denton, Texas, hereafter cited as TFWCC.

13. Variants on this interpretation are found in Molly H. Mullin, *Culture in the Marketplace: Gender, Art, and Value in the American Southwest* (Durham, N.C.: Duke University Press, 2001), 101–104, Beatrice Chauvenet, *Hewett and Friends: A Biography of Santa Fe's Vibrant Era* (Santa Fe: Museum of New Mexico Press, 1983), 175–186, Charles Montgomery, *The Spanish Redemption: Heritage, Power, and Loss on New Mexico's Upper Rio Grande* (Berkeley: University of California Press, 2002), 145–150, Arrell Morgan Gibson, *The Santa Fe and Taos Colonies: Age of the Muses, 1900–1942* (Norman: University of Oklahoma Press, 1983), 253–258, and Carter Jones Meyer, "The Battle Between 'Art' and 'Progress': Edgar L. Hewett and the Politics of Region in the Early Twentieth-Century Southwest," *Montana: The Magazine of Western History* 56, no. 3 (Autumn 2006): 47–59.

14. Montgomery, *Spanish Redemption,* 149.

15. The two organizations to object were a mutual aid society called La Unión Protectiva and El Centro de Cultura, a recently formed literary and arts society composed of middle-class Nuevomexicanos. El Centro de Cultura's organization is described in A. Gabriel Meléndez, *So All Is Not Lost: The Poetics of Print in Nuevomexicano Communities, 1834–1958* (Albuquerque: University of New Mexico Press, 1997), 197–198.

Oddly, right before the culture center controversy broke, the founding member of El Centro de Cultura, Camilo Padilla, appeared to offer support to the principal supporter of the culture center plan, Edgar L. Hewett, the director of the Museum of New Mexico. On the cover of the January 1926 issue of his magazine, *La Revista Ilustrada*, Padilla ran a picture of the Museum of New Mexico, calling the museum "Edificio de uno de los Centros de Cultura Más Importantes del País" (*La Revista Ilustrada*, 13, no. 4, January 1926). Further research might reveal how Padilla saw the Museum of New Mexico, Hewett, and the various contingents of the Santa Fe Anglo art community and illuminate the opinions of Santa Fe's Nuevomexicano literary elite on the place of the arts and tourism within Santa Fe.

16. Mullin, *Culture in the Marketplace*, 102.

17. Although he dismisses the event as a "tempest in a teapot," Oliver La Farge includes an account of the controversy and comments on the insistence of everyone involved to dictate the future image of Santa Fe. See Oliver La Farge, *Santa Fe: The Autobiography of a Southwestern Town* (Norman: University of Oklahoma Press, 1959), 287–294 and Mullin, *Culture in the Marketplace*, 104.

18. My conclusions about the women of the Dodge circle and their strategic use of an idealized vision of home draw from the insights of both humanist and feminist geographers. In their celebration of New Mexico as a home, the members of Dodge's circle appeared to conform to the theory of some humanist geographers who argue that humans gravitate toward a dwelling place where they can feel at home, and that individuals associate positively with landscapes and dwelling places they call home. See, for example, Yi-Fu Tuan, *Topophilia: A Study of Environment Perception, Attitudes, and Values* (Englewood Cliffs, N.J.: Prentice Hall, 1974). Feminist geographers have criticized this vision of home for failing to acknowledge the work and suffering that so often dominate women's experiences in homes. See, for example, Linda McDowell and J. Sharp, eds., *Space, Gender, Knowledge: A Reader for Feminist Geographers* (London: Arnold, 1997). I believe the women of Dodge's circle attempted to overcome some of the problems women had historically experienced in their homes by recasting the broader New Mexico landscape as an extension of their individual houses, and, thus, their individual domains. That is, the women of Dodge's circle accepted the sexist assumptions that linked women with homes provided they could redefine the meaning of home itself. I have been strongly influenced in this opinion by the essays in Vera Norwood and Janice Monk, eds., *The Desert Is No Lady: Southwestern Landscapes in Women's Writing and Art* (New Haven, Conn.: Yale University Press, 1987), particularly Lois Rudnick's "Re-Naming the Land: Anglo Expatriate Women in the Southwest."

19. On the formation of the Texas Federation of Women's Clubs and its contributions to cultural institutions and social policy, see Megan Seaholm, "Earnest Women: The White Woman's Club Movement in Progressive Era Texas" (Ph.D. diss., Rice University, 1988), 335–445.

20. On the Better Homes Movement, see Karen E. Altman, "Consuming Ideology: The Better Homes in America Campaign," *Critical Studies in Mass Communication* 7, no. 3 (1990): 286–307, Janet Anne Hutchison, "American Housing, Gender, and the

Better Homes Movement, 1922–1935" (Ph.D. diss., University of Delaware, 1989), and Janet Anne Hutchinson, "Building for Babbitt: The State and the Suburban Home Ideal," *Journal of Policy History* 9, no. 2 (1997): 184–210.

21. Because Martin was always referred to as Mrs. W. C. Martin, I believe she was Sally Katherine Beene, the wife of William Clyde Martin, a Methodist minister in Dallas ("Martin, William Clyde," Handbook of Texas Online, www.tsha.utexas.edu/handbook/online (accessed 12 March 2007).

22. Texas Federation of Women's Clubs, *Texas Federation News* (November 1925), TFWCC.

23. Undated reports of the Fine Arts Division by Mrs. Guy E. Brown and Mrs. W. S. Douglas, TFWCC.

24. *Texas Federation News* (May 1925). Also see statement by James Chillman, Jr., in the 1924 Report on the Board of Directors' Meeting in which he enjoined federation members to "stop reading art reviews, etc., and start being artistic by making things beautiful at home" (TFWCC).

25. *Texas Federation News* (May 1925).

26. In linking the sentiments of the Better Homes Movement and arts appreciation, the Texas federation was in keeping with a wider trend in the 1920s General Federation of Women's Clubs that encouraged self-improvement through art study guides. Most of these focused on civic beautification and domestic decoration, themes far from the avant-garde interests of the Anglo women of the Santa Fe art community and therefore a potential source of contention between the two groups of women. See Kathleen D. McCarthy, *Women's Culture: American Philanthropy and Art, 1830–1930* (Chicago: University of Chicago Press, 1991), 187.

27. On the formation of an art community in Santa Fe and the central role Hewett played in forming a national image of Santa Fe, see Chauvenet, *Hewett and Friends*, La Farge, *Santa Fe*, Montgomery, *The Spanish Redemption*, 89–157, Gibson, *Santa Fe and Taos Colonies*, Chris Wilson, *The Myth of Santa Fe: Creating a Modern Regional Tradition* (Albuquerque: University of New Mexico Press, 1997), Marta Weigle and Kyle Fiore, *Santa Fe and Taos: The Writer's Era, 1916–1941* (Santa Fe: Ancient City Press, 1982), and Edna Robertson and Sarah Nestor, *Artists of the Canyons and Caminos: Santa Fe, the Early Years* (Santa Fe: Ancient City Press, 1976).

28. Wilson, *Myth of Santa Fe*, 116–168.

29. On the Fred Harvey Company, see Marta Weigle and Barbara Babcock, eds., *The Great Southwest of the Fred Harvey Company and the Santa Fe Railway* (Phoenix and Tucson: Heard Museum/University of Arizona Press, 1996), Leah Dilworth, *Imagining Indians in the Southwest* (Washington, D.C.: Smithsonian Institution Press, 1996), and Lesley Poling-Kempes, *The Harvey Girls: Women Who Opened the West* (New York: Paragon House, 1989).

30. Wilson, *Myth of Santa Fe*, 141, Montgomery, *Spanish Redemption*, 141, Dilworth, *Imagining Indians in the Southwest*, 18–19, Margaret Jacobs, *Engendered Encounters: Feminism and Pueblo Cultures, 1879–1934* (Lincoln: University of Nebraska Press, 1999), 57–58, Lois Rudnick, *Mabel Dodge Luhan: New Woman, New Worlds* (Albu-

querque: University of New Mexico Press, 1984), 144, and Wanda Corn, *The Great American Thing: Modern Art and National Identity, 1915–1935* (Berkeley: University of California Press, 1999), 253–256.

31. On the impact of gender on white women's experiences in northern New Mexico's arts and scholarly communities in the early twentieth century, see Jacobs, *Engendered Encounters*, Mullin, *Culture in the Marketplace*, Barbara Babcock and Nancy J. Parezo, eds., *Daughters of the Desert: Women Anthropologists and the Native American Southwest, 1880–1980* (Albuquerque: University of New Mexico Press, 1988), and Nancy J. Parezo, ed., *Hidden Scholars: Women Anthropologists and the American Southwest* (Albuquerque: University of New Mexico Press, 1993). In an introduction to the writings of Austin and John Muir, Ann H. Zwinger writes that in Santa Fe Austin "found support for her feminist views in the invigorating presence of these women artists and writers and in an ambiance that was beginning to acknowledge the abilities and power of the female mind." Ann H. Zwinger, introduction to Mary Austin and John Muir, *Writing the Western Landscape*, ed. Ann H. Zwinger (Boston: Beacon Press, 1994), xxi.

32. Margaret Jacobs sketches this argument more fully in *Engendered Encounters*, where she also contrasts the "preservationist" approach of women like Dodge and Austin to the assimilationist approach of female reformers who had preceded Dodge and Austin to the Southwest (Jacobs, *Engendered Encounters*, 169–171). Also see Dilworth, *Imagining Indians*, 125–126 and Eileen Boris, *Art and Labor: Ruskin, Morris, and the Craftsmen Ideal in America* (Philadelphia, Penn.: Temple University Press, 1985). Anna Carew-Miller has also noted that many of the Native American female characters in Austin's fiction struggle to balance identities as women and artists. Carew-Miller argues, however, that they are more often comfortable than Austin's white characters with the liminality that results from their struggle. Anna Carew-Miller, "Between Worlds, Crossing Borders: Mary Austin, Liminality, and the Dilemma of Women's Creativity," in Melody Graulich and Elizabeth Klimasmith, eds., *Exploring Lost Borders: Critical Essays on Mary Austin* (Reno: University of Nevada Press, 1999), 105–128. I would add that those characters Austin portrayed as most in tune with their local landscape were comfortable in a liminal position. Like Carew-Miller, I do not believe Austin was ever entirely comfortable as both woman and artist.

33. As Mullin has argued, many of the women in the Anglo art community relied on the national circulation of images of New Mexico for their livelihoods as writers, patrons, and artists. In praising New Mexico, they not only encouraged tourism, they encouraged commodification of northern New Mexico as a place (Mullin, *Culture in the Marketplace*, 80–82).

34. Elizabeth Shepley Sergeant to John Collier, Reel 4 or Box 11, John Collier Collection, Manuscripts and Archives, Sterling Library, Yale University, hereafter cited as JCC.

35. Henderson, "Dance Rituals of the Pueblo Indians," 1922 Series I, subseries C, Box 20, Alice Corbin Henderson Collection, Harry Ransom Humanities Research Center, University of Texas at Austin, hereafter cited as ACHC.

36. Mary Austin, "Why I Live in Santa Fe," *Golden Book Magazine* 16 (October 1932): 306, 307.

37. On Greenwich Village bohemian women's marital and internal conflicts over

how to balance their domestic duties with their careers, see Christine Stansell, *American Moderns: Bohemian New York and the Creation of a New Century* (New York: Metropolitan Books, 2000), 258–262. On feminist recasting of domestic space to equitably distribute domestic work, see Dolores Hayden, *The Grand Domestic Revolution: A History of Feminist Designs for American Homes, Neighborhoods, and Cities* (Cambridge: Massachusetts Institute of Technology Press, 1981).

38. Elizabeth Shepley Sergeant, "The Journal of a Mud House," *Harper's Magazine* (March 1922): 411.

39. Sergeant, "The Journal of a Mud House," *Harper's Magazine*, April 1922, 588, 590–1; March 1922, 419; and April 1922, 590.

40. Sergeant, "The Journal of a Mud House," *Harper's Magazine*, April 1922, 590.

41. Sergeant to Dodge, August 1925, MDLP.

42. Sergeant to Dodge, [n.d.], MDLP.

43. Given Sergeant's extensive experience in the suffrage movement and in women's education, she might well have been aware of Susan B. Anthony's speech "Homes of Single Women," in which she discussed the independence and personal fulfillment a home brought unmarried women. See Susan B. Anthony, "Homes of Single Women," October 1877, in *The Elizabeth Cady Stanton–Susan B. Anthony Reader, Correspondence, Writings, Speeches*, rev. ed., ed. Ellen Carol DuBois (Boston: Northeastern University Press, 1992), 146–151.

44. Alice Corbin Henderson, ed., *The Turquoise Trail: An Anthology of New Mexico Poetry* (New York: Houghton Mifflin, 1928).

45. Mary Austin, *The Land of Journey's Ending* (New York: Century, 1924), 439. Although technically not in the territory Austin identified as the land of journey's ending, Santa Fe and Taos appear in her account.

46. Austin, *Land of Journey's Ending*, 187.

47. Austin as quoted in "Mrs. Austin Goes to Desert for Inspiration; Charges America Ignores Its Creative Geniuses," *Brooklyn Eagle*, 6 December 1925, MAP. In many ways, Austin's views mirrored those of Charlotte Perkins Gilman. Both argued women had skills and experiences specifically as women that provided them with unique insights on social conditions. They extended their arguments into several realms, but, like many feminists of the time, they justified their support for women's suffrage with the argument that women's supposedly superior understanding of home life and personal interactions were necessary for the functioning of the nation. Many scholars would classify them as cultural feminists because their focus on women's differences from men often led them to conclude that women were better than men. See Gail Bederman, *Manliness and Civilization: A Cultural History of Gender and Race in the United States, 1880–1917* (Chicago: University of Chicago Press, 1995), 121–169 for a discussion of Gilman's attitudes toward gender, sex, and race. Interestingly, both Gilman and Austin amplified their primitivism through their perspectives on gender, a process more fully explored in Austin's case in Jacobs, *Engendered Encounters*, 82–105.

48. Mary Austin, *The Young Woman Citizen* (New York: Woman's Press, 1918), 42.

49. "Wife Has Right to Boss Home," *American Pictorial*, 3 November 1922, MAP.

50. Sergeant, "The Journal of a Mud House," *Harper's Magazine* (March 1922): 414.

51. Mary Austin in Ansel Adams and Mary Austin, *Taos Pueblo* (San Francisco: Grabhorn Press, 1930), 7.

52. The club women passed a resolution in November 1925 stating they would use the term *creative art center* until the entire Southwestern federation had an opportunity to vote on the official name of the cultural center. The resolution articulated an ambiguous attitude within the federation toward the term *chautauqua,* which had begun to evidence itself at least a year before. That even those Santa Feans who supported the culture center objected to the term *chautauqua* is apparent in Charles Doll, "Cultural Center of the Southwest," *Palacio* 20, no. 9 (1926): 171–181.

53. "God's Art Center in the Sacramentos," *Texas Federation News* clipping included in November 9–14, 1925, Report of the Southwestern Chautauqua or Centre of Creative Art and Culture, TFWCC.

54. *Dallas Morning News,* 24 September 1925, clipping in TFWCC.

55. W. C. Martin, "Report of the Southwestern Chautauqua or Centre of Creative Art and Culture," November 1925, TFWCC.

56. "Opposition to Club Cultural Colony Holds Meeting and Petitions the City Council," *Santa Fe New Mexican,* 24 April 1926, cited in La Farge, *Santa Fe,* 288.

57. Mary Austin, "The Town That Doesn't Want a Chautauqua," *New Republic* (7 July 1926), "The Last Stand against George Babbitt," *Bookman* (August 1926), "Bigger and Better," *TIME* (12 July 1926), and Kyle S. Crichton, "Philistine and Artist Clash in Battle in Santa Fe," *World* (27 June 1926). Paul A. F. Walter repeatedly called the *Santa Fe New Mexican*'s response to the culture center "vicious" in a letter to Hewett. See Walter to Hewett, 28 April 1926, Beatrice Chauvenet Collection AC 038, Box 2 Folder 15, Fray Angélico Chávez History Library, Museum of New Mexico, Santa Fe, New Mexico, U.S.A., hereafter cited as BCC.

58. La Farge, *Santa Fe,* 289.

59. "Old Santa Fe Fans in Fear of Main St. Menace," *Santa Fe New Mexican,* clipping in Box 1, File 9, E. Dana Johnson AC116, Fray Angélico Chávez History Library, Museum of New Mexico, Santa Fe, New Mexico, hereafter cited as EDJ.

60. "Cultural Colony Would Make City 'Flimsy Fair Ground,'" *Santa Fe New Mexican,* 5 June 1926, cited in La Farge, *Santa Fe,* 294.

61. Elizabeth White to Alfred Kidder, May 1926, cited in Mullin, *Culture in the Marketplace,* 102–104.

62. The women who delivered the letter were Mrs. Francis Wilson, the wife of a prominent Santa Fe attorney, and Mrs. Ashley Pond, the wife of the founder of a school in Los Alamos, New Mexico. See Texas Federated Women Clubs to Wilson and Pond, 10 November 1926, Box 2, Folder 15, BCC.

63. Bob Wear to M. F. Wynne, 5 December 1926, Box 2, Folder 15, BCC.

64. White as cited in Mullin, *Culture in the Marketplace,* 103 and Mary Austin, "The Town That Doesn't Want a Chautauqua," *New Republic* (7 July 1926): 195.

65. Mary Austin, "An Open Letter to Club Women and Business Men," MAP.

66. Austin, "An Open Letter," MAP. Austin may have chosen this forum to subtly

criticize the art communities of Carmel and Monterey, California, as well. Although she had benefited from the artists' colonies there, she believed both communities had fallen prey to the middlebrow sentiments she saw in the culture center.

67. Austin, "An Open Letter," MAP. Emphasis is Austin's.

68. Alma Whitaker, "Keep Out," undated, unidentified newspaper clipping, MAP.

69. Texas Federated Women Clubs to Wilson and Pond, 10 November 1926, Box 2, Folder 15, BCC.

70. "Texas Federation of Women's Clubs," Handbook of Texas Online.

71. For Evans's involvement in the tourist trade, see the Spanish and Indian Trading Company stationery and correspondence in John Evans to Mabel Dodge Luhan, 1924–1925, MDLP. For Corbin's appeal to city leaders regarding the Camino del Monte Sol see Weigle and Fiore, *Santa Fe and Taos*, 12. Wilson pays particular attention to the Anglo expatriate community's adoption of Pueblo style and Pueblo Spanish revival style architecture in Wilson, *Myth of Santa Fe*, 141–145.

72. Dodge to Sergeant, 7 October [1929], Elizabeth Shepley Sergeant Papers, Yale Collection of American Literature, Beinecke Rare Book and Manuscript Library, hereafter cited as ESSP.

73. Dodge to Austin, [1934], MAP.

74. Dodge to Austin, [1934], MAP.

Chapter 7: D. H. Lawrence's Place

1. D. H. Lawrence, *Sea and Sardinia*, ed. Mara Kalnis (Cambridge: Cambridge University Press, 1997 [1921]), 116–117.

2. Ibid., 57.

3. Mabel Dodge Luhan, *Lorenzo in Taos* (New York: Knopf, 1932).

4. Leo Stein to Mabel Dodge Luhan, 9 November 1921, Mabel Dodge Luhan Papers, Yale Collection of American Literature, Beinecke Rare Books and Manuscript Library, hereafter cited as MDLP.

5. D. H. Lawrence, *Phoenix: The Posthumous Papers of D. H. Lawrence*, ed. Edward D. McDonald (London: W. Heinemann, 1936), 142–143.

6. Dodge Luhan, *Lorenzo in Taos*, 12–13.

7. D. H. Lawrence to Mountsier, 9 July 1922, Lawrence to S. S. Koteliansky, 18 September 1922, Lawrence to Mountsier, 6 October 1922, Lawrence to Mountsier, 28 November 1922, in *The Letters of D. H. Lawrence*, vol. 4, *June 1921–March 1924*, ed. Warren Roberts, James T. Boulton, and Elizabeth Mansfield (Cambridge: Cambridge University Press, 1987), 274, 296, 318–319, 343–344.

8. D. H. Lawrence to Dodge, 10 April 1922, *Letters*, vol. 4, 225–226.

9. D. H. Lawrence, "Indians and an Englishman," in Lawrence, *Phoenix*, 92–99. First published in *Dial* (February 1923).

10. "Taos," in Lawrence, *Phoenix*, 100–103. First published as "At Taos, an Englishman Looks at Mexico," in *Cassell's Weekly* (11 July 1923).

11. D. H. did complete eight pages of a piece he called "The Willful Woman,"

based on Dodge's first arrival in New Mexico (D. H. Lawrence, "The Willful Woman," in *St. Mawr and Other Stories*, ed. Brian Finney [Cambridge: Cambridge University Press, 1983], 199–203). The short draft describes Dodge well; in fact her last book of memoirs, *Edge of Taos Desert*, appears to take its inspiration from Lawrence's efforts. Lawrence, at Frieda's insistence, never finished the novel.

12. Lois Rudnick, *Mabel Dodge Luhan: New Woman, New Worlds* (Albuquerque: University of New Mexico Press, 1984), 209–210.

13. *Santa Fe New Mexican*, 13 July 1929, 5. Literary critics, Dodge's biographers, and Bynner's interpreters concur that the play satirized Dodge. See Rudnick, *Mabel Dodge Luhan*, 245–248 and James Kraft, *Who Is Witter Bynner? A Biography* (Albuquerque: University of New Mexico Press, 1995), 55.

14. Witter Bynner, *Cake: An Indulgence* (New York: Knopf, 1926), Rudnick, *Mabel Dodge Luhan*, 245–248, and Kraft, *Who Is Witter Bynner?* 55.

15. Journal entry, 21 June 1934, Box 18, folder 1, Spud Johnson Collection, Harry Ransom Humanities Research Center, University of Texas at Austin, hereafter cited as SJC. When Johnson broke off a brief relationship with a woman, he concluded: "I'd like to return the organ & everything she's given me—except that I'd like to keep the blanket she gave me for Christmas until it gets warmer or I can afford to buy one!!" Journal entry, 15 January (1934), Journal 1, Box 18, folder 1, SJC.

16. Others in the Taos Anglo art community, including heterosexual women, felt similarly constrained by their financial dependence on their patrons. In January 1929 artist Dorothy Brett wrote to Johnson: "I have been cast out of the Studio!! I intend to build a wigwam for my very own—what does a leaky roof matter—It is infinitely less harmful than being at the mercy of the rich. But unlike you, I give Mabel a Hell of a time over these changes of hers." Dorothy Brett to Johnson, 25 January 1929, Box 5, SJC.

17. Dodge Luhan, *Lorenzo in Taos*, 4–5.

18. Witter Bynner, *Journey with Genius: Recollections and Reflections Concerning the D. H. Lawrences* (New York: J. Day, 1951), 150–152.

19. Interestingly, Bynner included in his memoir of traveling with Lawrence a chapter about homosexual relationships in Lawrence's writing. Bynner considered male homosexuality "a heroic theme throughout history, outbalancing the Sapphic theme" (Bynner, *Journey with Genius*, 281).

20. D. H. Lawrence to Thomas Seltzer, 15 June 1923, *Letters*, vol. 4, 457.

21. D. H. Lawrence to Lee and Nina Witt, 3 May 1923, *Letters*, vol. 4, 440.

22. D. H. Lawrence to Tomas Seltzer, 9 May 1923, *Letters*, vol. 4, 441–442.

23. Frieda Lawrence to Bessie Freeman, 30 May 1923, *Letters*, vol. 4, 450. Misspellings in original.

24. D. H. Lawrence to Dodge, 17 October 1923, *Letters*, vol. 4, 514.

25. The Lawrences' separation was the closest they came to ending their marriage. D. H. spent their time apart miserably until Frieda finally invited him to rejoin her in Europe. See "Introduction," *Letters*, vol. 4, 17.

26. Dodge Luhan to Van Vechten, Carl Van Vechten Collection, Beinecke Rare Book and Manuscript Library, Yale University, hereafter cited as CVVC.

27. Ann Douglas describes and provides the interpretation of "Cocksure Women, Hensure Men" that I summarize here in *Terrible Honesty: Mongrel Manhattan in the 1920s* (New York: Farrar, Straus, and Giroux, 1995), 544–545.

28. D. H. Lawrence, "Women Are So Cocksure," in Lawrence, *Phoenix,* 167–169.

29. D. H. Lawrence, "Dance of the Sprouting Corn," in *Mornings in Mexico* (Salt Lake City, Utah: Gibbs Smith, 1982 [1927]), 131.

30. These were "Indians and Entertainment," *Dial* (October 1924) and "The Hopi Snake Dance," *Theatre Arts Monthly* (December 1924).

31. Frieda Lawrence to Dodge, 3 July 1930, MDLP.

32. Letter from Dodge to Leo Stein, [n.d.], Leo Stein Collection, Yale Collection of American Literature, Beinecke Rare Book and Manuscript Library, hereafter cited as LSC. I follow Rudnick's lead in reading "The Woman Who Rode Away" as a revenge fantasy. Rudnick also notes that when Dodge was at Croton she began thinking of writing her memoirs, a break from her previous desire that a man interpret the place that she had embraced (Rudnick, *Mabel Dodge Luhan,* 219–221). Laurie McCollum offers an alternative reading of "The Woman Who Rode Away" in Keith Cushman and Earl G. Ingersoll, eds., "Ritual Sacrifice in 'The Woman Who Rode Away': A Girardian Reading," in *D. H. Lawrence: New Worlds* (Teaneck, N.J.: Fairleigh Dickinson University Press, 2003), 230–242.

33. Bynner to D. H. Lawrence, 19 January 1928, in *The Works of Witter Bynner: Selected Letters,* ed. James Kraft (New York: Farrar, Straus, and Giroux, 1981), 122.

34. Rudnick, *Mabel Dodge Lujan,* 223.

35. Lawrence, *Mornings in Mexico.*

36. Dodge to Leo Stein, 27 December 1923, MDLP.

37. Alice Henderson to Dodge, [n.d.], MDLP.

38. D. H. Lawrence, "Altitude," *Laughing Horse* 20 (Summer 1938).

39. D. H. Lawrence, "St. Mawr," in *St. Mawr and Other Stories,* 19–156. The reference to a serpent-bird was probably a reference to his own novel *The Plumed Serpent;* or, given that Lawrence began drafting *St. Mawr* before *The Plumed Serpent,* the reference may have been an earlier examination of the theme.

40. D. H. Lawrence, "A Little Moonshine with Lemon," in *D. H. Lawrence and New Mexico,* ed. Keith Sager (Salt Lake City, Utah: Gibbs Smith, 1982), 93–94.

41. D. H. Lawrence, "New Mexico," *Survey Graphic* (1 May 1931): 153.

42. Ibid., 153.

43. D. H. Lawrence, *Studies in Classic American Literature* (New York: Thomas Seltzer, 1923).

Epilogue: Georgia O'Keeffe's Place

1. The photograph was taken by Maria Chabot. The touring, educational, and arts advocacy group Recursos de Santa Fe used the image along with the "Women Who Rode Away: New Lives in the American Southwest" text to advertise a 1992 symposium.

2. Lois Rudnick, *Utopian Vistas: The Mabel Dodge Luhan House and the American Counterculture* (Albuquerque: University of New Mexico Press, 1996), 144–183.

3. Roxana Robinson, *Georgia O'Keeffe: A Life* (Hanover, N.H.: University Press of New England, 1989), 35–313.

4. Wanda Corn, *The Great American Thing: Modern Art and National Identity, 1915–1935* (Berkeley: University of California Press, 1999), 26.

5. O'Keeffe to Dodge, [n.d.], Mabel Dodge Luhan Papers, Yale Collection of American Literature, Beinecke Rare Book and Manuscript Library, hereafter cited as MDLP.

6. For an excellent discussion of O'Keeffe's work and its relationship to the quest for an American identity through modernism, see Corn, *Great American Thing*, 239–292. For a discussion of O'Keeffe's natural evocations in her art, see Bonnie L. Grad, "Georgia O'Keeffe's Lawrencean Vision," *Archives of American Art Journal* 38, nos. 3–4 (1998): 2–19, and Sharyn Udall, *Carr, O'Keeffe, Kahlo: Places of Their Own* (New Haven, Conn.: Yale University Press, 2000), 80–200.

7. *Creative Arts* 8, no. 6 (June 1931): 407–410 in Mabel Dodge Luhan Collection, Yale Collection of American Literature, Beinecke Rare Book and Manuscript Library, hereafter cited as MDLC.

8. Rebecca Strand to Dodge, 1929, MDLP.

9. Robinson, *Georgia O'Keeffe*, 313–467.

10. Ibid., 406–410 and 448–450.

11. Corn, *Great American Thing*, 239–292.

12. Udall, *Carr, O'Keeffe, Kahlo*, 186.

13. Corn, *Great American Thing*, 239–292.

14. Robinson, *Georgia O'Keeffe*, 508.

15. Laurie Lisle describes the behavior of O'Keeffe fans in "On Being Georgia O'Keeffe's First Biographer," in Christopher Merrill and Ellen Bradbury, eds., *From the Faraway Nearby: Georgia O'Keeffe as Icon* (Reading, Mass.: Addison-Wesley, 1992), 212–213.

16. Georgia O'Keeffe, *Georgia O'Keeffe* (New York: Viking Press, 1976).

17. *Georgia O'Keeffe* (dir. Perry Miller Adato, 1977), film produced by WNET/Thirteen. Reissued on VHS as Public Media Home Vision OKE 01.

18. "A Landmark Show," *New Mexico Magazine* (August 1975): 30.

19. "O'Keeffe," *New Mexico Magazine* (December 1976): 29.

20. David Turner, "Discovering An Unknown O'Keeffe," *New Mexico Magazine* (November 1984): 21.

21. Sheila Tryk, "O'Keeffe: Her Time, Her Place," *New Mexico Magazine* (May 1986): 48.

22. Sheldon Rich to O'Keeffe, 5 February 1973, Santa Fe Chamber Music Festival correspondence, 1973–1986 (hereafter cited as SFCMF), Alfred Stieglitz/Georgia O'Keeffe Archive, Yale Collection of American Literature, Beinecke Rare Book and Manuscript Library.

23. Sheldon Rich to O'Keeffe, 11 October 1975, SFCMF.

24. Sheldon Rich to O'Keeffe, 14 November 1975, SFCMF.

Selected Bibliography

Archival Sources

Archives of American Art, Smithsonian Institution, Washington, D.C.
 Andrew Dasburg–Grace Mott Johnson Papers
Beinecke Rare Book and Manuscript Library, Yale University
 Alfred Stieglitz/Georgia O'Keeffe Archive
 Carl Van Vechten Collection
 Elizabeth Shepley Sergeant Papers
 Hapgood Family Papers
 Jean Toomer Papers, James Weldon Johnson Collection
 Leo Stein Collection
 Mabel Dodge Luhan Collection
 Mabel Dodge Luhan Papers
 Maurice Sterne Papers
Center for Southwest Research, University of New Mexico
 American Indian Oral History Collection, Pueblo Interviews
Fray Angélico Chávez History Library, Museum of New Mexico, Santa Fe
 Beatrice Chauvenet Collection
 E. Dana Johnson Collection
Harry Ransom Humanities Research Center, University of Texas at Austin
 Alice Corbin Henderson Collection
 Spud Johnson Collection
Henry E. Huntington Library, San Marino, California
 Albert B. Fall Papers
 Mary Austin Papers
New Mexico State Records Center and Archives, Santa Fe
 Francis Wilson Papers
National Archives and Records Administration, Washington, D.C.
 General Services Files, Records of the Bureau of Indian Affairs, Record Group 75
National Archives and Records Administration, Rocky Mountain Region, Denver, Colo.
 Northern Pueblo Agency (1904–1937), Correspondence, Reports, and Other North-
 ern Pueblo Agency (1904–1937), 83 General Correspondence File (1911–1935),
 Records of the Bureau of Indian Affairs, Record Group 75

Records Relating to the Pueblo Lands Board, 1918–1932, Records of the Bureau of
 Indian Affairs, Record Group 75
Texas Woman's University, Denton, Texas
 Texas Federation of Women's Clubs Collection
Yale University, Manuscripts and Archives Division
 John Collier Collection

Periodicals

New Mexico Magazine
New York Times
Taos Valley News

Interviews

Alfred Lujan, 13 March 2002
Gilbert Suazo, 13 March 2002
Jimmy Suazo, 13 March 2002
Juan Suazo, 13 March 2002
Natividad Suazo, 13 March 2002

General Sources

Adams, David Wallace. *Education for Extinction: American Indians and the Boarding School Experience.* Lawrence: University Press of Kansas, 1995.
Adato, Perry Miller, dir. *Georgia O'Keeffe,* film produced by WNET/Thirteen, 1977. Reissued on VHS as Public Media Home Vision OKE 01.
Almaguer, Tomás. *Racial Fault Lines: The Historical Origins of White Supremacy in California.* Berkeley: University of California Press, 1994.
Altman, Karen E. "Consuming Ideology: The Better Homes in America Campaign." *Critical Studies in Mass Communication* 7, no. 3 (1990): 286–307.
Anthony, Susan B. "Homes of Single Women," October 1877. In Ellen Carol DuBois, ed., *The Elizabeth Cady Stanton–Susan B. Anthony Reader, Correspondence, Writings, Speeches,* rev. ed. Boston: Northeastern University Press, 1992.
Appelbaum, Nancy P., Anne S. Macpherson, and Karin Alejandra Rosemblatt, eds. *Race and Nation in Modern Latin America.* Chapel Hill: University of North Carolina Press, 2003.
Atwood, Stella. "The Case for the Indian." *Survey* (October 1922): 7–11, 57.
Austin, Mary. *The Young Woman Citizen.* New York: Woman's Press, 1918.
———. *The Land of Journey's Ending.* New York: Century, 1924.
———. "The Town That Doesn't Want a Chautauqua." *New Republic* (7 July 1926).
———. "Bigger and Better." *TIME* (12 July 1926).

———. "The Last Stand against George Babbitt." *Bookman* (August 1926).

———. *Earth Horizon*. New York: Literary Guild, 1932.

———. "Why I Live in Santa Fe." *Golden Book Magazine* 16 (October 1932): 306–307.

Austin, Mary and John Muir. *Writing the Western Landscape*, ed. Ann H. Zwinger. Boston: Beacon Press, 1994.

Babcock, Barbara. "'A New Mexican Rebecca': Imagining Pueblo Women." *Journal of the Southwest* 32, no. 4 (Winter 1990): 400–437.

Babcock, Barbara and Nancy J. Parezo, eds. *Daughters of the Desert: Women Anthropologists and the Native American Southwest, 1880–1980*. Albuquerque: University of New Mexico Press, 1988.

Becker, Jane. *Selling Tradition: Appalachia and the Construction of an American Folk, 1930–1940*. Chapel Hill: University of North Carolina Press, 1998.

Bederman, Gail. *Manliness and Civilization: A Cultural History of Gender and Race in the United States, 1880–1917*. Chicago: University of Chicago Press, 1995.

Benjamin, Walter. "On the Mimetic Faculty." In Peter Demetz, ed. Edmund Jephcott, trans., *Reflections, Essays, Aphorisms, Autobiographical Writings*, 333–336. New York: Harcourt Brace Jovanovich, 1978.

Benton, Katherine. "What about Women in the White Man's Camp? Gender, Nation, and the Redefinition of Race in Cochise County, Arizona, 1853–1941." Ph.D. diss., University of Wisconsin–Madison, 2002.

Berle, Adolf A. *Navigating the Rapids, 1918–1971*, in Beatrice Bishop Berle and Travis Beal Jacobs, eds., *The Papers of Adolf A. Berle*. New York: Harcourt Brace Jovanovich, 1973.

Bernard, Emily. "What He Did for the Race: Carl Van Vechten and the Harlem Renaissance." *Soundings: An Interdisciplinary Journal* 80, no. 4 (Winter 1997): 531–541.

———. *Remember Me to Harlem: The Letters of Langston Hughes and Carl Van Vechten, 1925–1964*. New York: Knopf, 2001.

Bernstein, Bruce and W. Jackson Rushing. *Modern by Tradition: American Indian Painting in the Studio Style*. Santa Fe: Museum of New Mexico Press, 1995.

Blair, Karen J. *The Clubwoman as Feminist: True Womanhood Redefined, 1868–1914*. New York: Holms and Meier, 1980.

Bodine, John. "A Tri-Ethnic Trap: The Spanish-Americans in Taos." In June Helm, ed., *Spanish-Speaking People in the United States*, 145–53. Seattle: University of Washington Press, 1968.

Bordewich, Fergus. M. *Killing the White Man's Indian: Reinventing Native Americans at the End of the Twentieth Century*. New York: Anchor, 1996.

Boris, Eileen. *Art and Labor: Ruskin, Morris, and the Craftsmen Ideal in America*. Philadelphia, Penn.: Temple University Press, 1985.

Boyce, Neith. *Intimate Warriors: Portraits of a Modern Marriage, 1899–1944*. Ellen Kay Trimberger, ed. New York: Feminist Press, 1991.

———. *The Modern World of Neith Boyce: Autobiography and Letters*, ed. Carol DeBoer-Langworthy. Albuquerque: University of New Mexico Press, 2003.

Briggs, Charles. *The Wood Carvers of Córdova, New Mexico: Social Dimensions of an Artistic "Revival."* Knoxville: University of Tennessee Press, 1980.

Brody, J. J. *Pueblo Indian Painting: Tradition and Modernism in New Mexico, 1900–1930.* Santa Fe: School of American Research Press, 1997.

Brooks, James. *Captives and Cousins: Slavery, Kinship, and Community in the Southwest Borderlands.* Chapel Hill: University of North Carolina Press, 2001.

Burns, Edward, ed. *The Letters of Gertrude Stein and Carl Van Vechten, 1913–1946.* New York: Columbia University Press, 1986.

Bustamante, Adrían Herminio. "Los Hispanos: Ethnicity and Social Change in New Mexico." Ph.D. diss., University of New Mexico, 1982.

Bynner, Witter. *Cake: An Indulgence.* New York: Knopf, 1926.

———. *Journey with Genius: Recollections and Reflections Concerning the D. H. Lawrences.* New York: J. Day, 1951.

———. *The Works of Witter Bynner: Selected Letters,* ed. James Kraft. New York: Farrar, Straus, and Giroux, 1981.

Carew-Miller, Anna. "Between Worlds, Crossing Borders: Mary Austin, Liminality, and the Dilemma of Women's Creativity." In Melody Graulich and Elizabeth Klimasmith, eds., *Exploring Lost Borders: Critical Essays on Mary Austin.* Reno: University of Nevada Press, 1999.

Carlson, Alvar. "Spanish-American Acquisition of Cropland within the Northern Pueblo Indian Grants, New Mexico." *Ethnohistory* 22, no. 2 (1975): 95–110.

Cather, Willa. *Death Comes for the Archbishop.* New York: Vintage Books, 1971 [1927].

Chauvenet, Beatrice. *Hewett and Friends: A Biography of Santa Fe's Vibrant Era.* Santa Fe: Museum of New Mexico Press, 1983.

Coke, Van Deren. *Andrew Dasburg.* Albuquerque: University of New Mexico Press, 1979.

Coleman, Leon. *Carl Van Vechten and the Harlem Renaissance: A Critical Assessment.* New York: Garland, 1998.

Collier, John. "Tenement Dwellers to Give Pageant of the Peoples." *New York Times Magazine* (24 May 1914): 53.

———. "Pageant of Nations Reviewed by 15,000." *New York Times,* 7 June 1914, Section IV, 5.

———. "Caliban of the Yellow Sands: The Shakespeare Pageant and Masque Reviewed against a Background of American Pageantry." *Survey* (July 1916): 342–350.

———. "The Red Atlantis." *Survey* (October 1922): 15–20, 63–66.

———. "Plundering the Pueblo Indians." *Sunset Magazine* (January 1923): 21–25, 56.

———. "The Pueblos' Last Stand." *Sunset Magazine* (February 1923): 19–22, 65–66.

———. "Our Indian Policy." *Sunset Magazine* (March 1923): 13–15, 89–93.

———. "No Trespassing." *Sunset Magazine* (May 1923): 14–15, 58–60.

———. "The American Congo." *Survey* (August 1923): 467–476.

———. "The Pueblos' Land Problem." *Sunset Magazine* (November 1923): 15, 101.

———. *From Every Zenith: A Memoir; and Some Essays on Life and Thought.* Denver, Colo.: Alan Swallow, 1963.

Corn, Wanda. *The Great American Thing: Modern Art and National Identity, 1915–1935.* Berkeley: University of California Press, 1999.

Crichton, Kyle S. "Philistine and Artist Clash in Battle in Santa Fe." *World,* 27 June 1926.

Crunden, Robert M. *Body and Soul: The Making of American Modernism*. New York: Basic Books, 2000.

Deacon, Desley. *Elsie Clews Parsons: Inventing Modern Life*. Chicago: University of Chicago Press, 1997.

deBuys, William. *Enchantment and Exploitation: The Life and Hard Times of a New Mexico Mountain Range*. Albuquerque: University of New Mexico Press, 1985.

Deloria, Philip. *Playing Indian*. New Haven, Conn.: Yale University Press, 1998.

———. *Indians in Unexpected Places*. Lawrence: University Press of Kansas, 2004.

Deutsch, Sarah. *No Separate Refuge: Culture, Class, and Gender on an Anglo-Hispanic Frontier in the American Southwest, 1880–1940*. New York: Oxford University Press, 1987.

Dilworth, Leah. *Imagining Indians in the Southwest: Persistent Visions of a Primitive Past*. Washington D.C.: Smithsonian Institution Press, 1996.

Doll, Charles. "Cultural Center of the Southwest." *Palacio* 20, no. 9 (1926): 171–181.

Douglas, Ann. *A Terrible Honesty: Mongrel Manhattan in the 1920s*. New York: Farrar, Straus, and Giroux, 1995.

Dubofsky, Melvyn. *We Shall Be All: A History of the Industrial Workers of the World*. Chicago: Quadrangle, 1969.

Eldridge, Charles, Julie Schimmel, and William Truettner, eds. *Art in New Mexico, 1900–1945: Paths to Taos and Santa Fe*. Washington, D.C., and New York: Smithsonian Institution/Abbeville Press, 1986.

Everett, Patricia. "Andrew Dasburg's Abstract Portraits: Homages to Mabel Dodge Luhan and Carl Van Vechten." *Smithsonian Studies in American Art* 3, no. 1 (Winter 1989): 73–87.

———. *A History of Having a Great Many Times Not Continued to Be Friends: The Correspondence between Mabel Dodge and Gertrude Stein, 1911–1934*. Albuquerque: University of New Mexico Press, 1996.

Filene, Benjamin. *Romancing the Folk: Public Memory and American Roots Music*. Chapel Hill: University of North Carolina Press, 2000.

Fink, Augusta. *I-Mary: A Biography of Mary Austin*. Tucson: University of Arizona Press, 1983.

Foley, Neil. *The White Scourge: Mexicans, Blacks, and Poor Whites in Texas Cotton Culture*. Berkeley: University of California Press, 1997.

Forrest, Suzanne. *The Preservation of the Village: New Mexico's Hispanics and the New Deal*. Albuquerque: University of New Mexico Press, 1989.

Frank, Ross. *From Settler to Citizen: New Mexican Economic Development and the Creation of Vecino Society, 1750–1820*. Berkeley: University of California Press, 2000.

Franscina, Francis and Charles Harrison, eds. *Modern Art and Modernism: A Critical Anthology*. London: Harper and Row, 1982.

Frazer, Winifred. *Mabel Dodge Luhan*. Boston: Twayne, 1984.

Gibson, Arrell Morgan. *The Santa Fe and Taos Colonies: Age of the Muses, 1900–1942*. Norman: University of Oklahoma Press, 1983.

Grad, Bonnie L. "Georgia O'Keeffe's Lawrencean Vision." *Archives of American Art Journal* 38, no. 3–4 (1998): 2–19.

Green, Martin. *New York, 1913: The Armory Show and the Paterson Pageant*. New York: Charles Scribner's Sons, 1988.

Guilbaut, Serge. *How New York Stole the Idea of Modern Art: Abstract Expressionism, Freedom, and the Cold War*. Chicago: University of Chicago Press, 1983.

Gutiérrez, Ramón. *When Jesus Came, the Corn Mothers Went Away: Marriage, Sexuality, and Power in New Mexico, 1500–1846*. Palo Alto, Calif.: Stanford University Press, 1991.

Hahn, Emily. *Mabel: A Biography of Mabel Dodge Luhan*. Boston: Houghton Mifflin, 1977.

Hall, Emlen. "The Pueblo Land Grant Labyrinth." In Charles L. Briggs and John R. Van Ness, eds., *Land, Water, and Culture: New Perspectives on Hispanic Land Grants*, 117–126. Albuquerque: University of New Mexico Press, 1987.

Hapgood, Hutchins. *The Spirit of the Ghetto: Studies of the Jewish Quarter in New York*. New York: Funk and Wagnalls, 1902.

———. *A Victorian in the Modern World*. New York: Harcourt, Brace, 1939; reprint, Seattle: University of Washington Press, 1972.

Hayden, Dolores. *The Grand Domestic Revolution: A History of Feminist Designs for American Homes, Neighborhoods, and Cities*. Cambridge: Massachusetts Institute of Technology Press, 1981.

Heller, Adele and Lois Rudnick, eds. *1915, The Cultural Moment: The New Politics, the New Woman, the New Psychology, the New Art, and the New Theatre in America*. New Brunswick, N.J.: Rutgers University Press, 1991.

Henderson, Alice Corbin. "Death of the Pueblos." *New Republic* (29 November 1922): 11–13.

Henderson, Alice Corbin, ed. *The Turquoise Trail: An Anthology of New Mexico Poetry*. New York: Houghton Mifflin, 1928.

Hilliard, Kay. "The Texas Federation of Women's Clubs and the Santa Fe Culture Colony." MA thesis, Southern Methodist University, 1996.

Hine, Robert V. *California Utopian Colonies*. New Haven, Conn.: Yale University Press, 1953.

Hoffman, Frederick J. *The 1920s: American Writing in the Postwar Decade*. New York: Free Press, 1949.

Holloway, Mark. *Heavens on Earth: Utopian Communities in America*. New York: Dover, 1966.

Hoxie, Frederick. *A Final Promise: The Campaign to Assimilate the Indians, 1880–1920*. Lincoln: University of Nebraska Press, 1984.

Huggins, Nathan. *Harlem Renaissance*. New York: Oxford University Press, 1971.

Hughes, Langston. *The Big Sea: An Autobiography*. New York: Knopf, 1940; reprint, New York: Hill and Wang, 1993.

———. *Selected Poems of Langston Hughes*. New York: Vintage Books, 1959.

Hutchison, Janet Anne. "American Housing, Gender, and the Better Homes Movement, 1922–1935." Ph.D. diss., University of Delaware, 1989.

———. "Building for Babbitt: The State and the Suburban Home Ideal." *Journal of Policy History* 9, no. 2 (1997): 184–210.

Jackson, J. B. *The Necessity for Ruins and Other Topics*. Amherst: University of Massachusetts Press, 1980.

——. *A Sense of Place, a Sense of Time*. New Haven, Conn.: Yale University Press, 1994.

Jacobs, Margaret. *Engendered Encounters: Feminism and Pueblo Cultures, 1879–1934*. Lincoln: University of Nebraska Press, 1999.

Johnson, James Weldon. *Black Manhattan*. New York: Knopf, 1930.

Kanter, Rosabeth Moss. *Commitment and Community: Communes and Utopias in Sociological Perspective*. Cambridge Mass.: Harvard University Press, 1972.

Katz, Friedrich. *The Life and Times of Pancho Villa*. Palo Alto, Calif.: Stanford University Press, 1998.

Kellner, Bruce. *Carl Van Vechten and the Irreverent Decades*. Norman: University of Oklahoma Press, 1968.

Kelly, Lawrence. "Choosing the New Deal Indian Commissioner: Ickes vs. Collier." *New Mexico Historical Review* 49, no. 4 (1974): 269–284.

——. *The Assault on Assimilation: John Collier and the Origins of Indian Policy Reform*. Albuquerque: University of New Mexico Press, 1983.

Kraft, James. *Who Is Witter Bynner? A Biography*. Albuquerque: University of New Mexico Press, 1995.

Krech, Shepherd. *The Ecological Indian: Myth and History*. New York: Norton, 1999.

Kropp, Phoebe. *California Vieja: Culture and Memory in a Modern American Place*. Berkeley: University of California Press, 2006.

La Farge, Oliver. *Santa Fe: The Autobiography of a Southwestern Town*. Norman: University of Oklahoma Press, 1959.

Lawrence, D. H. *Sea and Sardinia*, ed. Mara Kalnis. Cambridge: Cambridge University Press, 1997 [1921].

——. *Studies in Classic American Literature*. New York: Thomas Seltzer, 1923.

——. "Indians and Entertainment." *Dial* (October 1924).

——. "The Hopi Snake Dance." *Theatre Arts Monthly* (December 1924).

——. *The Plumed Serpent*. New York: A.A. Knopf, 1926.

——. *Mornings in Mexico*. Salt Lake City, Utah: Gibbs M. Smith, 1982 [1927].

——. "New Mexico." *Survey Graphic* (1 May 1931).

——. *Phoenix: The Posthumous Papers of D. H. Lawrence*. New York: Viking, 1936.

——. "Altitude." *Laughing Horse* 20 (Summer 1938).

——. "Moonshine with Lemon." In Keith Sager, ed., *D. H. Lawrence and New Mexico*. Salt Lake City, Utah: Gibbs M. Smith, 1982.

——. *St. Mawr and Other Stories*, ed. Brian Finney. Cambridge: Cambridge University Press, 1983.

——. *The Letters of D. H. Lawrence*, ed. James T. Boulton. Cambridge: Cambridge University Press, 1987.

Lears, T. J. Jackson. *No Place of Grace: Antimodernism and the Transformation of American Culture, 1880–1920*. New York: Pantheon, 1981.

Lewis, Edith. *Willa Cather Living: A Personal Record*. New York: Knopf, 1953.

Lewis, David Levering. *When Harlem Was in Vogue*. New York: Penguin, 1997.

Lippard, Lucy. *The Lure of the Local: Senses of Place in a Multicentered Society.* New York: New Press, 1997.

Lisle, Laurie. "On Being Georgia O'Keeffe's First Biographer." In Christopher Merrill and Ellen Bradbury, eds., *From the Faraway Nearby: Georgia O'Keeffe as Icon.* Reading, Mass.: Addison-Wesley, 1992.

Ludington, Townsend. *Marsden Hartley: The Biography of an American Artist.* Ithaca: Cornell University Press, 1992.

Lueders, Edward. *Carl Van Vechten and the Twenties.* Albuquerque: University of New Mexico Press, 1955.

Luhan, Mabel Dodge. "A Bridge between Cultures." *Theatre Arts Monthly* 9, no. 5 (1925): 297–301.

———. "The Santos of New Mexico." *Arts* 3, no. 3 (March 1925): 127–137.

———. *Lorenzo in Taos.* New York: Knopf, 1932.

———. *Intimate Memories: Background.* New York: Harcourt, Brace, 1933.

———. *European Experiences: Volume Two of Intimate Memories.* New York: Harcourt, Brace, 1935.

———. *Winter in Taos.* New York: Harcourt, Brace, 1935.

———. *Movers and Shakers: Volume Three of Intimate Memories.* New York: Harcourt, Brace, 1936.

———. *Edge of Taos Desert: An Escape to Reality: Volume Four of Intimate Memories.* New York: Harcourt, Brace, 1937.

Massmann, Ann. "Adelina 'Nina' Otero-Warren: A Spanish-American Cultural Broker." *Journal of the Southwest* 42, no. 4 (Winter 2000).

McCabe, Tracy. "Resisting Primitivism: Race, Gender, and Power in Modernism and the Harlem Renaissance." Ph.D. diss., University of Wisconsin–Madison, 1994.

McCarthy, Kathleen D. *Women's Culture: American Philanthropy and Art, 1830–1930.* Chicago: University of Chicago Press, 1991.

McClintock, Anne. *Imperial Leather: Race, Gender, and Sexuality in the Colonial Context.* New York: Routledge, 1995.

McCollum, Laurie. "Ritual Sacrifice in 'The Woman Who Rode Away': A Girardian Reading." In Keith Cushman and Earl G. Ingersoll, eds., *D. H. Lawrence: New Worlds.* Teaneck: Fairleigh Dickinson University Press, 2003.

McDowell, Linda and J. Sharp, eds. *Space, Gender, Knowledge: A Reader for Feminist Geographers.* London: Arnold, 1997.

McKay, Nellie. *Jean Toomer, Artist: A Study of His Literary Life and Work, 1894–1936.* Chapel Hill: University of North Carolina Press, 1987.

McWilliams, Carey. *Southern California Country: An Island on the Land.* New York: Duell, Sloan, and Pearce, 1946.

Meléndez, A. Gabriel. *So All Is Not Lost: The Poetics of Print in Nuevomexicano Communities, 1834–1958.* Albuquerque: University of New Mexico Press, 1997.

Meyer, Carter Jones. "The Battle between 'Art' and 'Progress': Edgar L. Hewett and the Politics of Region in the Early-Twentieth-Century Southwest." *Montana: The Magazine of Western History* 56, no. 3 (Autumn 2006): 47–59.

Montgomery, Charles. *The Spanish Redemption: Heritage, Power, and Loss on New Mexico's Upper Rio Grande*. Berkeley: University of California Press, 2002.

Mullin, Molly H. *Culture in the Marketplace: Gender, Art, and Value in the American Southwest*. Durham, N.C.: Duke University Press, 2001.

Mumford, Kevin J. *Interzones: Black/White Sex Districts in Chicago and New York in the Early Twentieth Century*. New York: Columbia University Press, 1997.

Nieto-Phillips, John. *The Language of Blood: The Making of Spanish-American Identity in New Mexico, 1880s–1930s*. Albuquerque: University of New Mexico Press, 2004.

Nostrand, Richard L. *The Hispano Homeland*. Norman: University of Oklahoma Press, 1992.

O'Keeffe, Georgia. *Georgia O'Keeffe*. New York: Viking Press, 1976.

Orth, Michael. "Ideality to Reality: The Founding of Carmel." *California Historical Society Quarterly* 48 (1959): 195–210.

Orvell, Miles. *The Real Thing: Imitation and Authenticity in American Culture, 1880–1940*. Chapel Hill: University of North Carolina Press, 1989.

Otero-Warren, Nina. *Old Spain in Our Southwest*. New York: Harcourt Brace, 1936; reprint, Chicago: Rio Grande Press, 1962.

Padilla, Camilo. *La Revista Ilustrada* 13, no. 4 (January 1926).

Padilla, Genaro M. *My History, Not Yours: The Formation of Mexican American Autobiography*. Madison: University of Wisconsin Press, 1993.

Parezo, Nancy J., ed. *Hidden Scholars: Women Anthropologists and the American Southwest*. Albuquerque: University of New Mexico Press, 1993.

Pearce, T. M. *Alice Corbin Henderson*. Austin, Tex.: Steck, Vaughn, 1969.

Peterson, Theodore. *Magazines in the Twentieth Century*. Urbana: University of Illinois Press, 1964.

Philp, Kenneth. "Albert Fall and the Protest from the Pueblos, 1921–1923." *Arizona and the West* 12, no. 3 (1970): 237–254.

———. *John Collier's Crusade for Indian Reform, 1920–1954*. Tucson: University of Arizona Press, 1977.

Poling-Kempes, Lesley. *The Harvey Girls: Women Who Opened the West*. New York: Paragon House, 1989.

Porter, Dean, Teresa Hayes Ebie, and Suzan Campbell, eds. *Taos Artists and Their Patrons, 1898–1950*. Notre Dame, Ind.: University of Notre Dame, Snite Museum of Art, 1999.

Reed, John. *Insurgent Mexico*. 1914; reprint, New York: International, 1969.

Reed, Maureen. *A Woman's Place: Women Writing New Mexico*. Albuquerque: University of New Mexico Press, 2005.

Reich, Sheldon. *Andrew Dasburg: His Life and Art*. Lewisburg, Ohio: Bucknell University Press, 1989.

Robertson, Edna and Sarah Nestor. *Artists of Canyons and Caminos: Santa Fe, the Early Years*. Salt Lake City, Utah: Gibbs M. Smith, 1982.

Robinson, Roxana. *Georgia O'Keeffe: A Life*. Hanover, N.H.: University Press of New England, 1989.

Rodríguez, Sylvia. "Art, Tourism, and Race Relations in Taos: Toward a Sociology of the Art Colony." *Journal of Anthropological Research* 45, no. 1 (1989): 77–99.

Rosaldo, Renato. "Imperialist Nostalgia." *Representations* 26 (Spring 1989): 107–122.

Rosenstone, Robert. *Romantic Revolutionary: A Biography of John Reed.* New York: Vintage, 1975.

Rothman, Hal. *Devil's Bargains: Tourism in the Twentieth-Century American West.* Lawrence: University Press of Kansas, 1998.

Rousseau, Jean-Jacques. *A Discourse on Inequality,* trans. Maurice Cranston. New York: Penguin, 1984 [1775].

Rudnick, Lois. *Mabel Dodge Luhan: New Woman, New Worlds.* Albuquerque: University of New Mexico Press, 1984.

———. *Utopian Vistas: The Mabel Dodge Luhan House and the American Counterculture.* Albuquerque: University of New Mexico Press, 1996.

Rushing, W. Jackson. *Native American Art and the New York Avant-Garde: A History of Cultural Primitivism.* Austin: University of Texas Press, 1995.

Sando, Joe S. *Pueblo Nations: Eight Centuries of Pueblo Indian History.* Santa Fe, N.M.: Clear Light, 1992.

———. *Pueblo Profiles: Cultural Identity through Centuries of Change.* Santa Fe, N.M.: Clear Light, 1998.

Schwartz, E. A. "Red Atlantis Revisited: Community and Culture in the Writings of John Collier." *American Indian Quarterly* 18, no. 4 (1994): 507–531.

Scott, Anne Firor. *Natural Allies: Women's Associations in American History.* Urbana: University of Illinois Press, 1991.

Seaholm, Megan. "Earnest Women: The White Woman's Club Movement in Progressive Era Texas." Ph.D. diss., Rice University, 1988.

Seideman, David. *The New Republic: A Voice of Modern Liberalism.* New York: Praeger, 1986.

Sergeant, Elizabeth S. "The Journal of a Mud House." *Harper's Magazine* (March–April 1922).

———. "Big Powwow of Pueblos." *New York Times,* 26 November 1922, 69.

———. "Last First Americans." *Nation* (29 November 1922): 570.

Singal, David. "Towards a Definition of American Modernism." *American Quarterly* 38 (Spring 1987): 7–26.

Slotkin, Richard. *Regeneration through Violence.* Middletown, Conn.: Wesleyan University Press, 1973.

———. *Gunfighter Nation: The Myth of the Frontier in Twentieth-Century America.* New York: Atheneum, 1992.

Smalls, James. *The Homoerotic Photography of Carl Van Vechten: Public Face, Private Thoughts.* Philadelphia, Penn.: Temple University Press, 2006.

Smith, Sherry. *Reimagining Indians: Native Americans through Anglo Eyes, 1880–1940.* Oxford: Oxford University Press, 2000.

Stansell, Christine. *American Moderns: Bohemian New York and the Creation of a New Century.* New York: Metropolitan, 2000.

Starr, Kevin. *Americans and the California Dream: 1850–1915*. New York: Oxford University Press, 1973.

Sterne, Maurice. *Shadow and Light: The Life, Friends, and Opinions of Maurice Sterne*, ed. Charlotte Leon Mayerson. New York: Harcourt, Brace, 1952.

Stineman, Esther Lanigan. *Mary Austin: Song of a Maverick*. New Haven, Conn.: Yale University Press, 1989.

Stoler, Ann. *Race and the Education of Desire: Foucault's History of Sexuality and the Colonial Order of Things*. Durham, N.C.: Duke University Press, 1995.

Szold, Bernadine. "About Town." *New York Daily News*, 22 March 1925, 46.

Taussig, Michael. *Mimesis and Alterity: A Particular History of the Senses*. London: Routledge, 1993.

Toomer, Jean. *Cane*. New York: Liveright, 1975 [1923].

Torgovnick, Marianna. *Gone Primitive, Savage Intellects, Modern Lives*. Chicago: University of Chicago Press, 1990.

Trilling, Lionel. *Sincerity and Authenticity*. Cambridge, Mass.: Harvard University Press, 1972.

Tuan, Yi-Fu. *Topophilia: A Study of Environmental Perception, Attitude, and Values*. Englewood Cliffs, N.J.: Prentice Hall, 1974.

Tuck, Jim. *Pancho Villa and John Reed: Two Faces of Romantic Revolution*. Tucson: University of Arizona Press, 1984.

Udall, Sharyn. *Carr, O'Keeffe, Kahlo: Places of Their Own*. New Haven, Conn.: Yale University Press, 2000.

United States v. Joseph, 94 U.S. 614 (1876).

United States v. Sandoval, 352 (1913).

Usner, Don. *Sabino's Map: Life in Chimayo's Old Plaza*. Santa Fe, N.M.: Museum of New Mexico Press, 1995.

U.S. Senate. An Act to Ascertain and Settle Land Claims of Persons Not Indian within Pueblo Indian Land, Land Grants, and Reservations in the State of New Mexico. 67th Cong., 2nd sess., S. 3855.

———. Senate Subcommittee of the Committee on Public Lands and Surveys, Bills Relative to the Pueblo Indian Lands, Hearings on S. 3865 and S. 4223, 67th Cong., 4th sess., 23 January 1923, 189–202.

Van Vechten, Carl. *Peter Whiffle: His Life and Works*. New York: Knopf, 1922.

———. "'The Book of American Negro Spirituals': Review." *Opportunity* 3 (1925): 330.

———. "A Prescription for the Negro Theatre." *Vanity Fair*, October 1925.

———. *Nigger Heaven*. New York: Knopf, 1926.

———. "'Moanin' wid a Sword in Ma Han'." *Vanity Fair* (February 1926).

———. "Mean Ole Miss Blues Becomes Respectable." *New York Herald Books* (6 June 1926).

———. "Hey, Hey." *New York Herald Books* (31 October 1926).

Waters, Frank. *Masked Gods: Navajo and Pueblo Ceremonialism*. New York: Ballantine Books, 1960 [1950].

Watson, Steven. *The Harlem Renaissance: Hub of African-American Culture, 1920–1930.* New York: Pantheon, 1997.

———. *Prepare for Saints: Gertrude Stein, Virgil Thomson, and the Mainstreaming of American Modernism.* Berkeley: University of California Press, 1995.

Weigle, Marta. "Southwest Lures: Innocents Detoured, Incensed Determined." *Journal of the Southwest* 32, no. 4 (Winter 1990): 499–540.

Weigle, Marta and Barbara Babcock, eds. *The Great Southwest of the Fred Harvey Company and the Santa Fe Railway.* Phoenix and Tucson: Heard Museum/University of Arizona Press, 1996.

Weigle, Marta and Kyle Fiore. *Santa Fe and Taos: The Writer's Era, 1916–1941.* Santa Fe, N.M.: Ancient City Press, 1982.

Wenger, Tisa. "Savage Debauchery or Sacred Communion? Religion and the Primitive in the Pueblo Dance Controversy." Ph.D. diss., Princeton University, 2002.

———. "Land, Culture, and Sovereignty in the Pueblo Dance Controversy." *Journal of the Southwest* 46, no. 2 (Fall 2004): 381–412.

Whaley, Charlotte. *Nina Otero-Warren of Santa Fe.* Albuquerque: University of New Mexico Press, 1994.

Wilson, Chris. *The Myth of Santa Fe: Creating a Modern Regional Tradition.* Albuquerque: University of New Mexico Press, 1997.

Wolff, Janet. *AngloModern: Painting and Modernity in Britain and the United States.* Ithaca, N.Y.: Cornell University Press, 2003.

Wood, James Playsted. *Magazines in the United States.* New York: Ronald Press, 1971.

Index